British Painters
of the Coast and Sea

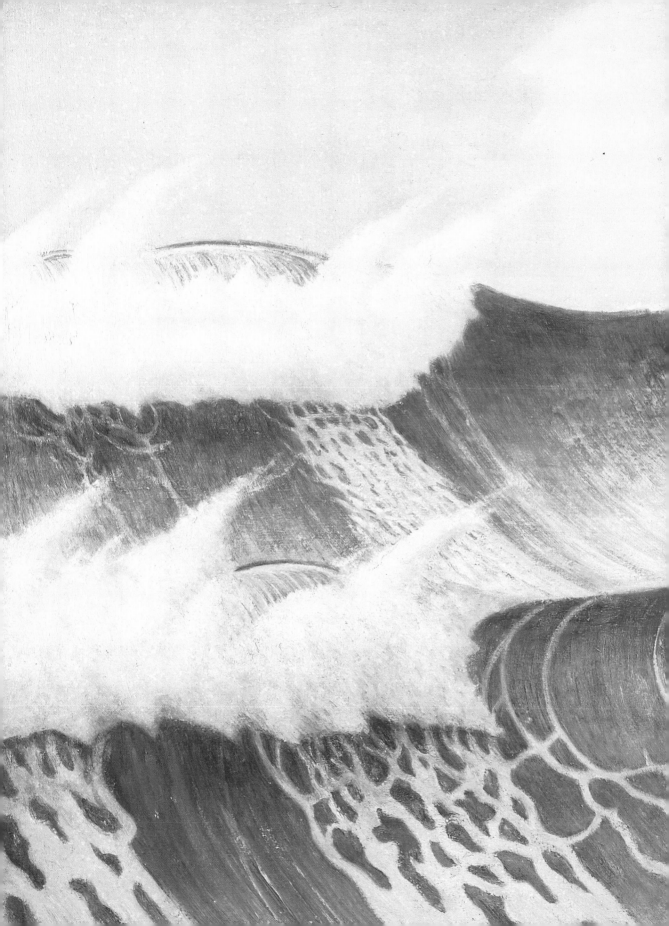

British Painters of the Coast and Sea

A History and Gazetteer

Charles Hemming

London
Victor Gollancz Ltd
1988

Acknowledgements

The Author and Publishers would like to thank the many curators and librarians for their help in tracing pictures and for their permission to use photographs. The source of each picture is acknowledged in the picture caption. Where the source of the photograph is different, this is mentioned below: for *Lovers on the Beach* by Richard Eurich our many thanks to the artist; for *Waterspout on the Solent* by Richard Eurich our thanks to The Fine Art Society Ltd, London; for *Dead Resort, Kemp Town* by John Piper, the Courtauld Institute of Art; for *The Avon Gorge at Sunset* by Nicholas Pocock, Bristol Museum and Art Galleries; and for *The Old East India Quay* by Samuel Scott, the Victoria and Albert Museum.

First published in Great Britain 1988
by Victor Gollancz Ltd
14 Henrietta Street, London WC2E 8QJ

© Charles Hemming 1988

British Library Cataloguing in Publication Data
Hemming, Charles
 British painters of the coast and sea :
 a history and gazetteer.
 1. British seascape paintings, 1650–1987.
 Biographies. Collections
 I. Title
 758'.2'0922

 ISBN 0-575-03956-6

Designed by Harold Bartram

Typeset by Centracet
Printed and bound in Great Britain by
Butler & Tanner Ltd, Frome

On previous page
John Everett (1876–1949) *Seascape* Oil on canvas 27¼in × 43in (National Maritime Museum, London)

Contents

List of Illustrations

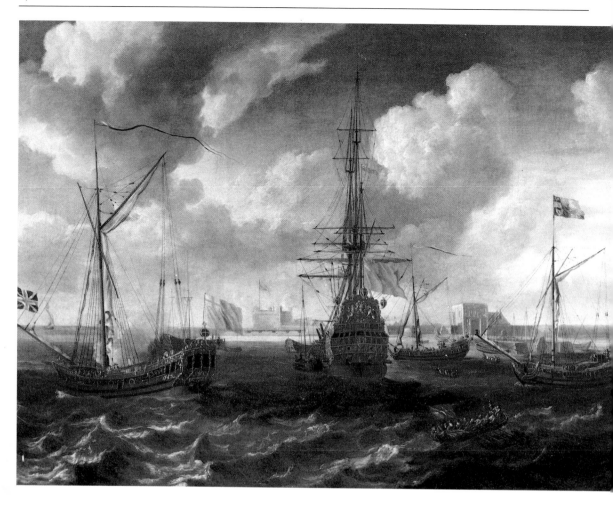

Isaac Sailmaker (1633–1721) attributed to *The Royal Yacht off Sheerness* Oil on canvas 42½in × 68¼in (Ferens Art Gallery, Kingston upon Hull)

Overleaf Willem van de Velde the Younger (1633–1707) *Dutch Vessels Close Inshore at Low Tide, with Men Bathing* Oil on canvas 24⅞in × 28⅜in (National Gallery, London)

Introduction

When Willem van de Velde arrived in England in the winter of 1672, to escape his wife, two illegitimate children, the invading army of Louis XIV, and the widespread flooding released to keep the French out, he was accompanied by his son, Willem the Younger, and Charles II of England acquired the services of the two most eminent marine artists of the day.

'He said he did not know if the English were interested in his pictures or in other fine things,' wrote Pieter Blaeu in a letter describing a meeting with the elder van de Velde in 1674. 'He had certainly done very little and had never done anything for anybody other than His Majesty and the Duke of York, and that kept him totally occupied.'

Willem the Elder had good cause to doubt the interest in painting of a maritime nation which had produced no indigenous marine artists. His own countrymen, such as Jan Siberechts, were responsible for the introduction of landscape pictures into England, an art form which they had developed from pictures of towns and mansions used to decorate maps, and Dutch marine art had grown from similar portraits of harbours and the capital ships in them. In England these two kinds of painting were to remain separate until the middle of the seventeenth century.

Just as their landscape or 'prospect' pictures featured mainly houses, not the land, Dutch marine pictures dealt principally with ships and only incidentally with the sea. The sea was portrayed as a finely stylized, shining rug, a lace cloth upon which vessels were displayed, usually as symbols of power and prestige. Unless their masters had displeased Providence, the sea was not seen to overpower them. When they lay off a headland or harbour it was given by name in the title, and its skyline was faithfully observed. So was the sumptuous carving and the portraits of towns which were accurately painted on the tafferels of capital ships, and so was the rig and every detail of the vessel, in the manner of a stately marine home. Shadows were distributed across the sea around them, as paths were laid out in formal gardens, to give perspective and a sense of depth. The foreground was dark, as it was in landscape pictures. Light was focused around the ship, the place of power and harmony, and shadows occurred further out to sea again, in the remote or 'desert' regions.

Willem and his son were not the first marine artists of any substance working in England. The aptly named Isaac Sailmaker (1633–1721) was painting in London when they arrived, and according to Sir Horace Walpole Sailmaker had been commissioned by Cromwell to 'take a view of the fleet before Mardyke'. He was a 'Flemming' and an apprentice to Georg Geldorp who was employed to 'oversee the King's pictures'. The small number of his works which survive reveal that he painted in a basic version of the Dutch style, making portraits of ships side on, stern and bow view. He was rather more vigorous than his pictures, outlived both van de Veldes and worked on well into the eighteenth century, having been a member of their studio, and probably copyist, before dying at eighty-eight.

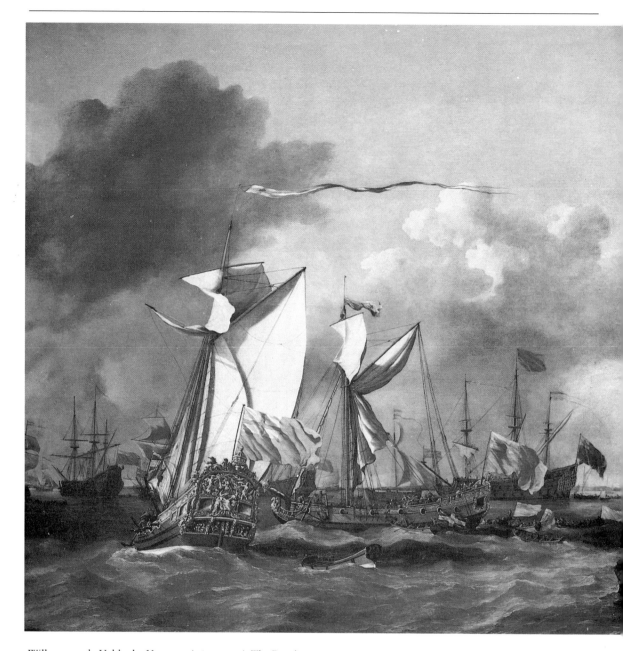

Willem van de Velde the Younger (1633–1707) *The Royal
Visit to the Fleet in the Thames Estuary, 5th June 1672* Oil
65in × 128in (National Maritime Museum, London)

But the van de Veldes were war artists, and their chief occupation had been
recording the actions of the Dutch navy. To do this, the elder artist sailed along
the edge of a naval battle in a small galliot and as the action unfolded, sketched it
in pencil on a long roll of paper. Most frequently these records and other
drawings were used as reference for grisaille pictures or *penschildering* – pen-
paintings – which enabled the artist to record with astonishing detail very similar

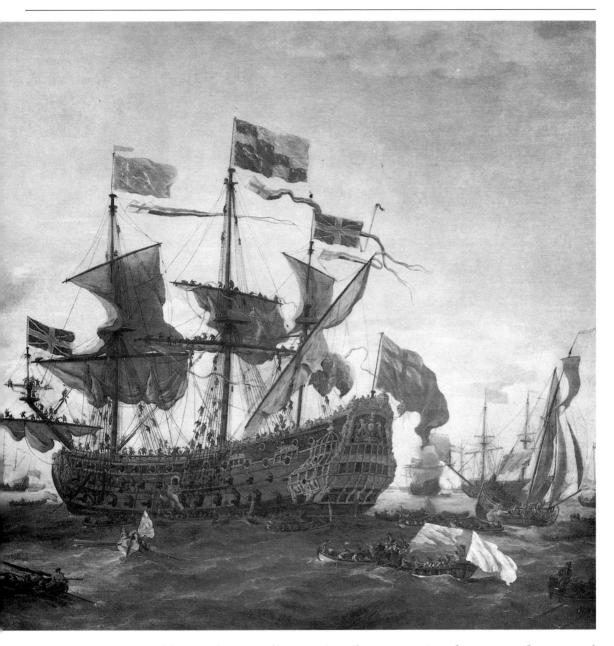

to an etching or later steel engraving, but possessing far greater fluency and vitality. The varying thicknesses of pen nib used on a polished white lead ground had the effect of a nineteenth-century newspaper engraving; it was full of fact but little visual realism.

Willem van de Velde the Younger (1633–1707), by far the more talented artist of the duo, received training in drawing in his father's studio, but, seeing his son possessed greater painting ability than he, his father sent him to work with Simon de Vlieger at Weesp, who taught him to observe the windy skies and changing silver-grey tones of the seascape and coast of northern Holland. But the young man was also influenced by Jan van de Cappelle, a wealthy and

entirely self-taught friend of Rembrandt, whose luminous *calms* – that is, offshore scenes of craft lying at rest on still, reflecting water – had a great effect on him.

It therefore became the method of the van de Velde studio for the Elder to produce the reference drawings while the Younger used these to construct finished paintings.

But Charles II's personal taste in pictures was for scenes of ceremony: arrivals, departures, visits of brightly decked ships and the gunfire of festive salutes. He forbade either painter to risk his neck near his fleet actions. So when he commissioned a major picture about two years after their arrival, *The Royal Visit to the Fleet in the Thames Estuary 5th June 1672*, the van de Veldes set out to make a drama out of the mottled sunlight, rolling clouds, flags and crowds, unified by light. On the herringbone-weave canvas with the usual red lead ground, the sky was given a silver primer and then progressively lightened with transparent glazes while the sails of the great, static silhouette of the warship *Royal Prince* were left dark, so that the sky grew in luminosity. Against the deeper shadow of the other side, brilliant sunlight was placed to catch the sails of smaller vessels, giving an effect of 3D to the observer. In the usual Dutch manner, the choppy water was divided into alternate patterns of light and shade like a tiled floor.

Despite this *tour de force* of chiaroscuro, the picture *was* weak in the middle, which seemed convenient to two Admiralty commissioners:

> . . . who likeing of it very well they said before Vande Welde that (they) would beg it of the King & cutt it in Two & each take a part. as soon as they were gone Welde took the picture off the Frame & rold it up, resolving they never shoud have it. nor they never had.

But the younger van de Velde did not depend solely on his father's fine drawings. In 1791 William Gilpin recorded that an old Thames waterman recalled taking him out in his boat in all weathers to make drawings of the sky with black and white pencil on large sheets of blue paper, which the artist called 'going a skoying' in 'his Dutch way of speech'. He made hundreds of drawings of the men and women of the Thames estuary as well as of their craft, which half a century later Samuel Scott would emulate. Despite the specialized basis of his art, he extended it steadily – when commitments permitted him – to studies of the sea and shore. The storm scene, *An English Ship Running on to Rocks in a Gale* (1690), was such a favourite of Sir Joshua Reynolds that he may even have produced his own version of it, which possibly explains the interest of British landscape painters of the Romantic Movement in van de Velde's work over a century later.

No other marine painter of his time had a similar command of style and materials; in *The English Ship Hampton Court in a Gale* (1680) the long sweeping brush strokes of the rigging lines were simply the longest single brush strokes painted up to that day. Only Philippe de Loutherbourg at the end of the eighteenth century approached his technical mastery. His Cappelle-like *calms* were models of offshore scenes which lasted beyond 1850.

These calms and storms were perpetuated by members of his studio in London: his son, William, his brother or son, Cornelis, Jan van de Hagen, Isaac Sailmaker, Jacob Knyff, and Peter Monamy. Of these, Peter Monamy (1681–1749) had by far the greatest talent. Monamy excelled in original variations of calms and coastal storms, such as *An Indiaman and a Royal Yacht in a Storm off a Rocky Coast*

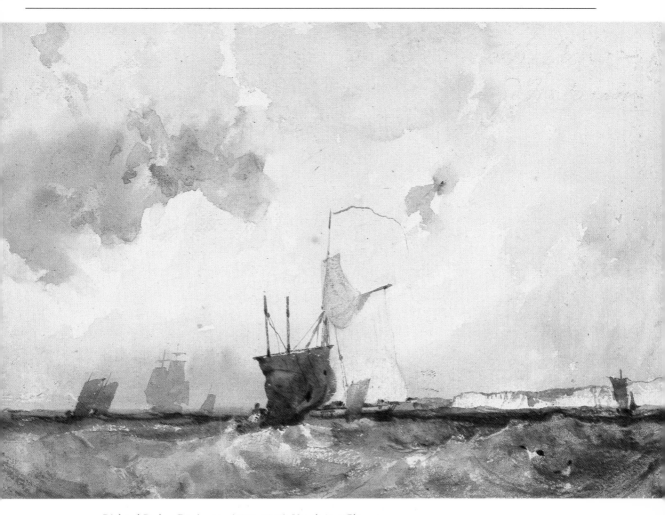

Richard Parkes Bonington (1801–1828) *Vessels in a Choppy Sea* Watercolour with scratching out on wove paper 5½in × 8⁷⁄₁₆in (Yale Center for British Art, Paul Mellon Collection)

with a Castle, but he perpetuated rather than advanced what van de Velde had done.

It was Samuel Scott who first expanded British marine pictures beyond this tradition, and explored the river Thames, its wharfs and people for their own sake. But his success in his lifetime was not built on such pictures although his fame rests on them today. They attracted praise but little attention precisely because they were pictures of the shore and its life, and at that time the people in these paintings and their lifestyle were of little account. They belonged to that amphibious margin of Britain which grew more and more crowded with the passage of time but was largely ignored by artists until the last quarter of the eighteenth century. The reasons for this were more social than aesthetic, ultimately more to do with fish, politics, patronage and the press-gang than paint, and they are worth exploring.

Calm and storm were the two images of the sea which the seventeenth-century

painter most often portrayed, and these contrasts frequently formed a pair of pictures to be displayed together; ships at rest on still, reflecting water, or beating about in a violent squall. This was as close as a painter came to picturing the sea as an element itself, its waves, its patterns and the coast whose shapes it engineered. The sea's disorder, its apparent lack of form, made it displeasing as a subject in its own right, so it was given order by regulating its waves into rhythmic billows which resembled rucked silk. It is possible that many painters may have used fabric as a guide to its shapes, as they used models as references for ships, and the ships remained the prime subjects in pictures of the sea and shore.

This did not reflect wholly upon the sea. In Britain at the beginning of the eighteenth century, landscape was a very minor art form, ranked below history painting and portraiture, and marine pictures also outranked it, because ships held the prestige of castles and mansions; the splashings of the water, on the other hand, were of no more account than the swayings of the trees.

The sea was also inaccessible. Although it completely surrounded them, most Britons never saw the sea, nor had they cause or opportunity to visit it. To the very small minority of people who bought pictures, it held little intrinsic interest, although rumour had spread that its water was beneficial to health. In 1660 Dr Wattie of Scarborough maintained that salt water was efficacious in reducing swellings and boils, and began a fashion for wealthy men and women to jump naked into the sea; but this remained the whim and therapy of those with leisure enough to acquire excess weight. Only at the very end of the eighteenth century did an idea equating the sea with leisure become popular currency among middle-class merchants and their wives as 'setting up their health'. To the rest of the population near the sea it remained a region of risky industry and superstition. As late as the middle of the nineteenth century mischievous Rev. Hawker, vicar of Morwenstow, frightened his superstitious parishioners by sitting on an offshore rock dressed as a mermaid, and only allayed their dread by standing up and singing the national anthem.

The sea was able to maintain and manufacture its legends as its coastal communities were isolated and secretive, while its major ports remained islands of internationalism, and seamen formed a group as wholly segregated from society as the army. The ports themselves, notably London and Bristol, were more usually the subject of painters, particularly visiting artists like Canaletto, who produced the archetypal tourist vista of the main river, domes and spires, with the assistance of a *camera obscura*, a drawing device which reflected an image of the view through a lens on to a glass panel, where the artist traced it on to a thin piece of paper. Canaletto possessed the ability to render shipping with relative ease, but many painters could not. George Lambert, a fine landscape and excellent figure-painter, was commissioned to paint views of the East India Company's coastal settlements, but he asked Samuel Scott, the marine painter, to add the ships for him. Scott could paint landscape as well as Lambert, but his versatility was rare. Few painters could manage the complexity of ships, and to the eighteenth-century mind a picture of the sea without them was unthinkable. The result, between 1680 and 1780, was a polarizing between 'ship-painting' and the rest of painting, including landscape, its closest cousin.

The experience of seamen and the rhythm of their lives divorced them from the cycle which dominated the lives of agricultural landsmen and town dwellers

alike. They were intimate with the sea to a degree unknown in the twentieth century, because they were wholly dependent upon sea winds and tides and because this knowledge and skill took years to acquire and then, because of the vessels they worked on, did not become obsolete. The marine technology of the later seventeenth century had reached a level of development which altered relatively little until 1830. Painters, few if any enjoying formal training, were home-grown in this specialized world. John Cleveley and his family, the brilliant and ill-starred Charles Brooking, the romantic opportunist Dominic Serres, the highly successful Nicholas Pocock and Clarkson Stanfield, and the superb George Chambers all grew out of various degrees of poverty amid the internationalism of the waterfront. Until the early nineteenth century their art stood aside from the mainstream of polite Academy art and they entered this portrait- and history-painting-dominated art world usually at the peak of achievement. Serres reached Academy heights after a picaresque career. As a youth in France intended for the priesthood, he balked at the prospect of becoming a village curé, and ran away to Spain, signed on as a deckhand on a ship to South America, and rose to become captain of a merchantman in the West Indies. When his ship was seized by a British frigate during the Seven Years' War he was taken under gratings to gaol in London, released after several years, married, decided to earn his living painting ships, received tuition from Charles Brooking, became a founder member of the Royal Academy in 1768, and was appointed Marine Painter to George III, hence manufacturing many scenes of British naval triumphs and French and Spanish disasters. Stanfield rose in similar manner when the officers on his warship discovered his talent for making scenery for their amateur theatricals.

George Chambers was not lucky enough to begin his career near the well-educated officers of the Royal Navy. He found himself serving a drunken captain of a Whitby collier. An undersized child from a slum, whose father could not afford the one penny per week to send him to school, he was apprenticed to a ship-owner at nine years of age. He was so small he fell through the ship's shrouds and was too puny for deck work: the crew thought him a useless joke and the captain beat him up to amuse himself. This finally ceased when the crew found he could decorate the ship; other masters asked if they could 'borrow' him to adorn theirs, and the ship-owner generously cancelled his indentures. Chambers had taught himself to paint by visiting churches when in the Baltic ports, and looking at their pictures. He worked as a house-painter and portrait painter of the whaling ships of his home port. He arrived in London almost destitute, was commissioned by a publican to paint a 'prospect' of Whitby, and thus attracted the attention of a theatrical director for whom he made stage designs, until his sea pictures were seen in a frame-maker's window by Admiral Lord Mark Kerr, who introduced him to George IV. His paintings thereafter drew admiration from Turner and Constable – although the Royal Academy spitefully ignored him – but physical damage done to him as a small boy caused his early death at forty-one, leaving his family almost penniless after the last eighteen months of his ill-health.

Brooking – along with Samuel Scott, the most talented of all British marine painters of the eighteenth century – died in similar poverty; Stanfield, Scott and Serres were relatively wealthy. The harshness of their background was typical, not in any way exceptional, for the lives of the seamen who surrounded them

were no different. In England, they were often rather better than elsewhere. The Dutch, England's chief marine rival in the seventeenth century, pressed men on to their East Indiamen, as the port of Amsterdam authorities locked any man without a permanent address and occupation in a large warehouse or marine gaol for months at a time, to provide crews for their merchant fleet. A seaman normally enjoyed three square feet of living space on a Dutch merchant ship; just enough to squat. Warships, with huge crews, took seamen during war from any vessel they had occasion to stop. Ships approaching the English Channel often had men taken from them by frigates setting out on a year-long voyage whose crew had already been at sea a year and were still unpaid, and whose families were left to fend for themselves. Captain Brooke of H.M.S. *Shannon* recorded regretfully that men in this situation had deliberately sawn off their fingers so he would put them ashore; he did not; it would set a precedent for release. An 'English' frigate with 250 men aboard might have a crew a quarter of whom were not British at all nor British subjects; they even included Frenchmen who were supposed to be at war with England. A substantial number of the remainder were often press-ganged from the British coastal community.

The villages, the people and the vessels of this coast concerned painters of the eighteenth century only in the composition of *calms*, where small vessels could dominate a picture design and so retain interest. These craft outnumbered the large, full-rigged, ocean-going ships by over twenty to one, but until the end of that century artists rarely bothered with them, or the life of the foreshore. Yet it grew progressively more vigorous and crowded. In the late sixteenth century the little harbour of Whitehaven on the north-west coast possessed one small vessel, the *Bee*, and six cottages. But the following century it began to build ships; it exported Cumbrian coal, and by 1730 it was a major port. In 1760 its population was 9,000; by 1860, 18,000 and still rising. Ship-building on the East Anglian coast around Aldeburgh dwindled with erosion and silting of harbour mouths, but the fishing industry and exports from Boston and King's Lynn outweighed it. Along the north-east coast coal, fishing and the whaling industry, which later supplied subjects to the artists of the Hull School, steadily expanded communities which were to double and treble with the export trade of the Industrial Revolution. In the west, Bristol and Liverpool vied with each other for trade with America, Bristol maintaining its advantage until the end of the eighteenth century. Its wealth, from both official and illicit sources, was formidable, and so was its enterprise. Tobacco, sugar, wheat and slaves flowed through it along the spectacular Avon Gorge on the direct route to Jamaica and Virginia. West Indiamen moving under these wooded precipices with wreaths of mist above their mastheads were a seductive enough sight to attract early watercolour artists of the late eighteenth century, and Bristol developed a thriving if not particularly innovative school of painters, of which Nicholas Pocock was the first bright star. Illicit wealth came to it through the scores of smuggling coves of the south-west, although the village of Sizewell in East Anglia is said to have landed 9,000 gallons of gin in one night.

The format of calm and storm which so occupied earlier marine artists reflected the prime concern of the men who commissioned ship and sea pictures: safe arrival or costly loss. If one of their vessels survived a violent storm, such a thing was worth a merchant company's celebration, perhaps in paint. Their fleet lying at rest – or loading – in a thriving home port was another. The lack of warning

and coastal aids to navigation hit harder than war. The ship-owner Henry Winstanley, having lost two vessels off Eddystone, built two successive light-houses there at his own expense, only to be killed in the second (a delightful, flimsy edifice bearing resemblance to Charles II's Flamsteed Observatory at Greenwich) when the Great Storm of November 1703 swept it away. The same storm wrecked thousands of vessels all along the coast, striking Admiral Beaumont's battle fleet in The Downs channel, sinking four capital ships and drowning Beaumont and 1,500 seamen.

Driftwood and flotsam are common foreground devices in late eighteenth- and early nineteenth-century pictures. Usually it is jettisoned topmasts, cut down by ships in a squall, but it also testifies to the lucrative scavenging along the shore and the deliberate practice of wrecking by false beacon lights. Certain coastal communities made their chief living in this way, usually murdering any survivors who reached the shore. But this too was a subject unbroached until the end of the century.

So as long as this gulf existed between the coast and the inland population, the sea and its traffic remained the province of the specialist painters, whose work was often polished but highly repetitive. Vessels altered little and so did their handling qualities. The rig of the three-masted sailing-ship was set as a standard by the *Royal Sovereign*, launched in 1637, and the French *Couronne* (1638): changes to the bowsprit and mizzen mast were the only developments that followed in the next 200 years. As a result they were also the only major changes in the repertoire of marine battle pictures over the same time-span. For British artists working in this vein, the van de Veldes had done their work too well. Ironically, it was in this province that land-based artists indulged in sea painting during the eighteenth century. To an art historian, some of the stock pictures on themes like *The Battle of the Glorious First of June* being churned out by well-established members of that old-boys' club, the Royal Academy, by 1790 are an example of the same old formula leading the fleet up the same old channel once too often.

By that time, this topic was one which artists who had not been to sea, let alone witnessed a naval battle, could paint with perfect confidence. This standard had been set by Samuel Scott who had broken new ground with his superb Thamesside river pictures but had made his reputation in life with formula battle scenes in the van de Velde manner. The supreme irony was that men who had actually witnessed sea fighting, like Dominic Serres and Nicholas Pocock, imitated him because the acceptable image had been set and they had to conform to it.

Yet the Royal Navy had been a great creative support to painters – men who would probably never have achieved success otherwise. Naval officers were generally intelligent and well-educated men: all received tuition in drawing and, by the later eighteenth century, watercolour painting. Some of the leading artists of their day, such as Paul Sandby and Alexander Cozens, taught at the naval college, and although their pupils used their training to draw headlands, harbour mouths and shipping for reference, it was difficult thereafter for them not to recognize good painting when they saw it. As E. M. Rodger's recent study of the Georgian navy makes abundantly clear, the British navy of the eighteenth century was by no means the brutal world of floating philistines which Holly-wood cliché, schoolroom history or pacifist polemics like *Billy Budd* portray in caricature. It was a world of relatively lax discipline officered by men who

governed largely by example in the manner of the landed gentry from which most of them came. Their regimes varied. One of Admiral Benbow's officers was court-martialled for failing to join action against an enemy vessel in case the recoil of his ship's guns damaged his collection of china. Officers frequently took their wives or 'sisters' on cruises with them, and women were not unknown on the other decks, although never officially mentioned on ships' lists. The savage discipline which Broke recorded came with the Napoleonic wars, when fear of rebellion among the ordinary population had alienated the gentry from the people they led. Broke in any case recorded the harshness precisely because it distressed him, not because he was indifferent to it. The misery suffered by sailors on naval ships was due to lack of sanitation, disease, overcrowding and an often desperate shortage of manpower because of this, rather than deliberate neglect. The navy used the dreaded press-gang because fear of being maimed in combat, of the sea itself, of disease, and the relative certainty of being away for months or years from one's family meant that very few men went to sea voluntarily.

The structure of this navy therefore had a fundamental effect on topics and attitudes of painters to the sea. Naval officers commissioned pictures of ships they had sailed in, ships they had taken as prizes (and thereby made their fortunes or increased their estates), and places they had visited. As they were portraits they wished them to be accurate, and they commissioned specialists to paint them, and professionals from the Royal Academy to create stylized epics of battle from formulae. Indeed, had they asked for anything less acceptable, more realistic as far as war was concerned, their disgusted guests would have turned quietly away at dinner. They had to strike a balance, and striking it were the prime patrons of marine art for nearly two centuries; sea painting in Britain would have died without them.

The change came in the 1790s with the rise of Romanticism reflecting the cultural ferment of the French Revolution. Artists like Philippe de Loutherbourg excelled in dramatic battle scenes but they also used the sea as a personification of human conflict and as a symbol of time and power. This brought a more rapid evolution of the coastscape picture than before, bringing both worlds together – sea and landscape – and enriching them equally. In the space of thirty years a body of painting which ranks among the finest of all marine art set the pattern – and the standard – which were the criteria for the rest of the nineteenth century and much of the twentieth. J. M. W. Turner, the greatest of all marine artists, used the shoreline and the coastal towns to explore every facet of human behaviour and used both oil and watercolour to do this. He produced watercolours which raised that medium firmly into the arena of high art alongside oil painting, where before it had been obstinately disdained by the Royal Academy as the province of map-makers, 'travellers' and amateurs.

The people whom Turner drew most in his sea pictures were of the shore communities of England and Wales. Although he deliberately exaggerated features of the shore in the Romantic manner the realism of his psychological observation stressed the bleakness and labour of their lives among the splendid spectacle of the coast which they viewed as a work place. The people who admired these pictures came from a different group and at the turn of the nineteenth century they had begun to find the coast a recreational spa.

In 1750 a certain Dr Russell had extolled the benefits of sea bathing for treating glandular disease at Brighthelmstone (Brighton) but, for those in health, it was

not made fashionable until 1783 when the Prince Regent developed a swelling in his neck and repaired to the place. Brighton was not the first marine holiday resort: Scarborough could lay claim to that, after its Dr Wattie, but it was by far the most fashionable and set the standard for all the rest. John Constable, who took his ailing wife there, detested the Brighton set, but found it was 'a wonderful place for setting people up', and, to avoid the socialites, did some painting there which anticipated the French Impressionists by over half a century.

Nonetheless, this beach holiday fashion remained the preserve of the relatively wealthy until mid-century. The one-guinea stage-coach fare from London to Brighton was far beyond the pocket of the majority, and the six-to-seven-hour journey it involved debarred a day trip. Yet, although the beach holiday was a British invention – Brighton's nineteenth-century hotels, the Metropole and Grand, were the model for those in America and continental resorts – relatively little evidence of this occurred in painting, except for the enormous popularity of marine and seashore pictures themselves.

The nineteenth century was a golden age for British sea painting. Naturally its quality varied but at its best it was formidably high. The gulf which divided 'ship' painters from other artists never wholly closed, but it became narrower than ever before – or since. Essentially, it included otherwise urban artists who, as Denys Brook-Hart has said, 'decided one sunny day to take the train and their paints out of smokey London and head for the coast'. By 1841 the yellow-painted trains of the London Brighton and South Coast Railway, later dubbed the 'Sunshine Line', provided cheap day-excursions, but the artists who went on it usually chose to paint labour along the coast, not leisure on the beach. Labour – the toiling English fisherman – sold. Or a picture of his wife, or sister or daughter seaweed-gathering or back-breakingly collecting mussels or cleaning nets or loading fish or gutting them (at a distance), or simply waiting, with a slightly more decorous pose than reality might endow but which the Royal Academy applauded.

The British offshore fishery reached its height in the last quarter of the century. In the west, Liverpool had replaced Bristol as the main port serving the western hemisphere, particularly North America. The steadily increasing size of cargo ships made Bristol's river entrance more and more difficult of access, whereas Liverpool offered six miles of waterfront. This was cancelled out for a time by Bristol's Great Western Railway link to its hinterland and London, the construction of deepwater docks and a floating harbour, and two steamships, the *Great Western* and the *Great Britain*, the latter the first all-iron built, screw-driven, ocean-going vessel, fast and reliable. But the greed of the Bristol Dock Company in gross dock charges compelled the Great Western Steamship Company to operate from Liverpool instead. This decline affected the economy of the whole of the west of England, from which it never fully recovered. The Cornish fishing industry began to suffer in the 1870s, and its fleets moved out to the Newfoundland grounds while inland recession set in. In 1896 resentment of east coast trawlermen caused Newlyn fishermen to riot on the pretext that their un-Godly competitors were fishing on the sabbath, and the militia arrived to quell their rancour. With Bristol's decline and that of the fishing industry the west began to acquire colonies of artists – a certain symptom of economic twilight by the 1880s, as these essentially urban people sought 'unspoilt' regions in which to live.

This increasing regional divergence was reflected in the behaviour of artists. The ports of London, Liverpool, Hull, Southampton and Glasgow attracted marine painters like William Wyllie, Charles Napier Hemy, and Frank Brangwyn, the spiritual descendants of men like Samuel Scott and the van de Veldes, while the nearly deserted highlands and islands, the south-west and Norfolk coasts gathered the followers of the imported French Impressionism, young painters believing themselves to be more innovative than they actually were, but at their very best represented by Philip Wilson Steer or later, at Staithes in Yorkshire, Laura Knight.

The Edwardian decade was the last passage of time when the marine and landscape art of Britain overlapped in a manner where division appears academic and arbitrary. The sea traffic, sail, steam, paddle and screw vessels, were clustered in the Thames and along the ports and harbours in profuse variety, at a time when Britain's marine trade was greater than ever before. All these vessels were attractive to painters. An artist like Alma Cull could reproduce without demur the massive armoured dreadnoughts of the Grand Fleet with the grave panache echoed by Winston Churchill's description of British warships passing through the Straits of Dover in July 1914, observing with metaphors mixed to potent effect: '. . . scores of gigantic castles of steel wending their way across the misty, shining sea, like giants bowed in anxious thought.'

These artists were divided by a conceptual barrier from those of the later twentieth century, a barrier built by the disaster of the Great War of 1914 and the economic twilight of the Great Recession. Where landscape painters returning to a rapidly altering society either reacted by bending the landscape image to fit their own personal concerns or immersed themselves in a fight to preserve it as they believed it should be, painters of the sea found a growing market, formed by men like Thomas Somerscales and Jack Spurling, in painting a vanished past which a bourgeois market found seductive, or turned their backs on theories of painting which were so narrowly urban in their conception of the world that they could not accommodate the demands of painting the sea. Certain artists, such as Paul Nash, John Everett and Richard Eurich rose above these divisions while others embraced them, carrying their own specialist field to a high point of professionalism and in doing so reverting to the segregations of the seventeenth and eighteenth centuries.

The Second World War accelerated this process. Ostensibly a military victor as in 1918, Britain came out of this world war economically ruined, with a disintegrating empire and a war debt, the interest on which she could not pay before the twenty-first century. Her ship-building industry was steadily undermined in the next fifteen years by cheap labour available in the Far East, while markets lost during the war were not regained and her merchant fleet decreased with the loss in foreign trade. Her fishing fleets shrank throughout the 1960s as E.E.C. pressure and then conservation difficulties from over-fishing took their toll. The port of London sank into a bickering televised twilight as reactionary trade union practices refused container traffic from the continent and suppliers shipped their cargoes elsewhere.

The effect of all this on marine art was to broaden and yet polarize it. Its breadth has grown very great, but it is not spread with equal force and strength. Above all, leisure and tourism replaced fishing and freight. Yachts replaced luggers, barges and trawlers, and shorts and suntan oil, kilted skirts and the smell

of gutted fish. A whole new order of boat people, coming from a disaffected middle class has grown up in these twilight harbours and booming resorts alike, seeking a traceless haven from insurance salespersons, income tax forms and mortgage schemes, inhabiting a dinghy-wharf-world, selling and reselling their leaky yachts and peeling houseboats among themselves, on which they sit and yarn like water-gypsies. This dinghy-squat society took to the water in the early 1970s and its boats make up the subject of countless watercolours.

In the warmed outflow from nuclear power stations fish congregate in great number, attracting flocks of seabirds which fill the wildlife oil studies of painters like Keith Shackleton; they perch on the restored Martello towers, built in Turner's time like outsized, upturned buckets with swivel guns to discourage French bellicosity, and are now tourist points, like the restored Thames barges which give the sea air from the Medway the tang of an open-air museum. The towers and the barges are the subjects of scores of painters in all media, for nostalgia is part of tourism, and tourism is an industry.

The supertankers, visual equivalent of Cull's dreadnoughts, enjoy no such prestige on canvas, and nor do the oil rigs with their billowy tassels of orange fire out on the horizon. It is not that they are contemporary in a world of saleable memories; it is not wholly that they are factories, with hulls like car-assembly plants and towers like electricity pylons, that leaves them almost unpainted. They are not unpaintable: they are spectacular. It is because they are usually too far offshore to be seen except by air: ships so large they fear to break their backs in the shallows, or steel islands marooned at sea, where trespassers rarely wash up, and are unwelcome. They remain unpainted because they are wholly marine.

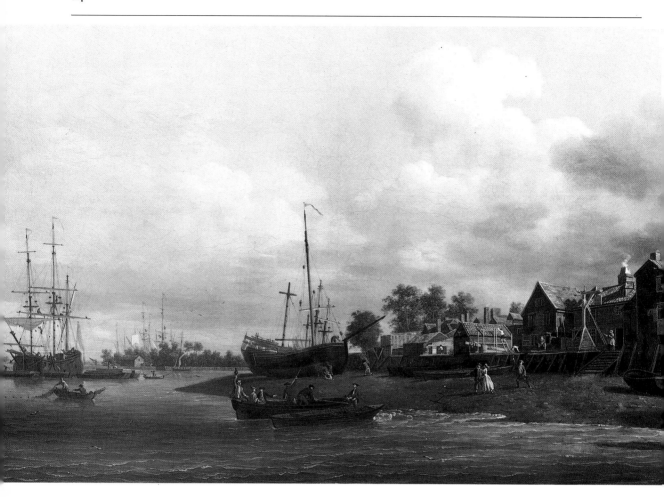

Samuel Scott (1701/2–1772) *A Morning, with a View of Cuckold's Point* Oil
on canvas 20½in × 37¼in (Tate Gallery, London)

A History

English Harbourmen, 1700–70

The Dutch, not the English, came exploring the harbours of England. They drew them in browning pen and ink, usually showing hilly mounds of houses heaped up around a narrow estuary mouth. They drew small fishing-boats resembling ink blots and a lethargic warship, bigger than any house, lying off a small fort with a sole gun, for which the local population had refused to supply any ammunition. The Dutch, Willem Schellinks, Jacob Esselens and Lambert Doomer, did their work well in the summers of the 1650s, and returned to Amsterdam. The English expressed no great interest in the Hollanders' drawings which were long and low – what the Dutch called *landschap* – which in this case included a blank area with a ruled horizon line above it, which was, presumably, the sea. The Dutch apparently made these drawings because they were strangers; but as the English knew perfectly well where they were, there appeared no need to draw these places for their own benefit.

Their ships, however, did make a splendid sight. A fleet of them together had the population of a large town, but ships were generally more difficult to paint than houses and it was the Dutch who supplied pictures of both. When Peter Monamy was able to produce pictures very like these, with ships displaying their carving and new rigging schemes riding out savage 'blows' or lying at calm anchor, they made up a rather pleasing and fanciful rumour that he had learned his trade by watching the ripples under London Bridge when he was a sign-painter, and had expanded them into storms. Monamy had actually come from the Channel Islands, but the ripples of London appeared more significant and befitting. They admired Monamy because he had done what the van de Veldes had done in Royal accommodation, so they admired Samuel Scott in the same way and all the more so, because he had apparently taught himself to paint in this manner.

Few of them recognized that Samuel Scott (1701/2–72) had created something quite unique in other pictures they found amusing and a little like Canaletto. These were the first wholly English paintings of the tidal shore; views of the tidal Thames, its buildings, waterfront and bridges, people and ships. The Prime Minister, Walpole, thought them delightful. But few people paid them as much attention as they paid his war pictures. They were, after all, picturing important events, worthy of higher praise. Scott had admired the Dutchmen. A sale catalogue of an auction of January 1773, three months after his death at seventy, reveals that he owned more paintings, drawings and prints by van de Velde the Younger than any other artist. His funeral heralded the jingle:

'Twas late the death of Scot was known
A painter of the town,

William Hogarth (1697–1764) *Five Days' Peregrination* Pen and ink (British Museum)

Who for his art was so much fam'd
The English Vanderveldt was nam'd.

In fact, Scott 'never was at Sea, except once in a Yacht . . .' a contemporary wrote, apparently referring to Scott's voyage to Holland in 1748 on one of Lord Anson's vessels escorting George II back from a trip to Hanover. Scott's other nautical sally the same writer discounted as unworthy of mention was his mock-heroic 'five days' peregrination' of 1732, along the Medway with his friend William Hogarth and three stalwart cronies, which never set keel beyond Chatham, and was recorded by Hogarth in a sequence of satirical sketches.

Yet the Thames teemed with craft, and Scott used them for serious study. Pen drawings in sepia, ink or pencil, and grey wash sketches bear great similarity to the Dutch in execution, spatial layout, and a foreground placement of figures. But it is these scenes, and not any influence of Canaletto, that formed his famous waterfront pictures.

At the age of twenty-six he obtained the post of 'Accomptant to the Stamp Office', which appointment he held until he was fifty-four. This left him time enough to paint seriously, an activity he apparently took up for amusement. It was a fortunate and unusual situation for a talented artist to enjoy this freedom to choose his subject in the early eighteenth century. Scott taught himself to paint through studying the van de Veldes' work, but he was not tied to the same subject by financial necessity. He indulged in imaginative compositions of vessels in combat or manoeuvring before the wind, for which he used dockyard models, and displayed such facility for picturing fleet actions he had never actually seen, that he won commissions from Admiral Lord Anson and Admiral Edward Vernon to commemorate their successes. This, more than his actual style, saddled him with the dubious title of the funerary jingle. It also laid the foundation for formula battle-pictures which in the hands of lesser painters were to degenerate into mannerism. But when the landscapist George Lambert was

John Cleveley the Elder (1712–1777) *St Albans Floated out
at Deptford 1747* Oil 36in × 62in (National Maritime
Museum, London)

commissioned to paint the East India Company's coastal settlements, he invited
Scott to paint in the ships. From that point on Scott began the series of
Thamesside scenes on which his reputation rests in the twentieth century.

These works, *View of the Thames at Deptford* and *View of the Thames at Wapping*
(c.1746) and *Shipping on the Thames with a View of the Tower of London* (1755), are
quite different in vision from the artificial battle scenes which made his reputa-
tion. The vision in these is uniquely English, and a fluent merger of marine and
landscape art.

If these river scenes have a certain superficial resemblance to Canaletto, that is
largely due to their clarity of colour and line, and their fineness of drawing. But
the light is cooler and greyer – something Canaletto never adjusted to in his
English city or ruin scenes – and the vessels and people are far more closely
observed. The warehouses in Scott's pictures are shabby but never decorously
decayed, and major buildings – like the Tower – are never touristic and
portentous. *A Morning with a View of Cuckold's Point* (c.1760) – a view of a wharf
and ferry with a ducking stool which gave the name to the dock, vessels being
tarred at low tide, under a cool and luminous sky – could never have been
painted by Canaletto. Scott was truly a painter of industrial tidal river scenes – of
the everyday work of waterside villages – not inflated naval epics. The latter built
his reputation, but were practised from formulae not observation, and did not
advance the development of British art. But his river scenes, as Walpole said,
were work 'that would charm for any age', primarily because they were sincere.

Scott's contemporary, Deptford-born John Cleveley the Elder (c.1712–77) has
more reason to be classed as a Thamesside Canaletto than Scott (who was largely
saddled with that tiresome attribute when he'd retired to Bath in later years), but
appears to have evaded it.

Cleveley possessed two distinct styles of painting, which ran concurrently. He
was by trade a shipwright, recorded as a carpenter 'belonging to His Majesty's

Charles Brooking (1723–1759) *A Ship in a Light Breeze* Oil
on canvas 27in × 27in (National Maritime Museum,
London)

ship the *Victory*', and he had three sons, also practised draughtsmen; altogether
the family depicted ships for over three-quarters of a century.

But Cleveley's own particular taste was for the ceremony of the 'great hulls' –
not wholly surprising in a ships' carpenter – when the massive warships of the
great naval expansion of the mid-eighteenth century slid from the ramps into the
still Thames. Decked in flags, dwarfing the façades of the Georgian buildings on
either side of the slipways, and surrounded by barges and yachts, they made a
spectacle that is in some ways almost surreal. On the level, polished water of
Cleveley's finely finished, delicately glazed tidal river pictures, bluer than the
Dutch school, the small craft seem to skate like sledges on a huge mirror: less
hectically, perhaps, than in Canaletto, certainly better organized, but undoubt-
edly Cleveley studied Canaletto's pictures to his advantage.

The small figures in Cleveley's pictures have a certain slenderness and grace
which typifies the eighteenth century, and is rarely if ever seen in the stocky,
sturdy, baggy-clad men and women who people the coast or harbour pictures of
the van de Veldes. It is as if the dignity of the newly launched ship had
transformed them all into carvings which had climbed down from its stern
galleries. Cleveley's are the most elegant dockyards anywhere in paint.

But if Cleveley portrayed a ship at sea he did so superlatively in the Dutch style – grey light, green sea, striated shadows – and it resembles the hand of another man. His twin sons, John (1747–86) and Robert (1747–1806), followed him in this. John Cleveley studied under the landscape watercolourist Paul Sandby, sailed in 1772 with the naturalist Sir Joseph Banks to Iceland as his official artist, and again under Captain Phipps to the North Pole in 1774, in the company of Nelson, then a midshipman. His brother rose to become marine painter to the Prince of Wales and draughtsman to the Duke of Clarence, continuing the 'official' Dutch style for 'official occasions'. Offshore, these men stayed Hollanders.

None of them, except Samuel Scott, possessed the talent of Charles Brooking. In his short life (1723–59) he produced a hundred or so works which establish him as the most talented British coast and marine painter of the eighteenth century. But Brooking was never to achieve material success in his lifetime, and died in poverty, which may have hastened his death, at the age of thirty-six. His subtle observation of English light anticipated the achievements of Thomas Gainsborough, John Crome, David Cox and John Constable, by as much as two generations. Like many apparently generous men – he helped the young Frenchman with a fraction of his talent, Dominic Serres, who rose to become marine painter to George III – he appears to have been cheated often, much of his work being sold through frame-makers and print-sellers who concealed the artist's identity, so starving him of both money and recognition. Like Scott he was influenced by Dutch seascape in his early years, but he too developed a distinctive personal style.

His figure drawing was excellent – weakness in this caused many marine painters to shy away from shoreside scenes – and in quite original coastal pictures his approach at first was so similar to van de Velde's and Simon de Vlieger's that it would be possible to take his work for theirs, if the ships offshore were not obviously eighteenth-century by their straight bowsprits. But in his later work it is the movement of wind over water and the almost impressionist treatment of the sky, echoed in Constable's cloudscapes, which is so distinctive. So is the sea. For the first time, it sweeps with the softness and fluency of a liquid, rather than arranging itself in those creased, sharp ridges of starched cloth or 'en papillote' with 'peruke-like puffs of farinaceous foam' as Ruskin contemptuously character-ized the seas of continental painters, under 'that volume of manufactory smoke' which passed for a sky.

Brooking's reputation appears to have grown gradually. When he was about twenty-two, in 1745, he painted the exploits of the 'Royal Family' privateers, a group of privately-owned warships named after members of the royal family, which were engraved in 1753 by Boydell. In 1752 the naturalist John Ellis asked him to illustrate a work on the Corallines marine parasite, and in 1754 he presented an outsize 6 × 10 foot canvas to the Foundling Hospital and was made a Governor of it together with William Hogarth and other donors. Yet within four years he was dead, leaving his wife and children destitute. His friend and pupil Dominic Serres remarked 'as a ship painter [he] excelled all his country-men'. He also excelled them in subjects other than ships.

Serres' escapades before his arrival in Britain were colourful, but his talent was less so. All his life he studied and made copies of van de Velde's work, such as *Dutch Coastal Craft on a Fresh Day off a Jetty*, inscribed D.S.1771, an exact copy

Dominic Serres (1722–1793) *The Arrival of Princess Charlotte at Harwich, in 1761* Oil on canvas 32in × 51in (National Maritime Museum, London)

of a van de Velde of 1672, *A Kaag in a Fresh Breeze off a Groyne.* It was appropriate enough for an artist who added nothing to marine painting in Britain but who perfected the *formula* of drama and pageants and controlled it so professionally in his compositions. His son, John Thomas Serres (1759–1825), adopted the same career and showed more spontaneity than his father when he stepped aside from the grand manner, and his pictures of wharfs and the tidal Thames at their best have an air of Samuel Scott. The forest of masts, the little human islands of gossip on the broad hay barges and the rickety detail, such as in *Shipping on the Thames at Limehouse* (1790), have a refreshing charm which his own life steadily lacked. He married the fatuous Miss Wilmot, an amateur landscape painter of dubious abilities and even more dubious claims to the title 'Princess of Cumberland'. Although he sought and received a separation from her in 1804 she ruined him in legal costs over her title claim, and he died an undischarged debtor 'within the Rules of the King's Bench', having produced the first book of instruction on marine drawing.

By the third quarter of the eighteenth century, marine pictures in England had therefore developed in three directions. The first was the third generation of painters who still worked in the Dutch style but who would break gradually away from it into a truly English school: these were Francis Holman and a group who bridged the eighteenth and nineteenth centuries: Thomas Whitcombe, Nicholas Pocock, Robert Salmon, William Anderson and George Webster.

The second group were the sea and coastscape painters who had their forerunner in Charles Brooking, such as John Crome, David Cox, John Constable and the Norfolk School; and the third were the Romantic painters who reacted against the formulae of people like Dominic Serres: John Singleton Copley, Benjamin West, Philippe de Loutherbourg, and, ultimately, Turner.

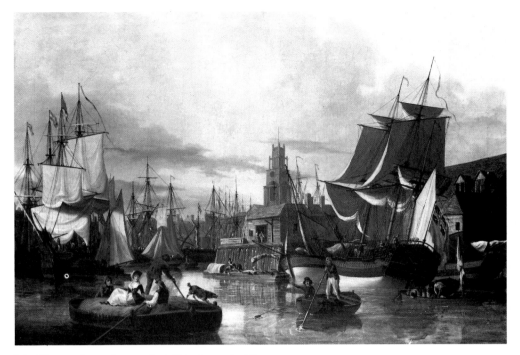

John Thomas Serres (1759–1825) *Shipping on the Thames at Limehouse* Oil on canvas 42½in × 60½in (Royal Collection)

Of the first of these groups, Francis Holman's pictures at their best had a charm and classical proportion found in American estuary painting of the 1840s. Holman (fl. 1760–90) often left the horizon line very low, only a third of the way up the canvas, leaving the rest to the bright sky. Gossiping groups of naval officers with their sedate wives, fishermen and fishwives about their work, and sailors with long clay pipes chatting and reclining, give a fascinating array all within the lower third of the canvas. The receding series of linear planes is an indication of no formal art training, and is the most obvious device of a naïve painter in establishing depth because it usually avoids vanishing point perspective. But it gave the work of Holman and his pupils a freshness that was rare in polished formula pictures.

In the 1760s John and Robert Cleveley had been fortunate enough to find themselves pupils of Paul Sandby. Cartographer and artist, Sandby had been sent north by the government after the Jacobite rebellion of 1745 at the age of seventeen to make the first large-scale map of the Scottish Highlands. The watercolour pictures that he made with the survey teams were executed with map-makers' ink and body-colour – opaque pigment mixed with water and glue. Watercolour was easier to carry than oil paint, and it could be used 'with water distilled from a clear spring' on good quality paper, not stretched canvas on a frame or a polished rigid panel. But until the 1780s the pigment had to be ground and then mixed by hand and some binding solution added to it. Paul Sandby's son claimed that his father first hit upon the idea of making the pigment into the hard cakes 'later perfected by Mr Reeves', but whether or not he did, Sandby came to be regarded as the founding father of British watercolour painting. As such, marine artists like the Cleveley brothers learned a technique which enabled them to work out-of-doors beside – or at – sea, and he gave them a tool which

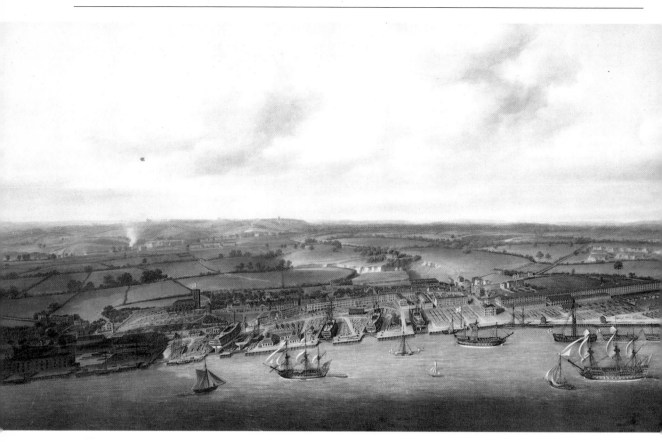

Nicholas Pocock (1740–1820) *Woolwich Dockyard* Oil
54½in × 110in (National Maritime Museum, London)

owed in its deployment nothing to the Dutch or French fashion of painting the sea. Watercolour painting is probably the greatest single British contribution to land and seascape art, and as watercolourists marine painters rapidly developed a distinctly British, and essentially English, school of their own.

An artist like Charles Gore (1729–1807), a wealthy and highly talented dilettante who produced scores of watercolours based closely upon the van de Veldes' drawings, nonetheless painted with a lightness and fluency of form, producing the surface of rippling water with a series of soft, feathery, parallel strokes that is utterly un-Dutch, un-French and unmistakably English. Gore was so awed by the van de Veldes, he not only owned many of their drawings and exactly reproduced their compositions, but actually indulged in the dubious habit of drawing over their originals and signing his own name on the paper. But he had no sinister motive in this: he never sought to pass such pictures off as his own work; this was just an instance of excessive admiration, which he shared with the great E. W. Cooke (1811–80). But his additions were in any case too distinctive to be taken as Dutch work. His manner of painting was by then wholly English.

Defective and difficult to use, 'unharmonious' when one tried to mix paints prepared by different 'colour-men', the late eighteenth-century watercolours were nevertheless an invaluable tool to John Cleveley in the Arctic, as they were

to Paul Sandby and the increasing number of landscape painters who found themselves touring with patrons along the highland coasts of England and Wales – and to a lesser degree Scotland – during the last fifteen years of the century.

Many of their pictures were 'drawings', for although Sandby, who was the sole watercolourist among the founders of the Royal Academy in 1768, called his pictures 'watercolour landskips' most artists still called the medium 'drawing' until around 1790, meaning that it could not aspire to being a finished fine art painting. But these 'drawings' were a thermometer of a steady and major change advancing over both landscape and marine pictures after 1775.

Since about 1759 the increasing appetite of the rising merchant classes for travel and their mounting capacity for doing so, fuelled by the rapidly expanding colonial wealth and naval power, had led to a taste for new and pleasurably provocative, 'awesome' experiences. This showed earliest in pictures of difficult, inhospitable terrain, like the Scottish Highlands, a taste spurred by Sandby's pictures. Edmond Burke expounded this desire for a vicarious thrill of fright in *A Philosophic Enquiry into the Origins of Our Ideas of the Sublime and Beautiful*, although the difficulty of actually visiting some of the terrain which was sublimely awesome involved artists in difficulties less sublime and by no means vicarious.

Burke defined sublimity as 'that which inspires a pleasurable sense of awe; an uplifting fear'. Through this idea an emotion, which ultimately led to Romanticism – crediting inanimate things either with human attributes or seeing them as symbols of the human condition – also spurred artists to produce images of the sea itself and its movements below high crags or named places, images of the shore for its own sake, and not just a surface on which ships could be carried.

Nor did artists necessarily find or present an image which was automatically polite and pleasurable. There rapidly grew up an aesthetic of the grotesque in which dramatic squalor or dramatic distortion was in itself satisfactorily awesome enough to constitute being sublime. Indeed, by 1813 the writer Richard Ayton collaborated with the artist William Daniell to publish a book ultimately entitled *A Voyage Around Britain 1814–25*, in which Ayton revelled in grotesque descriptions of ports like Swansea and fearful rocks lashed by foam, dark headlands and brooding ruins, very much in the manner of television journalism seeking out the most melodramatically shocking in order to make a programme 'work' as 'good reporting' – ultimately entertainment. Paradoxically many of Daniell's engraved illustrations showed scenes of idyllic calm which sat very oddly with Ayton's gothic word-painting.

But, in the meantime, the foundations of this way of seeing were being laid by improvements in paint surfaces which made the 'horrible' coast so much more sketchable. The invention of 'wove' pattern high-quality paper by James Whatman in the 1780s got rid of the 'grid' pattern which the moulds had previously impressed into the rag-paper used for drawing. This had distorted the image through the (usually) translucent watercolour washes, and now the 'wove' surface did not impede the brush or image. Nicholas Pocock in particular took to watercolour as a medium, adorning his ship's log and charts with countless sketches of the coastlands, and it was a medium which he used with far greater facility than oil colour. Sir Joshua Reynolds advised him that his oil pictures 'lacked unity of colour' in the sea and sky and hue of canvas affected by them, but Pocock seemed able to master these things easily in watercolour. But by the

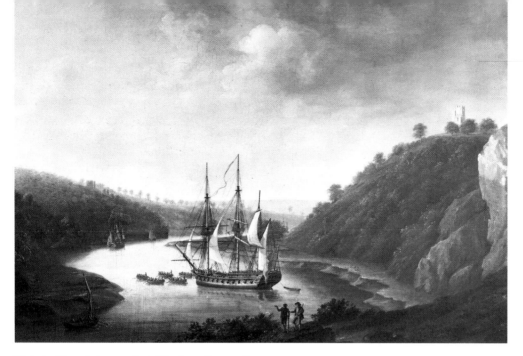

Nicholas Pocock (1740–1820) *The Avon Gorge at Sunset, about 1785* Oil on canvas (Society of Merchant Venturers, Bristol)

time Reynolds was giving Pocock this advice, the subject of the sea itself and the behaviour of the people beside it was being changed irrevocably by the three great revolutions which snuffed out the Age of Reason.

The Romantic Shore, 1775–1830

The shores and harbours which Samuel Scott, John Cleveley, Charles Brooking and Francis Holman had pictured were calm: gossip islands where the hay and wool barges of an agricultural nation passed the moored warships of a navy which, until the 1780s, possessed a relatively lax discipline based on persuasion by example, and in which all ranks feared disorder and theft less than they would in a London market.

Three things changed all that in the space of a decade.

The outbreak of the American War of Independence, which led directly to the French Revolution, caused artists to seek cultural refuge in Britain, where in 1776 the first trade union had formed in response to the pressure of embryonic capitalism in the expanding industrial towns. This atmosphere of all-pervading violence and hostility abroad and social unease within fuelled the Romantic Movement in Britain, which in England had been largely the province of landscape painting. Ultimately it led to an artistic revolution in Britain (through Turner and Constable) which anticipated artistic ideas on the continent by fifty years and in America by more than seventy.

The first of these refugees was the American, John Singleton Copley (1738–1816), who left the better paintings of his life behind him in 1776 when he

set sail for England while his irascible countrymen were busy dumping his uncle's tea into Boston harbour. Copley had little sympathy and no patience with the American rebellion, and was exasperated by the indifference of the American public to any painting beyond portraiture and sign-writing. But his isolation had led him to make superb, classically elegant pictures which stand as masterpieces of the late eighteenth century. In England he made nothing of the same calibre except a reaction to the growing chaos – *Brook Watson and the Shark* (1778).

This chilling spectacle of early Romanticism – the hideous encounter of a young midshipman who went swimming in Havana harbour to his almost certain death – remains a masterly essay in the symbolism of a disturbed age. Beyond the sophistication of the technique and beautiful positioning of the figures in the rescue boat it has an inalienably primitive quality. The shark seems to rise from the collective unconscious, the myths of the spirits of the deep. The sea and the creatures of it become a symbol of a Terror which had been touched off in the mind by the American rebellion and was to slither across the Atlantic.

Copley was among the vanguard of artists who came to see the sea coast as the symbol of a once-stable world now surrounded by storm and threat and crumbling in a state of flux. War – the agent which was shaping their lives – could be portrayed in a direct manner – itself a rebellious aesthetic – or the states of mind and body which gave rise to it could be mirrored in the natural world. With the direct war picture Copley's countryman, Benjamin West (1738–1820), had already won a sensational success at the Royal Academy in 1770 by portraying the British general, Wolfe, dying on the Plains of Abraham near Quebec in contemporary costume, instead of being clad as a Roman tribune. He had followed it with the marine *Battle of La Hogue* (1778) in similar vein, a brutal hacking match in half-swamped boats above which the carved sterns of warships loomed like baroque cliffs. It was a break with the formula marine battle picture of anonymous ships wreathed in bright smoke scrolls like inoffensive summer clouds. That break was carried further by Philippe Jacques de Loutherbourg (1740–1812) in the *Battle of Camperdown* (1799) and in a figurative masterpiece of marine fighting, *The Cutting Out of the French Corvette 'La Chevrette'* (1802), but he also used the sea and shore to express the same destructiveness and turmoil as Turner did after him.

De Loutherbourg was an influential French theatre designer who settled in London in 1771, where he carried out designs for Garrick. Born in Strasbourg he was a member of the Paris Académie, with an equal facility for landscape and marine coast. He gained the admiration of Gainsborough for his invention of a miniature stage with back-lighting and changing colour effects which he termed *Eidophusikon*. It enabled him to construct a picture by model and light it to his own satisfaction before painting the result. It is not untypical of Romanticism to credit the natural elements with human attributes having first arranged them in a miniature theatre. In *The Shipwreck* (1793) the convenient euphemism of 'the cruel sea' is augmented by the fratricidal cruelty of human beings beside the sea. Three survivors of a wreck have struggled ashore in their splintered longboat only to be hacked to death by looters from the local population.

De Loutherbourg's pictures of wreck and storm were typical of increasing numbers of seascape pictures by landscape painters in the last fifteen years of the eighteenth century. Unlike the artists of the Dutch school whose land was always a specific, named place in relation to their ships, theirs almost never was; it was

'the coast', ubiquitous and symbolic, although not necessarily more real. Under the brushes of Richard Wright (1735–1775) a Dutch sea with striated shadows billowed up to a craggy shore where covered carts trundled precariously under crags borrowed from Claude or Richard Wilson. George Morland (1763–1804) painted shipwrecks in a jarring break from pastoral calm.

Richard Wilson had taught William Hodges (1744–97) who sailed with Cook's Pacific expeditions and whose pictures did much to reinforce that further manifestation of Romanticism, the myth of the 'noble savage'. Hodges's pictures of the Tahitian heights shimmering in the sea air differ very little from the Welsh hills near Llangollen which Wilson celebrated, except that Wilson's decorative Welsh natives beneath were clothed and their boats had canvas, not tree-bark sails. John Webber (c.1750–93) followed Hodges's example, and as a young painter newly minted by the Royal Academy Schools he accompanied Cook on his third and fatal voyage of 1776. Bartolozzi's famous engraving of the moment when Cook was stabbed to death by natives on the Hawaiian shore was made from Webber's eye-witness drawing.

Little separated the spirit of de Loutherbourg's *Shipwreck* from Bartolozzi's engraving. Straying out on or beyond the sea was dangerous, whether it separated England from revolutionary France or symbolized the tide of that revolution. Even on one's home shore there was a threat of treachery, while on another?

But the Dutch style remained as a pillar of marine art throughout the height of Romanticism. Robert Salomon (c.1775–1840), ship-painter of superb draughts-

Philippe Jacques de Loutherbourg (1740–1812) *The Shipwreck* Oil on canvas 44in × 64in (Southampton City Art Gallery)

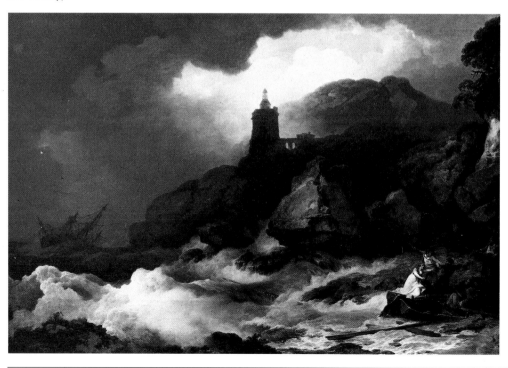

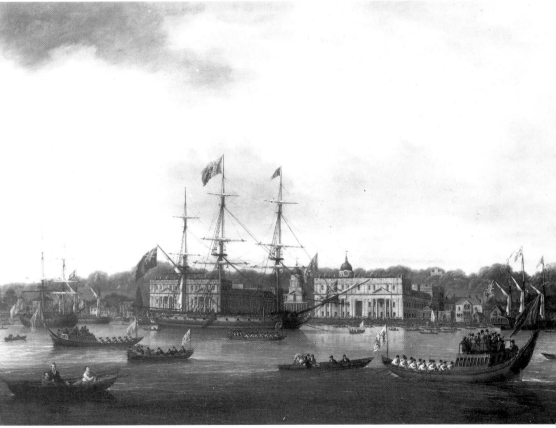

Top Robert Salmon (c. 1775–1840) *The Low Lighthouse,
North Shields* Oil on canvas 16½in × 25¾in (Yale Center
for British Art, Paul Mellon Collection)

Above William Anderson (1757–1837) *Return of King
George IV from Edinburgh to Greenwich* Oil on canvas
29½in × 42in (National Maritime Museum, London)

manship, perfected a wholly artificial image of wind-ruffled water while he produced a delicate portrait of Whitehaven or Liverpool or Greenock waterfront seen through the serene spider's web of his subject ship's rigging. These were the seas Ruskin was to detest when he wrote in celebration of Turner, but by that time Salomon was gone. He took his graceful formulae to America with him, changing his name to Salmon in 1828 when he left for Boston with 118 paintings he had made in two years. From him came much of the delicacy of American coastal art.

William Anderson (1757–1837), a Scot who was once described as displaying 'great amenity of colour' remained, and his gentle refined images influenced the great Hull School of the nineteenth century. Between these styles stood the vigorous, cool pictures of George Webster (fl. 1797–1832) whose work maintained the tradition of stating bald fact specifically – *An Eighty-Two Gun Man-of-War Lying off Dover* – while painting man-rationalized forms of sea and sky which existed nowhere on earth but in tradition's mind.

Meanwhile a certain J. M. W. Turner was sacked from an architect's office as his employer despaired of his ever grasping perspective.

Turner: Two centuries foreseen in fifty years

Joseph Mallord William Turner (1775–1851) was a barber's son. He grew into an inveterate traveller, speculative philosopher on the fate of man, Britain's finest landscape artist, and the greatest marine painter of the nineteenth century.

In his lifetime, Turner anticipated not only Europe's Impressionist movement by well over fifty years, but the abstraction of the twentieth century. He was so far ahead of his peers and contemporaries – and his successors – that by the 1920s the doctrinaire tunnel-vision of certain modernists failed to recognize that he had pre-charted some of their journeys, and they had forgotten him among the selective distortions of their cultural memory. He was, too, unlike so many artistic innovators, a superb technician, which enabled him to put into practice many of his fertile conceptions.

Yet Turner belonged to the last generation of British artists for whom nature was the natural expression of the world's *status quo*, rather than a saleable commodity with a moral or nostalgic overtone. But, unlike his great admirer and champion, John Ruskin, he did not display that fastidious hostility to industrial and technological change which might have otherwise constricted his extraordinary vision.

Turner was a product of the Romantic Movement, a state of mind often limpidly apparent in the watercolours of his *England and Wales* series made throughout Britain, especially in harbours and coastal towns. At eighteen his studies took him to the coasts of Kent, Sussex, the Isle of Wight and South Wales, but he held a deep respect for the Dutch marine school of the seventeenth century, and insisted that it was a print of ships in a squall by van de Velde the Younger that 'made me a painter'. He was deeply uncomfortable at Ruskin's criticism of the Dutchmen's style, and insisted that van de Velde was a better painter than he. Nonetheless, Turner had no doubt of his own enormous powers – far wider spread and of greater scope than those of the Dutchmen he admired – although the oft-quoted idea that he deliberately set out to out-do all his contemporaries is mere contentiousness. Certainly, Constable remarked on one occasion that Turner had 'been here and fired a gun' when he added a touch of

vermilion to a buoy on a quiet grey picture of his exhibited beside a boldly coloured painting by Constable, but Turner also temporarily dulled one of his own pictures with retouching varnish when it overpowered a quiet painting by Sir Thomas Lawrence next to it, explaining: 'Oh well poor Lawrence was so depressed and I can always rub it off tomorrow.'

From the age of twenty-one Turner painted in both oil and watercolour with equal facility. His earliest known oil painting is a night view off the Isle of Wight, *Fishermen at Sea* (1795), and he followed it with *Moonlight: A Study at Millbank*. This calm river scene was probably inspired by van de Neer's moonlit paintings: he admired the Dutchmen Ruisdael and Cuyp and always maintained that Dutch originality was founded on their being (unlike himself) 'stay at home painters'.

But Turner was a great traveller, in and out of Britain. In 1802 the short-lived Treaty of Amiens and subsequent access to the continent gave him the chance to examine the pictures of Cuyp and the Frenchman Claude first hand, and he strove for years to achieve the radiance of Claude's light. He did not manage that until he visited Italy in 1819, and although Ruskin applauded Turner for achieving vision where Claude failed, Claudian vision is spread liberally through Turner's views of England and Wales throughout the 1820s and 30s.

Even so, his paintings of the coastlands and shore are rarely quiet and serene; nor are they mere celebrations of light, that revelling in sense perception and little else that so much later Impressionism became. Instead, light in Turner's pictures reveals aspects of the human condition: its poverty, its mental as well as physical hardship, and the futility of its grand and often grandiose designs. The sea and sky appear as remorseless agents of fate and, in spite of them, flashes of humour and happiness may be snatched in the sun.

But Turner held this bleak view precisely because he was an humanitarian. He possessed great sensuality and a kindly sense of humour born of understanding, which gave him fondness for his fellow beings where men and women of less wisdom and more conviction would merely have preached and sloganized.

Typical is *Dartmouth Cove, with Sailors' Wedding* (c.1825–6), which has a foreground crowded by one of the massed weddings which the Regency navy allowed its often press-ganged seamen after years without women on leave from its crowded warships. Beyond sensually curved, neo-Claudian trees, the cove basks in a sunlit blaze of blue and gold. In *Saltash, Cornwall* (c.1825) the same light, this time after rain, casts a hazy glow beyond a party of marines being rowed ashore among a crowd of their brightly dressed wives and children. Ruskin praised the shimmering tones in the water reflections and there is an extraordinary clarity in the colour where Turner mingles blues and golds which other painters might merge to muddy browns where they met. This same finesse pervades peaceful golden *Aldeburgh, Suffolk* (c.1825–6), of fishermen salvaging a ship's fallen topmast in a calm while the squat silhouette of a Martello tower intensifies the sun's brilliance but recalls war. But Turner the Romantic took great liberties with the portrait of the location: in the blue and brown idyll of *Orford, Suffolk* (c.1825–6), the towers of the castle above the town rise to dream-like heights, as his ruins do in so many pictures.

More frequently these ruins (symbols of human pretensions) ashore are reflected by ruin at sea. Turner knew well how much the hovel communities along the coasts depended upon salvage – and of their close relationship with the

wreckers. *Dunstanborough Castle, Northumberland* (c.1825–8) basks in sun but the sea which has beached a vessel being stripped by gloomy men and women under the eye of a mounted coastguard remains squally, in a bleak blue shade of its own under ruined castle towers. In *Holy Island, Northumberland* (c.1825–8) a storm breaks and rowing-boats and bundles are scrambled ashore among ruins, while *Lyme Regis* (c.1834–5) where the town appears on the point of being swallowed by the sea and *Whitehaven, Cumberland* (c.1834–6) where coffins wallow among the dark combers all carry the same remorseless theme of people's opportunist cruelty often compounding the elements' huge indifference.

But like most Romantics, Turner also used the sea and sky as symbols of human joy or malice. In *Great Yarmouth, Norfolk* (c.1825–8) a livid storm rises at sea beyond the great bleak panorama of Yarmouth Sands. In the foreground a woman has laid out her washing and fish to dry in the sun, and turns to see her other belongings and basket blown away by the sudden fierce wind. The wind and the cloud is War. Between her and the storm a line of ships lies out on the North Sea, as Britain's naval barrier; in the foreground far below near Gorleston Pier stanchions like the bare ribs of dead creatures litter the foreshore.

The pendant picture to this, *Dockyard, Devonport, Ships being Paid Off* (c.1825–8) casts a golden sunburst from a receding storm cloud over un-rigged ships and boats crowded with blowsy, overdressed, excited women. Ruskin praised the sky in this picture as the finest of cloud studies, but he disliked the all-too-human figures. In fact, Ruskin rarely appreciated Turner's figure drawing or his general observation of people. He quite misread the posture of the tillerman in *Gosport, Entrance to Portsmouth Harbour* (c.1825–30), who under the phallic shaft of a tightly rolled sail stares at his boatload of doxies while the boat heads on a collision course for a brig. Ruskin, who was sexually all but indifferent (he was disgusted by the sight of his wife's pubic hair), just assumed that Turner had drawn the man's head backwards by accident. But Turner mixed comedy and pathos with fluency. For example, he added the initials 'C. H.' to an item of débris in a wreck scene of 1835 when his engraver Charles Heath was financially 'washed up'.

Lowestoft, Suffolk (1835) and *Longships Lighthouse, Lands End* (1834–5) show both Turner's pessimism and technical skill at their height. By soaking the paper and then brushing (or scrubbing) the paint into it, and letting the pigment bleed into adjoining wet areas, Turner could effect rain and cloud with fitful light glimmering through them. By adding gum to the watercolour paint he could make it a glaze and then scratch through it to the white surface of the paper, giving a stronger highlight than he might get by touching it up with white paint. In the *Longships* Ruskin praised the painting of the sea and cloud for:

> . . . throughout the rendering of all this there is not one false curve given, not one which is not the perfect expression of visible motion . . . while yet each is in itself a subject and a picture different from all else around. Of the colour of this magnificent sea . . . it is a solemn grey green (with its foam seen dimly through the darkness of twilight) modulated with the fullness, changefullness, and sadness of a deep, wild melancholy.

The steady loosening and merging of forms in the watercolours continued in his oils, where Turner's Impressionism moved smoothly toward abstraction. In the *Old Chain Pier, Brighton* (1830–1) the pier glimmers in an iridescent void of

Joseph Mallord William Turner (1775–1851) *Lowestoft,
Suffolk* Watercolour, gum and scratching out on paper
10¼in × 16¾in (British Museum)

light, similar to that in what is probably the most famous of all marine paintings,
The 'Fighting Téméraire' Tugged to her Last Berth to be Broken Up 1838 (1839).
There the stately ghost of the old warship becomes a poignant ivory shade behind
the irresistible progress of the steam tug, while the Thames beneath them,
between Sheerness and Rotherhithe, becomes a gleaming highway merging with
the sun. Far off, a sailing ship moves toward the apex of the fading light like a
departing spirit, beyond the black, burning pillar of the tug's high smoke stack.

Possibly Turner did not react against change as Ruskin did, precisely because
of the deep pessimism he revealed even in the idylls of his watercolours.
*Snowstorm: Steamboat off a Harbour's Mouth Making Signals in Shallow Water and
Going by the Lead* (1842) is comparable to his railway picture *Rain, Steam and
Speed* where the fiery ram of a steam train whirls out of the unknown (or
surpassed) into the unknown. In both pictures the now-near abstraction of the
natural elements has swallowed up the machine. Indifferent to past and present,
they are equally indifferent to this symbol of the future. As Turner's pictures
moved into abstraction, the human figure vanished completely, as Turner

believed the products of all human endeavour ultimately would. He did not resent change because he believed it was by definition transitory, purposeless, and the product of illusion.

John Constable (1776–1837), son of a prosperous Suffolk miller, was in many respects the antithesis of Turner whom he knew. He came relatively late into painting – he was twenty-four before he entered the Royal Academy Schools, having initially gone into his father's business – and rarely ventured beyond his native Suffolk.

He was a Realist not a Romantic, and as such was a more apparent forerunner of Impressionism than Turner as he believed translating what he saw before him into colour was enough in itself to constitute a work of art. He was no philosopher, and he encountered the sea for the first time in 1803 – at the age of twenty-six – on a trip from London to Deal on the *Coutts*, an East Indiaman, at the invitation of the captain, who was a friend of his father's. He spent more than a month aboard drawing ships in all situations, in a shorthand very similar to that used by the van de Veldes whom he had almost certainly studied. At Chatham he hired a boat to go out and draw warships in the harbour, including the *Victory* which being freshly painted he thought 'very beautiful'.

But he did not return to the sea until his marriage in 1816, when he took his wife to Weymouth and thereafter to Brighton for her health. He detested 'the receptacle of fashion and off-scouring of London' which made up Brighton society, but the breakers and the sky were recompense, forcing him to attempt to make 'something out of nothing' and 'almost of necessity become poetical'.

He did. His small masterpiece in oil, *Brighton Beach: Colliers* (1824) anticipates Monet by half a century, while other sketches of the open sea with only the single brush stroke of a distant sail evoke Whistler. His more finished seascapes of 1816 resemble those of late Victorians like David James. The Brighton oil sketches, brushed in with thin, fluid under-paint, and then heightened with

François Louis Thomas Francia (1772–1839) *St Helen's Roads* Watercolour on paper 11¼in × 15¾in (British Museum)

palette-knife strokes, have a freedom that the galvanized British Impressionists at the end of the century never achieved. They had forgotten by then what the French had learned when Constable and François Louis Thomas Francia exhibited together in the Paris Salon of 1824. In effect, they were to buy back their own past and think it a new commodity.

Naturally Constable's influence was more immediate in East Anglia than elsewhere in England, although his effect on British painting and the public was far less than it was on the French, who greatly admired him, as they did his short-lived contemporary, Bonington.

Richard Parkes Bonington (1801–28) owed a great deal to the Frenchman François Louis Thomas Francia, who in turn had formed much of his style in England where he had been watercolourist to the Duchess of York. Bonington's family had moved to Calais in 1817, and he produced most of his work in Normandy and Picardy. There his oil and watercolour techniques formed with equal ease and similarity. Bonington developed a deceptively simple form of Impressionism where objects formed colour blocks from a very limited range, and transitions and shifting forms – such as clouds and water – were made from mixtures of any two colours of this range. The result was a great subtlety, lightness and energy rarely equalled until Whistler's tone studies. Bonington died so young his promise is open to wide speculation: had he lived, Whistler's career might appear less significant.

The Norwich School
This explosion of vision in British art was compounded by John Sell Cotman (1782–1842) and artists of the Norwich School, 'founded' largely in 1803 by John Crome around the nucleus of the Norwich Society of Artists.

Cotman studied in London, and exhibited at the Royal Academy from 1800 although he never achieved any material success in the capital. Like Bonington, he could simplify form with astonishing finesse as in the watercolour *Yarmouth River*, building up objects by tonal area as though each were a coloured silhouette. Really, he was pursuing the traditional methods of watercolourists like John Robert Cozens (whose work he had studied) but strengthened, simplified and extended it.

David Cox (1783–1859), whose oils reflected Constable's fascination with cloud, rain, wind and light, and with the village people he pictured, built a reputation as one of Britain's leading landscape watercolourists, and his coastal pictures show the influence of Cotman. But like a number of otherwise exclusively marine artists of the early nineteenth century, Cox had originally worked as a colour-grinder and theatrical scene-painter, and this had the effect of loosening his style and 'knocking his colours about' as it did to George Chambers, one of the finest marine painters of the century.

Even so, Cox's cloud effects were rarely as dense or dramatic as Turner's, or as robust as Constable's. Often they had the delicacy of a watercolourist like Alfred Vickers (1786–1868) or the clear, romantic loneliness and measureless space portrayed by the Scot, Wilson Ewbank (1779–1847).

Like Cox, John Moore of Ipswich (1820–1902), one of the finest painters of the Norwich School, shared Constable's fascination with cloud and light, but he also retained the cool grace of Thomas Gainsborough's colouring and his method of execution. Moore's pictures have a sleekness not seen in Constable's, and his

Top John Sell Cotman (1782–1842) *Dutch Boats off
Yarmouth, Prizes during the War, c. 1823–4* Oil on panel
17½in × 25½in (Castle Museum, Norwich)

Above David Cox (1783–1854) *Rhyl Sands* Watercolour
on paper 10⅜in × 14¼in (Victoria and Albert Museum)

oils are among the best examples of the emerging 'English School' of marine painting which was to be well established by the 1850s. Moore never exhibited in the London galleries, nor the Royal Academy. As a result his reputation was largely local, and for a century, until the 1970s, he remained less known than many artists with half his talent.

No such thing had occurred with his Norfolk predecessors, the Stannards and the Cromes. Joseph Stannard (1797–1830) well deserved his reputation, built as it was on all too few pictures before his premature death. In nine years from 1820 he exhibited thirteen paintings in London; four at the Suffolk Street Galleries and the rest at the British Institution, and rather more than a hundred in East Anglia. He was a superb draughtsman and his Yarmouth beach pictures were forerunners of the beach scenes of the mid-Victorian era thirty years later. His brother Alfred Stannard (1806–1889), a landscape artist, and his eldest son, Alfred George Stannard (1828–1885), followed in his wake as the beach and coast scene grew in popularity. So did John Bernay Crome (1794–1842), John Crome's son. Dubbed 'Moonlight Crome' after his taste for moonlit river pictures inspired by van de Neer, his moonlight coast studies of Norfolk were unusual in showing the long night hours worked by fishermen – though the interest was aesthetic not social.

With daylight colouring, Peter de Wint (1784–1849), James Harding (1797–1863), William Shayer (1788–1879) and James Holland (1799–1870), Anthony Fielding (1787–1855) and the Norfolk artists Anthony Sandys (1806–83) and John Thirtle (1777–1839), all primarily landscape artists, took full advantage of the sheer variety of the British coast, its vessels and its people from the break with the Dutch style and the huge stylistic vista opened by Turner and Constable. Their views of this coast made stark and sometimes cruel contrast to the rubbery rocks and toy houses which still squatted on the horizon lines of pictures by ship portrait painters, whose business was ostensibly understanding the marine world.

The English School, 1830–80

Many of these journeyman painters of ships and their modest craft had been verbally chastised by the eloquence of the ubiquitous John Ruskin in his first volume of *Modern Painters*, a mammoth critical edifice that grew out of a celebration and defence of Turner's work in the 1840s. Turning his sincere contempt on the past's eminent marine and landscape painters for their insincere, patronizing contempt for nature, Ruskin had observed:

> A man accustomed to the broad wild sea-shore, with its breakers, and free winds, and sounding rocks, and eternal sensation of tameless power, can scarcely but be angered when Claude bids him stand still on some paltry chipped and chiselled quay, with porters and wheelbarrows running against him, to watch a weak, rippling, bound and barriered water, that has not strength enough in one of its waves to upset the flowerpots on the wall, or even fling one jet of spray over the confining stone . . . The fact is, there is one thing wanting in all the doing of these men and that is the very virtue by which the human mind chiefly rises above that of the daguerreotype or calotype, or any other mechanical means that have been or may be invented, Love. There is no evidence of their ever having gone to nature with any thirst or received from her any emotion as could make them, even for an instant, lose sight of

themselves; there is in them neither earnestness nor humility; there is no simple or honest record of any single truth; none of the plain words or straight effects that men speak and make when they once feel.

Where such as Claude had failed, what hope could the self-taught William Huggins (1781–1845) have to allay Ruskin's indignation? Such as the van de Veldes were keeled in clay, not spray: according to Ruskin, they regarded the sea as a: '. . . level-seeking and consistent thing with a smooth surface . . . in which ships were scientifically to be embedded . . .'

In 1834 Huggins had been appointed marine painter to William IV, and when Turner's *Battle of Trafalgar* was hung at Greenwich Hospital a disappointed veteran of the battle observed bleakly that 'we should 'ave 'ad a 'uggins'. But Ruskin was adamant. Huggins had 'little idea of the look of a ship of the line going through the sea', he said and, although he exaggerated, it was true that the Dutch formulae at the brush of second-rate painters possessed as much relation to reality as a fashion plate. Even so, their structure was a launching point for the self-taught to build upon. As such, George Chambers (1801–40), who had gone

William J. Huggins (1781–1845) *The Launch of the East Indiaman 'Edinburgh' at Blackwall Yard, 1825* Watercolour, bodycolour with gum arabic heightening 14⅝in × 22½in (National Maritime Museum, London)

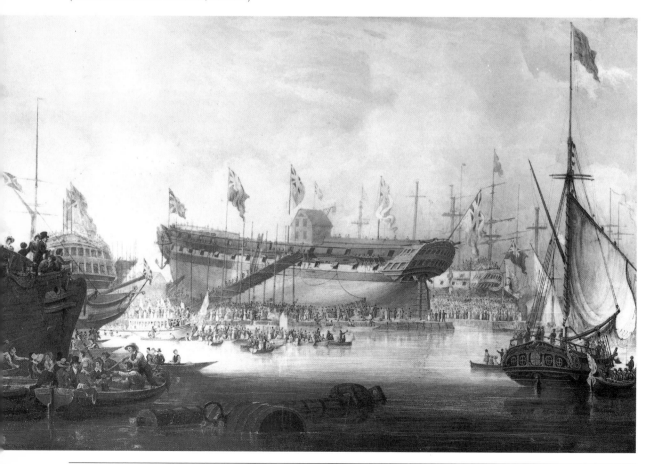

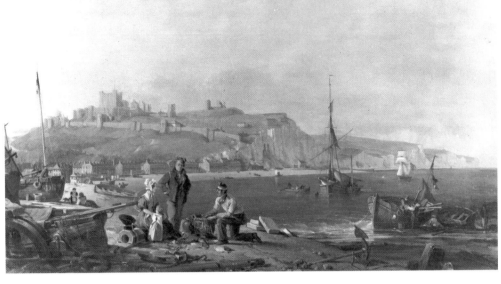

George Chambers (1801–1840) *A View of Dover* Oil on
panel 19in × 28in (Royal Collection)

to sea as a maltreated cabin boy and been released from his indentures by a ship-
owner who saw his talent had ultimately risen to receive royal commissions as
one of the finest British marine artists. He was an excellent figure draughtsman,
and his beach and seascapes have a naturalism and freedom between that of
Charles Brooking and Constable. They were the first true examples of the
'English School' of marine painting, and they gained Turner's praise and
appreciation.

Well before Ruskin's vigorous defence of Turner and his contemporaries, a
general loosening of the tight Dutch style had spread throughout marine painting
to artists of the second and third rank. It was apparent in the steadily changing
style employed by family groups of painters like the Callows, Meadowses and
Knells.

James Meadows (1798–1864) had been brought up in the Dutch tradition, but
gradually he relaxed it in his painting, and it faded out completely in the work of
his three sons. By the 1850s seas painted by him had a translucent swirling
quality and light patches covered the foreground as well as the middle areas of
the picture. The pale English sky, very bright without being vivid and hard, was
stripped of the solid, chunky clouds which in the traditional Dutch method often
resembled gilded cliffs. The pictures were gradually filled with a less theatrical,
more even light, but the vessels and harbour walls, coast and shore remained
sharply and well drawn. They were detailed and factual, and never became those
things of light and shadow they are in Turner.

James Meadows's son, Arthur Joseph Meadows (1843–1907) softened his style
still more, though his vessels were still very much solid forms, often seen against
Turnerian headlands where castles, abbeys or churches stand out in patches of
sun against soft, low cloud. His pastel-toned pictures are still more clearly
defined than those of his elder brother, the landscape specialist James Edwin
Meadows (1828–88), who sometimes painted the coast and sea. His pictures have

a softness which makes boats and groynes appear to grow out of water like moulded smoke, and the small oils of his other brother William (fl. 1870–95), though they are much brighter, have the delicacy of watercolour sketches, especially those made in Venice under vivid skies.

William Adolphus Knell (fl. 1825–74) rose to success using the Dutch method and then at the peak of his career steadily and smoothly shifted his professional style over to the 'English School' without ever losing his market. Indeed, by the 1860s, he may have done so to retain it. This looser sky and more 'liquid' sea gave his pictures a fineness and lightness which is sometimes missing from those of his son, William Calcott Knell (fl. 1848–79), although the son's pictures have a vigour his father's sometimes lack. They are also bluer in colour, with the Dutch tendency to use dark foreground shadow on the sea or shore, which often makes the sea look too dark for the pale sky. The choppy sea in William Calcott Knell's pictures can have an unpleasant tendency to resemble blue creased hessian or fluffy sheets of horsehair. His younger brother Adolphus (fl. 1860–80) lost all trace of the Dutch mannerisms, and his attractive pictures, often small oils on panels, have the appearance of sketches made by Turner for larger works. A century after these artists' deaths, the exaggerated importance of signatures to picture-dealers often leads to their paintings being confused, when the appearance of their work is totally dissimilar.

In his long life, William Callow (1812–1908) overshadowed the other artists bearing his surname by both talent and longevity, and in the pictures made by the Callow group it is quite possible to see a formula emerging, throughout the 1850s, for artists of the second rank when they composed inshore scenes. Like most artists of consummate talent, William Callow excelled beyond one specialist genre, and though he gained a formidable reputation as a landscape watercolourist and architectural portraitist, he made many harbour and inshore pictures which may have acted as guides for his less talented brother John (1822–78), who made a modest reputation as a marine painter.

John Callow's pictures were a blend of Constable and the Dutch system, with residual shadow on the foreground waves, bands of light over the sea, and usually, in the left or right foreground, a small boatload of fishermen being tossed on the swell. In this formula the figures are usually well painted and, when the drawing is confident, hard at work hauling in nets, tightening sheets, bringing down or raising billowing, shabby, much-patched sails bearing the number and the letter of their home port. Other boats, sometimes Dutch barges, otherwise British luggers, barges or ketches, are beating about, while a large three-masted ship in the background stands out to sea. On piers or shingle beaches men wade into the shallows, and women with kilted skirts and bare feet hoist baskets, gut fish, chat, or scour the shingle or mend nets. Smoke scurries from chimneys of fishing villages and is swept low over the water, sometimes conforming to the lie of the clouds, at other times merging with the skeins of smoke from side-wheel paddle-steamers, which are usually seen in the middle or far distance. A close-up view of one of these steamers (except in ship portraits) is rare in these narrative pictures before the 1880s.

Understandably, George Callow (fl. 1858–73) and James Callow (fl. 1860–82) are frequently assumed to be related to William and John, but there is apparently no provable connection between them. Although George Callow's work tends to be static (he had a propensity for conventional calms in the Dutch manner),

John Constable (1776–1837) *Brighton Beach with Colliers* Oil on
paper 5⅞in × 9¾in (Victoria and Albert Museum, London)

their pictures have sufficient attributes in common to make the artists appear
related, which only demonstrates how they had honed their formulae to what
sold.

But formulae can often reveal the differences between artists as uniform
clothing accentuates variations in physical stature. W. J. Leatham of Brighton
(fl.1840–55) enjoyed a freedom and energy in his small pictures by *implying* a
form like a barge as an area of carefully toned colour tailored to the exact shape
such a vessel might have as it tilted and rolled, rather than piling on a great mass
of explanatory detail. Leatham was a fine draughtsman: only an artist with
considerable graphic skill can portray forms so simply and have them remain
immediately understandable.

This lightness of touch, usually associated with watercolours, became wide-
spread among the Turner-inspired artists of the second rank who flourished
throughout the century. It acted as a springboard to those artists with the talent
to use it, and often as a catchnet for those who would never have been able to
cope with the highly detailed style arising from the upheaval caused by the Pre-
Raphaelite Brotherhood between 1848 and 1858, which, championed by Ruskin,
divided British painting at mid-century.

When they did not possess Leatham's skill, many secondary painters were able to use the freer effects to avoid their weaknesses. Often their figure drawing was not strong, and, as in the eighteenth century, the capacity to paint the human figure often dictated whether an artist concentrated on landscape or marine pictures and – if marine – ships, sea and sky, or whether he included scenes on the shore. This dictated the essentially decorative nature of what he did. The common refrain among art critics and historians alike that marine and landscape painting of the nineteenth century usually drew a veil over the harsher reality of working life to pander to the complacency of the picture-buying public, overlooks the fact that social comment is very difficult to paint without the human figure, and many painters of the second rank did not excel in drawing it. Many of their picture schemes, however seductive, such as deeply shadowed static groups and passive, singularly inactive women, are actually simple devices to avoid drawing people in motion. As these artists were working craftsmen they painted what they knew they could paint, and what they believed they could sell. Paradoxically, a social comment was usually a luxury enjoyed by a highly talented establishment painter – like Turner – also frequently of upper-middle-class origin, and often of private means. In this sense complaining that a working marine artist of the nineteenth century was not indulging in 'social realism' is a very élitist criticism: he couldn't afford to, even if he had the talent.

Painters of moderate talent, such as Robert Roe (fl.1868–75), William Wall (fl.1847–72), the de Breanski brothers Alfred (fl.1868–93) and Gustav (fl.1877–92), Frederick Whitehead (fl.1870–1902), Charles Mottram (fl.1876–1905) and Alfred Markes (1865–1901), William Williams (fl.1841–76) and Alfred Vickers's son A. H. Vickers (1853–1907) made this freer style their stock-in-trade, producing pictures of great charm and preserving Turner's direct, recognizable influence in marine pictures well into the first decade of the twentieth century. It is partly due to this that marine painting is the only area of British art where Turner has never fallen from favour, even during the 1920s when his name appeared to act as an emetic to fashionable critics.

What divided most of these Turnerian painters from the other artists making pictures of the British coast was an almost complete lack of narrative content in their work: they rarely made any attempt to tell a story; they concentrated on the view, the atmosphere and the light.

Many of these artists used oil and watercolours in such a way that lessened the visual differences between the two media. Edward Duncan (1803–82) achieved a watercolour delicacy in his estuary pictures in oil by giving his small, fine-weave canvas an amber ground colour over a white base, and then painting the silver-grey or pale-blue sky and reflecting water over this, while leaving parts of the amber layer showing through, at places where the shadows or reflections should be. Details in these pictures were then gently tinted up or toned down until the artist achieved an effect which was soft but clear, with an overall unity where shadows were translucent and highlights never harsh.

Alfred Montague (1832–83) was by no means wholly dependent on Turner's legacy, but he was able to use it as a springboard for his own abilities. Montague painted estuary and coastal scenes in Britain and France, his buildings often appearing as mellowed, rickety cliffs and his boats like bulbous round houses scattered on hazy *eau-de-nil* mirrors. Montague freely used Turner's difficult device of a central light source without making the picture specifically a 'dawn'

or 'dusk' scene: he shared his success with this device with artists like George Chambers Jr, William Webb and W. J. J. C. Bond.

After the manner of his more famous father, George Chambers Jr (fl. 1848–62) 'knocked his colours about' on the canvas. His freedom of technique was more pronounced than his father's, and his drawing, when he pictured furled sails, rigging and the bundles on wharves, has the whirling motion of multi-coloured cotton threads. His pictures have the warm, mellow tones his father's sometimes lacked, and there is the sensation of sunniness and warmth in his Thames and south coast pictures which he shared with the long-lived, good-natured Liverpool painter William Joseph Bond.

The pictures of W. J. J. C. Bond (1833–1926), known as 'Alphabet Bond' after the jingly jumble of his painted initials, are usually small. Serene, restrained, his first-rate Turneresque compositions were frequently 'large watercolour' size on wood panels or artists' board, and painted using a minimum of brushwork. Objects, especially piers and boats, seem to grow out of their reflections and appear spontaneous, a whim of the light. They are often filled with a honey-like, glowing tonality, as if they are copper-plated or lit from within.

William Bond had originally been a studio assistant to the Liverpool restorer and picture-dealer Thomas Griffiths, and this made him an expert in the chemical preparation and technique of oil painting – a vast advantage to an artist. Like Duncan, George Chambers Jr and many others, he often used a transparent under-painting, and then painted around the main image leaving it with an overall appearance of translucency; then he would touch up the details and highlights so that they appeared to float, giving the image a glassy, 3D effect. This meant that the densest colour was often on the 'empty' spaces in the picture and the thinnest on the 'solid' objects.

Originally, Bond had been enthusiastic about the highly detailed style of the Pre-Raphaelites, but Turner's influence held greater sway over him, its scope for a marine painter being wider and more comprehensive than any subsequent development entering British painting before 1900.

William Webb (1862–1903) remained deeply influenced by Turner all his life. A Manchester painter with fifty-five recorded exhibits in Manchester, Liverpool and London between 1890 and 1904 – the last exhibit being posthumous – and as much talent as a first-rate painter like Bond, Webb committed suicide at the age of forty-one, having struggled for years to achieve even the modest success which eluded him. Webb's pictures display not only professionalism of a high standard but, like those of Bond and Chambers, warmth and conviction. That is revealed in the richness and subtlety of colouring, the variety of the figures and the delicacy of people's anonymity even when they are reduced to silhouettes, such as oarsmen on a refracting river. Prolific as he was (and had to be) there is nothing in Webb's pictures that implies that he did not care what he painted: he did care, which is probably why he could not cope with the indifference and the pressure poverty put on his family.

Webb's death had many precedents. Throughout the nineteenth century as in the twentieth, the saleability of paintings had less to do with what a painter saw

Overleaf Samuel Prout (1783–1852) *An East Indiaman Ashore* Watercolour, pen and ink with surface scratching 19½in × 27⅝in (Whitworth Art Gallery, University of Manchester)

and how he presented it, than what lay people saw and wanted presented to them by a painter.

Thirty-six years before Webb's death, George Chambers's great contemporary, Clarkson Stanfield (1793–1867), had died at the peak of success after a long career. Named by his father after the slavery abolitionist Thomas Clarkson, Stanfield had served in the Royal Navy until 1818, where he had received encouragement to paint from officers who were impressed by his talent. Under their auspices he received painting commissions and worked, as Chambers had, as a theatrical scene-painter until marine pictures made his reputation. Between 1820 and 1867 he exhibited 135 paintings at the Royal Academy and was elected a Royal Academician in 1835, at the age of forty-one.

A friend and confidant of Charles Dickens, for whose family amateur dramatics he painted backdrops, Stanfield polished the English marine style of picture, blending Constable's naturalistic treatment of the sea and sky with the Dutch school. His pictures were robust, energetic, well-balanced and detailed, his draughtsmanship was excellent and his palette a mellower form of the grey Dutch style.

These technically excellent pictures, with their sturdy fisherfolk and robust coastal craft, boats which were always portrayed as slightly glossy as though made of polished leather, set the established standard for narrative marine paintings for the rest of the nineteenth century. They were the strong, forthright

Edward William Cooke (1811–1880) *Hay Barge and Man of War on the Medway, 1833* Watercolour 9in × 12¾in (National Maritime Museum, London)

pictures a rising imperial power enjoying absolute marine mastery would appreciate: intellectually undemanding, and in no sense innovatory, like the pictures of Thomas Somerscales at the end of the century; they had elements of muscular Christianity about them.

Stanfield's peer, the great Edward William Cooke RA (1811–80), the son of George Cooke and nephew of W. B. Cooke, Turner's engravers, established a name for himself by the time he was eighteen. At fourteen Stanfield had employed him to record the details of ships and their rigging, and at seventeen he began drawing and etching *Sixty-Five Plates of Shipping and Craft* which were issued in 1828 and 1829. Stanfield, whom Dickens had described as 'a good-hearted and generous man', encouraged him to take up oil painting, and Cooke was responsible for preserving the salient elements of the Dutch style well beyond the 1880s.

Cooke so revered the van de Veldes that he frequently signed many of his later pictures VAN KOCK. However, although he painted many copies of their work (very much in the manner of Dominic Serres), his own compositions often lack the formula clichés which characterized artists of lesser calibre working in the Dutch method, and his pictures remain firmly in the English School. Cooke's drawings are light and subtle, as might be expected from an etcher and engraver, while his oil paintings are colourful, energetic and naturalistic, packed with detail and of a slightly mellow tone so seductive to posterity, although Cooke did not use the bitumen additives which so bedevilled the colours of many contemporaries seeking 'traditional tones'.

Like Cooke's, the vigorous pictures of Henry King Taylor (fl.1857–69) produced enthusiastic comment in the newspapers for the knowledge they displayed of sails, ropes, sky and tides on the shore. Taylor was as restless as his pictures, travelling all around the British coast, his style a rather more graceful variant of John Moore's, and his pictures are among the finest examples of the English School style as it was during the first half of the nineteenth century. Indeed, Stanfield's, Cooke's and Taylor's pictures were the standard at which most marine painters of the traditional schools aimed, and by the 1840s the separate course of their art from that of the Pre-Raphaelites, Impressionists and other later developments in nineteenth-century painting was most marked in the big provincial ports of the north and east coasts.

In this way, the Scarborough artists William Joy (1803–67) and his brother John Cantiloe Joy (1806–66) both learned their craft from copying work of established Dutch-style painters. William Joy in particular produced paintings of considerable grace and energy, with very clear lines to his excellent drawing, and a luminous quality to his thin, oil-glazed colour, similar to late van de Veldes. At his best his pictures compare with those of John Ward of Hull (1798–1849) whose masterpiece, *The Return of the 'William Lee'* (c.1839), displays the superb draughtsmanship typical of many self-taught marine artists brought up in the Anglo-Dutch tradition. Even the formalized waters of the picture – which are a stylized version of a light breeze ruffling a calm – seem as natural and convincing as the graceful play of shadows so carefully designed to walk the eye into the picture plane like the lawn divisions of a formal garden.

Overleaf Joseph Mallord William Turner (1775–1851)
Saltash, Cornwall Watercolour on paper 10¾in × 16in
(British Museum)

John Ward (1798–1849) *The Return of the 'William Lee' at the Mouth of the Humber Dock, Hull 1839* Oil on canvas 24¼in × 36¼in (Ferens Art Gallery, Kingston upon Hull)

The son of a master mariner, Ward was probably influenced by the Scot William Anderson, worked as a ship- and sign-painter, and by 1838 advertised for pupils as his reputation grew in the Hull area. One of these was William Frederick Settle (1821–97), whose serene style echoes Ward's. He pictured areas of the Humber and Solent, although he was was well known in his day for painting Christmas cards for Queen Victoria. His pictures share a crystal-clear quality with those of William Clark of Greenock (fl.1827–41), whose reputation remained as regional as his talent was fine.

Of less talent but local reputation in Hull, William Penny (1834–1924), Thomas Brooks (1818–92), Henry Carter (fl.1827–30), James Wheldon (fl.1863–76), Thomas Binks (1799–1852), John Roberts (fl.1831–64) and William Griffin (fl.1826–39) typify abilities varying from the polished second rank like William Penny to the charming narrative naïveté of William Griffin.

J. E. Buttersworth (fl.1835–70), probably the son of Thomas Buttersworth who was marine painter to the East India Company, is a classic example of a painter of moderate talent excelling in the traditional, Dutch-derived English School style. With their amber tone and soft but stylized seas, his pictures had a great influence in the U.S.A. where there was far less competition and where he emigrated in mid-career. Far better known in the United States than in Britain, Buttersworth's pictures appear to belong to an earlier era than many of their true dates indicate. His work did not really change, as did that of the Liverpool painter Samuel Walters (1811–82), whose treatment of the sea changed radically as he grew older and the vessels he portrayed gradually merged sail with steam.

In Walters's pictures of the 1830s the sea has a fine, sweeping quality, rather like billowing satin, and it reflects the shape of sails; by the 1870s it often shows a choppy, chunky appearance, echoing the streaky puffs of funnel smoke, and acting as a contrast to the longer keel-lines of the steam-sailers he often painted.

Understandably, where the pure Dutch style persisted it was among self-taught artists of harbours, or immigrant Dutch artists, and it, too, continued until the opening of the twentieth century.

The Dutch Journeymen

Early in the century, the Dutch style was at its best in pictures by C. M. Powell (fl. 1807–21), a sailor and self-taught painter. Being a beautiful draughtsman with a wide knowledge of boats, ships, sky and water, he produced pictures which have an almost 3D quality. If Powell's pictures have a weakness, it is that the solid objects are so precise that they evoke beautifully illuminated models at times. His seas, too, have an eighteenth-century element, resembling folded or rucked velvet or crumpled lace more than water. His boats – especially the sturdy fishing-boats with their bulbous hulls and short thick masts – have a shiny-hulled look rather like Clarkson Stanfield's, although this gives them an appearance of being valuable and dependable.

Like many men of his kind, Powell's lack of education meant that he rarely reaped the benefits of his talent or developed it: dealers paid him meagrely, which forced him to churn out pictures, and it is remarkable that their quality remained as high as it did.

The quality of Powell's pictures is not shared by those of Abraham Hulk Sr (1813–97), a Dutchman who settled in London after studying at the Amsterdam Academy and visiting the U.S.A.

Hulk is a good example of a painter of moderate talent enjoying moderate success (as did the rest of his family) with a traditional style which teetered on the edge of mannerism. His glass-like calms and mellowed buildings clustering along the shorelines are pleasing formula creations, but it is astonishing to consider many of them were painted after Whistler's 'Nocturnes' (see page 75), and up to fifteen years before Roger Fry's Post-Impressionist exhibitions (see page 87). They have the air of being put together from a kit; the pieces don't always fit. In one a barge under full sail passes through impossibly shallow water on a collision course for others which would be aground, while under a squally sky groups of unconcerned figures chat on a sandy shore oblivious to this marine impossibility.

It is quality of figure painting and action – credibility – that contrasts the pictures of the Dommersen family with those of the Hulks. Pieter Cornelis Dommersen (fl. 1865–98) could frame a picture with figures so that the viewer is led into the activity of the shore by them, rather than seeing them dotted about the multi-coloured bollards. His son, William Raymond Dommersen (fl. 1870–1900) shared his ability, although the light in his pictures is somewhat harder than in his father's, with his shores sometimes viewed through a street scene.

This power of the human figure to make or break a traditional mode of

Overleaf Charles Napier Hemy (1841–1917) *Among the Shingle at Clovelly* Oil on canvas 17⅛in × 22½in (Laing Art Gallery, Newcastle upon Tyne)

picture-making can be seen in a painter like Henry Redmore (1820–87). The majority of his pictures are fine versions of the Dutch style, but he often painted – obviously when he chose – in the freer, realistic manner of the English School, with the fluid sea which owed so much to Turner and Constable, and foreground figures close inshore in small boats or on the shore. By contrast, his son, E. K. Redmore (c.1880–1939) who lacked his father's ability, plodded clumsily and doggedly along in the Dutch manner, with unwieldy fishing-boats in stereotyped situations. In father and son is all the difference between an artist who painted what he chose, and one who chose only what he could paint.

The Pre-Raphaelite High Tide

London acted as a magnet for provincial painters, especially those with formal art training. While many 'ship-painters' of the traditional school were content with their regional repute, painters of coastscape – the land, the sea, and the people and things between – sought recognition at the Royal Academy, the British Institution, and the Suffolk Street Galleries, showplaces of watercolours. This southward or eastward journey was frequently a mistake, as it was for the luckless Harry Williams (fl.1854–77), a Liverpool artist whose finely-toned coastscapes have an almost Pre-Raphaelite delicacy. Had he remained in Liverpool he would probably have established a name for himself, but he died poor and almost unknown in the capital. He was doubly unfortunate, as the Pre-Raphaelite movement, which thrived throughout the 1850s, and bridged the ideas of Turner and Constable to the English School of the later half of the century, shared with him a passion for detail which has become synonymous with Victorian painting.

The Pre-Raphaelite movement was initiated in 1848 by John Everett Millais (1829–96), William Holman Hunt (1827–1910) and Dante Gabriel Rossetti (1828–82), who were afterwards joined by William Morris (1834–96) and a number of other artists. Millais, Hunt and Rossetti were originally students at the Royal Academy Schools reacting against the conventions established there by Sir Joshua Reynolds (whom they dubbed Sir Sloshua) which were still maintained by the Academy. They also despised what they termed the graphic exaggeration which had developed from the Renaissance Italian painter Raphael. Theoretically, the 'Brotherhood', as they called themselves, wanted to return to the 'natural' style of the pre-Raphael Florentine painters of the 1480s. But what they actually produced was a synthesis of the attitudes of middle-class, mid-Victorian England: high Romanticism, meticulous attention to the details of material form (which they hoarded on their canvases just as their public hoarded objects) and strict 'Realism' of an almost Darwinist nature, laced with a frequently contradictory but high-minded morality. Initially attacked, by 1851 the Brotherhood enjoyed the powerful support of the critic John Ruskin, from whose *Modern Painters* they had been inspired to their theme 'truth to nature'.

Ruskin, whose original defence of Turner had mushroomed into the five monumental volumes of *Modern Painters*, was the most important art critic in Britain by mid-century. For over thirty years he directed Victorian taste, and although his influence is usually said to have been undermined by J. A. M. Whistler's success against him in a celebrated slander trial in 1878, it was more probably reduced in substance by his thoughts on political economy, *Unto this Last* and *Fors Clavigera*, which offended the Victorian art-buying industrialists.

William Dyce (1806–1864) *Pegwell Bay – a Recollection of October 5th, 1858* Oil on canvas 25in × 35in (Tate Gallery, London)

The mixture of faith, romance and factual integrity contained in the Pre-Raphaelite movement exemplified the difficulties facing Ruskin and other intellectuals at Oxford in the early 1840s. As an undergraduate he had to reconcile such discoveries as Sir Charles Lyall's about the age of the Earth with the biblical teachings of his evangelical background. Ruskin did this by affirming that the Old Testament words 'In the beginning' referred to a quite indefinite passage of time before the present state of the Earth and was therefore able to believe that nature revealed the wonder and infinite variety of God's creation. This led directly to the astonishing detail and finesse of Victorian land and seascape painting, and it reinforced the belief that the natural world retained a moral as well as physical cleanliness in total contrast to the grotesque urban squalor of the industrial cities.

Awareness of this belief was all the more prevalent among artists who were city-dwellers. In 1853 a national census revealed that for the first time the British urban population outnumbered the rural, and the artists who visited the coasts did so increasingly as tourists, like the middle-class figures in the foreground of William Dyce's *Pegwell Bay* (1859), or as business people researching a saleable commodity. The London-resident Dyce recalled: 'I made £400 by my trip to Ramsgate two years ago and £260 by my last trip to Arran . . .'

There are two prime features in British coastscape paintings of the later nineteenth century; labour and romantic loneliness. But while landscape painting can be seen as a graceful, passive protest against industrialization by its idealizing a rural past, the same is not strictly true of marine art. Its interest in scenes of

Charles Napier Hemy (1841–1917) *The Setting Forth* Oil
on canvas 21½in × 29½in (Royal Exchange Gallery,
London)

labour flourished from the fact that, unlike urban industry, marine industry
remained essentially manual with traditional tools, and it was still within the
elemental province of the seashore.

Although from the 1860s onwards the Victorian middle-classes took holidays
by the sea in the late summer and early autumn, hotels spread along the length
of sea-fronts to accommodate them, and photographs show beaches – and by the
1890s piers – crammed with day-trippers, beach holidays remain among the
rarest subjects in Victorian art. There are very few parallels to the Frenchman,
Monet's, Impressionist pictures of families taking their ease on the beach among
sand castles, sandshoes and parasols. British urban artists by contrast strode off
along the loneliest outcrops among the sea-mews and spray, or concentrated, as
Denys Brook-Hart has said, on 'The Fishermen of England' engaged in stalwart

toil. The urban Victorians were among the most Romantic people of their era, and they preferred the shores of Britain portrayed as invigorating places productive of wealth, labour and challenge rather than decorous – or rather less than decorous – leisure.

Although it shows a child with a spade and three holidaying women, Dyce's *Pegwell Bay, Kent – A Recollection of October 5th 1858* is in no sense a bland holiday picture. Its bleakly graceful sky grazed by Donati's comet, its wide metallic sea, shoals of distant cloud, the high, layered cliffs and the sand and shingle where the little figures wander and peer, make it a portrait of time. The three women and the child with a spade seem quite transitory, no more than intelligent things digging or probing their mysterious surroundings while the planet supports them for a while. The two baggy, stooping central women almost evoke ducks or small dinosaurs which have strayed a little from their flock. In 1843 Ruskin had spoken of the shaping hand of God apparent in forms of the Earth, but *Pegwell Bay* appears distinctly uneasy, evoking Matthew Arnold's thoughts in *Dover Beach* (1848):

The Sea of Faith
Was once too at the full and round earth's shore . . .
But now I only hear
Its melancholy, long, withdrawing roar,
Retreating . . . down the vast edges drear
And naked shingles of the world.

But the sun-drenched crowds on Ramsgate Sands in William Powell Frith's *Life at the Seaside* seem to have no such anxieties. Bought at the Royal Academy Show in 1854 for 1,000 guineas by Queen Victoria, Frith's rare picture is more a portrait of the people to whom artists like Dyce and his contemporaries hoped to sell their smaller pictures. Reading papers, protecting their complexions from a peasant-like sun tan, while their children dabble their toes in the shallows, these people could as well be present at *Derby Day*, Frith's other famous essay on Victorian recreation and sartorial fashion. *Life at the Seaside* is a fascinating panorama of objects, fabric, little poses of people secure in their hold on the world and their possessions. The sea glimpsed at the bottom margin of the canvas is tame, the share prices are arrayed in the newspapers, and the sands are a pale, firm pavement for these middle-class business people from the prosperous urban areas. In 1854 the Royal Navy's massive wooden warships had held unquestioned marine supremacy for half a century, but had they failed to protect this shore by some unthinkable aberration in the universe, this rampart of whale-boned crinolines and spear-point parasols formed another wall of Britain: on this beach, even the tide knew its place.

By comparison, Frederick Ifold's equally rare 1858 view of a placid sea over the spades, sandcastles and lacquered straw hats in his *A Day by the Seaside* had an almost naïve gentleness. But even here there is something of the domestic fort peopled with dolls, and the long perspective of the sea wall juts as a bastion into the infinity of the water. Yet the water is as tame as an English lake: the paddle steamer and the sailing boat passing on it could be toys set afloat by the china-doll children digging in the foreground under the eye of their mother (?) in her Paisley shawl. Even so, her two boys are far beyond the beach in their imagination: they are planting a tricolour on a sand mountain they've conquered.

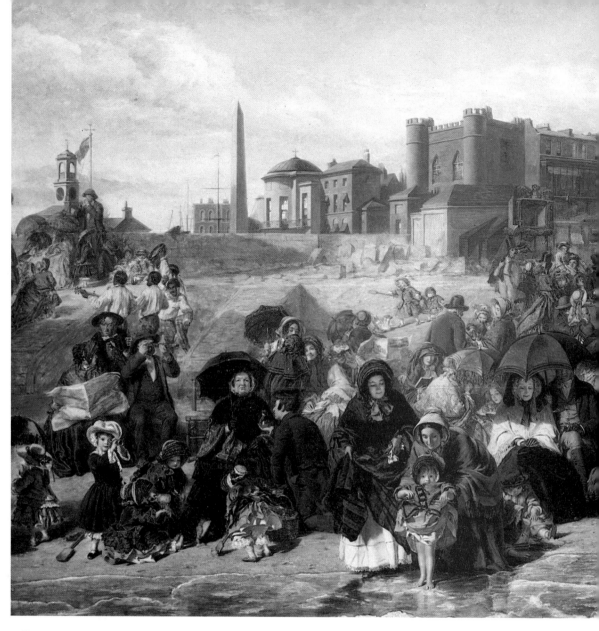

William Powell Frith (1819–1909) *Life at the Seaside* Oil on
canvas 30in × 60¼in (Royal Collection)

Like them, the Victorian imagination preferred its shores vigorous, a place of
toil, risk and drama.

Coastscapes and marines by members of the Pre-Raphaelite Brotherhood itself
are comparatively rare, but in watercolour, William Holman Hunt made pictures
in Cornwall and the south coast between the later 1850s and '60s, and these
small, vivid, occasionally harsh pictures are a good indication of the strength and
weaknesses of the Pre-Raphaelite way of painting.

The vividness of these small coastal watercolours makes a sharp contrast with
the mellowness of traditional styles at that time. They are usually as bright and
sharp as pictures of the late twentieth century, the coastline almost postcard

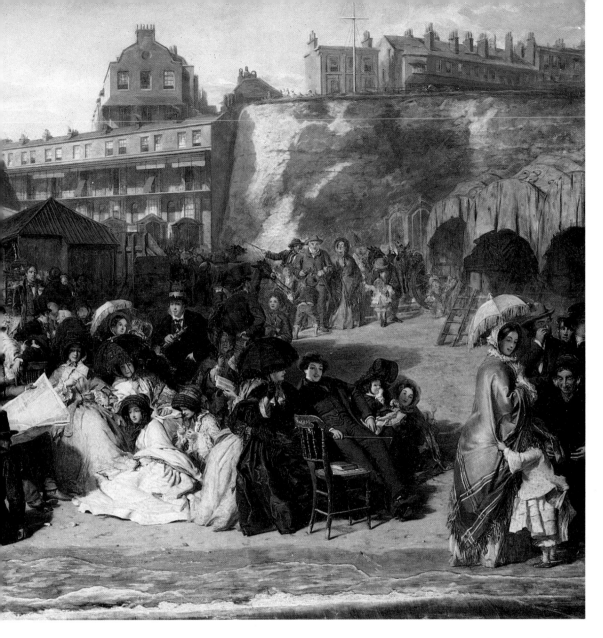

bright, with rock strata and heather fronds seen with vision fit for a bird of prey. But Hunt's sea seems paralysed; it evokes a blue rug, crumpled and immovable.

Still waters with dreaming faces mirrored in them, faerie lakes and glassy meres often offset the details of Pre-Raphaelite landscapes, but the sea's moving tide needed freer brush strokes that were softer, less tight and obsessive. Although Hunt did not substantially change his method of painting, this problem led other artists, like John Brett, further and further from Pre-Raphaelitism when they painted the sea.

Given the limitations of the Pre-Raphaelite system, it is all the more interesting that Hunt did paint the tidal coast when he changed his painting methods less than any other member of the Brotherhood during his career. But his personality may have overriden a need for change. Hunt was a kindly but unswerving evangelical Christian, with all the discipline and conviction of a man who had

risen from relative poverty by his own effort and talent. He shared Ruskin's belief in the virtue of God's Earth, and he employed his painstaking detail and bright colouring to put forward moral ideas in his pictures. These beliefs never wavered, and he was still working in this way when he died at eighty-three. Yet his knowledge of the effect of light and colour was very considerable, together with his understanding of the physical world.

This combination, coupled with the crispness and unfailing energy of Hunt's drawing, gives his coastal pictures an unmistakable sense of space and atmosphere. Unlike so many painters, he responded to the local colouring of the scene he pictured, instead of seeking places which suited the palette he happened to use. His small pictures show that, provided there is a substantial presence of solid forms such as cliffs, shingle, breakwaters, flotsam and growing things, the Pre-Raphaelite system could respond to the marine world.

From their painting of rocky crags it seems apparent that both Hunt and John Brett (1830–1902) were well acquainted with Ruskin's fourth volume of *Modern Painters* (April 1856) subtitled *Of Mountain Beauty*. That was a lengthy discourse in which Ruskin's remarks about painting occasionally interrupt his dissertation on archaeology, and under its influence Brett's painting was at first even more minutely detailed than Hunt's.

An ex-soldier, Brett entered the Royal Academy Schools in 1854, and under Ruskin's influence painted his most often reproduced and least typical picture, *The Stonebreaker* (1858), which established his reputation. It inspired Charles Napier Hemy, one of the leading marine artists of the century to take up sea painting when he saw its rock study. Although often glibly compared – to its disadvantage – with a deeply pessimistic picture of the same name by Henry Wallis, it was anyway untypical of Brett, who soon rejected Ruskin's system and became one of the most successful marine painters of the later nineteenth century.

But Brett never really threw off his Pre-Raphaelite legacy. His small seascapes and coastscapes have a concentrated delicacy where the rock structures possess that vivid clarity sometimes associated with surrealism. The movement of water, its myriads of reflections and wavelets, can be enclosed in a small area but when the picture becomes large, the minuteness loses focus. The tiny details lead progressively into emptiness, because they *imply* the lead-up to some object, some content, some meaning, and then there is nothing there, just space. And emptiness was the antithesis of Pre-Raphaelitism.

The best example of this is probably Brett's *Britannia's Realm* (1880), a model of portentous emptiness bought for the Tate Gallery by the Chantrey Bequest. Brett seems to be that type of painter whose pictures neatly illustrate a period or attitude, and in title and execution *Britannia's Realm* could only have been painted in 1880. To claim the ocean as one nation's sole property is a cameo of Victorian confidence. To enumerate each ripple as though each was a jewel in the Queen-Empress's crown and dot the planet's most powerful surface element with a few complacent yachts as the custodians of it has all the air of comedy that underlies most pomposity.

Opposite top John Brett (1830–1902) *Britannia's Realm* Oil on canvas 41½in × 83½in (Tate Gallery, London)

Opposite bottom Charles Napier Hemy (1841–1917) *Pilchards* Oil on canvas 44½in × 83½in (Tate Gallery, London)

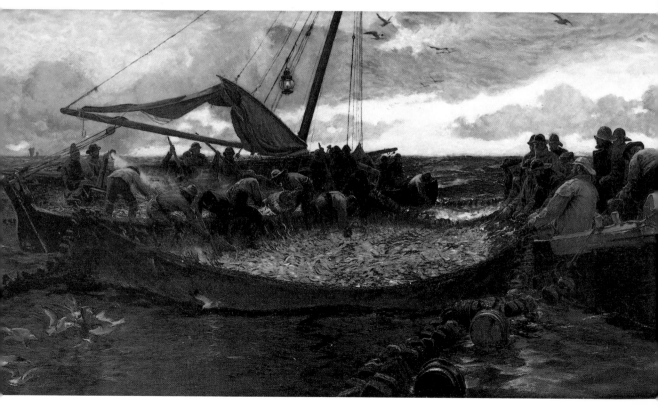

But Brett's smaller pictures have none of this grandiose vacuity. His small watercolours are delicate without ever becoming insipid or laboured, and by the 1890s Impressionism had loosened up his small oils too, with wriggling crescent rows of ripples. With denser seas where the swell was long and sleek there could be a danger of flatness on a small picture, and he used the device of small sailing boats and buoys to give a sense of receding distance, very much in the manner of Henry Moore and many others, including Whistler, Julius Olsson and Philip Wilson Steer.

Henry Wallis (1830–1916), on the other hand, possessed a deeply poetic feeling for land and seascape, and his coast pictures evoke that 'other planetary' view of the Earth one glimpses in Dyce's *Pegwell Bay*. Wallis, who studied in London and Paris and was fundamentally more interested in music and literature than in painting, came under Pre-Raphaelite influence during the 1850s and, when this declined, so did his concern with painting. Like many multi-talented artists, he found literature more effective than painting as a vehicle for social realism, and the brooding emptiness of some of his late coastscapes may reflect a sense of emptiness beyond that of physical space.

These solemn small pictures make the tight, light little panoramas of William Henry Millais (1828–99), Sir John Millais's elder brother, seem by contrast to be studies of delight. The coastscape, *The Valley of the Rocks* (1857), might have all the conviction seen in one of the Italian Renaissance landscapes of Giovanni Bellini. This intensity of vision never left Benjamin Leader (1831–1923), normally associated wholly with inshore landscape, but who made many coastal pictures such as *Sands of Aberdovey* (1888) or *Conway Bay and the Caernarvonshire Coast* (1892) which were imitated by his pupil Daniel Sherrin (fl. 1890–1912). More usually associated with marine pictures, Sherrin's mediocrities hold numerical advantage over his better efforts, owing to the production line of financial necessity. Cashflow crises sometimes prodded Sherrin's deft hand into signing his pictures 'B. W. Leader' for a quicker sale, and not deigning to carry any money in the Ritz, dressing up as a sheikh instead, and informing the manager that a member of his entourage would pay. But out of Arabic costume and with time at his disposal his coastal dunescapes have a delicacy approaching that of Brett, William Millais, or Hemy.

Charles Napier Hemy (1841–1917) owed to Ruskin and the Pre-Raphaelites the inspiration for his early masterpiece, *Among the Shingle at Clovelly* (1864). Hemy had just completed three years' stay at a Dominican monastery, having originally studied for the priesthood, but the year he displayed *Among the Shingle* at the Royal Academy *The Times* had noted that 'seashore pictures abounded' and Hemy's early passion for the sea and his talents as a painter set his course into marine art. He became one of the most eminent marine painters of the century, drawing on the Leathart Pre-Raphaelite Collection at Newcastle for inspiration, and upon the traditional methods of the van de Veldes, producing a vigorous style which married great detail with a powerful sense of movement and mass. In a forty-foot, broad-beamed fishing-boat converted into a studio and named the *Van de Velde*, and in its successor, the *Van de Meer*, he produced pictures whose style and technique were carried well into the 1970s by his pupil Montague Dawson (who unfortunately sensationalized where Hemy employed restraint). His river scenes of the 1870s and coastal pictures of the 1880s typify the robust, narrative Victorian realist picture, displaying an intimate knowledge

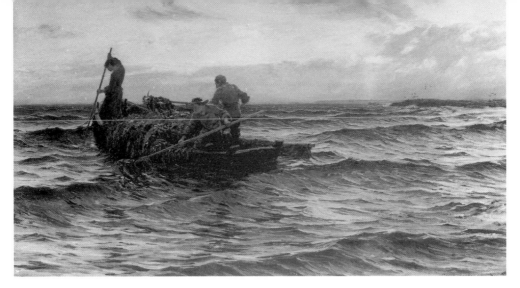

Colin Hunter (1841–1904) *Their Only Harvest* Oil on
canvas 42in × 73in (Tate Gallery, London)

of its subject and a similar knowledge of its buying public.

As far as that public was concerned, deserted coasts or seashore harvest subjects sold particularly well. They had a romantic, robust charm which could rise to substantial portraits of toil at the hands of a talented painter disinclined to sentimentalize the subject. Keeley Halswelle (1832–91), originally a genre painter and engraver who had worked for *The Illustrated London News* in the 1850s and was elected associate of the Royal Scottish Academy in 1866, excelled in scenes of the Newhaven fishing industry as well as of the Thames. The finesse of Halswelle's technique was invigorated by his magnificent skyscapes for which he made many studies from the Scottish Highlands to the Norfolk fen country. Halswelle's figures are often given drama by these skies, but never the sentimentality which the inland rustic scenes of many landscape artists so often possessed during the agricultural disasters of the 1870s.

Before the advent of artificial fertilizers, rowing-boats raked the often dangerous tidal shallows for hanks of seaweed and many thousands of tons were used annually on the land. When Colin Hunter (1841–1904) sold his 1879 picture of seaweed gatherers, *Their Only Harvest*, to the Chantrey Bequest he had produced an image which was immediately potent in the great agricultural depression which ran from the 1870s until the turn of the century. Hunter's picture attempts a sharp realism (although certain marine authorities consider that his sea looks too 'oily' for the condition of the weather), which nonetheless owes much to the Pre-Raphaelite grace of the previous decade, especially the pose of the standing silhouette in the bow of the boat. Hunter painted many pictures of the trawlers, lobster boats, shrimpers and the men and women who laboured in them and around them, who usually began work at dawn and finished it after twilight, seven days a week every week of the year, and his titles reflect their bleak lives.

Although John MacWhirter (1839–1911) won great popularity with a blandly decorative Tyrolean mountain landscape destined for the Tate, and went on to build himself a palatial neo-Renaissance house in St John's Wood, the coldness and poverty evoked by his picture of a seaweed gatherer's cart plodding along a coast road through a wet gale in *Spindrift* (1876) is palpable. A lifelong adherent to Ruskin's principles, MacWhirter wrote of the painting that:

Spindrift means the spray of the sea caught up and whirled away by the wind. I saw the seaweed cart coming along when I was working on a stormy day, and I made a note of it in my sketch-book. I afterwards made careful studies of the wet road, gravel . . .

James Clarke Hook (1819–1907) never achieved MacWhirter's or Hunter's power of expression, but Ruskin praised his work in 1859. His seaweed gatherers are usually the placid, fresh-faced young women who pose somewhat conventionally (and artificially) at their labour, and owe more to the 'contented English peasant' tradition of Myles Birket-Foster than might be good for them, but they never degenerate into the sentimental decorousness of so much second- and third-rank painting of the 1870s and '80s. In Hook's pictures one sees the free, sweeping brush strokes of Turner's seas, the spray often scrubbed in with a semi-dry brush, while the fine figure drawing, rocks, birds and boats have that careful, factual, but at best selective detail which Ruskin championed with such conviction. Hook shared this narrative style of coastscape and marine labour with a great body of artists such as John Wright Oaks (fl.1847–88), Frederick and William Underhill (fl.1851–75 and 1848–70), George Wolfe (fl.1855–73), John Mogford (fl.1846–85), and many others.

These subjects sold: successful labour on a calm or squally day, at sea or on the beach; the deserted shores, distant villages on cliffs, ships under sail passing Turneresque headlands. Full daylight was always preferable in a picture, up to the light of late afternoon (that implied a full day's work). But in contrast to the convention of the calendar photograph of the 1980s, sunrise and sunset were not much in demand. Nor, more understandably, were shipwreck and death, or the deserted sea.

An artist who dealt with these unpopular subjects was either not in need of or did not care about money. Vilhelm Melbye (fl.1853–67) may be poorly recalled because of his propensity for bleak sunsets, stormy shores, wrecks and vessels running before squalls. His constant changes of address may reflect flights from landlords due to lack of sales as much as a restless temperament; but possibly a temperament for squalls reflected lack of sales.

The same may be said of Ebenezer Colls (fl.1852–54), William Stuart (fl.1846–58), who usually painted still-lifes unless taken with a sudden urge to paint a

John MacWhirter (1839–1911) *Spindrift* Oil on canvas 32in × 56in
(Royal Holloway and Bedford New College, Egham)

James Clarke Hook (1819–1907) *The Seaweed Raker* Oil on
canvas 29in × 49½in (Tate Gallery, London)

storm at sea, Walter J. Shaw (fl. 1878–1904), James Webb (1825–95), and John
Warkup Swift (1815–69).

The unfashionableness of storms is in great contrast to their frequent appear-
ance in coastscapes of the late eighteenth century. The Romanticism which had
arisen at the time of the French Revolution had mellowed by the mid-nineteenth
century to a defensive reverence for nature among people who, by the late 1860s,
felt quite secure from social revolution but threatened by industrial tyranny and
insulted by Darwinism. If the planet was hostile, then it should be seen to be
overcome: a powerful friend who had erred pictured as being put back in place,
not an invincible and indifferent parent crushing its presumptuous children.

Some wrecks were more acceptable than others. Turner, by transforming a
storm into a study of shades and then giving the picture a pedantic, semi-
technical title like *Life-boat and Manby Apparatus going off to a Stranded Vessel (A
Vessel in Distress off Yarmouth)* had hidden his pessimism in the triumphs of
humane technology. Ship rescues at the foot of stalwart lighthouses, lifeboats
pitching through clouds of foam and figures clinging in the last stages of
deliverance to finely painted life-lines were also presentable: they were not
portraits of extinction. Darwin had talked too much about extinction. George
Gregory (1849–1938) in particular excelled at these pictures. He was an excellent
figure painter whose style was often reminiscent of Pieter Cornelis Dommersen,
a blend of Turnerian fluency and Dutch stylization. Thomas Rose Miles
(fl. 1869–88) produced some superb essays of wreck and rescue, in pictures of
almost Pre-Raphaelite fineness in which the eye is usually drawn to the hollows
and rhythms of the massive waves. Miles's pictures are as often as not studies of
the force of massed water, showing it as an element through which a finger or
an oar can pass as if through gossamer, but where each droplet's combined
weight becomes an awesome, irresistible force of nightmare proportion.

Rising to the rank of Admiral, Captain Richard Brydges Beechey (1808–95)
was under no necessity to sell his work, and so achieved the unusual reputation
of painting more marine disasters than any known artist of the century. It is rare
and difficult to find a painting by Beechey which is not of a vessel in flames,
dismasted, running aground, wallowing and waterlogged, or in the final stages

of foundering. Facile speculation into Beechey's taste for disaster-mongering, given the success of his naval career and his number of exhibits (40 in London, 19 of which were at the Royal Academy, and also 13 in the British Institution), might be circumvented by recalling that the creative scope which a subject offers a painter is quite different from the pleasure (or not) which it may give the observer. Many pleasing subjects bored and frustrated their creators to depression and alcoholism. (Portraits of be-ribboned poodles drove Landseer to drink, and much third-rate painting by competent painters in any genre more often betrays their boredom than lack of talent.) Beechey, in any case, was fascinated by the appalling power of the sea and portrayed it with the knowledge and respect of a lifetime spent upon it.

The other area from which an artist hoping for sales normally steered clear was picturing the bare, open sea. Lord Byron, whose cloudy-headed, literary Romanticism was only surpassed by his complete ignorance of visual art, could not believe that anyone should wish to paint the sea with no one sailing on it or drowning in it for human interest, and the modest reputations of artists who painted many pure seascapes show he was not alone in this attitude.

Nonetheless, Henry Moore (1831–95), who like John Brett began his career under Pre-Raphaelite influence, turned to painting open seascape and became famous for it in his lifetime. Over the thirty-five years of his career his style became steadily freer and more impressionistic, never reaching that almost Japanese lightness later employed by Whistler and Steer, but more defined, and more distinctly British for that. Indeed, Moore's technique appears emulated in the handling of the sea by realist illustrators of the late Victorian and Edwardian era like Mantania and Caton-Woodville, for whom the sea was merely incidental to their work.

With its strong shadows and highlights, clear definition, high detail but controlled, economic strokes, Moore's painting is quite unlike the flatter, looser-stroked, higher-coloured continental impressionism which was contemporary with it. Moore's billowing cloudscapes are quite identifiable as specific weather systems, his seas correspond to the condition of the wind and sky, and his pictures are portraits of the sea in many moods rather than essays in colour and the nature of paint.

Constable had said that a skyscape was the key to a landscape or sea picture, and to a marine painting without rock formations, harbour bar, beaches and possibly even a ship on the skyline, the skyscape was crucial. In Moore's paintings it often occupies over two thirds of the picture area.

Moore's great talent inevitably ensured that he never limited himself to one genre (in 1867 he was exhibiting landscapes at the British Institution), but only Julius Olsson at the end of the century equalled his capacity to paint the deserted 'pure sea'. Writing in 1919 A. L. Baldry considered that: 'beside the dramatic poetry of Turner [Moore's art was] fine prose, persuasive and dignified, but never rising to inspired fancy.' But he was qualifying enthusiasms of a paragraph before, when he had held that Moore was: '. . . next to Turner, the most learned and accomplished student of marine motives and the finest exponent of the facts of the sea whom any school has produced . . .'

David James (fl. 1881–97), a subtle seascape painter whose work is better known among collectors in the 1980s than the 1880s, produced deserted or bare sea pictures with a soft, blue-toned realism. Their grey, silver and blue appear-

ance was unusual among the greens and ambers of the nineteenth century, and together with their 'desert' appearance they could not have sold well. Just as in the twentieth century, the public preferred its seascapes – when it wanted the sea unadorned – under blue skies with open clouds, in the sun, and with white caps and plenty of boats tossing about on successful business. (Pleasure yachting pictures are largely the province of the twentieth century). Yet despite commercial necessity, and often for major exhibitions, painters like John Fraser (fl.1880–1904) and Edwin Hayes (1819–1904) produced powerful 'pure seascapes'.

In displaying *The Hollow Ocean Ridges Roaring into Cataracts* (1886), Frazer was certainly not celebrating human achievement and was commercially at best appealing to the public taste for the vicarious thrill of something awesome and grotesque. But, often, this kind of picture implied the presence of forces other than the brute power of the elements. Barren seascape is rarely wholly desert. Often glimpsed on the horizon between the waves is the distant (albeit tiny) tower of a lighthouse, or the tilted masts of a ship driving steadily before the wind. These objects gave reassurance as well as a sense of distance and perspective.

Frazer's style had the vigorous naturalism of Charles Napier Hemy, quite a contrast to that of Edwin Hayes. Instead, Hayes's deserted *Sunset at Sea, from Harlyn Bay, Cornwall* (1894), a Chantrey Bequest purchase for the Tate, has a freer impressionism whose lightness of stroke carries off the vast, otherwise overpowering expanse. Even here, two tiny vessels on the horizon seem indispensable. But because of the impressionism and the bright sky, the loneliness is not oppressive; it is exhilarating.

Impressionism and Tradition, 1880–1914

Whistler's Rebellion

Products of an urban artist who saw London as a vast series of shifting tones, almost all the paintings of James Abbott McNeill Whistler (1834–1903) which were not portraits were scenes of rivers and the sea.

This vain, arrogant, elegant young American from Lowell, Massachusetts was rejected by the U.S. military academy after three years, and learned etching in a survey office. He used this technique profitably in Paris where he was befriended by Fantin-Latour, before arriving in London in 1859, where he produced more profitable etchings, the 'Thames Set', and fell in with Dante Gabriel Rossetti and the poet Swinburne. From them and Albert Moore he developed the theory of 'art for art's sake', and his river scenes were among the first products of it. He persisted in calling his river scenes 'nocturnes' in as perverse a showmanship as he titled his portraits 'arrangements' or 'symphonies'.

His pictures of the twilit Thames were painted from memory, not life, but with their showers of light and looming shadows they were tonal studies of what Whistler remembered seeing, filters of memory. They led him into a famous law suit with Ruskin, who accused Whistler of being a 'coxcomb throwing a pot of

James A. McNeill Whistler (1834–1903) *Old Battersea Bridge: Brown on silver* Oil on canvas 25½in × 30½in (Addison Gallery of American Art, Andover, Mass)

paint in the public's face'. Whistler sued Ruskin, who was ill and unable to appear in court, for slander, and won a Pyrrhic victory; he was bankrupted by the legal costs and was awarded one farthing damages. It was a pregnant comment by the legal establishment on the value of aesthetics in court. The significance of the trial to the course of art in Britain has been greatly exaggerated. The general movement towards a looser technique and greater impressionism was prevalent throughout the country, even in the work of painters like Brett and Millais. In 1859 Millais had commented that Ruskin: '. . . does not understand my work which is now too broad for him to appreciate, and I think his eye is only fit to judge the portraits of insects.'

Whistler's 'Nocturnes' were merely an extreme example of a general trend and, as an abrasive exhibitionist, he rapidly discovered that courtrooms gave his pictures as much publicity as art galleries and a lot more newspaper coverage. The irony was that as his taste for law suits increased, his art, by contrast, became more defined, finished and elegant; and it was lack of 'finish' that Ruskin had criticized.

The influence of Japanese painting on Whistler, its economy of line and form, and sometimes single brush strokes to provide the whole representation or 'essence' of an object, gave his painting a polish and delicacy which was the antithesis of 'thrown pots of paint'. His often reproduced 1866 picture of Valparaiso harbour, Chile, shows the scope of impressionism to evoke distance, solid objects, and light over a wide expanse revealed by tints and tones of colour – something more typical of vision over the sea than the land. But even Whistler

found the presence of a shadowy ship necessary in his seascapes, as in *The Ocean – Symphony in Grey and Green* (c. 1866–67).

What remains unique about Whistler's pictures of the sea is the economy of their realism. His pupil Sickert was not exaggerating when he said: 'He will give you in a space of nine inches by four an angry sea, piled up, and running in, as no painter ever did before.'

Whistler influenced British painting less than Turner, whose versatility he could not equal, and his painting in any case coincided with the development of French Impressionism. However, when he moved to Paris in 1892 he regarded the Parisian Impressionists with distaste; with few exceptions their work was as loud as his was subtle, and compared to his Japanese tonalism their work to him seemed only fit for the wall of a *bal musette*.

Well before the Ruskin-Whistler trial, the Norfolk artist Atkinson Grimshaw (1836–93), a friend of Whistler's, had enjoyed much success with the softness and shadowy tonality of his moonlit pictures.

Grimshaw had begun to paint in 1859 while still employed as a clerk on the Great Northern Railway, and his early work had been essays in Pre-Raphaelite delicacy and minuteness, frequently of outdoor still life. He was already a successful painter by 1864, and, although his work grew steadily softer until it possessed a Turnerian vaporousness in which gas lamps looked like will o' the wisps around crucifixes, and roads glimmered like streams, a fine detail almost always remained, as in fishing-nets spread across harbour railings and spars glittering under harbour lamps. His harbour scenes of the north and east coast towns became increasingly gentle 'symphonies' of tone and shade, mixtures of artificial and natural light, and his 1885 pictures at the Grosvenor Gallery had much in common with Whistler's.

A man who strove for similarity was the naïve and luckless Thames river artist Walter Greaves (1846–1930), the son of a Chelsea boat-builder who had ferried Turner across the Thames. Walter Greaves and his brother Henry performed the same service for Whistler, ferrying him on the river at twilight to make preparatory sketches for his 'Nocturnes'. The Greaves brothers became Whistler's studio assistants, for which they never received any payment, and worked for him free of charge until he no longer needed them. Greaves lost his own style of painting in emulation of Whistler's, along with much of his own personality. The Tate Gallery's *Hammersmith Bridge on Boat Race Day* is an example of Greaves's naïve style and deep knowledge of boats, barges and river craft. But apart from a solitary exhibition of his work in 1911, Greaves's worship of Whistler brought him penury: dressed as Whistler in top hat and frock coat he haunted London bookshops until the 1930s offering his sketches for books, and died, an eccentric relic, in a poorhouse.

Norman Garstin (1847–1926) shared Greaves's admiration for Whistler and Whistler's enthusiasm for the subtlety and asymmetry of Japanese art. His 1889 picture *The Rain it Raineth Every Day;* a view of the British coast, as typical as it is rare, possesses all the silver, muted tones which were Garstin's prime contribution to the Newlyn School, which grew out of the art colony established there in Cornwall by Stanhope Forbes.

Garstin's picture was a microcosm of the divergent needs and interests pulling at British realist painters near the end of the century. A *tour de force* of light and reflection, it is a narrative view immediately recognizable to anyone in a coastal

town: its tones are beautifully modulated and it is a rain scene of the kind that had been hung in the Paris Salon over the previous decade. Yet it shows passivity in the grey haze. Were it a squall with positive action or a clear day with a bracing wind for the promenaders it might have been met with approval. Although it was accepted by the Royal Academy in 1889 it was not hung, and Garstin badly needed money at the time. Like so many British artists, he was forced into upper-class portraiture and sentimental narrative costume subjects to earn a living.

His situation was a common consequence of the British attitude, but it was not the rule. As always, British society was quite receptive to continental painters, such as Théodore Roussel (1847–1926), who arrived in 1874 and became a close associate of Whistler, producing many Whistlerian coastscapes in oil with loose, very fluid paint. Roussel painted particularly along the south coast, often using the dark shades of summer squalls to contrast the pale cliffs in pictures which sometimes achieve the delicacy of watercolours. But the main importers of French Impressionism were British artists returning from study in Paris during the 1880s.

The Impressionist Invasion

It was in the 1880s and 1890s that Impressionism took root in Britain, spreading chiefly through artists' colonies which emulated the French. Their colonies had been formed in 'unspoiled' or 'wild' areas – usually Brittany. Stanhope Forbes (1857–1947) worked in the Cornish village of Newlyn and formed an art school there in 1899; a 'Staithes Group' formed in the 1880s, taking the name of a Yorkshire fishing village, and in 1883 a group of Scottish painters, the 'Glasgow Boys', discovered Cockburnspath on the Borders' coast near Dunbar. At Newlyn, most of the founding members were conservative stylists influenced by the Frenchman Jules Bastien-Lepage, and the same applied to most of the painters of the other groups who had studied in Paris.

This French invasion was of no great benefit to British painting. Bastien-Lepage's Impressionism was mild-mannered and, although he lived and worked among the peasant communities which he painted, his pictures had little of the vitality of urban French Impressionism, and time has made them appear vapidly sentimental. Worse, his British imitators amalgamated their tendency toward moral anecdote with his diluted Impressionism, losing the technical vitality and finesse which had characterized the British School, and creating, as Quentin Bell has said in *A New and Noble School – the Pre-Raphaelites*: '. . . an Impressionism from which the colour had been removed, and to which a high moral tone had been added'.

By contrast, Britain's leading exponent of Impressionism at the close of the century, Philip Wilson Steer (1860–1942), only became interested in it on his return from Paris to England.

Steer had studied under Bouguereau at the Académie Julian and under Cabanel at the Beaux-Arts, and was one of the founder members of the New English Art Club in 1886. His taste for Whistler's work and his Francophile training led him during the 1890s to produce the ultimate in free style painting practised by a British artist, especially one frequently dealing with marine subjects. In Brussels he experimented with Seurat's *pointilliste* technique, building up the picture with tiny spots of pure colour but never indulging in the harshness of the French

pictures: he was a neo-Impressionist (if one must label him) at that time, and on his return he became more and more absorbed in the 'value' of tone – or the visual weight of one colour in relation to another.

He left pointillism when he had sufficiently explored it, and for close on twenty years (until about 1915) his thin, liquid paint, in oil or watercolour, was applied with a vigorous lightness which could evoke wide space or the human figure in a series of tonal strokes. Walter Greaves's comment that 'to Mr Whistler a boat was always a tone' applied equally to Steer.

At his best, Steer's marine pictures have the precision of Chinese or Japanese painting, with single strokes or areas of colour exactly placed so that one can understand the image without any elaboration. At times moving yachts appear to have 'after-images' as they might in time-exposure photography, or lingering on the retina of closed eyes. But Steer took increasing criticism of his drawing, with the result that his work gradually lost its graceful vitality. As the drawing became more sharply defined, the basic simplicity of his subjects could appear vacuous, and even trivial. As John Rothenstein has pointed out, Steer said nothing that had not been said already by Constable and Turner, and although he said it with great visual seductiveness, when he had to 'spell out the subject' in sharper drawing, he did not add anything to their statement. If anything, he said rather less.

Steer's work exemplifies the strength and weakness of Impressionism in marine pictures. Whereas the Pre-Raphaelite conviction in detail could lead to a static appearance of what should be flowing movement, and an over-burdening weight of solid matter, Impressionism could cope with huge spaces and drifting motion with relative ease. Wide areas of water were a tone or tint, a veil of colour which led the eye on an expanding journey, rather than intimidating or exhausting it. Conversely, Impressionism too often became *merely* an impression, a contentless exercise in tone and tint whose subtleties – *if* they were subtle – were all too often lost on the lay person and whose wider content was negligible. The hazard of 'art for art's sake', put into practice through the succeeding years, seduced artists into painting for each other in a chromatic language which became progressively more abstruse. Meanwhile, Impressionism could become a mind-less eye, like an insect reacting to colour without imparting thought.

Though not of Steer's standard, the brand of Impressionism which developed in Scotland during the last fifteen years of the century showed vitality, particularly the work of John Lavery, James Guthrie, George Henry and Arthur Melville who were associated with William York MacGregor's Glasgow studio.

In 1883–4 Arthur Melville who had also studied at the Académie Julian in Paris painted with Guthrie on the Berwick coast. He had developed a technique of sprinkling brushloads of strong colour on an already water-saturated surface, which in turn evolved into an original personal style of dabs of pure colour dropped on washes of pure colour. He thinned the paint with water but he never mixed two colours together, and so achieved the vividness of Seurat's technique unmarked by its 'frozen snowstorm' effect. In this manner, forms took shape by mass rather than outline, and although his work confused rather than offended critics, Melville's river pictures have a broken, sparkling brilliance which is the very essence of light refracting off crowded water. They use colour patterns to imply flickering movement of people and things just glimpsed, and as such stimulate the observer's imagination.

William McTaggart (1835–1910) *Broken Weather, Port
Seaton* Oil on canvas 23¼in × 30¾in (Kirkcaldy Art
Gallery)

James Guthrie (1859–1930) used a square-ended brush and a general lightness
of tone to achieve a chiselled effect in his painting which in coastscape gives the
impression of the sea and land being chipped with a colouring chisel. After
abandoning law at Glasgow University in 1877 Guthrie studied in London under
John Pettie who favoured pictures based on literary subjects, but he rejected this
to paint in the open air in emulation of Bastien-Lepage. Although he later
abandoned this way of working for successful portrait painting (which gained
him a knighthood) he influenced the Irish-born John Lavery (1856–1941) with
whom he worked at Cocksburnpath and who had also shared his enthusiasm for
Bastien-Lepage. Lavery gained a knighthood in the same way as Guthrie, but
never used the square-brush effect with the same mannerist result, and he
continued to produce delicate Impressionist marines; his view of a US battle
squadron lying in the Firth of Forth in 1918 almost credits the big dreadnoughts
with the grace of so many fenland ducks.

George Henry (1858–1943) who ultimately followed Guthrie and Lavery in
successful portraiture, combined an enthusiasm for the Celtic revival with a
Whistlerian interest in Japanese art. His moonlight riverscapes, although more
definitely drawn than Whistler's 'Nocturnes', have an economy of strokes often
associated with Wilson Steer.

None of these men had the vitality of the Edinburgh-trained William
McTaggart (1835–1910), who came quite independently to his own brand of
Impressionism.

As a crofter and member of the Reformed Church, McTaggart's father had
objected to his son becoming a painter, and apprenticed him to a Campbeltown

apothecary, who saw his talents and encouraged him to enter Edinburgh art school. Robert Scott Lauder, the colour theorist, was an influence, and he met John MacWhirter (the painter of *Spindrift*) and David Young Cameron, both of whose work contrasted greatly with his own, for MacWhirter was motivated by Ruskin and the Pre-Raphaelites, and Cameron showed an affinity to Guthrie.

The often eerie, dream-like impressionism McTaggart developed owed nothing to a brief visit he made to Paris in 1860. It is an extraordinary, vigorous, richly-toned thatch of strokes which often blends images of stone, heather, water, sand, sky and people into a whirling whole. Frequently, there is a curious two-dimensional quality in the image; it is as though a cliff top is only a few inches above the sea or the figure; and the figures appear to be growing out of it or into it; they might be scores of yards long and join cliffs and sea, or the land and sky, as though they were infants born out of the substance of the planet.

This high colour, strong – rather luxurious – brushwork, and disturbing blending and arising of forms, recurs in Scottish and Irish land and seascape painting well into the twentieth century: often with pictures by Samuel Peploe and particularly Jack Butler Yeats, whose figures seem to be slashed out in blizzards of paint or bound to the sea or sky. But people played a steadily decreasing part in McTaggart's pictures, and in stormscape almost vanish but for the clue of a hat brim or an outstretched hand.

McTaggart's work was the prime influence on the Glasgow artist Joseph Henderson (1832–1908). Landscape, portraiture and genre occupied Henderson for the first twenty years of his career, but thereafter, with McTaggart's sweeping brushwork and intense, often brooding atmosphere, his paintings became dominated by the coast, sea labour and deserted tidescapes, which he practised increasingly as the grand old man of Glasgow painting.

Henderson's seascapes have a freedom of brushwork of the kind which was refined and given greater control and economy by Julius Olsson (1864–1942), one of the finest turn-of-the-century painters of the sea.

At a Royal Academy banquet in 1949 Sir Kenneth Clark asked, 'Who now remembers the great Julius Olsson?'

Only six years after his death in 1942, Olsson's masterly essays on the open sea were already drifting into neglect. Yet in life he had achieved a considerable reputation. Over 175 of his pictures were hung at the Royal Academy, and a number, starting with *Moonlit Bay* for the Tate Gallery, were bought by the Chantrey Bequest. He rose to the Presidency of the Royal Institute of Oil Painters in 1919, and was twice on the jury of the Carnegie Institute at Pittsburgh, yet he had had no formal art training and was largely self-taught.

As with his predecessor, Henry Moore, he often included, on the very edge of the horizon, the distant geometry of a far sail, to give the eye a key-point and a gauge for scale, but he was able to give the deserted seascape coherence and movement without the aid of a 'solid object' like a boat or buoy. Olsson's waves never solidify into that ice-skeined-boulder appearance one often sees in today's heavier acrylic pictures, and by using modestly sized canvases and localized light, caused by patches of moonlight or sunbeams, he was able to give the eye navigation points through which to follow the wave patterns and see movement.

Olsson honed the Impressionism of the late nineteenth century and carried it into the twentieth as a yardstick by which marine artists could measure themselves. He had the power to achieve both atmosphere and the texture of

Julius Olsson (1864–1942) *Moonlit Shore* Oil on canvas
46in × 60½in (Tate Gallery, London)

water under various lights with astonishingly little brushwork, a feature he shared with almost all the greatest exponents of seascape.

This capacity to paint rolling, deep water was enjoyed by Thomas Jacques Somerscales (1842–1927), an artist whose memory is usually attended with reverence from marine artists and opprobrium from art critics respectively. The son of a Hull shipmaster, he served for seven years in the Royal Navy as a teacher and then lived in Chile for twenty-seven years, returning to England towards the end of the century. When he did, his *Corvette Shortening Sail* attracted immediate recognition at the Royal Academy; shortly after this his *Off Valparaiso* was bought by the Chantrey Bequest. It became one of the most popular prints of all time, and bred countless imitators.

With no formal art training, Somerscales was a very 'painterly' painter, achieving his effects through simplicity and vigour of stroke, with an interest in the texture of paint and colour. He was no method painter, like so many self-taught artists, painting systematically across the canvas, finishing each detail as he went, and his strong colours, powerful narrative content, fresh winds and sun on sail, made his pictures speak of clear horizons, difficult but successful journeys, an aim in life, 'freedom' and mental and physical strength. They have the elements of John Masefield's poetry, which was all enough to guarantee the dismissive hostility of any mid-twentieth-century art critic.

Somerscales's legacy cast a long wave. Although he painted the vessels of his own time, the popularity of his pictures led to numerous imitators carrying on not only his late nineteenth-century style of painting but also its content – deep-sea sailing ships – far into the twentieth century. This led to the accusation of creative bankruptcy and cynical nostalgia-mongering which in many eyes discredited not only them, but the artist whom they copied. Two other painters

of great technical talent, Jack Spurling and Charles Napier Hemy's pupil Montague Dawson, followed in Somerscales's wake, and what they did altered the focus of traditional twentieth-century marine pictures.

This accomplishment was not deliberate as it could not be foreseen, but it was certainly lasting. Throughout the nineteenth century, inshore scenes of fishing craft, beach labour, or deserted coastscape pictures had far outnumbered paintings of deep-sea ships by between eight and ten to one in exhibitions. But from the later 1920s this steadily altered, until marine pictures divided as never before. On the one hand there were those of the coasts and estuaries made by men and women who were often essentially landscape painters, and there were those of deep-sea ships, as often as not ships of the past, painted by men who specialized in these and little else.

But when the hotel calendars in the coastal resorts were hung for 1st January, 1900, the late Victorian marine painters of what would shortly become Edwardian England still enjoyed a sense of continuity in their methods and beliefs which was well-founded: in British marine painting as in British society, the twentieth century did not begin until 1918, after the Armistice of the Great War. Even then, the dominating skill and influence of the finest of them, such as William Wyllie and Frank Brangwyn, lasted well beyond the middle of the twentieth century.

Edwardian summer

They were singularly fortunate, this generation of painters, for in the Edwardian Summer between 1900 and 1914, the river traffic along the Thames and the Medway was probably more varied and colourful than at any other time: steam tugs with high, smoking funnels, steam coasters (the dirty British coasters 'with salt-caked smoke stack' and cargoes of 'cheap tin-trays' so beloved by Masefield), three- and four-masted sailing ships loaded with wood or wool, and the brown-

William Lionel Wyllie (1851–1931) *Toil, Glitter, Grime and Wealth on a Flowing Tide* Oil on canvas 45½in × 65in (Tate Gallery, London)

sailed Thames barges and scores of rowing-boats, all milling in the Pool of London below the smoking chimneys, unobscured church spires, the twin domes of Greenwich or the single dome of St Paul's, beside the crowded wharfs. An artist would have been feeble indeed not to have responded to this panorama. And William Lionel Wyllie (1851–1931) was one who did. Wyllie could take the simplest subject – a laden barge being rowed by the stern – and give it a sense of weight and drama as it moved through swirling tidal water, when most other artists would see – and paint – a skate-shaped shadow drifting on a flat grey void.

All his life, from the mid-nineteenth century till the 1930s, Wyllie was a painter of 'ships and sea and atmosphere'. When his *Toil, Glitter, Grime and Wealth on the Flowing Tide* was bought for the Tate Gallery in 1883, he was already considered by many to be one of the finest marine painters in Britain, and among maritime artists this belief has not changed. Wyllie had entered the Royal Academy Schools at the age of fifteen, then worked for twenty years for the *Graphic* magazine, and his finesse and versatility encapsulated the late Victorian 'English School' in full flower. In 1878 his Thames river scene, *The Silent Highway*, set a standard adhered to by most of the artists of his generation.

His method of painting, looser than Charles Napier Hemy and with more subdued tones, was less detailed than his pictures imply at a glance. They are made up of shadows which are then highlighted, the shadow having a great deal of 'outline detail' added, when inside the area of the form things are *implied*, but not spelled out in any way that would weary the eye and confuse the issue. This strengthens both the impression of light, and of physical weight.

These pictures have the narrative power of an illustrator and the economy of an etcher and advertiser. Wyllie did posters for the Orient Company, Union Castle and White Star Lines, and etched for Robert Dunthorne, who ran the Rembrandt Gallery; but his pictures have the unmistakable appearance of being products of an artist well-acquainted by choice with boats and tides. He often sailed in yachts and on the barge *Ladybird*, and later he was to fly in aeroplanes taking aerial views and photographs of the Thames and coastlands. Two years before he died he completed a panorama of the Battle of Trafalgar for the *Victory* museum, probably one of the most accurate reconstructions of the great fight of 1805 anywhere on view.

Until the Second World War the strong, dusky-toned watercolours of Charles Dixon, Frank Mason, Frank Wasley, Branston Freer, Frank W. Scarborough and Charles de Lacy, with their metallic river, rusty reds and dusty blues, summed up the Thames and Medway.

Charles Dixon (1872–1934) practised a style close to Wyllie's, but the colouring he used was higher. In his watercolours there is a weight one sometimes sees in small oils, and like Wyllie he used soft edges on large objects and then sharpened the main form with fine brushes, giving a feeling of unlaboured detail. Frank Wasley (fl. 1880–1914) used more opaque body colour than Dixon to gain a similar effect, as did Branston Freer (fl. 1905–15) whose Thames barge scenes are typical of many Edwardian watercolourists who could give a sense of unsentimental occasion to the ponderous vessels with their solemn dark sails against a leaden channel sky. Frank W. Scarborough (fl. 1890–1939) differed from this group in that he gave his industrial river scenes by day or night the loose, brooding Impressionist freedom which he had given to his north-eastern coast-scapes a decade before.

Frank Mason (1876–1965) changed his approach to painting little throughout his long life, and that approach was essentially a looser, lighter-textured version of the style practised by William Wyllie. The harbour scenes he made in the Middle East in the Great War of 1914–18 were freer still, as they were in Venice, but tightened again after, as if in response to a change of light. The same was true of Charles de Lacy (fl. 1885–1930), an oil painter of the Thames estuary in a Wylliesque style and a press artist and special correspondent to *The Illustrated London News*. A prime feature of all these artists' pictures (except perhaps Scarborough's), apart from their essential similarity and narrative energy, is that reproduced in black and white, their smoky contrasts give them all the effect of charcoal drawings, the keynote to their sophisticated tonality.

In Newlyn, Stanhope Forbes's school of painting lasted until the Second World War, and only his declining health brought it to a close. After his success in 1885 with *A Fish Sale on a Cornish Beach* at the Royal Academy, his painting continued in the manner influenced by Bastien-Lepage but always cooler in emotion, detailed and careful, showing a wide knowledge of the lives of the fisherfolk he lived amongst and with whom he was so popular.

His colleague at Newlyn until 1895, Henry Scott Tuke (1858–1929), continued to paint in a very similar but more delicate style. Tuke exhibited at the Royal Academy from 1879, had pictures bought by the Chantrey Bequest, but was not elected an R.A. until 1914. His drawings and paintings of the sea and ships were as sensitive as those many he made of nude boys and youths bathing, standing on the shore or lying upon rocks, a subject historians and critics would no doubt have remarked upon far less had they been women or girls. As it was, Tuke

Dame Laura Knight (1877–1970) *The Beach* Oil on canvas
50¼in × 60¼in (Laing Art Gallery, Newcastle upon Tyne)

created many fine narrative realist pictures like the cold, pessimistic *All Hands to the Pump* of 1889, vigorous enough to make a popular paperback book jacket nearly eighty years later.

Until the later 1920s, the traditional English School style of the late nineteenth century lived on in pictures by Frederick Aldridge (1850–1933), a Worthing painter who visited Cowes each year for half a century, the gentle estuary scenes of Charles Allbon (1856–1926), the Scot Struan Robertson (fl. 1903–18), American-born William Norton (1843–1916), Dudley Hardy (1867–1922), son of the popular marine artist, Thomas Bush Hardy, who painted in a slightly freer style than his father, George Gregory (1849–1938) whose approach was a softer version of Wyllie's, Sidney Goodwin (1867–1944) a nephew of Albert Goodwin, and Ernest Dade (1865–1935) whose delicate, light watercolours often resemble Henry Scott Tuke's.

The subjects and the methods of all these men can be found in the work of Frank Brangwyn (1867–1956), an inheritor of their tradition and one of the most notable marine artists of his time.

As a painter, etcher, lithographer and muralist, Brangwyn was almost wholly self-trained. Originally he had gone to work for William Morris, but finding Morris's craft-based institution too restrictive he abandoned it, and went off to live rough among the barge-men of the south coast, selling his pictures (usually of the boats or the men) to them for sixpence a time. He recalled that: 'First I made friends with the *Laura Ann*, and then other coasters. The first money I earned was by painting the name on a vessel's hull.'

According to his biographer he '. . . stowed sails, handled ropes, helped the cook, washed dishes, and made sketches of the ship'.

His first picture, a small oil, *A Bit on the Esk*, was hung at the Royal Academy in 1885, when he was eighteen. His watercolour *The Laura Ann* of the same year quite ignores all conventional compositional layout and is sombre in colour, two barges occupying the centre with all the grace of small waterlogged airships. But they evoke superbly the massive, sluggish element of ponderous working barges. Nonetheless, Brangwyn's time with Morris had not been wasted, and for some time he made his own paint, which partly accounts for the muted, brooding colouring of his early pictures. He ground the pigments himself and bound them either with an oil or glue medium (not unlike the gum Turner applied in his watercolours) and he experimented with various densities and mixtures.

Brangwyn's subjects were wide-ranging and as an etcher – particularly of architectural subjects – his deep-shadowed effects influenced many students working in the early 1920s. So did his brooding treatment of the sea and tidal estuaries, which affected the vision of Rowland Hilder, whom he introduced to Graham Sutherland whose work owed much to Brangwyn. Ultimately knighted, Brangwyn became something of an establishment figure. He adopted a free, vigorous style of realist painting with strong highlighting which always gave his simplest subjects a degree of drama, a practice his contemporary, Muirhead Bone (1876–1953) was to follow in more 'finished' form.

Brangwyn's influence on artists who were students during the etching boom of the 1920s was powerful, and it remains into the 1980s, especially among painters of the Wapping Group working along the Thames, and members of the RSMA, who by the early 1960s were painting a very different coastline from that which Brangwyn's contemporaries had known.

'The Glasgow Boys'

In 1912, the year the painter and critic Roger Fry held the second of his two great Post-Impressionist exhibitions which radically altered the course of art in Britain, John Lavery and James Guthrie were instrumental in founding the Scottish Society of Eight, which included Samuel Peploe and his friend Francis Cadell.

Francis Cadell (1883–1937) had studied at the Académie Julian in Paris on the advice of Arthur Melville, and until 1909 remained on the continent, where he was heavily influenced by Impressionism. By the time he returned to Britain he possessed a taste for brilliant colour and a brief, almost shorthand way of drawing. In 1920 he introduced his friend Samuel Peploe to the Isle of Iona on the Scottish west coast, which henceforth he visited each summer for the next twenty years, painting views of the coast.

Samuel Peploe (1871–1935) had studied at Edinburgh before he went to the Académie Julian, painting on Barra in the Hebrides on his return. At first, his Impressionism was expressed in a low-key range of colours which echoed the cool north light, but constant summer visits to France, and marriage which led him into the company of writers and artists such as Katherine Mansfield, Anne Rice and John Middleton Murry caused him to settle in Paris between 1910 and 1914. By the time he returned to Britain his palette too was bold, and his drawing rhythmic and simplified.

Peploe painted on Iona until 1930, focusing on the north shore's blue sky, green sea and light, vivid, shining sand, because he wanted to retain his French colourism. But he and Cadell painted the coastlands in all conditions, and often his style resembled that of William McTaggart; forms swirled and merged in an organic sea of paint. But he wrote that he preferred the days of 'blue skies and clear distance'. The weather of Iona with its rain veils was 'an immaterial thing, emotional, lyrical', and did not 'lend itself to larger canvas, the decoration, the static'.

Like Peploe's, the vigorous Impressionism of the Irishman, Jack Butler Yeats (1871–1957), is frequently reminiscent of McTaggart's. But unlike McTaggart's work, where figures seem to melt with belonging into the matter of the planet, Yeats's often single figures in coastscape appear to be assaulted by or foundering in a very welter of paint.

Brother of the poet W. B. Yeats, he drew for *Punch* magazine for many years under the name of W. Bird. Although Irish Civil War themes figured largely in his work during the 1920s, he travelled widely throughout the coastal islands, as did Edward Seago, with whom he shared the friendship of the poet John Masefield, and there is present in his pictures a wistful, often nostalgic sense of things which have passed away. Yeats's colours too could be bold from emotion as much as observation, and the high palettes of the Scottish and Irish Impressionists often gave their northern coasts a Mediterranean air that was born as much from feeling as continental training. Compared to this, the bright Impressionism of Terrick Williams (1860–1936) or David Davies (1864–1924), who painted around the harbours and coves of Cornwall, Devon or the southern French coasts, appears mellow or even cool. There is too in Williams's and Davies's pictures a tranquillity which was a forerunner of much coastal painting to come.

The same gentler warmth pervaded the pictures of Edward Morland Lewis (1903–43) who was strongly attracted to the coasts of Ireland and west Wales.

Charles Conder (1868–1909) *Silver Sands* Oil on canvas
25⅛in × 30¼in (City of Bradford Museums)

Lewis initially studied at the St John's Wood and Royal Academy schools, where he latterly met Whistler's pupil, Sickert, leaving in 1926 to work under him as assistant and pupil. Like Sickert, Lewis used many source photographs for his work, but even when he transferred the picture directly from the photograph, he could alter the whole composition just by adjusting the tonal highlights. He adopted Sickert's manner of painting, which meant using a patchwork of colour laid over a warm underpainting. That gave his pictures a richness which was mellow and often Mediterranean although he was painting the south and west coasts of the British Isles.

This shift to higher, intense colour affected Edward Seago (1910–74), particularly when he went painting in Cornwall, but in his 1947 memoir, *A Canvas to Cover*, he wrote of the 'elation of returning to the cool greens and greys of East Anglia'.

Originally, he had trained under the naturalist painter Bertram Priestman and at the age of nineteen was selling equestrian pictures in the Bond Street galleries. Impressed by the work of Alfred Munnings (who became famous for his hunting scenes) he had travelled widely on the continent and Britain with circuses, and John Masefield had written an introduction to his book, *Circus Company*, in 1933. But Seago became chiefly a landscape and seascape painter which gained him an international reputation.

A fine yachtsman, he settled in Norfolk, and although his colour range had been vivid in Cornwall, Brittany and north Italy, a progressive pearl-like unity increasingly came to dominate his pictures. His harbour scenes are especially lovely, often small in size, and in them the Golden Horn of Istanbul can be

pictured with the same iridescent quietude as the evening haze over the Norfolk dykelands. Although he ordered that one third of his work was to be destroyed at his death, many of his surviving paintings are among the best marines of the century.

Edward Seago's sophisticated Impressionism was similar to that of Rodney Burn (b.1899), who studied under Wilson Steer at the Slade, taught at the Royal College of Art from 1929 to 1931, and became Director of Drawing and Painting at the Museum of Fine Arts, Boston U.S.A., between 1931 and 1934. Burn later painted in Steer's wake around the south and west coasts of England, his pictures of the mid-1960s resembling Steer's watercolours and oils of 1912. As an R.A. and honorary member of the Royal Society of Marine Artists (R.S.M.A.) and then President of the St Ives Society of Artists from 1963, Burn's influence was substantial, and in the relatively conservative world of marine societies after 1945, it was also lasting. In coast and marine pictures, Impressionism has found its most lasting stronghold in British art.

In the closing years of his short life Charles Conder (1868–1909) produced a blend of Impressionism which included a fantasy element and atmosphere reminiscent of Watteau. Painted in Brighton, Newquay and Swansea Bay, Conder's richly coloured, thickly loaded oil paintings contrasted with the delicate style he used for the decoration of fans, which had made him well-known.

Philip Connard, (1875–1958) *St George's Day 1918 (on the bridge of HMS Canterbury* Oil on canvas 30in × 40in (Imperial War Museum, London)

With the New English Art Club – formed to spread the ideas of Impressionism – he exhibited beach scenes with wide-hatted, decorous women, sometimes displaying a sly and gentle sense of humour, and flanked by distant bathing-huts, parasols and shallow pools, all of which possess an air of retrospective romance. They evoke scenes that might have been painted by Victorian painters had they not disdained this sophisticated frivolity. Philip Connard, also exhibiting with the N.E.A.C., produced a similar vein of humour and grace in his figures, which he carried over into his work as a war artist, but the whole tone of Conder's pictures, although they evoke the eighteenth century, marks the subtle change from 'serious, moral romance' of the Victorian age to the 'Edwardian summer' on the verge of the twentieth century; rooted to the past, but moving forward despite itself by the self-induced momentum which would shatter it.

The Great War: Patterns of Chaos

It was the Great War of 1914 which changed marine pictures in Britain more directly than the colourful disturbance of Roger Fry's Post-Impressionist shows of 1910 and 1912, although the war affected pictures of the deep sea and ships more than those of estuary and shore. This was partly because the wars despatched urban painters to sea as war artists, and their interests were often with people rather than marine technology; this preference reached far beyond the wars. In 1914, artists like W. L. Wyllie and Alma Cull could celebrate the steel warships of their era lying off the coast with a Gothic romance, seeing them as castles rather than smoky military factories afloat, and view the dirtiest and rustiest of Masefield's coasters each as a sooty gem of Empire. By contrast, except for a minority of artists such as Richard Eurich, few painters by the 1960s, 70s and 80s could or would even grant an oil tanker at sea or in port or offshore space on canvas.

Secondly, the Great War caused confused, disorientated urban artists from new art movements to seek some structure and familiarity from painting the seashore they thought they had always known, and so regain their equilibrium after the social upheavals released by the war.

Well before the war, Norman Wilkinson (1878–1971) had gained fame as a painter of ships, and one of his pictures had gone down with the luxury liner *Titanic* in 1912. But his life was shaped by successive wars.

Like W. L. Wyllie, and numerous other marine artists of the twentieth century, Wilkinson was schooled in commercial art, having been introduced to the publisher and writer, Jerome K. Jerome, and by 1893 Wilkinson's work had appeared in the *Illustrated London News*. In 1899 he was in Paris, working for French illustrated magazines until forced home by anti-British pro-Boer feeling during the Second Boer War. Going to New York to picture the America's Cup races, he ended up drawing President McKinley's assassination and funeral; in Britain again, he finished pictures of the Russo-Japanese war.

His innovative railway poster designs for the London North-Western Railway Company brought him great notoriety between 1905 and 1910, and then in 1915, as a naval paymaster during the fighting in the Dardanelles his on-the-spot

drawings filled a book. But his capacity to simplify a form (from poster design) and his understanding of the strength of colour and illusion led him to invent 'dazzle' camouflage in 1917.

This was an extraordinary achievement, and it was immensely successful. The system, which transformed allied ships into 'a flock of easter eggs' was intended to confuse an enemy as to the range, type, speed and number of ships decorated, as they steered on a zig-zag course. When the artist J. Sholto-Douglas painted a strong, impressionist study of the *SS Lackawanna* in 1918 she had already survived three U-Boat attacks due to her zig-zagging with dazzled sides.

In the 1920s and '30s, Wilkinson worked for the Anglo-Persian Oilfields (BP), the government of the Bahamas and the Rio Tinto Zinc Company in Spain, but returned to Britain in 1939 to serve as an Airfield Camouflage Officer for the RAF.

A founder member of the Society of Marine Artists in 1938 (the title Royal was granted in 1966) he completed 56 pictures of naval actions in the Second World War (now in the National Maritime Museum), in which he prosecuted a tighter form of the distinctive, basically Impressionist style of painting which became more accentuated as he grew older. Like Edward Seago, Norman Wilkinson was capable of conjuring up an image with the minimum of brushwork, and his work contrasts sharply with his great contemporary Charles Pears, the first President of the R.S.M.A. and one of the great realist illustrators of his generation.

Between the approaches of Norman Wilkinson and Charles Pears lay that of Claude Muncaster (1903–74). The subject of the biography *The Wind in the Oak*, Muncaster had crewed as a deckhand in 1932 on the sailing clipper *Olivebank* to gain first-hand experience as a marine artist. In his long career he painted over 5,000 marine pictures from the second quarter of the century onwards, and his style was typical of the great majority of painterly realists who came to dominate marine pictures from then on. They shared the fine draughtmanship – and until the 1960s – the muted colouring used by Arthur Briscoe (1873–1943) and Arthur Burgess (1879–1957), another illustrator of periodicals like Wilkinson, whose commercial sense of communication coupled with their war service and deep understanding of the sea, light and ships make their pictures so memorable – and so popular.

Muncaster was romantic in his crewing aboard the *Olivebank*. Although it lingered until the eve of the 1939 war, the sailing ship was finished as a major freight carrier by the Great War. It could not maintain the constant speed necessary for sailing in convoy with steamships and, although frequently faster than older steam vessels, could not guarantee dates of arrival and under most circumstances was more vulnerable to attack. It lingered until the late 1930s as a carrier of bulky, cheap, non-urgent cargoes, but its gradual disappearance, along with that of the sailing trawlers, transformed the ports and harbours. This altered the marine and coastal picture market because it divided the matter-of-fact sailing vessels in fishing and harbour pictures, estuaries and seascapes of the Edwardians into distant time-pieces. After the 1914–18 war it was not so much a realist artist's style which was 'traditional' or 'reactionary', it was his subject matter. By painting a sailing vessel in a traditional manner, an artist was implying a retrospective attitude and therefore a political position.

Because of this, John Everett (1876–1949), who like Muncaster crewed on the

last working sailing ships, occupied a unique position in the marine painting of the century. As with so many artists of great ability, he worked far beyond the limits of one specialist genre, but like his two great contemporaries, Julius Olsson and Frank Brangwyn, he transcended the limitations others sought to impose on his favoured subject.

Everett went to sea after studying at the Académie Julian in Paris and the Slade School with two other brilliant draughtsmen, William Orpen and Augustus John. Signing on as an ordinary seaman on the barque *Iquique* in 1898, he sailed, on and off, all over the world for forty years. He had a private income and never offered any of his pictures for public sale, bequeathing 1,700 oils and nearly 2,000 drawings to the National Maritime Museum. His unique, distinctive, highly personal style of painting the sea and the coast, inshore, and deep-water sailing ships, owes nothing to nostalgia or, on the other hand, to an art credo divorced from the environment in which he painted. Everett's method reached out to the marine world around him, and unlike so many formally trained artists of his generation, did not try to bend the world to fit into his own limited aesthetic concept.

Everett is one of the finest painters of the century, although he remains among the least known. His discreet abstraction of patterning is interesting to compare with the stylizations of illustrative realists like Charles Pears. The treatment of the sea in Everett's *Bow View of the Ship 'Iquique'* (1920) is a portrayal of the same wave formation as that in Pears's pictures of Vian's Malta Convoy of 1942. But it is fined down to the economy that recalls the alien world of his *Seascape*. There the huge herringbone patterns of the waves with their spumy chevrons and receding crests evoke a wholly inhuman world where that very 'monotony of form', as Ruskin termed it, becomes a visual force in its own right. This view of the sea has all the hostile anonymity Turner gave the sea in his pictures of wreckers, but Everett's deserted picture displays – and displays accessibly – what is there for all to see but usually fail to notice: the power of abstract patterning in apparent chaos. It is one of the hallmarks of a great artist but, significantly, it is much less often the hallmark of financial success.

Surrealism to Nostalgia, 1920–88

Everett's *Seascape* celebrated the simple abstraction which gave Paul Nash (1889–1946) solace when he returned after the Great War and settled in the 1920s at Dymchurch on the Kent coast. There the geometry of the beach and breakers gave him a sense of natural order and structure which contrasted with the structurelessness of the society to which he had returned.

Nash painted the sea and shore with translucent washes, and painted in certain heavy objects as he would have done with oil paint, using opaque body colour – gouache – which made them appear rugged and dense compared with the light 'fragility' of the sea. Otherwise, these pictures had elements of the late eighteenth-century watercolours of Thomas Girtin.

From 1929 onwards, Nash began a series of paintings or 'object poems' in which a land- or seascape was viewed through a great foreground still-life. He

Paul Nash (1889–1946) *Winter Sea* Oil on canvas
28in × 38in (York City Art Gallery)

did this by arranging odd or familiar objects in such a way as one sees them in a new light – as in a dream – often to imply another meaning by allusion. He made many photographs and watercolour sketches on the spot if such objects were too large to take away, and frequently cut out the photograph or watercolour, fixed it temporarily to the canvas in the manner of collage and then painted it in when the composition satisfied him.

The sea remained a frequent motif in what he did, culminating in the great *Totes Meer* of 1940–41. A massive pool of mangled aircraft gathered on a shore – a dead mere – under the moon. They evoke a harvest of fish, or the thoraxes of moths and the shards of their wings, as though they had fallen from a scalding lamp. Just as broken aircraft were recycled and flew again with different shape and markings, so do moths break from the chrysalis, fly by the moon, die, crumble, and their descendants fly again. The cycle of the tide on the shore pulled by the moon was treated quite differently by him in 1941 from the way he showed it in the abstracted *Coast Scene* (1921) or *Winter Sea* (1925–37), but the coldness of tone and the undulating, folded forms are basically the same. *Dymchurch Wall* (1923) and *Dymchurch Strand* (1922) as great sweeps of coastal landscape possess the same rhythmic flow of the earth and water, being the hard and soft forms of the same organic totality.

But Nash's obsession with the cycle between life and death meant that he never did more than flirt with abstraction or surrealism. Although he was a founder member of the group Unit One in 1933, he possessed an imagination too broad and distinct to be encompassed by any one group, and his pictures bear little resemblance to those of other Unit One members. Nash responded to the mysterious, rhythmic, organic nature of objects and the sea – as did Turner – and they did not. They sought to impose systems upon them.

John Piper (1903–) *Boats on Shore, 1933* Oil on canvas
17¾in × 22in (Huddersfield Art Gallery)

Indeed, the divide between Nash and the other Unit One members revealed
the lack of lasting effect which the two great 'isms' that stirred European painting
before and after the Great War, Cubism and Surrealism, had on marine art. The
sea revealed their shortcomings, and Cubism in particular had very little to say
about the element which covered two thirds of the world's surface. Abstraction,
on the other hand, could embrace the very essence of the sea.

John Piper (b.1903) was unusually successful when he employed both these
approaches to painting the sea coast. Five years before the foundation of Unit
One, Piper had been working as an articled clerk in his father's law firm, but had
decided to become an artist when his father died in 1928. After the Slade he
became an art critic, and wrote for *The Nation* and *The Listener* magazine, and in
1933 was in Paris, where he met the painters Georges Braque, Fernand Léger and
the sculptor Brancusi. Their influence was apparent in the coastal pictures of
Cornwall he made that year. The collage-type images he painted on a two-
dimensional picture plane enabled him to present areas of the sea and land as a
combined region where the borders of the elements merged and interchanged,
like the super-imposed images of memory.

As an author, muralist, illustrator and stage designer, Piper's attitude to the
coast and sea was similar to his attitude to landscape: a blend of images where
the colour and the association of the place were gathered together, a deeply felt
emotion which he could nevertheless astutely channel into work for the *Shell
Guides* and the *Brighton Aquatints* of 1939.

Edward Burra (1905–76), Unit One member and Rye recluse, is not usually associated with marine art, but the stylistic layers of his powerful picture, *South West Wind* (1932), are typical of its time and its difficulties. In it Cubist legacies in the foreground objects merge with a romantic feeling for the natural elements; there is an almost naïve quality to the action and figures, in places reminiscent of the French naïve Rousseau, and a sinister overtone permeates the semi-Realist cloud shoals of the threatening sky.

Cubism and later Surrealism helped Unit One's Edward Wadsworth (1889–1949) to impose the language of a poet crossed with that of an engineer on his harbour and beach-scape pictures. The engineering was Wadsworth's, but the poetry was that of the Italian metaphysical painter (or semi-surrealist) Giorgio de'Chirico.

Wadsworth had trained in Munich as an engineering draughtsman, but he returned to England to attend the Slade School in 1910. Later he became associated with the Rebel Art Centre of Wyndham Lewis. To speak of Wadsworth as being drawn to the sea would be misleading, although he produced so many marine pictures. He had an engineer's sensibility, and was fascinated by marine objects; he chose to portray them in the style originated by de'Chirico.

His taste for incisive clarity led him to use tempera on smooth polished panels, a medium quite unsuited to the soft transitions typical of the sea and sky because of its rapid drying time, but where colour and form remain vivid and clear-cut. When he needed to achieve gradual transitions of tone, Wadsworth built these up with a mass of very fine, carefully graded strokes resembling brushed horsehair. This reveals how uninterested he was in the elements of air, water and stone, the very stuff of sea and shore.

Most of Wadsworth's pictures would be fairly unremarkable if he hadn't adopted de'Chirico's 'magical' way of seeing. His pictures *look* intellectual, implying a profundity they do not have, but they are powerful and memorable. He executed large decorative panels for the liner *Queen Mary*, illustrated the 1926 publication, *Sailing Ships and Barges of the Western Mediterranean and Adriatic Seas*, and produced tempera pictures of harbours shown at the Leicester Galleries. As such, he was one of the most important modernist painters concerned with the marine world before 1950. Never profound, sometimes arid, but never banal, his paintings are austerely beautiful, and they achieve a feat rare with technology – they grant it poetry.

Memories of the past's technology were chiefly what inspired the Cornishman Alfred Wallis (1855–1942), and Wallis's place in British painting is extraordinary on three counts. First, he was one of the few *genuinely* naïve artists who have had any effect at all on the course of painting. Secondly, he remained quite unaware of his influence on the members of Unit One and, thirdly, he only began to paint, as a lonely widower, at seventy years of age. Almost certainly uneducated, he went to sea at the age of nine with the deep-sea fishing schooners and then after 1880 with the Cornish Mousehole and Newlyn fleets. When he left the sea he worked with his brother in the rag-and-bone trade until that declined along with the fishing industry. After his wife died he began to paint on old pieces of grocers' card 'for company'.

Wallis's pictures looked back nostalgically to the heyday of the fishing fleets he'd known: 'I paint only what used to Be what we shall see No more everything is altered.'

His pictures bore no relation to aesthetic convention. Everything – piers, jetties – was seen in plan form, like a map, and the ships and boats side on, pointing upwards, down, or across without any attempt at conventional perspective. Together with the irregular shape of the surplus card the 'plan form' of the picture design had all the mysterious symmetry, and detail, which results from the memory of an adult merging with the technical simplicity of a child. It was something that the Paris avant-garde selfconsciously aimed for but could never achieve.

In 1928 Christopher Wood (1901–30) and Ben Nicholson (1894–1982) 'discovered' Wallis at St Ives. Wood had already been described in Paris as the most promising of young British painters. He was a charming and highly impressionable man, who'd been apprenticed to a London fruit merchant after abandoning architecture at Liverpool University. But circulating around the London clubs he had made the friendship of the wealthy Jewish patron Alphonse Kahn, who took him to Paris. There the Chilean diplomat Antonio de Ganarillas paid for him to attend the Académie Julian, and he enjoyed the influential friendship of Picasso and Cocteau – although under Cocteau's decadent influence he became addicted to opium. Meeting Ben and Winifred Nicholson in 1926, he was impressed by their quiet, anti-socialite, work-immersed lifestyle, and went painting with them in Cumberland and Cornwall.

The effect of Alfred Wallis's bold, asymmetrical, semi-abstract pictures altered both Wood's work and Nicholson's.

In 1934, in his book *Unit One*, Ben Nicholson argued that everything perceived in nature is a construction of the human mind, which was the main underpinning of the abstract idea of painting. For the rest of his life he was to alternate between painting abstraction and still-life set in landscape, scenes usually set in Cornwall or Italy.

Wood's painting, though, never went into abstraction, swaying to the boundary of surrealism during the last months of his life in 1930, but in his last two summers he produced some of the finest essays in coastscape made by a British painter. In *Lighthouse, Entrance to Tréboul Harbour, Boat in Harbour, Mending the Nets* and others in 1929–30, the iron-coloured sea, dark sails overlapping stone houses, sails against fir tree skies – all executed at speeds of between two to six hours – have a vivacity and yet uneasy mingling and estranging of things from their usual places belied in the sang-froid of Wood's comment: 'I have a little sailing boat which I adore, I sit in it and glide slowly along looking quietly at all the things I love the most, I see the lovely fishing boats with their huge brown sails against the dark green fir trees . . . instead of always against . . . an insipid sky'.

Before his premature death, Christopher Wood much influenced the witty, vigorous and versatile Richard Eurich (b.1903), who from 1924 had studied at the Slade, where he'd spent much of his time haunting the sculpture collection at the British Museum.

Opposite top Ben Nicholson (1894–1982) *St Ives, Cornwall* Oil on canvas board 16in × 19¾in (Tate Gallery, London)

Opposite bottom Alfred Wallis (1855–1942) *Harbour with Two Lighthouses and Motor Vessels* Oil on card (Kettles' Yard, University of Cambridge)

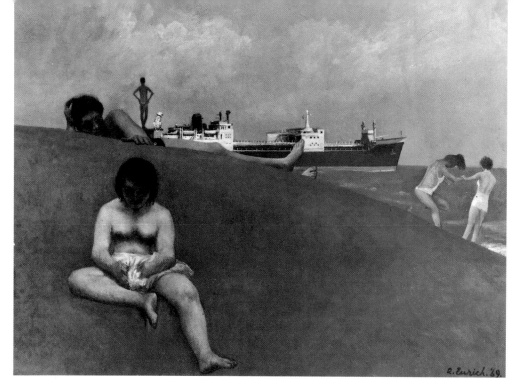

Richard Eurich (1903–) *Lovers on the Beach, 1969* Oil
on canvas 12in × 16in (Private Collection)

An urban youth from Bradford, Eurich was a poet with a sculptor's sense of
space, a painter's sensitivity and an illustrator's narrative ability and sense of
humour. In many artists such breadth of ability might have led to creative
diversion and overall mediocrity from lack of definite purpose: it made Eurich
one of the most memorable painters of land and seascape of his time.

Eurich's achievement was to marry so many of the unmarriageable tangents
which had polarized painters like Edward Wadsworth on the one limb and
Wilson Steer's impressionism on the other. Eurich always considered himself
self-taught as a painter, and indeed in the narrative detail of his human figures
there is an almost naïve quality, which he shares with Turner. But his seemingly
effortless ability to place objects associated with visual indigestion – such as oil
tankers – and all the beach and harbour objects which engaged Wadsworth in
such a way that they strengthen rather than dominate the picture is extraordinary.
Lovers on the Beach (1969) is dominated by figures, but without the outsize ship
the composition would lose most of its force. The vessel is by no means
'picturesque' but it makes the picture.

Eurich's treatment of the sea itself ranks him as a peer of the very best nineteenth-
century marine artists. His enthusiasm for Turner, the greatest of all British marine
painters, wasn't encouraged at the Slade in 1925, he told Brook-Hart.

'When I went . . . Turner's name was a dirty word. I was terribly enthusiastic about
his work, but found that people gave me sidelong glances. The teachers said that
Turner had nothing to offer any modern student and that sort of rubbish . . . One of
my sketches was hung and old Tonks' comment was 'This student has been influenced
by painters who have not been dead long enough!'

Eurich had the force of character to evade this doctrinaire tunnel-vision, and his admiration for Turner is clear in his 1954 picture *Waterspout in the Solent*. His breadth of talent and aesthetic open-mindedness served him well as a war artist attached to the Royal Navy from 1940 to 1945, and he produced some of the most memorable pictures of the Second World War. Probably the best known is *Withdrawal from Dunkirk* but the finest of them, *Survivors of a Torpedoed Ship*, transcends specific time and place for universality. The bleak, anonymous, hazy infinity of the ocean surrounds an upturned ship's boat, while three seamen, a Negro and two Caucasians, grey and blue with cold, cling interlocked on the narrow keel, unable to move, and drift into death from exposure. An indifferent seabird perches at the bow like a white vulture. When the picture was displayed in 1943 it was withdrawn because of the shock which it generated according to Brook-Hart; but the objection had not come from the Merchant Navy: 'Far from it,' they told Eurich, 'we can't deal with the number of men who want to join, and this is just the kind of picture which is true and admirable.'

Although he returned to paint Yorkshire landscape after the conflict, Eurich continued to paint the sea coast with provocative versatility. His free and vigorous brushwork, more noticeable in skyscape than on heavy sea, gives his figures a frequently poignant, toy-like quality, which reinforces the power and size of the elements which surround them.

Eurich's achievement as a marine painter is formidable. His pictures embrace humanity, technology, and the natural world instead of dividing them up as compartments for slogans to channel limited ideas which usually cohere to limited talent.

Laurence Stephen Lowry (1887–1976), often thought to be a self-taught and even naïve urban painter, revealed his long training and sophisticated range in his pictures of the sea coast. Lowry spent over fifteen years in part-time art school training, while working as an accountant's clerk before becoming a chief rent collector for this firm, though he pretended he lived by art alone.

Though he gained fame through his North-Country urban scenes he illustrated Harold Temperley's *A Cotswold Book* in 1931 and for over forty years painted the pure sea, harbour and coastal scenes in a style varying at will from the quasi-naïve mill-town technique which gave him fame to the Impressionism of Wilson

Richard Eurich (1903–) *Survivors from a Torpedoed Ship* Oil on canvas 14in × 24in (Tate Gallery, London)

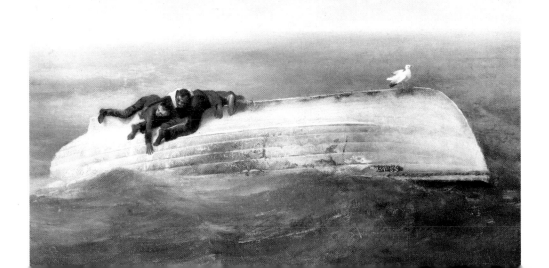

Steer. Unlike Steer, though, Lowry often left the surface of these impressionistic pictures with a crusty impasto, in which the brush strokes formed a relief pattern and mist has a texture like rock, while a sail in a 'haze' has the quality of a chalk mark on a paving-stone.

At other times, he employed a style which had a smoothness and calculated coolness which appears more sinister and pessimistic than anything by Edward Seago or Wilson Steer. In *The North Sea* of 1966, the impersonal geometry of the deserted sea leads remorselessly into infinite space. This is a disturbing gateway for the layperson into abstraction, and the simple repeated horizontal strokes

Charles Ginner (1878–1952) *Building a Battleship* Oil on canvas 33in × 24in (Imperial War Museum, London)

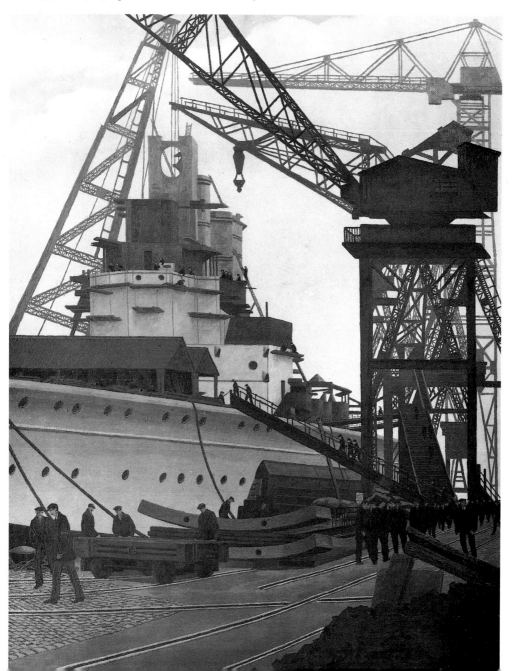

have the enormity of numbers adding up to eternity. By contrast Joan Eardley used storm to picture this void.

In 1956, Joan Eardley (1921–63) left the Glasgow slums where she had chosen to live and where she had painted many pictures of children, and took a cottage on the Scottish coast at Catterline, where she painted for what remained of her short life. Each time a weather forecast predicted a storm she set up her equipment on the cliff and painted quickly in near-abstraction the impression of the squall on the leaden sea, usually on small canvases, the easel weighed down with rocks against the wind. Although she painted in the fields behind Catterline in the summer months, it was these distinctive storm pictures which established her lasting reputation, not her long years in Glasgow.

The concentrated focus of Joan Eardley's pictures on places where wide areas of colour come together – the margin where sea meets shore – is typical of a specific kind of near-abstraction which began to characterize so much British landscape and sea coast painting after the Second World War. Its exponents, such as Peter Lanyon, Joan Eardley, Ben Nicholson, John Piper – and Lowry – increasingly began to widen the divide which separated them from the more conservative Impressionists and Realists who came to dominate marine societies after 1945.

Reluctant Realists

The Second World War had sent its artists to sea as illustrators. Some of them were veterans of the Great War, such as Muirhead Bone and Charles Pears. But whether they were innovative modernists like Eric Ravilious (1903–42) with his distinctive, angular, watercolour style derived from woodcut technique, or Post-Impressionists like Charles Ginner (1878–1952), or Stanley Spencer (1891–1959), the war ensured they represented what they saw in an essentially 'realist' way. Many chafed at this for different reasons. Commissioned to make twelve large panels of *Shipbuilding on the Clyde* between 1939 and 1945, Stanley Spencer found the subject more complex than anything he'd ever made previously. The aridly mechanical aspect of shipyard technology didn't interest him, but the people there did. He wrote in his notebook:

> I soon found the shipyard . . . is only one aspect of life there. There were rows of men and women hurrying . . . and sunlit factory walls . . . and early shoppers going to and fro; one day through a crack in a factory wall I glimpsed a cascade of brass taps; in a [trafficky] roadway . . . children lying on the ground using the road as their drawing board and making drawings in coloured chalk . . . old men sat removed from passers-by remote like statues . . .
> Back to the bottle again: I just had to paint another Resurrection.

John Nash (1893–1977), an official artist in both wars, had preferred to fight in both. In 1940 he made three watercolours and eighteen sketches of submarine pens, but in November that year his brother Paul wrote: 'He didn't like being an official artist for the Admiralty – couldn't do anything he said and just went on nagging until he got back into active service. Was there ever such a chap?'

But the net effect of the Second World War on marine art echoed Charles Ginner's Neo-Realist manifesto of 1914:

> The creative power has always been realist: each age has its landscape, its atmosphere, its cities and its people. Realism, loving life, loving its Age, interprets its Epoch by

John Armstrong (1893–1973) *September 1940* Oil on panel
18¾in × 30in (City Art Gallery, Manchester)

exacting from it the very essence of all it contains of great or weak, of beautiful or sordid, according to the individual temperament.

The irony was that many of the Realists who exhibited with the Royal Society of Marine Artists from 1946 onwards loved any other time but their own.

In 1947 the Chairman of the Port of London Authority suggested holding an exhibition of pictures of the London River to members of the Langham Sketching Club, which led to the formation of the Wapping Group. Limited to twenty-five full members this group thrived, and their conservative pictures bore witness to the twilight years of the port of London and its death-throes in the 1960s. The flavour was set by artists like Arthur Bond (1885–1958), Leslie Ford (1885–1959), W. Eric Thorp (b. 1901), Jack Merriott (1901–68), Henry Denham (1893–1961), John Davies (b. 1901), Patrick Jobson (b. 1919) and Josiah Sturgeon (b. 1919). Later it included Vic Ellis (b. 1921), Bernard Bowerman (b. 1911), Dennis Hanceri (b. 1928) and Trevor Chamberlain (b. 1933).

These artists witnessed the Thames empty of cargo ships and all the polyglot traffic Wyllie and Brangwyn had known. Over the thirty years of decline a soft impressionism gradually asserted itself among the younger artists joining the group, a celebration of atmosphere over objects, as the objects afloat became harder to find. While Rowland Hilder continued producing Brangwynesque essays of light and shade on a Thames full of ships which had vanished, the red-sailed Thames barges appeared more and more often in the work of his successors. They looked dangerously like nostalgia-mongering to many critics, but by the 1970s that criticism missed an essential feature of the London River: that the river was concerned with tourism as much as trade, and tourism was much concerned with nostalgia. The barges and a sprinkling of Mississippi-type

paddle-steamers were the chief vessels afloat: nostalgia was to paint cargo ships and tugs – it was they which were gone.

Nonetheless, there remains a certain blandness in so much of the Wapping Group's later pictures. Jack Scamp's dockers in the 1960s passed loudly across the television screen but invisibly across the oils, acrylics and watercolours of these artists. Thorp, Sturgeon, Terence Storey and their contemporaries possess the finesse of Samuel Scott or Thomas Serres, but none of their robust, wharf-side vision. They are such very well-mannered technicians, these men, so very discreet and essentially Victorian about the death of a great industry; it is never allowed to rock the boat, even when it takes the boat away.

Jean Barham (b.1924), whose pictures focus on St Katherine's Dock and Greenwich, produced a picture absolutely typical of its time when she painted *The Tower of London from St Katherine's Dock* for the 'Spirit of London' competition of 1979: an Impressionist idyll across a tourist area full of antique craft, showing a view that was soon to be obliterated by a high-rise building. Very much the spirit of what had once been a great port, and the complete antithesis of Wyllie's *The Silent Highway* a century before.

The same contrast shows between the offshore scenes of the late nineteenth century and the late twentieth. Yachts with luminously white Terylene sails have replaced the stocky Victorian offshore fishing boats with their patched, faded buff canvas. The seas have lessened and become smoother and bluer – those rather two-dimensional blues which come with dense acrylic paint pigments – than the more translucent and believable green-brown seas of a century ago. But pleasure-sailing is an expanding marine industry, and in the 1980s members of the R.S.M.A. share two things in common with their Victorian forebears: a respect for traditional technique and for their customers. A boating public buys these pictures, and a boating public prefers its seas blue, with a light wind, and a sky of broken cloud. In harbour there is tranquillity, and Leslie Kent (1890–1980), Clive Kidder (b.1930), John Horton (b.1935) and Frank Gardiner (b.1942) display more of it than Wilson Steer. The delicate watercolours of Noel Morrow (b.1915), Edward Mace (fl.1916–1948), John and Jo Cooper (b.1942 and b.1933) all deal frequently enough with the shabby working diesel trawlers of the coast, but there is a sense of quietude – almost poignancy – about them.

The legacy of impressionism remains very powerful in East Anglia. It is present in the cool, clear tones and tints of Hugh Boycott-Brown (b.1909), James Chambury (b.1927), Raymond Thorn (b.1917), John Snelling (b.1924), John Sutton (b.1935), Kenneth Denton (b.1932), Dennis Hodds (b.1933), Robert King (b.1936) and David Wood (b.1933), whose pictures typify the coast from the Wash to the Thames. This is largely the case with other East Anglian painters with less of an Impressionist legacy, such as John Davies (b.1901), Rowland Fisher (1885–1969), Sheila Fairman (b.1924), Freda Pelling, Heather Shuter (b.1918), Cyril Stone (b.1912) or Michael Norman (b.1930). Elsewhere, Impressionism underpins the pictures of Richard Bonney (b.1902), Jean Corsellis, Sybil Glover and Richard Joicey (b.1925). The strong-toned photo-realism of painters like James Brereton holds a relative parity with the free, Camberwell-school Impressionism of Faith Sheppard (b.1920) and the vigorous but mellow-toned work of Phyllis May Morgans and Frances Phillips. Rowell Tyson's cool, geometric cliff tops and finely controlled colour areas indicate the emotional range of abstraction if they are compared to the storm studies of Joan Eardley,

but they are far outnumbered by Impressionism and Realism.

Realism is a strange term to use to describe that great body of painters descended in direct line from the Dutch and English School, and dedicated in the 1980s to producing portraits of vanished ships and altered harbours once known to Samuel Scott or George Chambers, and now portrayed with a near photo-realist precision.

To a degree, these artists are marine archaeologists in the manner of Jack Spurling. In 1923 his magnificent studies of clippers began to appear monthly in the P. & O. magazine *Blue Peter* and continued to do so each month for a decade until his death. The magazine offered a prize of £1,000 – no trivial sum in the 1920s – to anyone who could find an error in Spurling's sails or rigging. No one ever won it. Yet the artist hardly ever drew these ships 'from life'. They were all retrospective reconstructions from the shipping companies' plans and data; the pictures were akin to re-fleshing a skeleton by a palaeontologist, and awing the marine world, they seduced the public. From this point on, a steadily growing specialist gulf began to open in marine art wider than the gap which had separated such men as William Joy from Holman Hunt in the 1850s.

As a painter of vanished ships and altered harbours, John Chancellor (1925–81) exemplified this particular hybrid which British art has produced since mid-century. A member of the Society for Nautical Research, he might spend as long as three hundred hours investigating a past vessel or event, and seven hundred hours building up a picture of it. A method painter, building up the images rope by rope, plank by plank, he established an international reputation within four years. His first exhibition in 1973 sold out in forty minutes; his second, in 1976, in a day.

Chancellor differed more in method than in talent and conviction from Derek Gardner (b.1914) another wholly self-taught painter of consummate skill, painting in the method of the early nineteenth century, and specializing in naval actions of the eighteenth, nineteenth and twentieth centuries. Barry Mason (b.1947), whose work enjoys particular popularity in the United States, works in a similar vein to Gardner, although his palette is rather harsh. In sharp contrast is John Stobart (b. 1929), whose work possesses the delicacy of the nineteenth century American luminist Fitz Hugh Lane. American-born Mark Myers (b. 1945) affects a watercolourist subtlety while using acrylic to achieve an oil-like effect, although without its colour depth – a technique used by Roy Cross (b. 1924) and often by David Cobb (b.1921) and Deryck Foster (b.1924). These artists are all highly professional illustrators, and while their commercialism alienates them from the indulgence of critics, to dismiss their art is to judge a lawn-tennis player by the values of the squash court. If anything makes their art vulnerable, it is a lack of irony: it is so clean a hybrid, dealing with a world that once existed, that only the historian may take issue with it. But perhaps that is its irony: it is a bastion of realism dedicated to picturing what does not exist.

The gap between the painting of the coast and the deep sea which had shrunk to nothing with the realism of the nineteenth century, and was opened to a rift again by Somerscales and Spurling, has grown ever wider. But the origins of this rift do not lie in polished nostalgia. In the later twentieth century they lie in a coast given over increasingly to leisure instead of labour, and viewed as Matthew Arnold saw Dover Beach and Joan Eardley observed Catterline: as the margin and shore of the painter's inner world.

A Gazetteer

Aberystwyth
Dyfed

A university town and resort on the shore of Cardigan Bay, on the A487. The ruined castle on a low headland divides the two main beaches, and the château-style of the Victorian Gothic old university building beside it (built as an hotel) leads a long sweep of largely Victorian façades which remain the town's dominating feature.

NICHOLAS POCOCK made watercolours of the bay and town during a 1794 visit, first from the north side of the bay and then directly across the town, the castle and low houses then giving it a totally different aspect.

JOHN BRETT painted studies of winds blowing low over calm, and rough seas here during the later 1860s, and in the 1880s sketches of incoming tides, with lower cloud and an impressionistic image of smaller fishing vessels. THOMAS ROSE MILES worked here during the mid-1870s, painting highly detailed 'pure sea' pictures viewed from a low angle with a very high horizon line.

Aberdovey or Aberdyfi
Gwynedd

The song *The Bells of Aberdovey* appeared first in an eighteenth-century opera, but derives from a Welsh legend of the city of Cantre'r Gwaelod, said to lie submerged in Cardigan Bay, its bells echoing beneath the sea. Now a prosperous holiday resort on the A493, Aberdovey was a major port rivalling Fishguard and Holyhead linked with the Liverpool shipping companies.

The 2-mile-wide, 5-mile-long sands of the Dovey (Dyfi) estuary to the S. (now a nature reserve) and the romantic legend of the song produced saleable subjects for BENJAMIN WILLIAMS LEADER who painted here in the later 1880s, working along the Welsh coast. His pupil, DANIEL SHERRIN, emulated him.

JOHN BRETT painted close-detailed studies of the sea here during the late 1860s and, visiting the region again during the 1880s, painted in a different style, more open and less tightly observed. Work which he made along the Welsh and Irish coasts toward the end of his career was progressively more impressionistic; in larger pictures made on the south coast he continued to produce a more laboured detail.

Aldeburgh
Suffolk

A resort on the A1094, 17 miles N.E. of Woodbridge. An international music festival is held annually in June. The bleak lives of the Suffolk fishing communities were described by George Crabbe, born in Aldeburgh in 1754; his portrait of the fisherman Peter Grimes being used by the composer Benjamin Britten for his first opera. It was a fashionable resort by the 1820s, the letterpress for an engraving by J. M. W. TURNER noting that: 'for the mean clay-built cottages of the poor, the appearance of which too forcibly announced the dirt and misery that prevails within, we now find many neat and comfortable dwellings belonging to persons of rank and fortune who occasionally reside in them. It is pleasing to be able to add that the morals of the lower classes are much improved.'

Turner's watercolour of 1825 views Aldeburgh from Slaughden Quay, where the River Alde runs parallel to the sea S.W. for 10 miles down beyond Orford Ness.

FRANÇOIS LOUIS THOMAS FRANCIA worked in the area at the turn of the nineteenth century. Francia rarely painted a picture of a specific vicinity, concentrating on 'pure sea' or wholly marine compositions in which the land occurred merely as a necessary shade, but he found the fishing vessels of the area excellent subjects. WILLIAM JOY and JOHN CANTILOE JOY made watercolour sketches and delicate studies of fishing craft here during the 1850s, before their move to the south coast.

JAMES CALLOW visited the region during the 1870s, picturing fishing-boats in groups offshore, and utilizing the long open line of the coast to give the composition a sense of breadth and bleakness.

JOHN MOORE of Ipswich produced studies of fishing vessels at rest and sea, Dutch as well as English

vessels, as did the Joys, at intervals during the latter three decades of the nineteenth century. WILLIAM DANIEL PENNY, a Hull artist, retired to Aldeburgh in 1897, and kept the 'Artist's Rest' public house there, until his death in 1924. PHILIP WILSON STEER, Impressionist, produced coastal studies during his period at Walberswick during the 1880s, and again after the turn of the century, before the Great War, and the 'tightening up' of his style. The pictures were very similar to the loosest of his Thames studies, more concerned with light and blends of colour than with a description of the area.

During 1937 the Euston Road painter, CLAUDE ROGERS, painted extensively at Aldeburgh; his pictures explored the holiday beaches more than the river estuary, and were made in a Cézanne-like, organized series of patterns which were beginning to merge into a looser, more 'Romantic' style of picture which he practised from the 1940s. JOHN PIPER, essentially a landscapist, painted at Aldeburgh, where the church of St Peter and St Paul has a memorial window to the composer Benjamin Brit-

ten designed by him. The marine painter, HUGH BOYCOTT-BROWN, frequently worked in the area, where the skyscape and sailing craft offered him dramatic compositions. WILFRED GEORGE MORDEN, who exhibited with the R.S.M.A. from 1951 to 1955, produced numerous watercolours on the Alde, particularly the estuary flowing south toward Havergate Island 4 miles S. of the Martello tower at Slaughden Quay. MICHAEL DESROCHERS painted watercolours here in the early 1970s, between the Snape Maltings and along the Alde to Orford, such as *Winch at Aldeburgh* and *The Orange boat*. RAYMOND STANLEY THORN, also in watercolour, pictured the barges once used for the barley trade and now kept for recreation and educational purposes out of the Snape Maltings in the later 1970s, working at Iken, the site of a thatched church, St Botolph, by the river, roofless from a fire of 1968 and never restored. JAMES CHAMBURY, an Ipswich artist, pictured the fishing vessels in the early morning light off Aldeburgh in 1978, sketches made at about 4 a.m. for a series of six paintings.

Amlwch

Anglesey

A major Shell Oil terminal where supertankers pump oil directly to the English Stanlow refinery. At the beginning of the nineteenth century 80,000 tons of copper ore per year were mined here, and from 1790 Amlwch minted its own coinage, bearing a druid's head on one side and the company's arms on the other. The trade collapsed in the 1890s from U.S. and South African competition.

JOHN McDOUGAL retired to Amlwch in 1897, continuing to paint there, and exhibiting such works as *The Gold and Silver of Sky and Sea* at the R.A. in 1903, an observation of the region similar to J. M. W. Turner's at Beaumaris (see below). RICHARD BRIAN ENTWHISTLE, who specializes in picturing the everyday working craft of the coast, has painted in the region since the early 1970s, his work appearing in the Oldham Art Gallery, Boydell Gallery, Liverpool, and Parker Gallery, London, while having work commissioned by shipping companies in the U.K. and abroad. This choice of subject makes Entwhistle unusual as a marine artist. A Liverpool artist, JOSEPH HEARD, painted portraits of ships trading along the Anglesey coast, and vessels pictured by him, and by MILES and SAMUEL WALTERS, occasionally show views of the Anglesey coast as part of their backgrounds.

George Howard, 9th Earl of Carlisle (1843–1911) *The Northumberland Coast at Bamburgh* Oil on canvas 17¼in × 40¼in (Christopher Newall)

Anstruther

Fife

Formerly a small fishing village on the A917, 'Anster' as it is locally known now contains the Scottish Fisheries Museum; the North Carr light-vessel, now a maritime museum, was moored in the harbour in 1976, together with the massive herring drifter *Reaper*, launched in 1900.

KATE MCCAULEY visited here during the later 1870s, and two Glaswegian painters ALEXANDER FREW and ROBERT COVENTRY during the 1890s. The *Isle of May*, about 4½ miles offshore (now a bird reserve) with its high, vertical cliffs, ruined priory, and numerous lighthouses offered them a dramatic horizon.

Arran

Strathclyde

An island off the Scottish west coast 12 miles square, lying E. of Kintyre across Kilbrannan Sound. The northern half has spectacular mountain peaks rising above 2,000 feet, while the southern is a fertile, partly forested plain. The largest village, Lamlash, on the east coast, abuts a sheltered shingle bay shielded by the 1,000-foot cliffs of 2-mile long Holy Island. Brodick, 2 miles further north, is the ferry centre for Ardrossan; Brodick Castle contains a fine collection of porcelain, furniture and painting.

An Edinburgh artist, JOHN NESBITT, painted here in 1873, pursuing his interest in the dawn light of western Britain. JOHN MOGFORD worked here during 1875, and a Lancastrian artist, REGINALD ASPINWALL, made twilight studies in oils. JOHN MACWHIRTER sketching on the northern coast on a stormy winter day observed *Spindrift* (1876), one of the best Realist pictures of coastal labour. The Scottish Impressionist, WILLIAM MCTAGGART, drew on the west coast as a boy, and later during visits between 1860 and 1880.

STEPHEN BONE pictured the area in his work for the 12th Shell Guide, *The West Coast of Scotland*.

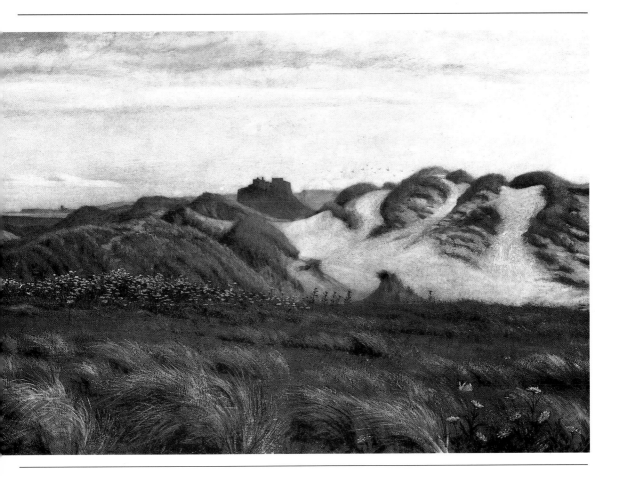

Bamburgh
Northumberland

In the nineteenth century the regal silhouette of *Bamburgh Castle* with its massive towers and long, rose-red walls rising on a 150-foot outcrop above wide sand-dunes, which stretched 7 miles N. to Lindisfarne (see below) was the focal point for many coastal paintings. With the fishing-boat as the equivalent of the country cottage and the full-rigged ship the castle or mansion, the ruined castle and shipwreck were synonymous of one another.

Stormscapes were the speciality of VILHELM MELBYE and he chose Bamburgh Castle as the backdrop for a number in wreck scenes during the 1860s, showing successful rescue beneath the heights. The Greenwich artist, W. D. DOUST, also painted there for R.A. exhibits during the 1860s, as did JOHN WARKUP SWIFT and ALFRED WILLIAM HUNT who pictured the castle from the sea. GEORGE HOWARD, 9th Earl of Carlisle, grandfather of the painter WINIFRED NICHOLSON, a professional artist and thirty years Chairman of the Trustees of the National Gallery, painted along the Bamburgh coast during the 1880s, picturing the castle and sea between the heights of the dunes. JAMES WEBB, who had a pronounced taste for castles by the sea, painted here in his vigorous manner during the 1870s, from out at sea and looking along the shoreside. ERNEST DADE, in the late 1880s and early 1890s, visited the region and pictured the coast here.

Bamburgh Village

A picturesque cluster of largely eighteenth-century cottages around a green, on the B1341 and B1342 off the A1. The church of St Aidan has a memorial to Grace Darling, the daughter of the keeper of Longstone Lighthouse off Farne Island, who with her father rescued nine men from the steamer *Forfarshire* in their small rowing-boat during a violent storm in 1838. The subject much appealed to Victorian genre painters; C. J. STANILAND produced the best-known painting of the event. The R.N.L.I.'s Grace Darling Museum was opened at Bamburgh in 1938.

Barmouth (Abermaw or Y Bermo)
Gwynedd

A little resort at the mouth of the Mawddach estuary on the A496, overlooked by the North Wales mountains. An art exhibition is held in August and an arts festival in September. It is the starting pont of the Three Peaks Yacht Race.

NICHOLAS POCOCK drew and painted the estuary and town during a tour of 1802, as did his acquaintance JOHN VARLEY. Varley pictured the place looking from the north across the estuary with beached vessels in the foreground, almost no buildings, and the mountains beyond; the region looks quite deserted. A marine painter, KEELEY BRAZIER, lived at Barmouth throughout his career, while painting along the Welsh coasts from the early 1920s until c. 1950.

Beachy Head
East Sussex

'Beachy' is derived from the Norman-French name *Beau Chef* – 'beautiful headland'. Two miles S.W. of Eastbourne, the white chalk cliffs rise sheer 534 feet from the sea. At their base the 142-foot red-and-white tower of the lighthouse resembles a small striped candle at the side of a vast cake. Until 1834 the light, then known as Belle Tout, was situated on the cliff-top 1½ miles to the W.

CHARLES BROOKING, making a set of pictures of the accomplishments of the 'Royal Family' privateers during the 1740s pictured the loss of one of their prizes in a squall off the headland. The rendering of the sea, even for the engraving, is remarkably fluid and soft, which is typical of Brooking's work. During the early 1800s JOHN THOMAS SERRES pictured frigates lying off the Head, awaiting pilots. GEORGE WEBSTER portrayed men-of-war here, usually combined with fishing vessels, and WILLIAM HUGGINS East Indiamen returning up-Channel off the Head, during the 1820s and 1830s.

The Plymouth artist, JAMES GRANT, painted 'Beechy' (sic) on numerous occasions during the course of the 1830s, the alteration of the light tower from the heights to the base of the cliffs adding variety to the location. G. W. BUTLAND explored the same variation. JAMES FRANCIS DANBY, favourer of sunrise and sunset, painted the headland at intervals between 1842 and 1876. GEORGE FREDERICK GAUBERT set it as the background of sea pieces.

GEORGE CHAMBERS SR made watercolour studies of vessels in the Channel off the area, greyer in his later years than the more warmly coloured former work. J. E. BUTTERSWORTH portrayed capital ships offshore there, before leaving for the United States in mid-career. CLARKSON STANFIELD, who tended to picture substantial fishing vessels off the English

coast, and warships and East Indiamen abroad, placed trawlers and luggers and ketches off the headland. E. W. COOKE showed it at a distance if picturing fishing vessels, which he generally portrayed in the northern Channel and off the Dutch coast. WILLIAM CALLCOTT KNELL showed it in the 1850s and 1860s behind shipping of all types, but generally larger vessels. WILLIAM BROOME and RICHARD HENRY NIBBS also portrayed it as a distant background to warships in the English Channel.

During the 1880s and 1890s WILLIAM H. BOND, GEORGE MEARS and HENRY BADHAM featured the headland in their work along the south-east coast. JOHN EVERETT included it among sketchwork he made of inshore scenery although such an approach to the sea was not his prime concern. SIR FRANK SHORT, working here and in the Rye area, produced many drawings and watercolour sketches, etchings and mezzotints during the late 1880s and early 1890s, making a number of storm and threatening cloud scenes over Beachy Head.

CHARLES PEARS portrayed incidents during the Great War off Beachy Head, as did the illustrators FORTUNINO MANTANIA and CATON-WOODVILLE, whose style of illustrating marine events owed much to Henry Moore and W. L. WYLLIE, usually portraying dramatic incidents between armed trawlers and German submarines.

During the 1920s and 1930s CLAUDE MUNCASTER produced marine work situated off the area, as did MONTAGUE DAWSON, showing yachts and vigorously painted small sailing craft, most often portrayed in watercolour and body-colour, without the usual emotional inflation which marred much of Dawson's later pictures.

The shipping pictures of NORMAN WILKINSON, ARTHUR BURGESS and CHARLES CUNDALL during the 1940s and early 1950s concerning the Second World War described air and sea incidents in the area, and the headland recurred in the work of G. H. DAVIS and WALTER BRAZIER.

Beaumaris

Isle of Anglesey

The Norman-French name means 'beautiful marsh'. Now Beaumaris is an elegant little town taking its name from the superb fortress built there by Edward I within a deep moat which gave access to the sea. Beyond this castle an open shingle beach with strong tides glitters against the backdrop of the Caernarvon hills.

J. M. W. TURNER visited Anglesey only once, between July and August 1792. His diary recorded the acute poverty of the local inhabitants compared with the great wealth of the landowners there, and the stunning beauty of a sunset he saw over the heights, which seemed 'to be from the rays of the setting sun impregnated with gold and silver'. Thirty years later he painted the memory of that sunset with the hovel folk looking for shellfish in the shallows,

and the fortress and mountains as iridescent shades beyond. NICHOLAS POCOCK painted Beaumaris Bay from the vantage of Redhill on Anglesey during a visit of 1814.

JOSIAH CLINTON JONES, who studied in Liverpool in the late 1850s, and worked throughout his career in Wales, visited during the 1870s and 1880s when the place was not greatly changed from Turner's time. Jones worked in watercolour on such visits. A landscape and coastal painter, JOHN McDOUGAL, who lived in Anglesey from 1900, painted Beaumaris after the poverty of the local population was less noticeable, producing pictures that concentrated on the colour and form of the land and sea. In much the same vein DONALD McINTYRE, resident in Bangor, and exhibiting work at the R.S.M.A. between 1954 and 1975, enjoyed the scenic sweep of the region looking north along the Menai Strait.

Brighton and Hove

East Sussex

A major resort on the S. coast on the A23 and A27. In the Royal Pavilion a painting by REX WHISTLER (1905–44) *The Prince Regent Awaking The Spirit of Brighton* portrays the near-naked Prince lifting a veil from a young sleeping woman. The picture is typical of Rex Whistler, Brighton and the Prince Regent, who popularized Brighthelmstone, previously a fishing village, where he built his mock-oriental pavillion. Now it is a university town, with art galleries, ornamental gardens, excellent Georgian, Regency

and Victorian terraces and the largest man-made yacht harbour in Europe. *Hove* is a separate borough, divided from Brighton at the regal Brunswick Square, quieter than Brighton with wide lawns and more modernist building. Its own Museum of Art contains ship models and an extensive collection of pictures of Sussex.

PHILIPPE JACQUES DE LOUTHERBOURG made sketching tours in Brighton during 1794 and '95, concentrating on the coastal scenery more than the effects of light and atmosphere which were his more usual theatrical concern. NICHOLAS POCOCK visited the

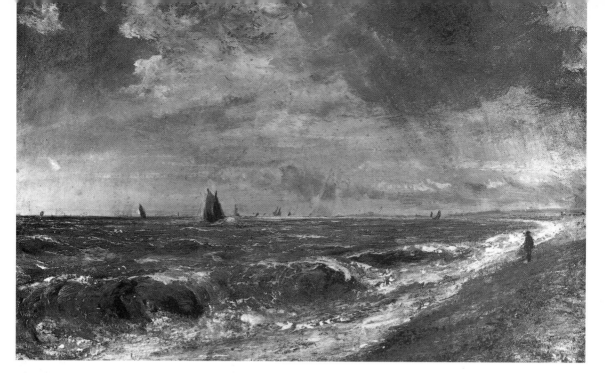

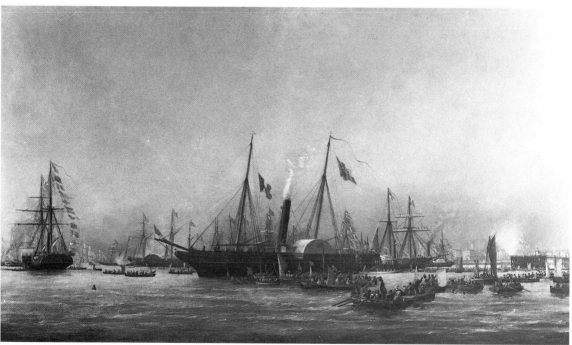

Top John Constable (1776–1837) *Hove Beach* Oil on paper laid on canvas 12½in × 19½in (Victoria and Albert Museum)

Above Richard Henry Nibbs (1816–1893) *The Landing of Queen Victoria at Brighton Chain Pier in 1843* Oil on canvas 40¾in × 65½in (Royal Pavilion, Brighton)

town at intervals from 1800 to 1809, and JOHN CONSTABLE Brighton and Hove from 1816 onwards at intervals for his wife's health; his *Colliers: Brighton Beach*, and various oils and watercolours of *Hove Beach* are among the finest early Impressionist pictures in European art. By comparison, his *Marine Parade and Old Chain Pier, Brighton* (1827) is a finished and detailed image more typical of his Suffolk land-

scapes, a contrast to J. M. W. TURNER's limpid Impressionism of *Chain Pier, Brighton* (1830). Turner also made pictures here for his 'Southern Coasts' series of watercolours in 1820, and the town was included by the writer Richard Ayton and painter and engraver WILLIAM DANIELL, in their *Voyage Around Britain* between 1815 and 1825. A watercolourist, ANTHONY VANDYKE COPELY FIELDING, lived and worked in Brighton part of each year between 1800 and 1810. RICHARD HENRY NIBBS was a resident (c.1815–95), a versatile landscape and marine painter who worked as a professional violinist until a legacy enabled him to paint fulltime. He excelled at marines, at their best in *Queen Victoria Landing at the Chain Pier 1843*. He published a number of books of the regional coast and inland scenery, including *A Marine Sketch Book of Shipping, Crafts & Coast Scenes* (1850). GEORGE CHAMBERS SR died in Brighton in 1840, on return from a cruise to which a friend had treated him in an effort to restore his health. A ship-portraitist, GEORGE MEARS, worked prolifically in the Brighton area, and W. J. LEATHAM of Brighton, under the influence of Turner, produced some of his best work in Brighton and Hove between 1840 and 1855. Beach and fishing scenes attracted JOHN DUJARDIN, W. W. FENN – who found Brighton hog boats were especially attractive – G. GOODEN, O'BRYEN LOMAX and JOHN THORPE who all made oil pictures of the chain pier or ships. W. E. BATES was a resident painter between 1850 and 1870, and WILLIAM H. BOND, who produced many coastscapes, until 1904. EDWARD LESLIE BADHAM, a landscape and marine painter, who worked in Sussex, painted in the area before the Great War, and at intervals during the 1920s and '30s. G. H. DAVIS, a member of the R.S.M.A. for 1947–59, lived in Brighton throughout his career. GEOFFREY IAN LILLEY, painter of pure seascape, skies, coastal scenes, landscape and forest,

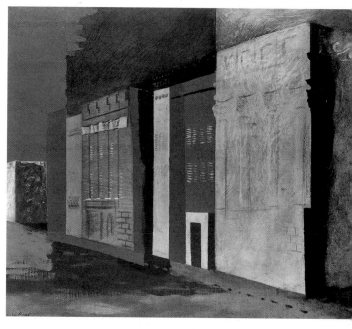

John Piper (1903–) *Dead Resort, Kemptown, c. 1939* Oil on canvas and board 18¼in × 22¼in (Temple Newsam House, Leeds)

and author of over 300 articles for the popular press, has lived and worked in the vicinity since 1973. RODNEY WILKINSON, a painter of coast and estuary, painted along the Ouse in the late 1960s, his last exhibit at the R.S.M.A. being *The River Ouse* in 1969. ROXANE LOBANOW-ROSTOVSKY, born in Athens, studied at Brighton, and settled at Hove. Her interest in the coast's capacity for offering marine still-life with beach objects, gives her pictures something in common with the less organic compositions of Edward Wadsworth.

Bristol

Avon

A major commercial, cathedral and university city on the Avon, on the M4 and M5, six miles S.E. of the Severn Estuary. Its main docks and container port are now at Avonmouth, on the Estuary; the city docks are redeveloped into a residential, world-trade and marine leisure complex. Clifton, a residential district on the heights above the Avon Gorge, still retains a wealth of Georgian and Regency architecture. Despite great wartime damage and some egregious redevelopment during 1955–1970, much excellent building survives and it remains one of the most spectacular cities in Britain. Brunel's suspension-bridge spanning the Gorge post-dates the

heyday of the Bristol School painters. The City Museum and Art Gallery retains an extensive collection of work by NICHOLAS POCOCK, JOSEPH WALTER and other Bristol artists.

NICHOLAS POCOCK was probably born at 41 Prince Street, off Broad Quay, in 1740, the son of Nicholas Pocock, a mariner who appears to have owned his own vessel, and was apprenticed to the ship-owner Richard Champion. From c.1767 he commanded Bristol merchant ships on the Atlantic and Mediterranean until the American War of Independence, and another ship to the Mediterranean, becoming a professional painter between 1776 and 1780. He remained in Bristol at Prince Street until moving with his family to London in 1789. During the 1780s

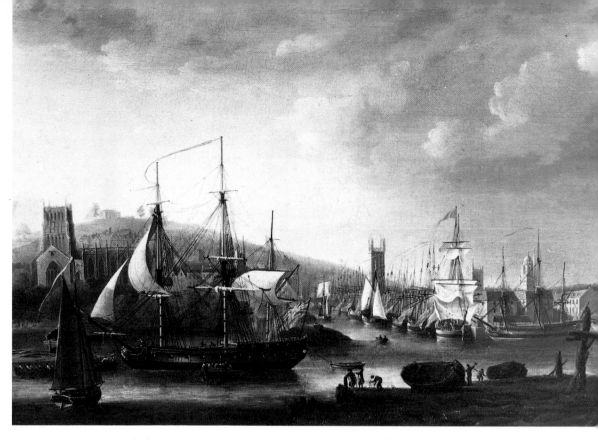

Nicholas Pocock (1740–1820) *Bristol Harbour with the Cathedral and the Quay* Oil on canvas 22½in × 32in (City of Bristol Museum and Art Gallery)

he made a number of paintings in oil and watercolour of the central harbour area, looking S.W. towards St Mary Redcliffe church and W. across the Frome river to the cathedral and Broad Quay. He made 8 aquatints of these views in 1782, which were published at intervals from then until 1801. Between 1785 and 1791 he produced oils and watercolours of the Avon Gorge, viewed from high up on Durdam Down to the N.W., and particularly from 1787 the 300-foot high St Vincent's Rocks, the river below the terraced heights of Clifton (1788), and the Hotwells Spa area near the Rownham Ferry, south of the Gorge (1791). Some of his earliest watercolours (1779) pictured the seaward reaches of the Avon; Kingsmead Roads, where vessels often stood awaiting favourable winds to take them down the Bristol Channel, and the landward regions of Kings Weston to the N.W. of the city, between 1781 and 1791.

A ship-portraitist, JOSEPH WALTER, lived throughout his career in the port, being its chief marine artist for 40 years until his death in 1856. He exhibited in London between the late 1830s and early 1850s, 3 of the 10 exhibits at the Royal Academy and 7 at the Suffolk St Galleries. Most of his pictures portrayed West Country vessels, such as *A Severn Trough Passing the New Lighthouse at the Mouth of the Avon* (1841), some period pieces from marine (naval) history, and work made along the south coast during the early 1840s; but he was primarily notable for his portraits of steamships, particularly *Great Western* and *Great Britain*, and his work covers the last heyday of the port before its eclipse, giving him a reputation both in Britain and America.

JOHN SYER, chiefly a landscape watercolourist, was resident from 1832 until 1872, when he moved to north London. There were sea pieces among his 190 London exhibits, but few concerned Bristol. His son, JAMES SYER, based in Bristol, painted coastal and inshore subjects from 1867 until 1878, many of them in the S.W. peninsula. GEORGE WOLFE, a land- and coastscape painter, lived from 1855 until 1872 in Clifton, although the bulk of his work was produced in the S.W. and the W. Wales coast. Of his 107 London exhibits, 74 were at the Suffolk St Galleries and 8 at the Royal Academy.

CHARLES KNIGHT was resident from 1853 to 1878. Formerly a sailor, he left the sea during the late 1840s, when he had lived in the Welsh Backs area. Sometimes described as a landscapist, Knight painted many sea- and coastscapes: of his 103 London exhibits 33 were sea pieces. In the 1860s he painted some fine pictures in the Avon Gorge area, such as *Indiaman Coming up the Avon* (1867). Many of his

other pictures were set on the S. or W. coasts. In 1878 he moved to Tiverton, Devon, and to London in 1890.

EDWARD PRITCHARD lived here during the first 6 years of his career – 1852–58. During this period he painted chiefly in S. Wales and the S.W. coast, in the Plymouth area. In 1858 he moved to Weymouth, Southampton in 1860, London in 1862, and finally to The Vicarage, Staton, Cheltenham, in 1866.

ARTHUR WILDE PARSONS lived and worked in the Bristol area all his life from the 1840s until his death in 1931. Between 1867 and 1904 he exhibited 18 pictures in London, with 6 at the Royal Academy, and his other work in regional galleries. His strong distinctive style suited his robust coastal subjects. EDWARD GOULDSMITH was based in Bristol while working along the N.E., S. and S.W. coasts between 1877 and 1901. FREDERICK JOHN (BARTRAM) HILES lived in Bristol from 1908, until his death in 1927. Having lost both arms in an accident Hiles held the brush in his teeth. He painted both marine and landscape pictures, but to a higher standard than is usual with artists handicapped in that manner. EDWIN JOHN BOARD (born 1886) remained a resident throughout his career, ignoring oil and concentrating on watercolour and pastel work, producing subjects

along the Bristol Channel and the S.W. peninsula. He exhibited at the R.A. and the Royal Watercolour Society

WILLIAM HALE, concentrating on coastal subjects, settled near Bristol in 1916. The greater part of his work was done in the late nineteenth century, but he continued to work in the Bristol area until close to his death in 1929, his style changing little from that of the 1890s. HENRY SCOTT (fl. 1950–66) began his career with the R.S.M.A. exhibit of the Portishead Light, the same general vista as Nicholas Pocock had painted in watercolour 160 years before. MAURICE TAYLOR, living near Bristol, who states that he taught himself to paint to finish off some inherited colours, and specializes in harbour scenes, tugs and contemporary shipping, paints in the area and has exhibited with the R.S.M.A. since 1974. His painting contrasts with that of ALEXANDER DOW, resident in Bristol, whose mildly surreal coastscapes in acrylic or oil are frequently deserted, and may appear archetypal although often of specific places in the S.W. peninsula. His work regularly appears in the Royal West of England Academy.

Joseph Walter (1783–1856) *The Steamship 'Great Western'* Coloured aquatint 18¼in × 27⅜in (National Maritime Museum, London)

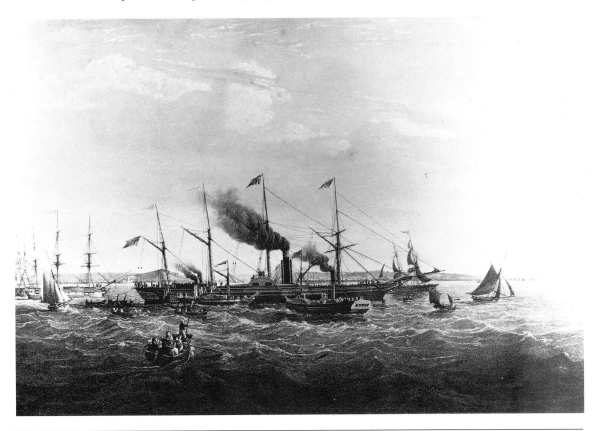

Brixham and Torquay

Devon

Now a major resort on Tor Bay, a mile S.E. of Paignton, Brixham was England's premier fishing port for over 300 years. In the late eighteenth century, the powerful 75-foot Brixham trawler pioneered deep-sea trawl-fishing, and its design was copied for the expanding North Sea fishery by the fleets of Hull, Grimsby, Fleetwood and Lowestoft. This vessel appears in more nineteenth century coastal seascape painting than any other trawler. Brixham's Old Market House, built 1800, now houses the British Fisheries Museum.

Tennyson described Torquay as 'the loveliest sea village in England'. Now a large resort at the north of Tor Bay, it was popularized by the Great Western Railway from 1848, and its mild climate which sports palm trees, its red beaches and red cliffs give it an air of southern France. Torre Abbey is now the town art gallery.

J. M. W. Turner gave a Mediterranean atmosphere to Brixham when he painted Tor Bay from the high ground above Brixham harbour showing sunrise over a turquoise sea looking toward Torquay. He visited the town in 1811 and painted it thus in 1816. James Francis Danby painted here and in Tor Bay at intervals between the late 1840s and 1870, portraying sunrise and sunset scenes as well as full daylight fishing pictures. Danby was unusual in this. He shared this taste with Alfred Clint, who produced many sunset studies in Cornwall and Devon from the 1840s until the 1880s, many of them in the Tor Bay area. J. G. Philp worked in watercolour here during the 1850s, fishing scenes with vessels drawn up at the quayside or coming into harbour. Henry Sandercock, a Devon artist, painted regularly here during his career, from 1867 to 1883.

Charles Napier Hemy portrayed the Brixham fleet in all its various aspects in all weathers and situations, on and off the coast. As his career progressed he developed a trait of placing his vessels high up on the canvas so that the mastheads were cut off out of the picture area; this closeness added a sense of drama to what he painted, which was lacking in the hack work of people like Thomas Bush Hardy and Charles Thornely. Hemy continued to make pictures set in the area until the Great War. Albert Hodder, who visited the area from the Government School of Art, Worcester, painted here at intervals from c.1876 to 1890. Bryan Hook, essentially a landscapist, also portrayed the coast in the region during the last 15 years of the century, including it in his R.A. exhibits. Walter Shaw, a Salcombe artist, paid frequent visits from c.1875 and continued to exhibit paintings made here until 1904. From the 1890s until the early 1930s, an Impressionist, Terrick Williams, pictured the fishing vessels, landscape and harbours of the south-west, and painted in Brixham. His paintings of the harbour cover the transitional time from the heyday of fishing until the rise of tourism. The watercolourist and oil painter Edwin Hayes made very delicate pictures here at the end of the nineteenth century.

John Edmund Mace, oil and watercolourist, lived at Torquay and in London. During his career (fl. 1916–48) he painted extensively in the Torquay area during the late 1930s and '40s, and his marine pictures have a delicate airy quality with fine draughtsmanship, also reflected in his numerous landscape and flower paintings. Hilary Dulcie Cobbett, oil and watercolourist, painted here during the mid-1940s, while in her early 60s, entering a picture of the harbour at the inaugural exhibition of the R.S.M.A. in 1946. W. Atherton Cathcart worked here in watercolour during the early 1950s, especially in the crowded inner harbour. Mrs M. O. B. Hall, another watercolourist, portrayed French and English fishing-boats in the harbour in the later 1950s, before the acrimonious fishery disputes of the 1960s. Leonard G. Andrews, coast- and landscapist, used the same medium in 1959 for the same subject. Henry James Denham of the Wapping Group made some of his last paintings here in 1961, watercolours of *The Crowded Harbour, Brixham*, exhibited posthumously in 1962. Peter J. Carter, originally an engineering designer, moved to Devon in 1962 and painted here at intervals until his death in 1979. His careful, highly finished pictures of the working boats of the coast concentrated especially upon the Thames barges and Brixham trawlers, both of which he found blended practicality with beauty. David Willis, concentrating on coast and harbour subjects, painted here in oils in 1964. Maurice Wilson produced watercolours here in 1972. John Russell Chancellor lived here from 1972 until his death in 1982. He produced the greater body of work on minutely researched and painted ships which made his name within 2 years.

Broadstairs

Kent

One of the Thanet trio of resorts together with Ramsgate and Margate on the east Kent coast, with the twisting streets of a pre-Victorian fishing village. The town is dominated by the memory of Charles Dickens who wrote *David Copperfield* in the bleak, battlemented Fort House which overlooks the har-

bour and curving sands of Viking Bay. A mile N. is the North Foreland Lighthouse, an 85-foot tower, which throws a light beam for 20 miles, warning of the Goodwin Sands (see below) 7 miles offshore.

Marine painters F. and C. J. SARTORIUS worked here at intervals between 1800 and 1820, the elder artist particularly between 1803 and 1806. R. W. BENGOUGH worked along the coast from Broadstairs to Pegwell Bay from 1830 to 1836, painting offshore scenes and Broadstairs harbour. WILLIAM POWELL FRITH visited Broadstairs before making his painting on Ramsgate Sands, and made various studies in the area. CLARKSON STANFIELD, a close friend of Charles Dickens, spent time at Broadstairs during the 1840s, although his marine scenes of the area concern the fishing vessels off the Goodwins more than the town. JOHN BRETT, travelling around the coast, stayed here during the 1860s and regularly during the next 30 years, making many studies from the high ground above the bay, the kind of vision which later formed panoramas like *Britannia's Realm*. By contrast, an Impressionist, THÉODORE ROUSSEL,

made sketches here during his period at Dover during the 1870s, again concentrating on the effects of atmosphere moving over the sea seen from a high vantage point. JOHN THORPE worked here in the early 1880s and WILLIAM H. BOND in the 1890s. FREDERICK JAMES ALDRIDGE made occasional visits here in the 1890s, primarily to watch vessels off the Goodwins. CHARLES MURRAY PADDAY also pictured some of the boating fraternity and sailing vessels in the area before the Great War, although he worked further west. FORTUNINO MANTANIA, the illustrator, made wave and beach studies here before the Great War and pictured warships at manoeuvres in the Channel. ROWLAND HILDER pictured the resort during the 1930s while making many scenes of Kent, and G. H. DAVIS during the late 1940s, and WILLIAM HENRY INNES, making 'pure sea' studies of the Channel.

A sea- and landscapist, ROWELL TYSON, made a number of his geometric studies of the high cliffs here in the late 1970s, the economy and starkness of the pictures and the clearness of the watercolour giving an image of the bleakness of the coast.

Budleigh Salterton
Devon

A small resort on the A376. SIR JOHN MILLAIS painted *The Boyhood of Raleigh* here, using his two young sons and the local ferryman as models by the sea wall. Raleigh was born nearby at Hayes Barton, the family farmhouse, in 1552, and a pew in East Bud-

leigh church bears the arms of his family. A quiet Victorian resort, the town has not changed greatly since Millais painted there, and the house where he stayed still exists.

A marine and landscape watercolourist, TOM BALL, lived here from 1922 until his death in 1930.

Caernarvon
Gwynedd

This port on the Menai Strait remains dominated by its massive castle, built when Edward I crushed Llewelyn the Last's revolt in 1282, a masterpiece impregnable by direct assault until the advent of gunnery.

NICHOLAS POCOCK portrayed the castle and port beneath it from the S.E. during a visit of 1794, picking out the sailing vessels below the walls with particular finesse and showing a naïve detailing of foreground figures. J. M. W. TURNER pictured the castle above the port in its most ruined state, his watercolour of the 'England and Wales' series of 1833 portraying it rising from a dreamlike mist above a Claudian scene of tranquillity, with bathers beyond the moored ships at sunset under a crescent moon, the hills of Anglesey across the Menai Strait rising to romantic heights in the shimmering air. JOHN VARLEY portrayed the Menai Strait and the castle above the harbour during a tour of 1802, in a style similar to Pocock's. JOHN BRETT painted in the

estuary area during the early 1870s, as did THOMAS ROSE MILES. FREDERICK WILLIAM HAYES, a Liverpool artist, also painted in the area before he moved south in the late 1870s. JOHN MCDOUGAL, resident in the region, painted here at intervals throughout the last 20 years of the nineteenth century. JOSIAH CLINTON JONES, painting all along the Welsh coast, continued to work in the Menai region at intervals until the 1930s; Caernarvon offered a blend of landscape and marine picture which had initially attracted Pocock and Turner and Jones found this constantly variable. DONALD MCINTYRE living on Anglesey painted here during the 1950s. A post-Impressionist, FAITH TRESSIDER SHEPPARD, portrayed the castle and estuary in oil work here during the mid-1970s.

Overleaf Alfred William Hunt (1830–1896) *Blue Lights, Tynemouth Pier – Lighting the Lamps at Sundown, 1868* Watercolour, bodycolour, gum and scraping out 14⅝in × 21¼in (Yale Center for British Art, Paul Mellon Fund)

Campbeltown
Kintyre, Strathclyde
In the nineteenth century this sombre grey town on the A83 beneath the bare hills was a centre of whaling, coal-mining, distilling and herring-fishing. The last two remain, augmented by tourism and sailing.

WILLIAM MCTAGGART was sent here in the late 1850s to study under an apothecary when his parents disapproved of his painting. He returned during the 1860s and '70s while working at Machrihanish 4 miles away (see below) to paint coasts in the region.

Cardiff
South Glamorgan
The capital of the Welsh principality and a major port. Originally the site of a Roman fort and Norman castle, it remained a small trading port until the 2nd Marquis of Bute expanded the docks in 1839 for the worldwide export of south Welsh, high-grade steam-coal. The infamous Tiger Bay area E. of the river Taff was the haunt of seamen of all nationalities and every kind of marine and shore-based vice, a contrast to the city's impressive civic architecture, whose National Museum contains one of the finest collections of Impressionist painting in Europe. Now renamed and redeveloped the docklands' chief connection with their past is their Maritime Museum, containing massive steam exhibits, sailing vessels, cranes and channel steam tugs. Both Museums contain collections of marine painting.

Most of the marine and coastal painters of the Bristol Channel area made pictures here during the mid- and later-nineteenth century. EDMUND GOULDSMITH and CHARLES KNIGHT worked here during the 1870s; EDWARD PRITCHARD in the 1860s. RICHARD SHORT lived and worked in Cardiff from 1882 until 1900, his full working career, portraying both the port and docklands and the south and west Wales coastlands. A Swansea painter, JAMES HARRIS, and WILLIAM EDWARD WEBB, who produced a number of fine, Turnerian oils, both painted here during the 1890s.

Carnoustie
Tayside
A small, affluent town 2 miles E. of Dundee on the A930, noted in the last 150 years for its golfing championships. Its expanding yacht club is its chief dealing with the Firth of Tay. WILLIAM MCTAGGART, Impressionist, lived and worked here most of each year between 1860 and 1889.

Chatham – see under MEDWAY

Chichester
West Sussex
The administrative centre of West Sussex on the A27, Chichester – the Roman *Noviomagus* – lies just E. of a beautiful, marshy natural harbour which is divided into three channels: the Chichester Channel, ending at Dell Quay and the Roman Palace at Fishbourne; the central Bosham Channel, and the Thorney Channel furthest west. (The Bosham Channel was the place where the much-maligned King Canute demonstrated he could not control the sea to silence the excessive demands of courtiers who thought his powers infinite.)

WILLIAM JOY and JOHN CANTILOE JOY were resident here during the 1850s before finally moving to London. Many of the delicate watercolours of William Joy set at Portsmouth harbour date from this period; they frequently exhibit unusual colour-tones of amber and indigo washes from the distinctive light of the area.

CHARLES MURRAY PADDAY, marine, coastal and landscape artist who made some superb pictures of yacht-racing in the Solent area during the Edwardian period, lived at Bosham in 1895, before moving to Hayling Island. CHARLES DIXON, best known for his tidal Thames pictures after 3 major exhibitions of his work re-established his reputation in 1973, lived at Itchenour where the Chichester and Bosham Channels join at Chichester harbour, from c. 1900 – until his death in 1934. A marine oil and watercolour painter, MARGARET BEALE who worked from the 1920s onwards, and exhibited 3 pictures at the R.S.M.A.'s inaugural exhibition in 1946, lived at Chichester from where she continued to paint until c. 1969. Rodney Burn, Impressionist painter, kept a motor yacht at Birdham and Dell Quay, between 1947 and 1965, from which he explored most of the harbours of the south and west coast. His admiration for the work of Philip Wilson Steer is apparent in his pictures of Chichester harbour. A German-born

artist, KARL HAGEDORN, who took British nationality began exhibiting at the R.S.M.A. in 1954 with watercolours of Dell Quay. NOËL MORROW, watercolourist, typographer and book designer notable for his delicate pictures of coastal subjects and marsh and marine birds, has produced much work in this area, living at Havant, between Chichester and Portsmouth. LESLIE KENT painted frequently at Chichester during the 1950s and 1960s, and the area featured strongly in the work of JOAN MEADOWS during the late 1950s, J. H. DASHWOOD, ROGER and MARY REMINGTON during the late 1960s, and JOHN LESLIE HUDSON, SYDNEY ROWE, EDWARD NORMAN and JOHN MORTIMER during the 1970s.

Clovelly

Devon

A fishing village and resort with the appearance of a beautiful time-capsule, on the B3237 off the A39, 10 miles W. of Bideford. Between 1884 and 1936 Christine Hamlyn, owner of the Clovelly Estate, restored almost all of this harbour's buildings, many of which were Tudor in origin. The steep, cobbled street, known as the 'Up-a-long', leads to the small harbour with a low quay which served the big herring fleet that sailed from there throughout the eighteenth and nineteenth centuries.

CHARLES NAPIER HEMY began his career with the superb *Among the Shingle at Clovelly* in 1864; *The Times* noted that Devon and Cornwall were the favoured locations for the great number of inshore paintings of that year. In 1855 the Royal Watercolour Society's SAMUEL P. JACKSON had been able to charge £150 for his *Clovelly* at the Royal Academy. A landscapist J. F. ANDERSON's *In the Harbour, Clovelly*, and *The Quay, Clovelly*, painted between 1879 and 1882, led Graves's *Dictionary* to classify him as a 'marine painter'.

J. W. L. ASHE also worked in the harbour during the 1870s, while resident in London; most of the marine scenes he exhibited at the R.A. were painted in Cornwall or Devon. WILLIAM H. BORROW visited while painting in the region between 1866 and 1874; after this time he worked largely in Hastings, where he lived from 1876. CHARLES MOTTRAM, while still in London, painted in the area during the 1880s, and continued to do so until 1901, when he finally moved to St Ives. HENRY SANDERCOCK, resident in Devon from 1872, worked here during the late 1870s. A Bristol painter, EDWARD PRITCHARD, visited the area late in the 1850s.

During the 1880s the Bristolian, CHARLES KNIGHT, produced work here, as did his colleague EDWARD GOULDSMITH. Another Bristolian, ARTHUR WILDE PARSONS, exhibiting work until 1904, painted here during the 1880s and 1890s, in a strong, distinctive style with romantic titles like *When Boats Rock Idly in the Sheltered Cove* (1902). Parsons continued to paint in the S.W. peninsula until the late 1920s, and visited Clovelly numerous times. DUFF TOLLEMACHE, painting portraits until the mid-1890s, visited the area in the early 1900s after beginning seascape. TERRICK WILLIAMS, painting in the S.W. peninsula, painted here before the Great War, and before and after the war, ARTHUR WHITE, a marine painter based at St Ives, painted here. So did PETER MOFFAT LINDNER on occasion until the 1930s. EDWARD J. BOARD another artist from Bristol made visits until the early 1920s. RODNEY BURN, Impressionist, sailing along the south and west coasts during the 1950s and early 1960s worked in the area. HOWARD BARRON and LILY BARNARD produced work here at the time.

JASPER GELLER, the precision of whose drawing has sometimes been compared to the great E. W. Cooke, worked here in 1975, picturing the beached trawlers in pen and sepia ink, building up his drawings so that they achieved a 'glaze' effect with many layered strokes – an accuracy of drawing fairly rare until the mid-1970s.

Clyde, Firth of

(Greenock to Glasgow)

Until the draught of shipping greatly increased in the second half of the nineteenth century, Greenock and Port Glasgow on the south bank of the Firth and Dumbarton on the north bank 5 miles upriver from them were the chief ports of the Clyde. Now adjoining Port Glasgow on the A8, Greenock originally flourished by shipping herring to France and the Baltic ports in the 1600s, and by ship-building in the eighteenth century. The clipper *Cutty Sark* was built at Dumbarton in 1863. Glasgow's Clydebank yards became the centre of the shipping industry in Scotland after 1880 until the early 1970s.

The Whitehaven painter, ROBERT SALMON, produced some of his finest work at Greenock during the early 1820s, influencing WILLIAM CLARK, born here 1804/5 who probably saw Salmon's work whilst in his teens. Clark began as a house-painter but by the mid-1820s was receiving commissions from ship-owners and builders, and set up a studio at 10 William Street. His ship-portraits were frequently lithographed, often engraved by Thomas Dutton and published by Clark. One of this series was

Henry Wallis (1830–1916) *A Coast Scene* Oil on board
8⅞in × 14in (Walker Art Gallery, Liverpool)

Queen Victoria's Visit to the Clyde of 1847 which
included the portraits of fourteen vessels (Greenock
Corporation).

Salmon's contemporary, GEORGE NAPIER, of the
family of Robert Napier and Sons, the Clyde ship-
builders, was also influenced by him. Throughout
the 1850s and 1860s Napier painted from 6 Salisbury
Street, together with his brother Alexander Napier,
a decorative painter. Both were related to John J.
Napier, who exhibited in London between 1856 and
1876 and who painted Samuel Cunard, whom
Robert Napier had backed in founding the Royal
Mail Steam Packet Company in 1839. Among ves-
sels George Napier portrayed was the ship built
initially for the China tea trade and sold to the
American Confederate Navy to become the notori-
ous warship *Shenandoah*.

J. WILSON EWBANK visited the area during the
1820s and the Englishman ANDREW DURNFORD
during the 1850s. JOSEPH HENDERSON, who had stud-
ied at the Trustees' Academy, settled in Glasgow in
1852, at the age of 20, and until around 40 years of
age concentrated upon landscape painting. After that
time he painted largely sea pieces in a style strongly
influenced by William McTaggart. He spent the
whole of his career in Glasgow, where he died in
1908, being a leading figure among the local artists.

ALFRED MONTAGUE, painting along the Scottish
western coasts, worked in the area west of Greenock
and painted vesels on the Clyde. JOHN NESBITT, on a
tour of the western coasts, portrayed fishing vessels
there in the late 1870s. JAMES KAY, who lived and
studied in Glasgow, painted in the area from 1889
until 1904, but he continued painting in the Clyde
well into the 1930s; he died in 1942. ALEXANDER
FREW was resident in Glasgow during his career (c.
1890–1898) his coastal pictures stressing the natural
elements more than figurative detail.

SIR JOHN LAVERY, who painted a number of very

impressive marines although a landscape and portrait painter, ran away to Glasgow and later entered the School of Art there in 1876, where he studied until 1879. He returned to Glasgow in 1885 and became a member of the powerful Glasgow School, including JOHN PEPLOE and FRANCIS CADELL, who painted on Iona and the Western Isles after the Great War. STRUAN ROBERTSON lived throughout his career in Glasgow, from 1903–1918, working in oil and watercolour, and portraying fishing vessels on the Clyde and coastal subjects generally exhibited at the Glagow Institute of Fine Arts. WILLIAM MERVYN GLASS, President of the Scottish Society of Artists, worked in the Clyde area after the Great War exhibiting work at the Glasgow Institute. MARY DEVLIN, a watercolourist, produced work in Strathclyde and exhibited at the Glasgow Institute 1920–1936.

PATRICK DOWNIE, a coast and landscape painter, lived at Greenock at the beginning of his career in 1887. Between then and 1904 he painted along the English N.W. and Scottish coasts. FREDERICK DONALD BLAKE, a coastal and landscape artist working in watercolour and acrylic, was born on 7th June 1908 in Greenock. Blake's pictures, often semi-abstract and of considerable vigour, frequently por-tray no specific place, but the essence of the jumbled detail and certain rhythmic forms which typify so many small-boat harbours. Between 1920 and 1940 ARTHUR COULING exhibited marine work in Glasgow. During the late 1920s ALAN GOURLEY, later President of the Royal Institute of Oil Painters, studied in Glasgow and produced early marine work on the Clyde.

Between 1940 and 1945 the post-Impressionist, SIR STANLEY SPENCER, was employed as a war artist on the Clyde. He produced 11 panels, each 20 ins x 194½ ins, showing the ship-building industry in the Clydebank yards. THOMAS HALLIDAY O.B.E., watercolourist and etcher, made numerous pictures of the ship-building scenes on the Clyde before and after the Second World War. He exhibited with the R.S.M.A. from 1954 until 1969, when he exhibited *The Birth of a Ship*. ARTHUR DUCKWORTH, painting on the Strathclyde coast, also showed work with the R.S.M.A. between these dates, working along the Firth of Clyde westwards. CECIL KNOX, sailing and teaching with the College of the Sea between 1968–1971, portrayed Clyde shipping by showing the superstructure of freighters as dramatic architecture through which seascape could be viewed.

Cockburnspath
Borders
Sixteen miles N.W. of Eyemouth on the A1 or A1107 and locally called Co'path, this village and the surrounding area has a Cornish appearance, partly responsible for making it an art colony of the Glasgow painters in the 1880s. Half a mile away is Cove, a harbour at the bottom of steep red sea cliffs reached by steps cut into the rock.

A group of Glasgow painters, notably JAMES GUTHRIE, E. A. WALTON, ARTHUR MELVILLE, JOHN LAVERY, GEORGE HENRY, ALEXANDER ROCHE, E. A. HORNEL and JOSEPH CRAWHALL settled here during 1883, JAMES GUTHRIE remaining here for three years. None of them were specifically or primarily marine artists, but Lavery and Guthrie produced some of the first quasi-Impressionistic coastal pictures by indigenous British artists here, in the area of Cove. Lavery's approach was lighter than Guthrie's, and he later produced a number of impressive images of shipping during the Great War.

Colwyn Bay
Clwyd
A small resort 7 miles W. of Rhyl on the A55. A centre for sailing, water-skiing and swimming beside a 3-mile stretch of sand.

JAMES AIKEN, painter, lived here from 1889, working along the Welsh coast during the 1890s, alternating with visits to the Whitby area and the S. coast.

Conway or Conwy
Gwynedd
Probably the best preserved medieval town in Britain, and a major tourist and fishing centre. Conway Castle, one of Edward I's fortresses, dominates the beautiful river estuary immediately to the N.E. of the town, and the three bridges which span the river.

NICHOLAS POCOCK made a number of charming and characteristically delicate watercolours of the town while on a tour of 1796, their delicate rendering of water and bright sky contrasting with the finesse of the shipping and naïveté of the human figures.

A Liverpool artist, GEORGE COCKRAM, was a resident after 1890, producing coastal and 'pure sea' pictures such as *The Plunging Seas* (1893) *The Waves make Toward the Pebbled Shore* (1899) and *The Silent*

Sea (1904). HUBERT COOP, a Birmingham artist, lived overlooking the Morfa Sands from 1898, and worked here at intervals between 1900 and 1930. Not an adventurous painter, his pictures were images of considerable conservative talent. THOMAS CORDEAUX visited and painted the estuary in 1901. BENJAMIN WILLIAMS LEADER visited Conway at the end of the 1850s and at intervals during the 1860s and 70s, while living near Worcester. His prolonged Welsh excursions ceased around 1890 when he finally moved to Gomshall in Surrey. GERTRUDE COVENTRY, working in Scotland and N. Wales, painted along the estuary in similar vein during the 1920s and '30s, usually in watercolour. ROBERT EVANS HUGHES, painter of coast, landscape and figures, pictured Conway in the later 1950s, and Deganwy, just across the estuary. DONALD MCINTYRE, resident in Bangor, painted at Conway during the 1950s, beginning his R.S.M.A. exhibits in 1954 with an oil of the town.

Cowes, East and West
Isle of Wight

This, the world's premier yachting centre, became fashionable in the 1890s, when Edward VII, then Prince of Wales, raced yachts there. The regattas of Cowes Week are held during nine days of August, and a Round-the-Island race in June. The mouth of the river Medina divides East from West Cowes, forming a harbour packed with boatyards and backed by narrow ascending streets, and overlooked by the Royal Yacht Club's twenty-one small brass cannon.

J. M. W. TURNER visited here in July and August 1827, staying with the architect John Nash at East Cowes Castle, which he had been commissioned to paint. His tranquil sunset watercolour study of the harbour looking toward West Cowes contrasted with the busy traffic shown in two oils he exhibited in 1828. *Shipping off East Cowes Headland* was an equally quiet oil picture. The tower of St Mary's Church (built 1816 by Nash) appeared as a linchpin of the West Cowes painting. During the Napoleonic Wars, Cowes Roads had been the assembly point for convoys leaving British waters and Turner portrayed these larger ships.

ALFRED VICKERS SR, a distinguished landscape artist, painted many coastal works in the Solent and Cowes between 1820 and 1840, his light feathery stroke well suited to skyscape reflected in shallow estuary waters. JAMES MAULE and HUME LANCASTER worked here during the 1840s, as did CLARKSON STANFIELD and E. W. COOKE. EDWARD TURTLE, native of Ryde, and J. M. GILBERT of Lymington, many of whose pictures were stone-lithographed, painted during the 1850s. FRANCIS MOLTINO, FRANK OSWALD and W. A. FOWLES of Ryde all recorded the variety of vessels and the people of Cowes and the Solent before yachting became the central activity. CHARLES GREGORY of Cowes was resident from 1810 to 1896; sometimes described as a landscape painter, most of his work was of the Isle of Wight and Solent coasts. FREDERICK BARRY lived at Cowes from 1848; JAMES BURTON painted here between 1830 and 1844, and THOMAS DEARMER between 1840 and 1867.

BARLOW MOORE, Marine Painter to the Royal Thames Yacht Club, and FREDERICK JAMES ALDRIDGE, an artist from Worthing, visited Cowes regularly for the regattas, Aldridge every year for fifty years until c.1930. Their pictures, set in the Solent, reveal how much sail the early yachts could carry and still remain stable in the strong winds referred to nonchalantly as a 'fresh breeze'.

GEORGE GREGORY, son of Charles Gregory of Cowes, was resident from 1849 until 1938; painting throughout the area's rise to fashion and although his pictures explore far wider aspects of the Solent and Isle of Wight, they have only recently achieved the recognition they merit. EDUARDO DE MARTINO, previously painter to the court of Dom Pedro II, Emperor of Brazil, arrived in England in 1875, and spent the rest of his life in London and Cowes, where he usually stayed with King Edward on the Royal Yachts, having previously become Marine Painter in Ordinary to Queen Victoria. FRANK WATSON WOOD, chiefly a watercolourist, who specialized in naval shipping and accompanied the Navy on frequent Royal visits, painted at Cowes between 1890 and 1930; Czar Nicholas II bought work from him while visiting Cowes.

JOHN EVERETT, in his mid-thirties, painted at Cowes and although primarily concerned with deep-sea sailing, produced some of his best offshore pictures in the region in the decade before the Great War, especially between 1910–12, and at intervals thereafter until his death in 1949. FRANK WILLIAM BOVILLE, who exhibited chiefly oil work with the R.S.M.A. between 1950 and '54, painted in the area during 1953, and on the S.W. side of the island. WILFRED FRYER (exhibiting with the R.S.M.A., 1947–1968) painted here during the early 1960s. EDWIN MEAYERS, a watercolourist, worked during the same period.

An Impressionist, RODNEY BURN, painted here and throughout the Solent area during the 1950s and 1960s; DERYCK FOSTER, a marine painter well known for his highly finished and vigorous pictures of historical and contemporary vessels of all kinds, produced many oils in the region between 1950 and

later '60s, before moving to Bermuda. The HON. KATHERINE WILLIAM-POWLETT, painting watercolours here in 1964, and JOHN HUMPHREYS oil in 1974, *The 'Safari' and 'Charisma' at Cowes*, typify two forms of Cowes' portraiture. MICHAEL TURNER with *Yacht Racing at Cowes* (1974) and FRED MARSHALLSAY, both watercolourists, also typify the genre. PETER LEATH, a highly polished and self-taught painter specializing in vessels before steam propulsion, whose draughtsmanship is rather superior to his colour sense, and who has designed two of his own trawlers, has set a great proportion of his subjects in the region. DAVID COBB, President of the R.S.M.A. (1979–1983), aptly describing himself as a painter in oils of 'everything of any period that floats', with a great experience of the sea, has produced some of the finest pictures of the vessels of the Cowes and Solent area of the later twentieth century.

Criccieth
Gwynedd

This small resort town on the A497 with its terraces of white-painted houses and hotels is divided by a high headland dominated by a Welsh-built castle of 1260. A sweeping curve of sand runs eastward to caves, and Black Rock in Tremadog Bay, opposite the high hills of Harlech across Glaslyn.

J. M. W. TURNER's image of salvage by coastguard officers in 1835 after a storm shows tiny figures under the looming heights of the castle, which the artist contrasts with the pathetic hovels of Criccieth itself.

Cromer
Norfolk

A port on the A149 noted today for its crab fishery, the bravery of its lifeboat crews in the Second World War, and as a tourist resort since the end of the eighteenth century. The presence of affluent visitors was reflected early in the grand church of St Peter and St Paul, with its 160-foot Perpendicular tower, the highest in Norfolk.

ALFRED STANNARD, the son of Joseph Stannard, produced inshore and offshore scenes along the beach and within the harbour and at sea here from the later 1830s until the 1880s. Cromer light was a strong element along the open coast here, and was utilized by Stannard as by other artists such as EDWIN MEADOWS.

JOHN MOORE of Ipswich and MILES EDMUND COTMAN made inshore pictures here and painters of the Meadows family, JAMES and ARTHUR MEADOWS, and particularly JAMES EDWIN MEADOWS, who was noted for landscape painting, pictured the foreshore. The distinctive Gangway, a granite stone ramp with angled blocks to give horses a footing as they hauled cargo up from the sand and shingle beach, as well as the tall Cromer Light on the high ground in rear of the cliffs made a strong backdrop. WILLIAM COLLINS painted here in 1816 and in 1845; FRANCIS MOLTINO in the mid-1860s, and a London artist, JAMES BURRELL, in 1865, concentrating on beach scenes. BRYAN WHITMORE came here during the early 1880s.

During the Great War CATON-WOODVILLE, an illustrator, and FORTUNINO MANTANIA portrayed naval scenes offshore, particularly the activities of the British destroyer and battle-cruiser squadrons in the North Sea, as did PHILIP CONNARD.

During the 1930s LESLIE J. WATSON visited the harbour while crewing on fishing vessels in the North Sea. ROWLAND FISHER, resident at Great Yarmouth, painted the Cromer vessels and the harbour there before and after the Second World War.

JOHN HUMPHREYS painted here during 1973–4, his first R.S.M.A. exhibit being a work set on Cromer beach. ROBERT KING, landscapist, portraitist, and coastal painter, much of whose work is set along the Norfolk coast or the Solent, made oils of the crab boats here during the 1970s, work which he alternated with visits to Egypt, France, Venice and Morocco.

Dartford – see under THAMES ESTUARY

Dartmouth
Devon

Built in 1905, Dartmouth Naval College dominates the hill above this port and resort on the A379. Dartmouth's cobbled quay at Bayard's Cove remains the subject of painters and has changed relatively little in 200 years; it terminates at Bearscove Castle, part of Henry VIII's coastal defences of 1537. A chain defence passed beneath this across the Dart to Kingswear on the far shore. Houses and hotels now climb

the wooded slopes there.

NICHOLAS POCOCK visited Dartmouth during his years as a ship's master and pictured it in watercolour in 1790, one of the very few Devon ports which he painted despite being a West Countryman.

J. M. W. TURNER poetically exaggerated the height of the wooded hills on their side of the estuary in his picture of 1825–6, *Dartmouth Cove with Sailors' Wedding*, viewed from Kingswear. Influenced by Turner, EDWARD DUNCAN pictured Dartmouth during the 1840s, an idyll with the smoke from cottage chimneys rising perpendicularly into a clear sky above glassy waters. JAMES FRANCIS DANBY produced equally tranquil images of the port during the 1850s, and EDWARD PRITCHARD painted in the area during the same decade.

CHARLES NAPIER HEMY pictured fishing vessels set against naval ships lying at rest (with lines of washing between their masts) in the early 1870s. The figurative painter, JOHN REID, and the 'landscapist' GEORGE ADAMS, touring in Devon, painted here c.1870, as well as a Kent artist, J. W. L. ASHE, and a painter from Hastings, WILLIAM BORROW. THOMAS HART pictured the Cove and town from the heights inland to the south during the later 1870s.

During the last two decades of the nineteenth century, the rarely recorded WILLIAM GARTHWAITE painted at Dartmouth, in the harbour and the outer estuary; and near the end of his career in 1880, CHARLES FOTHERGILL, a watercolourist, worked along the mouth of the Dart. SAMUEL JACKSON and CHARLES MOTTRAM produced watercolours here during the early 1880s, as did HARRY MUSGRAVE.

CHARLES KNIGHT and EDWARD GOULDSMITH both painted at Dartmouth during the last fifteen years of the nineteenth century, as did WALTER SHAW. Shaw continued to make paintings in the area until the Great War. FREDERICK JAMES ALDRIDGE, a painter from Worthing, painted at Dartmouth at intervals from the late 1880s until after the Great War.

RODNEY BURN, Impressionist, pictured the port and the surrounding coast on numerous occasions during the 1950s, his approach giving the region a dream-like, Mediterranean appearance despite its business which was not inaccurately portrayed.

MARK MYERS, American-born illustrator, has produced gouache and acrylic pictures of Dartmouth in the seventeenth and eighteenth centuries, and both JOHN CHANCELLOR and DEREK GARDNER have portrayed naval actions and naval ships sailing from the port during the seventeenth and eighteenth centuries.

MARY WILLIAMS, a pupil of Claude Muncaster, painted the period sailing-craft *Elsa* moored at Bayard's Cove, Dartmouth, while the BBC was filming *The Onedin Line* there during 1971.

Deal

Kent

An east coast resort 8 miles N. of Dover on the A258. A Cinque Port, Deal's shingle beaches did not supply sand for children and as a result there is no great development of Victorian hotels, leaving the town with a strong eighteenth-century appearance. (The beach is traditionally believed to be the landing-place of Julius Caesar's abortive expedition of 55 B.C.). Henry VIII's castle of 1540 was formerly residence of the Captain of the Cinque Ports, a gun-fortress with the ground plan of a Tudor rose. Just N. of it the Black Ball Tower, synchronized with Greenwich, and was used by vessels anchored in the Downs Channel offshore to check their chronometers. The castle, tower and the shingle boats carrying passengers to ships were the prime subjects of painters portraying Deal, and its relationship with the Goodwin Sands (see below).

DOMINIC SERRES and his son JOHN THOMAS SERRES pictured vessels lying in the Downs worked here, as did JOHN and ROBERT CLEVELEY who made watercolour drawings along the coast between 1780 and 1809, and NICHOLAS POCOCK who made sketches for a series of harbour pictures which never came to fruition. PHILIPPE JACQUES DE LOUTHERBOURG made many studies of the coastlands, closer to portraiture than atmospheric romantic essays. GEORGE WEBSTER, about whom little can be established, may have been resident or spent considerable time in Deal between 1797 and 1832; he made a large number of very fine oil pictures in his Anglo-Dutch style set off the town. JOHN CONSTABLE terminated his marine sketching tour of 1803 at Deal in the East Indiaman *Coutts*. The small boat traffic and fishing vessels attracted painters such as C. DOWNTON SMITH (1845), F. W. OVENDON in 1842, and W. H. POLLENTINE between 1847 and 1850. WILLIAM CRAMBROOK was resident here until 1840.

NICHOLAS CONDY pictured vessels off Deal, with less verve and panache than Webster, but gracefully drawn. THOMAS GOLDSWORTHY DUTTON produced some very fine profiles of shipping off the port, as did WILLIAM BROOME. E. W. COOKE exercised his enjoyment of Dutch and English fishing craft on the coast and in the Downs Channel, as did CLARKSON STANFIELD, who pictured capital ships there besides packets and East Indiamen, a regional subject of JOHN HUGGINS. JOHN CHRISTIAN SCHETKY portrayed warships and vessels of the Navy's experimental squadrons assembled off Deal and passing up the Channel, as well as racing and pleasure craft. JACK

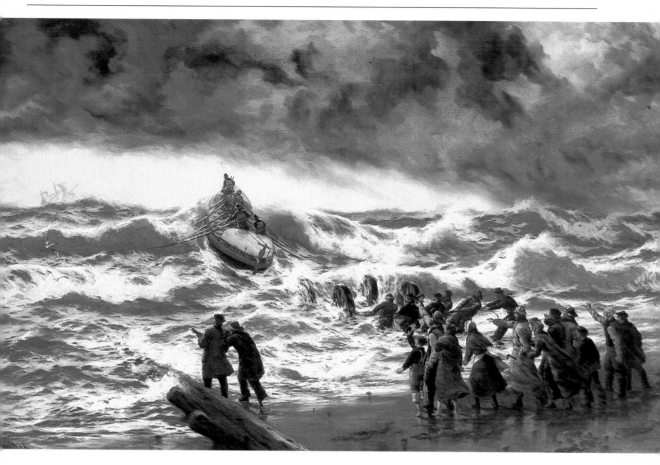

Thomas Rose Miles (fl. 1869–1888) *Launch of the Life Boat* Oil on canvas 30in × 50in (Royal Exchange Gallery, London)

SPURLING, reconstructing sailing vessels, portrayed them in this area of the Channel when not far abroad, and both MONTAGUE and NELSON DAWSON por- trayed packets and other ships in the area before and after the Great War. Montague Dawson pictured the Black Ball packets in a number of his 'high seas' pictures. CHARLES PEARS and JOHN EVERETT pictured shipping in the Downs Channel as did CLAUDE MUNCASTER and ARTHUR BURGESS. LESLIE WILCOX, painting historical reconstructions of shipping – often coastal barques – has set them in the vicinity as an approach to the Thames and Medway.

Deptford – see under THAMES ESTUARY

Devonport – see under PLYMOUTH

Dover
Kent

England's main cross-Channel port for two millennia, at the start of Watling Street, now the A2. A Roman *Pharos*, or light house, was built there soon after the conquest in the first century A.D. and its octagonal lower portion still remains, the tallest surviving Roman structure in Britain. The chief Cinque Port, its castle is one of the most massive and dramatic fortresses in Britain. The huge outer harbour was built to accommodate ships of the Grand Fleet before the Great War, and now contains pleasure craft while the Western Docks operate freight and ferries to France and the Low Countries.

WILLEM VAN DE VELDE THE ELDER portrayed the passage of Mary of Modena from Calais to Dover in November 1683 in the yacht *Cleveland* and her landing, led up the beach by the Duke of York, later

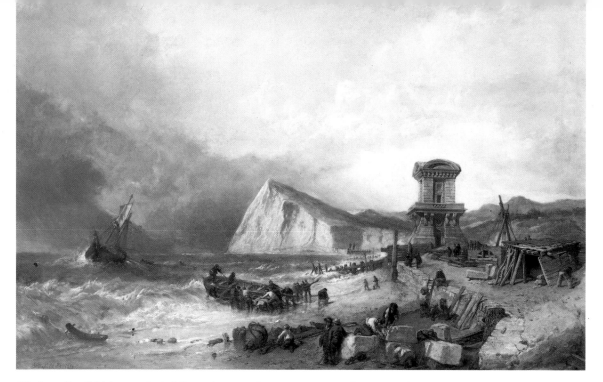

Clarkson Stanfield (1793–1867) *A Brig in Distress off Shakespeare Cliff, Dover* Oil on canvas 23in × 36in (National Maritime Museum, London)

James II, with the harbour and town as a detailed panorama.

CHARLES GORE made a number of delicate watercolours of Dover during the 1760s, their format owing greatly to the van de Veldes except in the execution of the water which was delicate and less formalized. NICHOLAS POCOCK painted some of his earliest watercolours here, a typical piece being *A* *View of Dover and a Ship-of-War Making Sail* (1769); he worked here in the 1790s and the first decade of the nineteenth century. ROBERT CLEVELEY was killed by a fall from the cliffs in 1809. DAVID COX produced a notable Romantic impressionist watercolour of the 300-foot-high, white chalk headland, Shakespeare Cliff, to the W. of the town, which Edgar described to his blind father, Gloucester, in *King Lear*:

Charles Gore (1729–1807) *A View of Dover from the Pier, 1767* Pen and ink with watercolour 7⅞in × 28¼in (National Maritime Museum, London)

... and dizzy 'tis to cast one's eyes so low!
The crows and choughs that wing the midway air
Show scarce so gross as beetles ...

The ship portraitists and marine painters F. SAR-TORIUS and C. J. SARTORIUS visited the area frequently between 1800 and 1820. J. M. W. TURNER depicted Dover from offshore during the 1820s, showing the South Foreland Lighthouse to the right and Dover Castle in a cliff cleft to the left of the composition. The Edwardian art historian Rawlinson praised Miller's engraving of the picture as 'one of the finest seas in the *England and Wales* [series] ... the whole scene is so *English*, so exactly what one sees when landing at Dover on a sunny, windy day'. WILLIAM HENRY PRIOR and SIR AUGUSTUS WALL CALLCOTT pictured the town and harbour during the 1830s, one critic having exhorted Turner to emulate Callcott if he wished to gain experience and standing. (In spite of this, Callcott's reputation has survived.) A Lancastrian artist, J. HENDERSON, painted here in 1814. HENRY CLAUDE MORNEWICK pictured Shakespeare Cliff from offshore in 1846. JOHN DUJARDIN, from London, worked along the coast and harbour here between 1830 and 1860. JAMES BURTON made numerous visits during the later 1830s. CLARKSON STANFIELD and E. W. COOKE visited Dover throughout their careers, portraying shipping and craft of all kinds off the coast. WILLIAM HENRY PRIOR was typical of the mid-Victorian second-ranker who could produce a fine panoramic view of the port and cliffs as he did in 1857. GEORGE H. BROWN, who painted cutters in a gale off Dover in 1872, and ALFRED VICKERS, who made delicate panoramas of

the town and sea viewed from the heights above the castle, were both exploiting the most popular points of vision by the last third of the nineteenth century.

PHILIP WILSON STEER, while employed as a war artist during the Great War, produced 6 pictures of Dover (Imperial War Museum) in a much tighter and more representational manner than any of his earlier work. These showed the harbour with the castle on the skyline and submarine nets, dazzle-camouflaged vessels, warships and motor-torpedo-boats. The foreground of these pictures uses the delicacy of a soft-toned photograph for small motor-launches with close-seated figures, while the water and sky are rendered in the manner of Constable's Brighton sketches.

ARTHUR KNIGHTON HAMMOND, chiefly a landscapist, painted some excellent coastal pictures here in oil just after the Second World War, particularly *The Cliffs of Dover* shown at the R.S.M.A. in 1947. JAMES C. MIDDLETON of the Wapping Group made watercolours here in 1949–50, showing the dry dock area servicing ships. NANCY HEARSEY, who had specialized in Thames and other marine subjects, painted the white cliffs at Dover for her last R.S.M.A. exhibit in 1957. TREVOR CHAMBERLAIN of the Wapping Group painted along the coast in the area during the late 1960s and 1970s, attracted by the coastal scenery and variety of craft.

Dungeness
Kent

Three lighthouses mark this headland, 7 miles S. of Dymchurch. They are the remains of Samuel Wyatt's tower of 1792, the tower of 1904, now an observation point, and the present light, dating from 1961 and throwing a beam 17 miles. On the shingle beach a mixture of temporary huts and 'houselets' made from old boats, sheds and railway carriages forms a village. A little hamlet lies behind at the end of the Romney, Hythe and Dymchurch railway. To the E. the great square silhouettes of nuclear power stations Dungeness A and B often resemble brooding mirages over the Romney and Walland Marshes. Beyond them the shingle runs for 5 miles to blend with Broomhill Sands, E. of Rye.

JOHN THOMAS SERRES, working very much after the drawing manner of Charles Brooking, pictured frigates and larger men-of-war here during the closing years of the eighteenth century. ROBERT CLEVE-LEY also pictured shipping here in similar vein, again with small fishing craft, ketches and luggers in the fore- and background. The intermingling of large warships and merchantmen with fishing vessels on this part of the coast within the easy axis of artists centred in London or the Medway nurtured the

nineteenth century coastal format which was to develop fully in the 1830s. GEORGE WEBSTER pictured shipping in this manner here. During the 1840s E. W. COOKE worked in the area, a vigorous subject offered by the cross-tides and the numerous fishing vessels from the Rye area both exposed to the strong winds. The notorious sea mists here attracted the disaster interests of RICHARD BRYDGES BEECHEY who was rewarded by various trawler wrecks during the course of his long career. CLARKSON STANFIELD and F. W. OVENDON were attracted by the rough, fast waters here during the 1840s and their effect on the trawl nets of fishing fleets during hauling-in.

JOHN LYNN, a fine but little recorded artist, produced some superb pictures of the fast, squally waters off this headland, with trawl boats in the shoals offshore. WILLIAM C. SMITH, painted the Hastings fleet here in the 1860s.

THOMAS BUSH HARDY produced some of his better pictures here during the 1880s and 1890s. SIR FRANK BRANGWYN, working among coasting craft, made some of his earliest marine pictures here, painting with home-made colours and self-ground pigments. SIR FRANK SHORT made many drawings in the area in the early 1890s, although with etchings he made no preparatory work, etching straight on to the plate from life.

JOHN OWEN painted the people of the fishing community at Dungeness during the mid-1960s, a relatively rare subject in coastal and marine painting in the late twentieth century as it was in the eighteenth. CHARLES N. LONGBOTHOM explored the bleak atmosphere of the coast in winter studies in watercolour in 1967. DENNIS HANCERI, in his favourite medium of watercolour and body colour pictured Thames barges off Dungeness in the mid-1970s, giving a sensation of the misty distances typical of this part of the coast. EILEEN JAMES, a self-taught artist exhibiting with the R.S.M.A. since 1977, painted the fishing vessels and their crews on the foreshore here in the late 1970s.

Charles Pears (1873–1958) *Falmouth Approaches* Oil on canvas 31½in × 50in (Royal Exchange Gallery, London)

Dunstanburgh
Northumberland

The stronghold of John of Gaunt, who ruled England during the minority of his nephew, Richard II, Dunstanburgh Castle was built by Thomas, Earl of Lancaster in 1313. It stands 1½ miles E.S.E. of Embleton which is on the B1339. Once accessible from the sea, its harbour is now earthed in under turf fields. Repeatedly besieged during the Wars of the Roses, it is unapproachable except on foot for the last mile. Its dramatic, romantic ruins, described on Boswell's *Antiquities*, were painted five times by J. M. W. TURNER, who made three oil paintings,

Francis Place (1647–1728) *Coquet Island* Brown wash with pen and ink over pencil on wove paper 3¼in × 16¾in (Yale Center for British Art, Paul Mellon Collection)

two watercolours and a mezzotint plate of the fortress on a tapering ledged headland jutting out to sea. In the watercolours viewed from the sea in the mid-1820s he used it as an image of ruin set in storm and repeated tragedy. EDWARD WEBB painted here during the 1850s, the coastal castle being one of his prime interests. VILHELM MELBYE, who had also portrayed wrecks at Bamburgh, painted Dunstanburgh under storm in the 1860s.

Dunster and Blue Anchor
Somerset

A village of thirteenth and fourteenth century buildings on the A396, off the A39, Dunster is a beauty spot under wooded hills. Dunster Beach, 4 miles long and ½-mile broad, stretches W. to Minehead over the remains of a petrified forest, and E. to Blue Anchor, now a caravan park. NICHOLAS POCOCK painted here during 1800, along the foreshore and looking inland toward Dunster from Blue Anchor. These pictures are among the finest of Pocock's West Country coastal watercolours.

In the early 1850s, EDWARD PRITCHARD painted here before moving S. to Weymouth in 1858.

CHARLES KNIGHT, working along the Bristol Channel coast, made a number of visits here during his career, the land and seascape offering the kind of composition which particularly pleased him. His facility for landscape composition has obscured the quality of the coastal pictures Knight made, frequently views from land out to sea rather than scenes on or looking along the seashore. During the 1880s ARTHUR PARSONS visited the area, and PETER LINDNER at the turn of the century. ARTHUR WHITE worked here before the Great War. RODNEY BURN painted here before and after the Second World War, during the later 1950s.

Dunwich
Suffolk

Norman Dunwich was a prosperous town with about 5,000 inhabitants; in January 1326, a violent storm blocked its harbour mouth with a million tons of sand and shingle and killed its trade. By 1677 erosion had flooded the market place. It is now a small village.

PHILIP WILSON STEER visited the area while with the Walberswick community during the 1880s and later when he was at Aldeburgh.

WILFRED MORDEN painted in the area during the

mid-1950s, and EDWARD SEAGO pictured vessels and coastscape here during the same decade. A third of Seago's work was destroyed at his instruction on his death, and may have included work done here. MICHAEL DESROCHERS painted here during the early 1970s, and is represented at the National Maritime Museum by the painting, *Midday at Dunwich*. DONALD BUTLIN, painting coastal scenes focused on the east coast, began his exhibits at the R.S.M.A. in 1977 with *Dunwich Beach* and 1978 with *Men of Dunwich*.

Dymchurch
Kent

A township of the Romney Marshes on the A259, behind a massive sea wall known as Dymchurch Wall, which may date back to the Roman period, and extends approx. 2½ miles. The stretch has three Martello towers; one of these small round forts is fully restored with its swivelling smooth-bore gun and displays of the coastal defences of the Napoleonic period.

PAUL NASH stayed at Dymchurch during the early 1920s, producing watercolours of the coast and sea, particularly *Dymchurch Wall* (1923) and the more abstracted *Coast Scene* (1921). *Dymchurch Strand* (1922) shows a huge area of land and coastscape, and these watercolours and oils show a connection with oils such as *Totes Meer*, made 15 years later, in their atmosphere and structure of design.

Eastbourne
East Sussex

This rather sedate resort on the A259 and A22 expanded during the 1850s, and its 3-mile-long seafront has much fine Victorian architecture; its sky-blue roof-tiled bandstand and long pier are archetypal of their time. Preceding them in the centre of the front is the Wish Tower (a nickname deriving from the Saxon *wisc*, 'marshy place'), or Martello Tower 73, the most westerly but one of the small-fort string built to defend the S.E. coast during the Napoleonic wars, and it houses a museum describing the invasion scares and the coastal defences. The Towner Art Gallery has an extensive collection of marine pictures.

NICHOLAS POCOCK painted the small town and its foreshore with its passing coastal craft in 1800, long before it expanded. His style and subject treatment resemble that of Michael Angelo Rooker at that time. JOHN BRETT painted 'pure sea' studies here during the 1870s and 1880s, the long coast in the area and good vantage points favouring this activity. DAVID JAMES, also producing pure sea subjects, worked in the area during the 1880s, his silver-grey skies and blue-grey seas typical of the area but untypical of public (or artistic) taste at the time. JOHN FRASER also pictured open sea here in the late 1880s, using a lower vantage point than James; he worked at Folkestone in similar vein.

The nature of the resort attracted landscape and figure painters such as R. H. DYKE, a London artist, who arrived by rail to produce such pictures as *Sea Coast at Eastbourne, Sunrise* (1867), at the low-middle price range of £6.

WILLIAM H. BOND painted here energetically but more conventionally during the 1890s, his 'fresh breeze' subjects being attractive and saleable. LESLIE BADHAM worked here at intervals during the 1920s and 1930s, and G. H. DAVIS from 1947–1959.

NINA WINDER REID, a marine artist who was a particular exponent of pure sea pictures, lived in Eastbourne throughout her career from 1911 until her death, c.1969. WILLIAM HENRY INNES, from 1978–79 a member of the Selection and Hanging Committee of the United Artists Society, and a self-taught artist, produced oils and pastels of the pure seascape here during the late 1970s.

Eddystone Rocks

Fourteen miles off Plymouth harbour, the Eddystone Rocks have received 5 lighthouses since 1698. The first two were flimsy structures more suitable as village clock towers, erected by Henry Winstanley who perished in the second during the Great Storm of 1703. The third, a wooden tower of 1709, designed by John Rudyard, was burnt down in 1755. Its successor, John Smeaton's granite tower with 20 candles in optical reflectors was a fine structure only replaced when faults appeared in the rock beneath it in 1879. (It is now Smeaton's memorial on Plymouth Hoe). The present light, completed in 1882, twice the height of its predecessors, is visible for 20 miles and now mounts a helipad.

GEORGE WEBSTER pictured packets off Eddystone in the 1820s. A Scots marine painter, JOHN 'JOCK' WILSON, made at least 5 paintings of Smeaton's light, with vessels passing securely but close off the rocks and the composition balanced by the tower about a third of the way across the canvas and the height of the foremast of the main vessel. C. H. SEAFORD typically chose Queen Victoria's visit of 1837 to the light on the frigate *Forte* for a Royal Academy exhibit of 1838. C. H. MARTIN, with his penchant for lighthouses, painted Smeaton's light as often as Wilson, between 1838 and 1858.

SIR OSWALD WALTER BRIERLY, who portrayed shipping of all kinds and especially warships and sporting vessels, set his subjects off Eddystone on a number of occasions, such as Queen Victoria's visit to the new light in 1837, and the passage of state visitors past the light (not the rocks) during the 1850s and 1860s, on their way up the English Channel. By contrast, CAPT. RICHARD BRYDGES BEECHEY com-

posed possibly 20 compositions during his career concerning various wrecks on the Eddystone Rocks. Beechey's pictures are superbly painted and are not necessarily specific, being dramatic episodes in their own right, variations on a real event. CLARKSON STANFIELD set shipping off the Eddystone, as did MONTAGUE DAWSON, EDWIN HAYES, JULIUS OLSSON and HENRY MOORE, the light being generally no more than a pointer above the waves. During the Great War EDWARD ALLFREE portrayed naval vessels off Eddystone. CHARLES PEARS pictured convoys off the light, as did CHARLES TURNER during the Second World War.

LT COMDR J. S. DALISON, 2 of whose pictures appear in the Imperial War Museum and who exhibited with the R.S.M.A. from 1946 to 48, painted warships off the Eddystone at the close of the Second World War, including *U.S.S. 'Augusta' bearing President Truman past Eddystone and H.M.S 'Renown'*, shown at the R.S.M.A.'s inaugural exhibition, a picture much in the tradition of Dominic Serres.

DAVID COBB set a number of his historical reconstructions off Eddystone, such as the 1,000-guinea wager race in 1834 between the schooner *Galatea* and the brig *Waterwitch*, from the Nab lightship, off the Isle of Wight, around Eddystone and back, won by the *Waterwitch*.

Edinburgh

Lothian

Leith was the prime port of Edinburgh on the Firth of Forth until it was absorbed into the city in 1920. Trading with the Low Countries, its mixture of eighteenth- and early nineteenth-century buildings with high cranes resembles Antwerp. Newhaven was a fishing harbour founded by James IV; predictably Britain's George IV was more interested in its women than its fishery, and pronounced them the most attractive fishwives he had ever seen. Yachts have now replaced the fishing industry.

J. WILSON EWBANK painted at Newhaven during the earlier part of his career. He studied under Alexander Nasmyth in Edinburgh and was elected a Royal Scottish Academician in 1823. Graves' *Dictionary* lists him as being the same as J. Ewbank living in Westminster, London, in 1832, but this may well be an error. Edinburgh and Sunderland Museums have pictures of Ewbank's, but his work is now very rare. He painted along the Firth of Forth and the English N.E. coast. WILLIAM WILSON JR, a son of the famous 'Jock' Wilson, painted at Newhaven and Leith during the late 1820s and early 1830s; work by him at the Suffolk Street Galleries included pictures made along the Firth, and he continued to paint the area until the early 1850s. WILLIAM FLEMING VALLENCE, marine painter, lived in Edinburgh throughout his career (c. 1840–1873), exhibiting at the Royal Scottish Academy from 1849. He painted numerous pictures along the Firth. COLIN HUNTER, a marine and landscape painter, lived almost all his working career in Edinburgh from c. 1860. He portrayed many harbour scenes involving trawlers and lobster boats, and between 1868 and 1903 displayed 97 pictures at the Royal Academy. JOHN NESBITT lived in Edinburgh during his career, between 1870 and 1888 painting widely along the Scottish coast. In the late 1860s he painted Leith and Newhaven scenes, then crowded with the fishery and continental trade. CHARLES A. LODDER, resident of George St, Edinburgh between 1874 and 1882, exhibited 8 pictures at the Suffolk Street Galleries in London, and worked in Scotland and England (Portsmouth); he painted the Edinburgh waterfront, and moonlit pictures in the Firth. W. WILSON, a Dundee painter, visited Edinburgh in the later 1880s while making pictures in the Firth. MASON HUNTER, an Edinburgh painter better known as a landscapist, also made harbour and coastal pictures in the area in the late 1880s, his 7 entries to the Royal Academy including one of *Newhaven Harbour* in 1891.

From the 1890s, the etcher and watercolourist, JAMES KAY, visited the area and exhibited at the R.S.A. JOHN CAMPBELL MITCHELL produced pictures in the Firth area during the first decade of the twentieth century and exhibited in Edinburgh, as did DUNCAN WHYTE. ROBERT PURVES FLINT, brother of Sir William Russell Flint, lived in Edinburgh from 1883 until the mid-1930s, painting in the region and on the English coast. WILLIAM MERVYN GLASS, later President of the Scottish Society of Artists, exhibited work in Edinburgh after the Great War and painted in the area at intervals until the 1950s. DAVID WEST painted in the port area during the 1920s. CECIL KING, Founder Member of the R.S.M.A. and honorary painter to the Royal Thames Yacht Club, was made an official naval artist in 1918 and painted a number of watercolour pictures of dazzle-camouflaged ships being unloaded and repaired at Leith. SIR JOHN LAVERY, a war artist, also painted warships at Leith, in a delicate, sensitive Impressionism which belied their weight and that of the industrial port. AGNES TROTTER FALCONER, painter and lithographer, lived in Edinburgh during her career (1916–1940), making a number of marine and harbour pictures. ARTHUR COULING, a Scottish artist born in China, studied in Edinburgh, and produced some of his

earliest marine work there, c. 1920. ALAN GOURLEY, President of the Royal Institute of Oil Painters, studied in Edinburgh during the 1930s and produced early marine and coastal subjects there. ROB TRENAMON BACH studied and painted there. CECIL PETER KNOX, specializing in working ships, sailing vessels, fishing vessels and small harbours, and art-tutor to the College of the Sea 1968–1971, travelled on and pictured merchant shipping of all types and produced and exhibited work extensively in Edinburgh during the 1970s.

Erith – see under THAMES ESTUARY

Exeter

Devon

A port, university and cathedral city and county town of Devon on the M5 and A38. The Maritime Museum near the seventeenth-century Custom House on the Quay contains the world's largest collection of boats, including the oldest working steamship in the world. The canal is the oldest pound-lock waterway in Britain, built in 1566 when the Countess of Devon blocked river access to the city by building a weir.

In J. M. W. TURNER's picture of 1829 the cathedral is partially obscured by the roofs of Colleton Crescent, symbolizing decline in status of the church and its architecture in the growing nineteenth-century industrial town, and he used the dense river traffic at sunset to accentuate this. GEORGE WHITAKER, a coastal painter, was born in the town and lived there throughout his career, working along the Cornish and Devon coast between 1859 and 1873. His figure painting was accomplished and he used it to produce harbour scenes of considerable charm, as well as storm scenes such as *The Wreck of the Barque 'Padre'* (1862). FREDERICK JOHN WIDGERY studied in Exeter from 1878, and returned throughout his career, which lasted into the 1940s. Of great clarity and accuracy, his pictures still remain typical of the estuaries of Devon today. A prolific marine artist, FRITZ ALTHAUS, left London for Exeter in 1893 and lived there until his death, painting until about 1900. MARY WILLIAMS, watercolourist, studied at Exeter and privately under Claude Muncaster (c. 1928). She painted in the region during the 1950s, and her work appears in a permanent collection at Exeter. A marine painter, BARRY MASON, whose highly-coloured historical subjects are so popular in the United States, studied at Exeter during the mid-1960s.

Exmouth

Devon

In 1566 the countess of Devon blocked the River Exe to cut off the harbour of Exeter and bring trade to her port at Topsham, 4 miles upriver from Exmouth, by building a weir. Exmouth was then one of England's major ports and in the second half of the eighteenth century rose to become an elegant resort. Long lines of beach huts and Georgian terraces remain.

No early paintings of Exmouth as a thriving port are extant. But between the 1840s and early 1870s a Cornish artist, WILLIAM WILLIAMS, painted extensively along the Exe. He was a fine figure and marine artist, and his picture of the river estuary below the Countess Weir painted there in 1853 is particularly lovely. JOHN MOGFORD, a watercolourist, worked here in 1853 on the foreshore An Exeter painter, GEORGE WHITAKER, painted on the estuary and shore during the 1860s. ALFRED CLINT, whose delight in sunset and sunrise subjects, especially those reflected in the broad, still, shallow waters of estuary regions, painted here during the late 1860s and at intervals until the middle 1880s, the period when a London artist, WILLIAM INGRAM, visited the harbour before moving to Cornwall. WALTER SHAW, resident in Salcombe after 1878, painted on the estuary until the turn of the century. FRITZ ALTHAUS, living in Exeter after 1893, made numerous paintings here until he ceased exhibiting in London in 1900. TERRICK WILLIAMS, working in the S.W., painted here before the Great War, as did FREDERICK JOHN WIDGERY, resident in Exeter almost all his life, from 1861–1942. Widgery painted extensively all along the estuary, in a clear, limpid format which appears excessively colourful to eyes unacquainted with the clarity of the light in the region.

A watercolourist, JOHN HANSON MELLOR, worked in the Exmouth area during the 1970s, producing high-contrast calms with stark silhouettes, giving an almost tropical appearance to the river estuary and the nearby harbour of Lympstone.

Eyemouth

Borders

An old fishing port 6 miles N. of Berwick-on-Tweed via the A1 and A1107, with a busy harbour and market. In the previous century its fishwives travelled the coast from May to November, following the fishing fleet down to Yarmouth or up to Shetland, cleaning and barrelling the catch. In October 1881 the Eyemouth fleet lost 129 fishermen in an hour when a violent gale struck and sank 23 vessels without warning. The museum displays the history of N.E. coast fishing.

A Glasgow artist, JAMES WHITELAW HAMILTON, who painted and made his reputation on the continent, visited Eyemouth in the 1880s, making a peaceful, colourful Impressionist idyll of *plein air* painting which gave little hint of the bleak hardship of the industry or the region. COLIN HUNTER visited the area that same decade, producing work which did reflect the bleakness of the North Sea fishery. HAMILTON MCCULLUM worked here at the end of the 1880s, and MASON HUNTER during the last decade of the nineteenth century. JOHN LAVERY visited the port in 1883, and JAMES GUTHRIE, both having a certain interest in the fishing community. Guthrie painted some of the locals, with a form of 'realism' based on the somewhat calculated model of Jules Bastien-Lepage.

Falmouth and St Mawes

Cornwall

A port and holiday resort on the A39, with a harbour off Carrick Roads. Fast European and American packets sailed from the port from 1688 until 1852, 40 operating by 1810. They ceased when the Post Office began sailing steam vessels from Southampton. Much of the old town of Falmouth remains, including the Regency Customs House, and the Queen's Pipe, an incinerator for burning contraband cargo; Pendennis Point is capped by Henry VIII's castle of 1530.

St Mawes, a charming village of colour-washed houses and cottages on the Percuil estuary and Carrick Roads, on the A3078. Dubbed part of the 'Cornish Riviera' for its mild climate, its small harbour is crowded with dinghies near small sandy beaches. St Mawes Castle with its clover-leaf plan was built between 1530 and 1540 to protect Carrick Roads with its artillery.

J. M. W. TURNER painted St Mawes three times: in oil in 1812, and in watercolour for engraving in 1824 and 1829. All showed pilchard-sorting among men and women on the foreshore, with St Mawes Castle above and Pendennis Castle across Falmouth Bay. He also paid a number of visits to Falmouth, whose estuary he portrayed in the 1830s with a Mediterranean air.

Ship portraitist and marine artist GEORGE WEBSTER painted warships and packets at the mouth of the estuary, typified by *An 80-gun Man-of-War off Falmouth* (1801). SIR AUGUSTUS WALL CALLCOTT painted here in the early 1800s, watercolour work with brigs and coastal craft pulled ashore and in harbour. EDWARD DUNCAN painted delicate, Turneresque scenery here during the late 1830s and early 1840s. EDWARD PRITCHARD visited the area early in the following decade. W. L. ASHE and WILLIAM H. BORROW visited Falmouth and St Mawes in the mid-1860s, as did JOHN BRETT. CHARLES MOTTRAM and HENRY SANDERCOCK worked in the area during the 1870s.

CHARLES NAPIER HEMY settled at Falmouth in 1883 and converted a broad-beamed 40-foot fishing-boat into a floating studio called the *Van de Velde*. He painted most of his major pictures in this and its successor, the *Van de Meer*. He died here in 1917. A painter of the Newlyn School, HENRY SCOTT TUKE, was resident at Falmouth from 1879 and throughout his later career, c.1890–1929.

EDWARD GOULDSMITH and CHARLES KNIGHT painted Falmouth and St Mawes in the 1890s, as did STANHOPE FORBES and NORMAN GARSTIN. Salcombe-based WALTER SHAW painted in the area at the turn of the century. FRANK BRANGWYN visited both places before and after the Great War, as did JOHN EVERETT.

JOHN EDGAR PLATT, who produced a number of pictures of convoys off the S.W. peninsula while a war artist (1941–1945), made oil and watercolours in the Falmouth area, displaying a watercolour of St Anthony's Lighthouse with a convoy approaching Falmouth in the R.S.M.A. exhibition of 1948. ALAN MIDDLETON painted the boatyards at Falmouth during the early 1950s. W. ATHERTON CATHCART visited the town during 1963, picturing its older areas such as Customs Quay and the inner harbour. RICHARD PLINCKE, whose conviction that marine painting was too concerned with detail and technique led him to produce many experimental pictures and abstract art during the 1960s, painted along the Fal estuary in 1975. By contrast, JOHN ALFORD painted many highly detailed, vigorous offshore pictures here during the same period, showing many of the local type of sailing craft, from visiting steamships to the regional Quay Punts. SONIA ROBINSON, whose paintings concentrate on the jumbled closeness of harbour buidings, wharves and quaysides, painted numerous pictures enjoying the geometric patterns formed by the moored boats here in the later 1970s.

Filey
Yorkshire

Filey Brigg, a rocky headland, juts out sheltering a wide sweep of sand curving 6 miles to the S. Behind, above red clay cliffs, Filey is a small resort sporting an elegant run of Victorian terraces on the A1039.

ROBERT ERNEST ROE, a proto-Impressionist from Cambridge, painted here in the early 1870s, his unfussy style picturing colliers and fishing cobles on the long, reflecting sands.

Fishguard or Abergwaun
Dyfed

The main western ferry port to Southern Ireland, divided into distinct halves. The Welsh name means 'Estuary of the River Gwaun' and Lower Fishguard is a fishing village at the river mouth. Upper Fishguard occupies the high hill above, its square focused on the Royal Oak Inn, where in 1797 the superannuated Irish-American Colonel Tate surrendered his motley force of soldiers and convicts who constituted the last invasion force to land in mainland Britain.

ALFRED PURCHASE, a local painter who described himself as a specialist in 'rock pictures', lived here. His chief working dates, 1874–1889, ended when he finally succeeded in getting his *Serpentine Rocks* exhibited at the Royal Academy.

During the 1930s GRAHAM SUTHERLAND painted in the south Pembrokeshire area, especially in the region of St Brides Bay and its hinterland, where he found the forms of the sea-shore and its high cliffs mirrored the shapes of the inland hills. MICHAEL AYRTON, acquainted with Sutherland, visited the area during the later 1940s and 1950s, as did Sutherland, Ayrton's pictures being made chiefly along the southern Pembrokeshire coast and inland. JOHN ELWYN, a Carmarthen-born painter, has worked extensively along the Cardigan (now Dyfed) coasts and southward as far as St Brides Bay since the Second World War. NAP FISHER, painting widely along the Pembrokeshire coast, has made and exhibited large numbers of pictures here.

WINIFRED DOBNEY, oil and watercolourist, painting along the Pembrokeshire coast on 1956, made watercolours here.

JANE CORSELLIS, in similar vein, stressing the silvery grey light of the winter coast of west Wales, has produced many studies in watercolour of the area since the 1970s.

Flamborough Head
Humberside

A chalk peninsula 4 miles N.E. of Bridlington on the A165, with cliffs averaging up to 150 feet in height, and rising to 400 feet at Bempton Cliffs on the N. side. Now an R.S.P.B. reserve, these cliff terraces support 33 species of sea-birds. North Landing cove, with steeply sloping shingle, has a lifeboat station below massive chalk pillars. The headland is capped by the 85-foot lighthouse of 1806.

A London artist, ANDREW DURNFORD, painted here in 1839; observing the aftermath of a shipwreck, he produced *On the Yorkshire Coast near Flamborough – Clearing a Wreck in the Distance* (1840). ROBERT WATSON's visit of 1846 produced *A Distant View of Flamborough Head, with Vessels Standing On and Off* (1847), a typical blend of action, vessels and view which peaked at mid-century. EDWIN ELLIS, a pupil of Henry Dawson, produced strong-coloured, proto-Impressionist foreshore scenes of the headland during the late 1870s and early 1880s.

S. B. ROBERTSON RODGER painted at Bridlington, on the S. side of Flamborough Head, during 1953–4. JOHN COOPER, living at Bridlington, and specializing in marine subjects, particularly trawlers, has made a large number of paintings set off Flamborough, particularly of lifeboat launches, stormscapes and scenes of the fishing industry in the North Sea from the mid-1960s onwards. PETER RICHARD COOK, a watercolourist specializing in harbour scenes, seascape and aviation, lives at Bridlington and has exhibited with the R.S.M.A. from 1977 and at Hull, at the Ferens Art Gallery, from 1978. His work is partly influenced by that of John Ward of Hull.

Flint
Clwyd

No longer a port, with its harbour silted, Flint, on the A548 overlooking the Dee estuary, is still dominated by its ruined castle, the first of Edward I's great chain; the one in which Shakespeare portrayed Richard II trapped by usurper Bolingbroke – although the true site was probably Conwy.

J. M. W. TURNER portrayed Flint twice. His first picture of the 1820s was in a more traditional, realist style with a dramatic sunset, stark castle, and shapely, well-defined beach figures. In 1834 he made

a second, more sophisticated Impressionist image, which Ruskin described as 'the loveliest piece of pure watercolour painting in my whole collection; nor do I know anything anywhere that can compare, and little that can rival, the play of light on the sea surface and the infinite purity of colour of the ripples as they near the sand'. This picture portrayed the castle 'floating' on the misty air with shrimp boats and fisherfolk in the shallows who appear as colour points in an iridescent infinity.

CHARLES DEACON, watercolourist, working frequently along the Dee estuary, painted here in 1946–7, looking across the wide sand-flats to the Wirral shore, and westward to the Point of Air.

Folkestone
Kent

A large south-coast resort and port on the M20 and A20. A fishing village until the railways caused its expansion during the 1840s, it is unusual in that the railway runs along the harbour wall, and it has no proper 'sea-front'. Although it is the busiest cross-Channel port after Dover, its main street is still lined with sixteenth-, seventeenth- and eighteenth-century houses. East of the town three Martello towers dominate grasslands above the white chalk cliffs.

PHILIPPE JACQUES DE LOUTHERBOURG included the area in his sketching tour of 1794–95.

J. M. W. TURNER made watercolours of the white cliffs in 1830, often showing smuggling and the system of 'sinking and creeping', or throwing weighted tubs from a boat at a pre-arranged spot into the sea and having 'fishermen' recover them later. *The Coast from Folkestone Harbour to Dover* (c. 1830) shows an excise officer with a map having them dug up.

JOHN CHRISTIAN ZEITTER painted here as the resort was becoming established in 1840. J. W. YARNOLD and W. H. WILLIAMSON, with his idiosyncrasy of depicting fishing vessels as though they were always sinking by the stern, painted regularly here throughout the 1840s, and JOHN DUJARDIN during the 1850s. CLARKSON STANFIELD included the resort and port in his collection of coastal subjects in the later 1840s. CHARLES AUGUSTUS MORNEWICK SR pursued his taste for squalls and their aftermath with *After A Storm, Folkestone* (1871). JAMES HENRY SAMPSON made many figurative and 'local colour' pictures during the 1870s, with titles such as *Old Bob's Boat, Folkestone* (1872). JOHN FRASER painted 'pure sea' pictures here in 1887.

CHARLES MURRAY PADDAY lived at Folkestone from 1928 until the end of his painting career in 1940. The greater part of his work was produced along the south coast, as far west as Portsmouth, much of it concerning the yachting fraternity, but with far greater compositional vigour and imagination than is usual in paintings of leisure sailing. LESLIE J. WATSON painted around the Folkestone area during the mid-1930s, while sailing out of Ramsgate in a Bermudian sloop. A large group of pictures he made there formed an exhibition he held at Portsmouth in 1938, which led to his becoming a founder member of the R.S.M.A.

FRANCIS LAKE, exhibiting with the R.S.M.A. from 1961 until 1976, made vessels off Folkestone his last entry.

Fowey
Cornwall

A small, busy china-clay port on the A3082, 4 miles E. of St Austell. Ocean-going cargo ships up to 15,000 tons share the harbour with hundreds of yachts. The port was famous both for smuggling, piracy and its privateers who haunted the entrance to the English Channel.

St Catherine's Fort, built by Henry VIII overlooking Ready Money Cove just W. of the harbour mouth, is the linchpin in the violent stormscape J. M. W. TURNER executed in watercolour in 1825–6, showing survivors of a wreck struggling in small boats all but swamped by a huge sea, while torches flare from the shore. AUGUSTUS WALL CALLCOTT painted in the area during the 1840s, and SAMUEL P. JACKSON during the early 1850s, a watercolourist able to command high prices for his coastal and harbour subjects, executed with the same vigour and scale as oils. JAMES GEORGE PHILP worked here during the following decade, and JOHN BRETT, touring the coast. JAMES FRANCIS DANBY, SAMUEL P. JACKSON and CHARLES MOTTRAM all explored the harbour and the steep rising land to both sides, which they portrayed generally from a ¾-angle from the harbour up and across the mouth of the river Fowey, usually from Ready Money Cove looking N.E. up the sloping wooded creek at Bodinnick, or from Polruan looking west across the harbour to Ready Money Cove and St Catherine's Castle there. CHARLES NAPIER HEMY frequented the harbour in the 1880s. EDWARD GOULDSMITH visited during the 1890s, as did DUFF TOLLEMACHE and OTTO WEBER in the late 1880s. ARTHUR WILDE PARSONS painted here before the Great War, as did NORMAN GARSTIN, STANHOPE FORBES and HENRY SCOTT TUKE. During

the later 1920s JOSEPH SOUTHALL, one of the Society of Painters in Tempera, worked in the area, painting the *The Botanists*, two middle-class women on their hands and knees searching the grass above Ready Money Cove, executed in an antique manner of tempera stretched over silk.

GYRTH RUSSELL, a marine artist and landscapist, painted in the region during the late 1940s, as did ROWLAND FISHER, who produced stormy seascapes

at the R.S.M.A. in 1947.

SARA MACLEAN, coastal and landscape oil-painter, lived at Fowey from 1914 until the end of her painting career (c.1934), her pictures of the region appearing at the R.A., S.W.A. and Royal Cambrian Academy. LISA ANN HAWKEN, a self-taught artist signing herself 'Kimberley' who has specialized in painting sailing vessels held exhibitions of her work in Fowey in 1979 and 1980.

Glasgow – see under CLYDE, FIRTH OF

Goodwin Sands
Kent

Reputed to be the remnant of the landstrip of Lomea owned by the Saxon Earl Godwin, which was submerged by a storm, the Goodwins are a sandbank 12 miles long, 5 miles wide and 80 feet deep, lying on a chalk bed in the English Channel 4 miles off Deal. There is no geological evidence that they were ever land. A narrowing, safe channel between the coast and the Goodwins is known as The Downs, but the sands are gradually shifting westwards and may ultimately join the Kent coast. Marked by 3 Trinity House lightships and 10 warning buoys, they have a morbid reputation reflected in the ghoulish nickname 'The Ship Swallower'. In 1954 the South Goodwin lightship itself capsized and sank into them, with all its crew, and they are covered within the radius of 7 lifeboats, the most intensive concentration for a single area in the world.

W. CRAMBROOK, resident of Deal, recorded wrecks there between 1824 and 1862, such as his British Institute exhibit of 1851, bleakly titled *Shipwreck on the Goodwin Sands*. More 'saleable' wreck themes were implicit in the titles of CHARLES A. MORNEWICK JR's *The Deal Boats 'Earl Grey' and 'Tiger' Going Off to a Ship on the Goodwin Sands* (1852), and CHARLES MORNEWICK SR of Dover, who could charge a hundred guineas in 1858 for his *A Pilot Cutter Rescuing the Surviving Crew of a Vessel Wrecked on the Goodwin Sands*. The Sands' reputation

attracted 'rustic landscape' painters like LIONEL PERCY SMYTHE in pictures like *A Thick Night on the Goodwins* (1869). ROBERT CHARLES RICKETTS made sure of a 'positive' wreck image with a long explanatory title like his R.A. exhibit of 1871: *A Deal Lugger and the 'Sabrina' Lifeboat Rescuing the Crew of the 'Honey Sverne' (Norwegian Barque) Wrecked on the Goodwin Sands, October 11th, 1870.*

RICHARD BRYDGES BEECHEY pictured a number of wrecks on the Goodwins; schooners and merchantmen, many of whose crews appear to have been rescued, although the art of Beechey's best disaster pictures is to give the tension of doubt. E. BROOME pictured the stages of a rescue off the Goodwins (see Ramsgate). THOMAS ROSE MILES pictured lifeboats in the area, whose launchings were numerous. CHARLES NAPIER HEMY pictured fishing vessels in 'demanding' situations in the vicinity, and THOMAS BUSH HARDY, in an occasional foray out of his set formulae of French fishing-boats bobbing in and out of Le Havre, pictured their fleets off the sands. During the Great War FORTUNINO MANTANIA illustrated trawler and submarine actions off the sands, and CHARLES E. TURNER, whose highly detailed and finished pictures of naval vessels later formed the model for the box-lids of the construction kits which filled the bedrooms of small boys throughout the late 1950s, illustrated the sea war in the area. NELSON DAWSON also painted vessels off the sands as did ARTHUR BURGESS.

Gorleston – see under GREAT YARMOUTH

Gravesend – see under THAMES ESTUARY

Great Ormes Head
Gwynedd

The largest of two massive granite headlands lying on either side of Llandudno, Great Orme rises to 679 feet and overshadows Conwy Sands and the Conwy

Estuary immediately to the S.

Two years after his return to Liverpool SAMUEL WALTER painted his impressive picture of the American packet ship, *Ocean Monarch*, which caught fire and foundered off the Great Orme in 1848, a subject

taken up on both sides of the Atlantic. WILLIAM GARTHWAITE, an excellent and rarely recorded artist, pictured the burning of the ship thirty-nine years later in 1888 after a visit to the Great Orme.

Great Yarmouth
Norfolk

A large holiday resort and port on the A47. The town was originally squeezed into 145 lanes on a peninsula caused by the River Yare flowing parallel to the sea for 3 miles. It grew wealthy on the herring industry, its fleets attracting many painters; over 1,000 drifters sailed from the port in 1912. Overfishing led to the vanishment of the fleet by 1963, and the industry was replaced by North Sea oil and gas exploration. The East Anglian Maritime Museum on Marine Parade contains work by the Norfolk School and east coast painters.

NICHOLAS POCOCK made some of his last coastal watercolours here in 1815, picturing a vessel in distress off the harbour. FRANÇOIS LOUIS THOMAS FRANCIA painted a number of squall scenes and made offshore marine sketches along the coast during the first decade of the nineteenth century. J. M. W. TURNER pictured the town in 1828 looking N.E. from Gorleston-on-Sea, now a southern suburb; behind the long South Beach he portrayed the Norfolk Pillar, a 144-foot column topped by Britannia, built in honour of Nelson in 1819, who landed at Great Yarmouth after the battles of the Nile (1798) and Copenhagen (1801), the picture being a symbol of the arising of war like a gale over the sea. RICHARD PARKES BONINGTON and JOHN SELL COTMAN both painted at Gorleston and Great Yarmouth, particularly the southern harbour behind the Norfolk Pillar, Cotman's style varying from relatively high-detailed pictures of galliots and larger ships in the Roads to delicate, impressionistic oils on small panels showing the harbour and foreshore, produced with a 'blocking-in' technique which his contemporaries did not much appreciate. MILES EDMUND COTMAN practised breezy offshore pictures but also many static calms in Gorleston harbour. JOSEPH STANNARD, an excellent figure artist, painted on the beach and jetty during the 1820s, as well as offshore. JOHN BERNAY CROME, 'Moonlight Crome', used this nocturnal approach to show the town and Yarmouth Roads during the 1820s and 1830s.

JOHN CALLOW and GEORGE D. CALLOW, apparently unrelated, painted contrastingly here, in the 1840s and 1850s, John Callow's work showing vigorous wind and wave with a heavier technique, George Callow's usually calms in watercolour. A London artist, ROBERT WATSON, chose calm water in Yarmouth Roads for subjects when he stayed in 1845. CHARLES TAYLOR SR worked here from the late 1850s to 1871, picturing the herring fleets and the lifeboat launchings from Gorleston Harbour. His son, CHARLES TAYLOR JR concentrated on the complementary area of the Gorleston Pier, while FRANCIS MOLTINO used the long pier as an observation point and compositional device to paint squally seascape, apparently from a boat. For estuary scenes he followed the hay barges on the Yare during the early 1860s. A Londoner, J. F. BRANEGAN worked from the jetty for his R.A. exhibits of 1871. JAMES W. CALLOW, possibly a brother of George Callow, although described by Graves as a landscapist, painted offshore scenes here during the 1880s.

In 1912 SIR MUIRHEAD BONE worked in Great Yarmouth, producing a large number of drawings and etchings, making prints of the town. CAMPBELL P. MELLON, having studied under Sir Arnesby Brown, retired to Gorleston-on-Sea in 1924, and devoted the rest of his life to painting. Until his death in 1955, he pictured the holiday crowds in the town and on the beaches at Great Yarmouth, a relatively rare image of the port.

The oil and watercolourist ROWLAND FISHER, member of the R.S.M.A., who painted sea- and landscape, lived at Gorleston throughout his career until his death in 1969. JOSIAH JOHN STURGEON, member of the Wapping Group and practising architect, painted the Scandinavian ships trading with Yarmouth and their arrival with shifted cargoes on rough seas, and their difficult passage across the

John Crome (1768–1821) *Moonrise at the Mouth of the Yare* Oil on canvas 28in × 43¾in (Tate Gallery, London)

Campbell A. Mellon (1876–1955) *August Bank Holiday, Yarmouth* Oil on canvas 20in × 24in (City of Bristol Museum and Art Gallery)

dangerous bar at Gorleston harbour during the later 1960s and 1970s. DENNIS ROY HODDS, a Member of the Great Yarmouth Guild of Arts and Crafts, and resident at Southtown, Great Yarmouth, has worked in the region of the coast since the 1950s, producing strong semi-Impressionist oils and watercolours of the harbour, shorelands and shipping of the East

Anglian ports. ALBERT JOHN HENRY CLIFFORD, painter in oil, watercolour and acrylics of boatyards, harbours and seascape, resident of Gorleston, painted the area throughout the 1970s, picturing the vessels involved in North Sea Oil exploration, the rigs of the oil fields, the lifeboats of Yarmouth and the ill-fated sailing ship *Marques* (1979), which was to founder during the Tall Ships' Race. ALAN J. SIMPSON, illustrator and designer, and member of the R.S.M.A., painting among the East Anglian ports, worked here during the late 1960s and 1970s.

Greenock – see under CLYDE, FIRTH OF

Greenwich – see under THAMES ESTUARY

Grimsby
Humberside

A major fishing port on the Humber for almost a millennium. The Victorian buildings of the docks are dominated by the 309-foot-high Dock Tower, a folly modelled on the medieval tower of the Palazzo

Pubblico in Siena. The long, covered arcade of the fish market surrounds the dock perimeter. The deep-sea fleet having declined, fishing is now generally by small seine-net trawlers in shallower water.

JOHN WARD of Hull pictured Grimsby ships in the later 1830s, many of the vessels working and trading

the sea routes as Hull ships. RALPH STUBBS, from 1800 until 1845, and WILLIAM DANIEL PENNY pictured Grimsby vessels up to the mid-nineteenth century. JOHN WARKUP SWIFT portrayed the Grimsby fishing-boats as did HENRY REDMORE between c.1850 and 1880. His little-talented son, E. K. REDMORE, continued to do so well into the 1930s.

A Leeds artist, JOHN ATKINSON GRIMSHAW, painted many scenes of the Grimsby docks by dusk and twilight between 1870 and 1890, working partly from photographs and sketches, the finished pictures owing much to Turner and Whistler. Contemporary copies of these pictures can still be found.

During his long career, HARRY HUDSON RODMELL, a founder member of the R.S.M.A., pictured Grimsby trawlers and his work appeared in the Ferens Art Gallery and the National Maritime Museum. His pictures were always very precise, and Rodmell believed that working from the plans of ships also increased the artist's knowledge of their painterly qualities. NORMAN WILKINSON frequently portrayed the Grimsby fleets after the Second World War; unlike Rodmell he applied a technique of the greatest simplicity and economy, yet made the types of vessel instantly recognizable. With his deep interest in trawlers, JOHN COOPER has also portrayed the ships of the Grimsby area in all weather conditions.

JAMES CHARLES MIDDLETON, oil and watercolourist, metalworker and engraver, painted here during the 1950s and early 1960s, generally in watercolour. JAMES ALFRED KIRBY served with the R.N.V.R. and then with the Royal Navy (1939–1945), otherwise spending all his working life in the fishing industry. He painted North Sea trawlers here in the late 1960s, particularly the vessels which then fished the Greenland grounds.

Guernsey
Channel Islands

The northernmost of the Channel Islands, notable for its coastal scenery, early spring produce, commercial centre and tourism.

THOMAS PHILLIPS made drawings and engravings of Castle Cornet, Guernsey, in the early 1670s as part of an Admiralty survey of the fortifications of Crown possessions. And as part of the same duties, JOHN THOMAS SERRES depicted the coast, particularly Castle Cornet, during the 1790s, showing vessels and the architectural details of the harbour with great precision. He also portrayed the same area at St Peter

Port for the translation of Bougard's *Little Sea Torch* published in 1801.

A Jersey painter, PHILIP OULESS, working in the Channel Islands all his life from the late 1830s until his death in 1885, portrayed a number of vessels off Guernsey, generally St Peter Port, although the bulk of his pictures depicted them on the Jersey coast. ALFRED HERBERT pictured schooners and yachts off the harbour c.1848, favouring rough or very breezy weather for his compositions. C. B. HUE painted all around the Channel Islands between 1857 and '63, favouring the S.W. coast of Guernsey around Rocquaine Bay, Lihou Island, Perelle Bay and the eastern coast at St Peter Port. FREDERICK SANG visited the port during the early 1890s after painting on Jersey. Between 1880 and 1920 a Jersey miniaturist, SARA LOUISA KILPACK, painted areas of the coast, most of her images no larger than 2in x 2in and vividly

John Thomas Serres (1759–1825) *View of Castle Cornet, Guernsey* Watercolour, pencil, pen and black ink with grey and brown washes 9¾in × 26in (Yale Center for British Art, Paul Mellon Collection)

coloured. FRANCIS WILLIAM LE MAISTRE, a Jersey-born painter, painted the Guernsey coast in oil and watercolour from the 1890s until his death in 1940. A marine oil painter, ROBIN GOODWIN, painted in Guernsey between 1948 and 1952, particularly in the St Peter Port area. Watercolourist CHARLES DEACON painted here during the mid-1950s. During the early 1960s JAMES C. MIDDLETON painted widely on Guernsey, at St Peter Port and St Sampson, and the S.W. cliffs. In the mid-1960s WILLIAM SCUDDER made oil paintings of yachting off St Peter Port, which were exhibited at the R.S.M.A. in 1966.

SHEILA MACLEOD ROBERTSON painted in Guernsey during the 1960s and 1970s, her coastal studies – usually in watercolour – having considerable delicacy as well as strength. PETER RICHARD COOK, a watercolour artist influenced by John Ward of Hull and specializing in harbour scenes, sea and aviation, has painted reconstructions of the steamships which frequented St Peter Port at the turn of the century, with the intention of capturing the atmosphere of a past era, rather than merely picturing the vessels as historical objects.

Harwich
Essex

A major port at the mouth of the Orwell and Stour, on the A604, trading with Holland, Denmark, Sweden and Germany. The assembly place for Edward III's fleet which defeated the French at Sluys, departure point of the *Mayflower* for America in 1620, and parliamentary seat of the diarist Samuel Pepys, Secretary to the Admiralty under Charles II.

WILLEM VAN DE VELDE THE ELDER witnessed the Dutch attack upon Harwich in July 1667, after De Ruyter's assault along the Medway. Contrary winds and shoals impeded the Dutch ships so that their attempt to capture Landguard Fort failed. Van de Velde portrayed the fortress duelling with De Ruyter's ships through a gap in a forest of masts and longboats swarming in the shallows. DOMINIC SERRES painted both oils and watercolours here during the later part of the eighteenth century. One of his earliest watercolours, owing much in style to Paul Sandby, shows the arrival of Princess Charlotte at the port in 1761, at the mouth of the Orwell near Landguard Fort, a foreground group being a rare record of ordinary sailors' costume. The Norwich School painters, MILES EDMUND COTMAN and JOHN SELL COTMAN worked along the two rivers and harbour during the three opening decades of the nineteenth century. During the 1820s JOSEPH STANNARD painted harbour and off shore scenes and JOHN MOORE of Ipswich harbour and fishing, which owed much to John Constable. GEORGE FREDERICK GAUBERT made oils of the harbour during the 1840s. A London painter, W. F. MEYER, produced moonlit pictures such as *Harwich Harbour by Moonlight* (1875). WILLIAM DURANT READY painted his R.A. exhibits of 1865, for example, *Coast Scene Near Harwich*, their £15 price-range reflecting the middle-market and

their popularity at that particular period.

PHILIP CONNARD, an official marine War Artist to the Royal Navy during the Great War (with 80 pictures in the Imperial War Museum), produced a number of works at Harwich portraying ships of the Harwich Force, some of them of great compositional originality, using the ships' structure as he used architecture in landscape: views through their masts, funnels and gun-platforms, rather than conventional broadside views of warships at sea.

EDWARD BRIAN SEAGO, living in Norfolk while in England, and very knowledgeable of the light of East Anglia, produced superb sea and coastal pictures in Harwich and its approaches between 1947 and the late 1960s, often four-fifths of the picture area consisting of sea and sky, and the hazy geometry of sailcraft acting as anchor-points in the expanse. WILLIAM BURTON, prints of whose paintings by Solomon and Whitehead were rated the most popular prints for 1967-68-69, produced highly detailed pictures of coastal craft and the estuaries of the Harwich (and Essex) area, exhibiting in East Bergholt, Suffolk, as well as London, and with the R.S.M.A. from 1976. DON BUTLIN, painting along the east coast of England, has produced various vigorously Realist pictures of the Harwich approaches, often with strong character studies of the people involved with the boats, and barges. He has exhibited with the R.S.M.A. since 1977. ALFRED P. TOMPKIN painted here in 1961, making oils of the old harbour. DAVID INNES SANDEMAN WOOD, grandson of Frank Watson Wood the marine artist, has painted extensively in the Harwich region since the late 1960s, attracted by the dramatic cloud effects and the wide variety of shipping which he often sets behind numerous foreground figures.

Hastings
East Sussex

A resort and fishing port on the A21 and A259. In the middle ages one of the most powerful of the

Cinque Ports, Old Hastings is hemmed in on both sides by steep cliffs, with the massive fortress built by William the Conqueror dominating West Hill. Below, The Stade, the beach of the old town, still has a large fishing fleet often drawn up on the shingle, in front of tall, black-painted, net-drying sheds. Modern Hastings has spread W. of the castle.

THOMAS CAFÉ worked in Hastings at intervals between 1820 and 1840, picturing the harbour and coast when not making portraits or landscapes. A London artist and librarian of the R.A., WILLIAM COLLINS, painted here during the 1830s. JAMES BURTON, best-known as a landscapist, painted in Hastings during that time, and a landscape and coastal painter, JOHN THORPE, lived in St Leonards adjoining Hastings between 1855 and 1863, making marine pictures in the area. JAMES FRANCIS DANBY, who excelled at sunrise and sunset pictures, visited the town and coast frequently between 1846 and 1876. Watercolourists WALTER MAY and JOHN MOGFORD worked here during the 1840s and 1860s respectively. EDWARD CHARLES WILLIAMS painted along the coast in the 1860s, and the variable CHARLES THORNELY in the following decade.

The fishing fleet was a favoured subject of painters during the nineteenth century. GEORGE ALBERT ADAMS, although considered more as a landscape artist, chose Hastings for a number of coast and marine paintings. In 15 exhibits at the British Institution in 20 years 9 were coastal views, such as *On the Coast Near Hastings* (1858) and fishing vessels, *A Hastings Lugger Returned from Fishing* (1865). His coastal watercolours were usually priced higher than his oils. In 1860 he charged 8 guineas for *A Lugger on the Beach, Hastings*, but only 3 guineas for oils of like subject. WILLIAM H. BORROW lived in Hastings after leaving London in 1876 and remained until the end of his career in 1890. The scarcely recorded E. (EDWARD?) GENTLE, whose rather 'jolly' coastal pictures are set in Kent and Sussex, frequently painted Hastings between 1880 and 1900.

SIDNEY CAUSER, marine and landscape watercolourist, painted at Hastings before and after the Second World War, his opening exhibit at the R.S.M.A. in 1948 being *September Afternoon, Hastings*. WILLIAM HODGES, marine watercolourist, produced a number of pictures here during the first three years of the 1950s. MARTIN HUTCHINSON, another watercolour artist, opened his R.S.M.A. exhibits in 1955 with *Hastings Beach*; watercolourist FRANK WILLS visited here in 1958 and 1959, and ALBERT TAYLOR the dry docks in the early 1960s. Oil and watercolourist WILFRED FRYER painted some of his last pictures before his death on the beach here in 1967. A watercolour medium was chosen by EDWARD PALING in the later 1960s for net-mending scenes on the beach. TREVOR CHAMBERLAIN painted here during the 1970s, in a free Impressionist oil technique, which conveyed much information and atmosphere in a few brush-strokes. CLIVE KIDDER made a number of stark, middle-sized acrylics of the beaches during the later 1970s, in an attempt to convey the expanse of the sea and sky and the smallness of people beside the technical ingenuity of their marine inventions – working boats. RICHARD MILLER, marine oil-painter, painted the old town area and waterfront in 1978-9.

Hove – see under BRIGHTON

Iona
Strathclyde

The vivid white sand and lush grass against a blue sea give this 3-mile long island, 1 mile off the Ross of Mull, at the end of the A849, an almost Mediterranean appearance when the sky is bright and clear. St Columba founded a monastery in 563; after his death the community was massacred by Vikings, much of it slaughtered on *Traigh Ban nam Monach*, the 'White sand of the Monks', a N.E. beach painted 1,400 years later by JOHN PEPLOE and FRANCIS CADELL. But the monastery persisted, and over 60 Celtic and Norse kings are buried here from Ireland, Scotland and Norway, including Duncan and his murderer, Macbeth.

In 1920 FRANCIS CADELL, an Edinburgh painter, introduced SAMUEL JOHN PEPLOE to the island. Peploe painted there at regular intervals throughout the 1930s, concentrating with Cadell on the northern shore where the colour of the sand rocks and sea suited the palette he had developed when painting in the South of France. Francis Cadell painted on Iona every summer for 20 years, until the eve of the Second World War. Both artists painted the island in all conditions, and the pictures they produced are among the finest coastscapes painted by the Scottish post-Impressionists.

Ipswich
Suffolk

The county town of Suffolk with extensive docks, Ipswich was the largest port in Anglo-Saxon England. The town seal, dating from 1200, is the first illustration of a ship with a modern rudder in place of the old steering oar. For centuries a centre of shipbuilding, the harbour had silted by 1800, and was recovered after extensive dredging. The massive Orwell Bridge below the docks carries heavy transport to Felixstowe, while the dozen miles of the Orwell estuary are crowded with yachts and barges. Ipswich Museum covers the history of the port itself, while the sixteenth century Christchurch Mansion contains pictures by Gainsborough and Constable.

EDWARD ROBERT SMYTHE of Ipswich worked throughout his life in the area, being born here in 1810. An excellent figure painter, he produced many sporting and rustic pictures, but excelled in the traffic of the Orwell estuary, as did his brother THOMAS SMYTHE, b.1825. From c.1830 his work showed the influence of John Crome, and his marine pictures concentrate upon the shoreline. From c.1845 Thomas Smythe pictured the last of the boat-building yards which had extended along the Orwell as far as Nacton until the industry declined. Thomas continued to work here and at Yarmouth until the turn of the century. WILLIAM JOY and JOHN CANTILOE JOY showed work here during the early part of their careers (c.1833) while working in the Great Yarmouth area. JOHN MOORE of Ipswich, influenced by both Crome and Gainsborough, produced many 'calms' along the Orwell as well as vigorous offshore fishing scenes beyond the estuary. From c.1840 he painted the Thames barges which carried hay, grain and bricks to London, and returned with horse-manure for farmland. He also included barques and fishing-boats as subjects until the early 1900s. Between 1875 and 1901 he exhibited 332 pictures in the annual exhibitions of the Ipswich Art Society.

CHARLES D. TRACY O.B.E., lived in Ipswich during the latter part of his career until his death in 1947. From 1908 he painted in the area, as well as in Sussex and Cornwall, although the greater part of his work was offshore seascape. C. ALLEN MOLD, oil-painter, pastel- and watercolourist, began to exhibit at the R.S.M.A. in 1949 with watercolours of the Pin Mill area of the Orwell estuary, already notable among painters for its barges and houseboats. EDWARD BRIAN SEAGO, a Norwich-born landscapist and initially an equestrianist, painted along the estuary after the Second World War and during the 1950s. RONALD CRAMPTON, marine and landscape watercolourist, visited the estuary during the later 1950s, and watercolourist GERALD EDWIN TUCKER who, after leaving the Slade, made a reputation for himself with coastal scenes and pictures of Thames sailing barges, bought a Thames barge which he turned into an art gallery moored at Pin Mill until the later 1960s. JOHN SNELLING, notable for oils and watercolours of East Anglia, has regularly exhibited at Ipswich. JOSEPHINE (JO) COOPER, Paris Salon Silver Medallist 1974, Rowland Prize Winner 1977 and Diplôme d'Honneur, Caen 1979, painted extensively in the region, especially around the Pin Mill harbour area.

MICHAEL NORMAN, the coastal, architectural and landscape watercolourist, was born in Ipswich in 1933. An experienced racing dinghy sailor he has lived and painted in the area throughout his career. JOHN SUTTON, with a wide range of marine and coastal subjects set in various historical and present periods, and a firm believer in the traditional methods and subjects of marine art, has produced many paintings of the past vessels of the coastal waters of Essex and East Anglia, including the Ipswich waterways. ALAN JOHN SIMPSON, who has painted in oil, watercolour and gouache along the south, west and East Anglian coasts, in a style somewhat reminiscent of Edward Pritchard the Bristol painter, has made tranquil but crisply textured pictures of the Ipswich estuaries which usually invite a softer, smoother treatment.

Jersey
Channel Islands

The southernmost of the Channel Isles, with the air of a French province, notable for its rocky coast, mild climate and properties as a tax haven.

A ship-painter, PHILIP OULESS, lived at St Aubin, originally Jersey's main port, and later St Helier, from 1817 until 1885. His lasting reputation owes much to the finesse of his paintings which usually show vessels off individual areas of Jersey. The little-known EBENEZER COLLS pictured St Helier and the coastscape between 1852 and 1854 in a style reminiscent of Richard Henry Nibbs of Brighton. ALFRED HERBERT, a Thames artist whose painting had much in common with John Callow's, painted offshore scenes here in the later 1840s, particularly off St Helier and St Brelade's Bay, off St Aubin, showing schooners, yachts and barges in rough, windy seas. GEORGE H. BROWN, a London landscape and marine painter, visited the island during the 1850s, painting the sweep of St Catherine's Bay, on the E. Jersey coast, the small town of Gorey and the impressive

Mont Orgueil Castle with its thirteenth-century keep, Elizabethan tower and extensive outworks on the rocky outcrop above the bay. EDWARD PRITCHARD pictured this fortress from the sea in 1865, as did JAMES WEBB in the mid-1870s.

The rocky coast attracted C. B. HUE, especially to the area of Plémont Point in the N.W., where a holiday camp now sprawls. Hue painted extensively around all the Channel Islands from the later 1850s until c.1863. FREDERICK SANG painted at St Helier during the early 1890s. SARA LOUISA KILPACK lived and worked in Jersey for 40 years, from 1880 until the German occupation in 1940. Painting all around the coast her pictures were usually tiny, generally in the realm of 2 ins x 4 ins, with a jewel-like appearance. She rarely produced a picture larger than 6 ins x 6 ins. FRANCIS W. S. LE MAISTRE was born in Jersey in 1859 and lived and painted in the Channel Islands until his death in 1940. MALCOLM ARBUTHNOT, sculptor, oil-painter and watercolourist, lived in Jersey during the later 1920s and 30s, painting marine subjects around the coasts before settling in Cornwall. CHARLES DEACON, watercolourist, painted squally seas along the Jersey coast during the mid-1950s, this subject being his final exhibit with the R.S.M.A. in 1955; and watercolourist RAY EVANS painted seascape along the S. coast during the early 1970s.

King's Lynn
Norfolk

Known as Bishop's Lynn in the middle ages when it was one of the most prosperous ports in England, this town at the mouth of the Great Ouse retains an elegant Georgian centre.

GEORGE LAIDMAN, a watercolourist of considerable accuracy and charm and an accomplished oil painter, pictured the vessels and harbour here for over 40 years from c.1900 until the end of the Second World War. A ship-master at 20 years of age, he later worked as a waterguard at the port. He died here in 1954. His work is displayed at King's Lynn Art Gallery. A Chatham-born painter KENNETH DENTON, notable for his atmospheric pictures of the coastal harbours, beach scenes and sailing craft, lives and paints in the town.

Kingston-Upon-Hull
Humberside

A major freight, fishing and ferry port, with 7 miles of modern dock waterfront. The Old Town of Hull, between the Hull and Humber rivers, still retains much of its medieval street plan. William Wilberforce, the slavery abolitionist, was born here in 1759. Much of the old docks is now a marina, and Queen Victoria Square houses the maritime museum known as the Town Docks Museum. It contains a fine collection of seamen's scrimshaw carving, and pictures by painters of the Hull School, as does the Ferens Art Gallery.

WILLIAM ANDERSON was present in Hull during the 1820s, where his work had considerable influence on JOHN WARD, the brightest star of the Hull School. ROBERT WILLOUGHBY, a ship-portraitist who later worked with Ward, also lived here throughout his career until his death in 1843.

ABRAHAM WARD, captain of the *Nancy* brig, and father of the marine painter John Ward of Hull, appears to have painted in the town, including the *Whaler 'Swan'*, now in Hull Trinity House. His son, John, lived his life in Hull where he was born in 1798 until his death as one of 2,000 cholera victims there in a plague of 1849. Initially he worked as a house-painter but advertised as a 'Marine Painter' from 1838, when he sought pupils, announcing that '. . . specimens can be seen of portraits of vessels accurately drawn and painted'. From 1838, he lived at 23 North Street. John Ward may very well have painted outside Hull, along the Thames and S. coast, but entries in the Royal Academy lists confused him with John Ward of London, and his London pictures may have been copies of William Anderson's. He voyaged to the Arctic whale fishery, and benefited from the rivalry between two firms running passenger vessels from London to the N.E. ports who employed him to promote their ships through engravings.

Ward's pupil and cousin, WILLIAM FREDERICK SETTLE, the ship-portraitist, was resident from 1821 until 1897. THOMAS BINKS between c.1820 and 1857, JOHN LEWIS ROBERTS between 1831 and 1864, WILLIAM GRIFFIN from 1826 until 1859; all were concerned with the whaling industry and ship-portraiture and lived throughout their careers in the town. The landscape and marine artists RALPH STUBBS SR and JR were natives of Hull and were based there from 1800, Stubbs Sr dying in 1845, and his son working there until 1888. The little known WILLIAM DANIEL PENNY worked in Hull until 1897. JOHN WARKUP SWIFT, who painted widely along the English and Scottish coasts, was based in Hull; HENRY REDMORE pictured the Humber fishing fleets frequently for 30 years between c.1850 until 1880.

JOHN ATKINSON GRIMSHAW, who termed Hull 'the Venice of the North', made some of his most effective Impressionist pictures along the waterfront during the 1870s and 1880s. By using a projection device similar to the magic lantern, Atkinson was able to throw an image of his original painting on to another canvas, achieving many similar views of the port, although all are variously different.

THOMAS JACQUES SOMERSCALES was born in Hull in 1842, but painted little there, making his name with blue-water pictures made during his years in Chile (1865–92). He returned to Britain in 1892 and to Hull where he lived and continued working until his death in 1927. A marine painter ALLANSON HICK was born in Hull in 1898 and lived there throughout his life until 1975, where he recorded the docklands, shipping and offshore scenes including those during the Second World War. Watercolours of this subject were among his 4 exhibits in the R.S.M.A.'s inaugural exhibition of 1946. BERNARD HAILSTONE, a principal portrait painter, was appointed as a War Artist (1941–45) and as a result painted and drew a number of harbour and marine pictures, including a number in Hull showing ammunition ships loading during 1943. HARRY HUDSON RODMELL was born in Hull in 1896 and studied at the Hull School of Art to which he won a scholarship. His first one-man exhibition was held at the Ferens Art Gallery during the early 1930s, and his work is in the permanent collections of the Town Docks Museum and the Ferens Art Gallery. A founder member of the R.S.M.A. he lived on North Humberside.

COLIN VERITY, an architect with a particular interest in merchant and naval steamships of the nineteenth and twentieth centuries, has worked in the Hull area and has been well-represented at the Ferens Gallery. Watercolourist PETER COOK, influenced to some extent by John Ward of Hull and Atkinson Grimshaw, has produced a range of work in the Hull area and exhibited at the Ferens Gallery since 1978. JOHN STEPHEN DEWS, oil and watercolourist, exhibited work in the James Starkey Galleries at North Humberside in 1976, and continues to paint in the area. He lives at Beverley, North Humberside.

Kynance Cove – see under LAND'S END

Land's End

Cornwall

This promontory counts as the most westerly part of mainland Britain rather than Cape Cornwall by just 1,000 yards. Ownership of the land above its 200-foot high granite cliffs has changed twice since 1982, since when visitors have paid a charge to enter the area. The promontory normally appeared as background detail to ship portraits, usually featuring the Lizard rocks, until the latter part of the nineteenth century.

Just over 1¼ miles beyond Land's End are the granite rocks and reef of the Longships, which have been marked by a light since the end of the eighteenth century. The light was initially positioned at Sennen Cove, ¾ mile N.E. of Land's End, and the tower was re-erected block by block on the Longships rocks. A pleasant tale claims one keeper was kidnapped by wreckers but his daughter kept the lights going by standing on the family bible to reach them. The present tower was built in 1873 and fitted with a helicopter-pad in 1974.

J. M. W. TURNER painted a magnificent picture of *The Longships* in 1834 (see page 40), which Ruskin considered distinguished 'nature and Turner from all their imitators'. Wreckage and the light in the darkness imply the only human presence (there are no figures, only the glare of sinister torch-lights) in a picture which is a study of desolation and remorseless violence. The sea was a work of 'the utmost mastery of art'.

WILLIAM HOLMAN HUNT, the Pre-Raphaelite painted here in 1860, his minutely-detailed, highly-coloured watercolours showing the rock structures of the coast and the wave formations around Kynance Cove.

A Devon painter, HENRY SANDERCOCK painted in the area in the later 1860s, and visits by the English south-coast painter, W. F. BARKER, led to his R.A. exhibits of the early 1870s. A London artist, SAMUEL TROTMAN worked in the area during 1869, showing his work at the Suffolk Street Galleries in 1870. JOHN U'REN, watercolourist, and DUFF TOLLEMACHE painted here late in their careers, at the turn of the century, and ROBERT GROVES produced an image typical of his in *Running into Harbour – Sennen Cove, Land's End* of 1903, amalgamating the scenic drama of the coast with narrative action.

The wide, open seascape invited 'pure sea' painting here. London-based Otto Weber began his coastal-painting career with pictures made here between 1884 and 1887. A York artist, JOHN WINDASS, stayed and painted here in 1903.

Exeter-based FRITZ ALTHAUS painted here in the late 1890s; ALFRED WARNE BROWNE, c.1898, and EDMUND G. FULLER at the turn of the century.

CHARLES MOTTRAM visited c. 1902 and JOHN REID at the same time. PETER MOFFAT LINDNER visited here at intervals from before the Great War until the later 1930s. GEOFFREY S. ALLFREE, an official War Artist drowned on active service in 1918, painted a number of vigorous oil pictures in the region, his manner of painting the sea having much in common with that of Charles Pears; his *Torpedoed Tramp Steamer off the Longships* (1918) is one of the best such pictures of the Great War (Imp. War Mus.) showing the beached ship with its dazzled hull under a headland striated by the sun under a stormy sky.

PHILIP MAURICE HILL, of the St Ives Society of Artists, painted at Land's End, exhibiting his work at the great marine art exhibition held in Portsmouth in 1938. WILLIAM PIPER, who worked through the late 1940s and '50s, first exhibited at the R.S.M.A. in 1948 with *The Cathedral Rocks, Land's End.* MARION DIXON painted in the area in the late 1950s. JOHN EDGAR PLATT painted here at the end of the Second World War; and PETER LANYON, who was killed in a gliding accident in 1964, painted here during the 1950s.

Lamorna Cove
Cornwall

During the nineteenth century, ships loaded granite in this tiny harbour from quarries above. The small village lies ¼-mile inland in a wooded valley off the B3315. A mile westward along the cliffs is Tater-du, the first fully automatic lighthouse in Britain, completed in 1965. JOHN BRETT, whose *Stonebreaker* had

so inspired Charles Napier Hemy, visited Lamorna in the 1870s. JOHN (later LAMORNA) BIRCH first visited the cove in 1890. He settled there permanently in 1902, painting the archetypal form of

John Anthony Park (1880–1962) *Silver Morning, St Ives* Oil on board 13in × 16in (Royal Exchange Gallery, London)

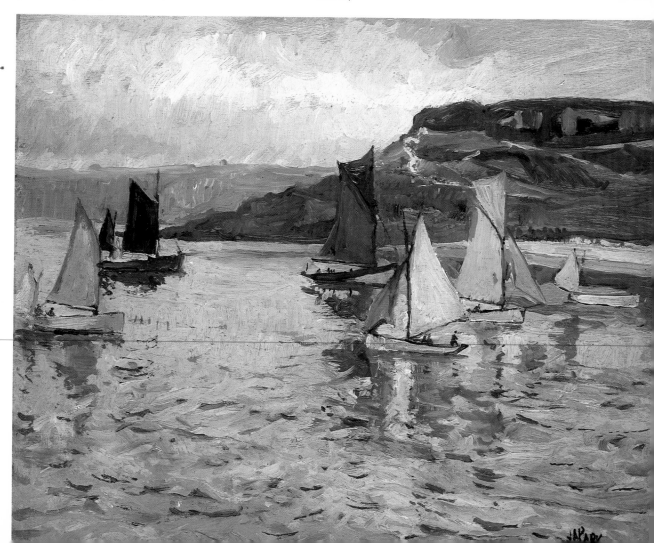

English Impressionism for which Cornwall became notable. From 1908 he was visited there by HAROLD and LAURA KNIGHT. The Knights lived at Lamorna from 1913 until 1918, receiving annual visits from Sir Alfred Munnings between 1911 and 1915. 'Cornwall', commented Laura Knight, 'is beauty so fanciful it is an easy part of the country for an artist to go to sleep in'.

Laugharne
Dyfed

Pronounced 'Larn', this small town on the A4066 beside the Taf estuary is primarily associated today with the poet Dylan Thomas as the setting for his play *Under Milk Wood*. Previously known as a haunt for wreckers, under the shadow of its castle, built by the Welsh prince Rhys ap Gruffydd, legal and illegal salvage was a major revenue from the seventeenth to the nineteenth century. In 1833 a Carmarthen tradesman openly hired out carts to wreckers before their intended victims appeared offshore. The locals arrived with hatchets and carts at any stranded vessel, and in 1840 destroyed an undamaged ship.

J. M. W. TURNER visited Laugharne c.1795, and in his watercolour *Laugharne Castle, Caermarthenshire*, (1832) exaggerated the mouth of the Taf river into an ocean strait in a grim image of storm, wreck and salvage under the ruined heights of the fortress. Ruskin wrote in *Modern Painters*:

'The grand division of the whole space of the sea by a few dark continuous furrows of tremendous swell . . . furnishes us with an estimate of space and strength, which at once reduces the men upon the shore to insects . . .'

EDWARD MORLAND LEWIS painted here during the late 1920s and early 1930s, making patchworks of colour laid over warm underpainting.

Lee-on-Solent
Hampshire

Part of Gosport, and site of the H.M.S. *Daedalus* Fleet Air Arm base, its small shingle beach is much used by bathers and water-skiers.

ALMA CLAUDE BURLTON CULL, remembered largely for his superb pictures of Edwardian warships which he painted for Edward VII, died here in 1931. Much of his work was destroyed during the Second World War.

Leigh-on-Sea
Essex

Now a suburb of Southend-on-Sea, this fishing village remains identifiable because a railway has prevented development swamping it, and it retains much charm.

A sea- and landscape painter, DONALD GREIG, son of the Scottish painter James Greig, was inspired to early marine work by the atmosphere of Leigh with its barges and old cockle-sheds. He studied at Southend Art School; 3 of his watercolours won the Gold Medal at the Paris Salon in 1966. He exhibited with the R.S.M.A. from 1964. HEATHER MERYL SHUTER studied at the Southend Art School at the same period and has worked in the area throughout her career. Exhibiting with the R.S.M.A. from 1977, her work appears in galleries in the area. FREDA PELLING, coastal oil painter, worked here during the early 1950s, her first R.S.M.A. work showing low-tide studies and the old harbour docks. DOUGLAS ETTERIDGE made watercolours here at the same time. A. E. HAYES, a watercolourist, painted here regularly through the 1950s, making pictures of the boat-building yards and seascapes. SHEILA FAIRMAN, notable for her marine still-life, shells, and seabird feathers, shellfish and débris as well as miniatures and open seascape, studied at Southend College of Art (1935–1940), and lives at Leigh-on-Sea, exhibiting with the R.S.M.A. from 1971. MARION COKER, also a student at Southend College at the end of the 1920s, lived at Leigh-on-Sea after 10 years in Fleet Street advertising studios, painting Leigh cockle-boats, fishing vessels and inshore scenes. Her work appeared at the R.S.M.A. from 1964. JEAN KEVAN painted in the area of the Leigh marshes in the late 1960s. A self-taught oil painter, COLIN MOORE, specializing in past and present sailing vessels, lives at Leigh-on-Sea. VIC ELLIS, painter of all kinds of past and present shipping, but particularly vessels of the E. coast, has lived at Leigh-on-Sea since the Second World War, during which he served in the Royal Navy, being awarded the D.S.M. in 1945. A self-taught painter from the age of 10, Ellis's work has been chiefly concerned with the Thames estuary and E. coast.

Leith – see under EDINBURGH

Limehouse – see under THAMES ESTUARY

Lindisfarne (Holy Island)
Northumberland

The tip of a wide peninsula of sand 5 miles N. of Bamburgh, cut off from the mainland by the tide for 11 out of every 24 hours. The monk Aidan of Iona founded a monastery there in 634; although destroyed by the Danes during the ninth century, the Lindisfarne Gospels, a masterpiece of illuminated Celtic art survived. A priory replaced the monastery in 1093. A tiny fishing village exists today, and Lindisfarne Castle, built on a high pinnacle in the 1500s to repel Scottish raiders, was romantically remodelled by the architect Sir Edwin Lutyens in 1902.

J. M. W. TURNER visited Lindisfarne between 1825 and 1828. A watercolour and engraving of the 'England and Wales' series looking S.E. along the S. coast portrayed supplies being landed from a departed steamship under a summer-storm sky. The ruins of the priory church show in a sun pool, but the dramatic fairy-tale castle is shifted away to the right of the composition.

Liverpool
Merseyside

One of the largest ports in the world, which rose to prominence with the decline of Chester during the eighteenth century, and spurred by its hinterland of the industrial north. By 1880 40 per cent of world trade was carried by Liverpool ships. Much of the 7 miles of dockland is now disused E. of Pier Head, with trade focused on the Seaforth Container Docks to the N.W. side of the city. The Liverpool Maritime Museum is the centre of the preservation scheme for the old dock region: it includes a full-sized sea-going replica of a Liverpool pilot schooner. The Walker Art Gallery houses one of the best collections of marine painting in Britain.

The Whitehaven-born ship-portraitist ROBERT SALMON, to whom much of the American marine painting tradition is owed, lived and painted here until 1827. Many of Salmon's pictures show the wide spread of the Liverpool waterfront in great detail, for he nearly always portrayed vessels in a specific location. A ship-painter, JOSEPH HEARD, arrived in Liverpool c.1833, about 6 years after Salmon's departure, and, unlike Salmon, concentrated more on depicting the shipping to the exclusion of other detail. Also from Whitehaven, he remained in the city throughout his working career, and died there in 1859. Salmon's contemporary, MILES WALTERS, first appeared in the Liverpool directories as 'Artist' in 1832, although he had been painting Liverpool ships since 1823. In 1834 he set up a framing, carving and gilding business at 27 Berry Street. His son SAMUEL WALTERS, born at sea in 1811, worked with his father at this address at painting, many of their pictures being signed 'Walters & Son'. Miles later relinquished painting to Samuel, who exhibited pictures in Liverpool Academy for the next 35 years, and at the Royal Academy (1842–1861). He had great success with his *View of Liverpool* engraved by Reeve, and toured ports throughout Britain (and Holland). In 1845 he left for London, but regretted it, and was back in Liverpool in 1847. In the 1850s the business was expanded under his brother, while Samuel Walters's eldest son, GEORGE STANFIELD WALTERS, assisted his father, exhibiting his first picture at 15. In the later 1850s Samuel moved to rural Bootle (with his affluent customers) where he remained until his death in 1882. By then he had been commissioned by every major ship-owner in Liverpool and most in America.

From 1860 Liverpool directories list WILLIAM YORK as a ship-painter, but doubt exists whether York was one man or father and son, successively listing William York, William Yorke, William H. Yorke and lastly William Hord York. The pictures, signed 'W. H. York' followed by 'Liverpool' were produced from 1858 until 1902. The Knotty Ash painter, W. J. J. C. BOND, worked as apprentice to the restorer Thomas Griffiths here in the late 1840s, before beginning a body of Turneresque painting much of which was exhibited in Liverpool and the R.A. and R.B.A. A ship-painter, THOMAS DOVE flourished here during the 1870s, the rare surviving work revealing study with the Whitby painter George Chambers. JOSEPH WITHAM established a reputation among Liverpool shipping circles during the early 1880s, his painting *Follow the 'Leader'* depicting a pilot schooner so named guiding a fleet into the Mersey on 8th February 1881 in a fierce N.W. gale. Reproductions of his work appeared in John Masefield's *The Wanderer* (1930), in the Bibby Line histories, and his pictures of troopships in Rogers's *Troopships and their History* (1963).

A watercolourist WILLIAM FREDERICK HAYES was resident in Liverpool until 1880, and the ill-fated HARRY WILLIAMS was born and flourished here until

leaving for London in the mid-1870s. JOHN WRIGHT OAKS, although essentially a landscapist, lived and worked in Liverpool throughout his career at the end of the 1880s. JOHN ATKINSON GRIMSHAW painted a large number of twilight studies of the dockland region in the earlier part of that decade, using the aid of photography. ALFRED CLINT, President of the Society of British Artists, painted less familiar views of Liverpool from the Mersey between the 1850s and the late 1870s, looking downstream from Ellesmere and the marshes near the Stanlow Banks. JOHN McDOUGAL lived and worked here from 1877 to 1897. TERRICK JOHN WILLIAMS was born here in 1860, later leaving to study in Antwerp and Paris.

BERNARD BENEDICT HEMY, brother of the great Charles Napier Hemy, produced a number of harbour scenes at Liverpool, showing the unusual structure of small steam tugs in the later decades of the nineteenth century, although his work was generally greatly inferior to that of his more famous brother Charles. THOMAS MARIE MADAWASKA HEMY, Charles's other brother, who painted until 1937, also portrayed Liverpool's waterfront in pictures of very high quality the equal of Charles's, but they are very rare.

A marine watercolourist SAMUEL JOHN BROWN was born in Liverpool in 1873 painting here before and after the Great War. RICHARD SHORT, initially a merchant navy sailor, painting in the late nineteenth and early twentieth century, exhibited work in Liverpool and painted there. JOSIAH CLINTON JONES, working chiefly in Wales, studied in Liverpool during the late 1850s and early 1860s. LEONARD CAMPBELL TAYLOR, a portrait and figure painter, produced three rare watercolours of the Liverpool docklands while serving with the R.N.V.R. during the Great War. ROBERT MACDONALD FRAZER was born in Liverpool c.1890; the greater body of his work was produced between 1910 and 1938, mostly oils and a considerable number in the Mersey area.

JOHN WORSLEY, a marine artist, portrait painter, illustrator and sculptor, was born in Liverpool in 1919, leaving to study at Goldsmiths' College, London, in the mid-1930s. From 1939 Worsley served in the R.N.V.R. until being made a War Artist on the C.-in-C.'s staff in the Mediterranean, and being captured in November 1943. He later constructed a life-sized dummy for a successful escape project afterward portrayed in the play and film *Albert RN*. He concealed his drawings of prison camp life in the Red Cross milk-tins. Over 60 of his pictures are in the collection of the Imperial War Museum.

JOHN STOBART, painter of inshore shipping, historic scenes and ships at sea, and from 1980 Vice-President of the American Society of Marine Artists, spent many hours on the Liverpool waterfront observing shipping of all kinds as a boy during the 1940s. DAVID MUIRHEAD BONE, who excelled in almost all pictorial media, made and displayed work at Liverpool throughout his career. ARTHUR BURGESS, Australian-born marine artist and illustrator, and from 1922–1930 art editor of *Brasseys Naval and Shipping Annual*, pictured Liverpool harbour as he did most of Britain's major ports, particularly in his oil exhibits at the R.S.M.A. in 1951. WALTER THOMAS, marine oil and watercolourist and poster designer, was born in Liverpool in 1894, portraying the harbour and the Mersey at intervals throughout his career until his death in 1971. JOHN HARDY MEADOWS, living at Southport, Merseyside, has painted the tramp steamers and steamships of all kinds, ocean liners and dock and harbour scenes in the region since the late 1930s, apart from a wide range of high-sea pictures and portrayals of wartime convoys. E. SCOTT JONES, marine oil painter and watercolourist, painted in Liverpool old docks in 1967, and began to exhibit at the R.S.M.A. in 1968 with *Albert Dock, Liverpool*. JOHN LINCOLN ROWE, a Marine Society artist, has specialized in painting aboard British Merchant Navy ships and has painted and drawn many of the 'unpicturesque' freighters sailing from Liverpool since the mid-1970s. A marine and railway artist and illustrator, BRIAN ENTWHISTLE, studied at Liverpool College of Art during the early 1950s, with work displayed at the Boydell Gallery, Liverpool. Entwhistle has painted many vessels and marine subjects of the Mersey region, especially coasters, tugs and motor vessels of the 1950s. LESLIE ARTHUR WILCOX, a highly polished commercial artist who took to full-time marine painting in 1945, in his mid-forties, has specialized in historical subjects, and has painted numerous scenes of old Liverpool, especially the vessels of the Black Ball fleet of packets, in a style and technique traditional of the realist mid-nineteenth century.

Lizard
Cornwall

On this southernmost tip of mainland Britain, Cornwall's first lighthouse was built in 1619 by Sir John Killigrew, to the great animosity of the locals who regarded the salvage of innumerable wrecks as their most profitable legal occupation. Marconi used the cliff, Pen Olver, to make the first radio contact with the Isle of Wight in 1901. A mile inland, Lizard village produces ornaments in polished serpentine marble, first made fashionable in 1846 by Queen Victoria during her Cornish visit that year.

Edward Brian Seago (1910–1974) *Sailing Boats on the River Deben at Woodbridge* Oil on board 15¾in × 24½in (Royal Exchange Gallery, London) See p. 142

Ship-painters like GEORGE WEBSTER set vessels off the Lizard, particularly America-bound ships and warships during the 1790s until the early 1830s. NICHOLAS CONDY, and his son MATTHEW, working at Plymouth, pictured packets and warships here between the later 1830s and c.1850, such as *The Falmouth Packet 'Sandwich' Captained by Captain Schuyter, Up Anchoring off the Lizard, Flying a Red Ensign and Red Pennant; In the Background a 12-Gun Naval Brig.* The highly productive JOHN CHRISTIAN SCHETKY pictured naval vessels exercising off the Lizard, generally between 1810–1870, a subject also embraced by SIR OSWALD WALTER BRIERLY between c.1840 and 1890. CAPT. RICHARD BRYDGES BEECHEY pictured the wrecks of merchantmen and warships off the Lizard between the late 1830s and mid-1870s. THOMAS GOLDSWORTHY DUTTON produced some beautifully drawn ship-portraits off the place from the early 1840s, such as the Blackwall frigate *Serringapatam*. 'JOCK' WILSON pictured the headland during the 1830s, and C. H. MARTIN during the 1840s. The Royal Watercolour Society's SAMUEL P. JACKSON painted here during the mid-1850s, JOHN BRETT and HENRY SANDERCOCK in the following decade, as did the pre-Raphaelite HOLMAN HUNT. THOMAS HART lived and painted in Lizard village between 1865 and 1880, painting the headland many times. His delicate watercolour technique was well suited to rendering the fine strata of the rocky coast and fall of light. Although by then living at Regent's Park, London, THE REV. FREDERICK JACKSON submitted pictures of the Lizard to the Suffolk Street Galleries in 1871, having formerly lived at nearby Helston until 1870. WILLIAM WARREN, a Peckham artist, made pictures in the area in 1867, among many other marine subjects, although generally thought of as a landscape painter. A Londoner, HARRY MUSGRAVE, portrayed vessels off the headland in 1886, and BRYAN WHITMORE a coastscape, *Old Lizard Head*, in 1884. DUFF TOLLEMACHE departed from portraiture for land and seascape in 1896, and the third seascape he

ever exhibited in the R.A. was *Off the Lizard* in 1903. ALFRED WARNE BROWN selected the headland for moonlit seascapes in 1896, and WILLIAM EDWARD WEBB made some fine Turnerian paintings in the later 1890s. MONTAGUE DAWSON and NELSON DAWSON both portrayed shipping off the headland, both of them producing watercolour work superior to oil on the subject, before and after the Great War. The Devon and Cornwall painter, ALFRED MITCH-ELL, made numerous variations of the Lion Rocks off the Lizard, displaying two in the R.A. in 1894. WILLIAM SAMUEL PARKYN, pastel- and watercolourist, lived at the Lizard for much of his later career,

before moving to St Ives where he died in 1949. NORMAN HOWARD, marine artist and illustrator, painted at the Lizard at the end of the Second World War, where he portrayed autumn gales exhibited at the R.S.M.A.'s inaugural exhibition of 1946. DR E. H. SEARS, a marine oil-painter who exhibited during the 1960s, worked at the Lizard during 1970, the work among the last he exhibited with the R.S.M.A. DERYCK FOSTER and TERENCE LIONEL STOREY, painting ocean-going yachts and tall ships, have produced marine pictures of vessels off the point, which also appears in the work of JOHN COBB and JOHN HAMILTON.

Lowestoft
Suffolk

A large seaside resort and port at the northern end of the Suffolk Coast Path, on the A12 and A146. The base of the world's first effective lifeboat, the *Francis Ann*, in 1807, it rose to prosperity on its lugger fleets and then steam drifters working the Dogger Bank and North Sea fishing grounds. Its fishery attracted many painters during the nineteenth century; there were 700 drifters working out of the port before the Great War. Now less than fifty remain. The town is divided in half by Lake Lothing, the southern resort portion laid out during the last century by Sir Samuel Morton Peto, designer of the Houses of Parliament. The old northern half has a series of unique parallel lanes or 'scores' between the buildings. The Maritime Museum has an extensive collection of Norfolk and E. coast painting.

WILLEM VAN DE VELDE THE ELDER witnessed the opening battle of the Second Anglo-Dutch War offshore on the 13th June 1665. The action was a Dutch disaster, fiercely fought until their flagship *Eendracht* blew up with the commander-in-chief and nearly all her crew. The Dutch lost over 30 ships in their confused flight, which van de Velde later recorded in three panoramic drawings thought to be of 1674, showing a seascape littered with burning and dismasted ships. The artist's galliot is shown in the lower right-hand corner of the third drawing, by the inscription 'Van de Velde, his galliot, employed by order of the State'.

WILLIAM DANIELL visited the harbour c.1810–1820, during his survey for the *Voyage Round Great Britain*. A landscape and seashore painter, WILLIAM COLLINS, painted in the area between 1816 and 1820, and again during the early 1840s, usually showing figurative incident inshore rather than vessels against seascape.

J. M. W. TURNER visited Lowestoft c.1830, and produced one of his most violent stormscapes here for the 'England and Wales' series, c.1835, set at an hour before dawn in a violent storm of rain and

wind, with half-swamped boats in the aftermath of a shipwreck brought on by the local wrecker economy. MILES EDMUND COTMAN painted here at intervals between the mid-1830s and 1850; an excellent sea painter, he inherited the talent of his father for conveying light and atmosphere of distance with great economy. ANDREW DURNFORD, a London painter, produced vigorous, wind-swept compositions here while working along the Norfolk coast in the 1840s. Another Londoner, ROBERT WATSON, also painted the same vigorous subject matter here later in the same decade. JOHN BRETT, sailing around the British coast in the early 1860s, visited and made sketches here, in the transitional style from his pre-Raphaelitism. The prolific WILLIAM J. CALLCOTT visited the area during the 1850s and 1860s, like his contemporaries giving a vigorous, wind-blown air to his pictures. JOHN C. OGLE, who alternated between making pictures of military and naval events and the fishing community, painted here in 1859/60, his British Institute entry of 1860 being luggers at Lowestoft harbour. He charged £20 for this, the same as a battle-piece. Turning to sea-pieces after 1845 (before which he had made history-paintings), CHARLES TAYLOR SR painted herring luggers here and at Great Yarmouth during the late 1860s and early 1870s, as had his son, CHARLES TAYLOR JR, two or three years earlier. The son was primarily a marine artist. GEORGE H. BROWNE, usually a landscape artist, visited the area in the early 1870s, while making North Sea pictures and a few pieces of the Dogger Bank fishery. J. F. BRANEGAN, painting coastal scenes between 1871 and '75 pictured fishing vessels here during that period.

ALFRED CONQUEST, who painted on the East Anglian coast during the 1880s, and ERNEST DADE, after he had left London late in the decade, both painted here, Conquest concentrating on the shoreside while Dade included offshore scenes. The enormously productive GEORGE STANFIELD WALTERS, who more often painted estuary scenes on the S.

Henry Moore (1831–1895) *Lowestoft* Watercolour on wove
paper 11½in × 15¼in (Victoria and Albert Museum)

coast, worked along the east later in his career and
made cool watercolour pieces during the last 15 years
of the century. JAMES W. CALLOW produced fishing
scenes in oil set off the coast late in the 1880s and off
Great Yarmouth. During the last 10 years of the
nineteenth century HENRY MOORE made a series of
watercolour paintings at Lowestoft which were out-
standing for their simplicity and economy of brush-
stroke, the sweep of the tide occupying over three-
quarters of the picture area and the land appearing as
a series of short strokes to imply masts or buildings.

Between 1910 and 1913 MUIRHEAD BONE worked
in the vicinity, while part of the Walberswick com-
munity 7 miles down the coast. Many of his pictures
made while employed as a naval war artist are set in
the North Sea and off the East Anglian coast, and
portrayed naval vessels operating from Harwich and

Lowestoft during the Great War and the Second
World war. An East Anglian artist, OSCAR MAC-
DONALD, made marine pictures here at intervals
throughout his career (c. 1925–1970). ARCHIE WHITE,
a marine and coastal painter, painted in the area
before and after the Second World War, and LESLIE
J. WATSON, one of the founders of the R.S.M.A.,
did so while crewing fishing vessels during the
1930s. NORMAN WILKINSON, who painted fishing
vessels in the North Sea, recorded the fleets here
before their disappearance at the end of the 1960s.
ROWLAND FISHER, living at Great Yarmouth, painted
here regularly over the course of his career
(1920–1969). His R.S.M.A. exhibits of 1946 included
pictures of the Lowestoft fleet. During the later 1940s
EDWARD BRIAN SEAGO, painting on the Norfolk and
Suffolk coasts, pictured drifters and trawlers here as
did H. E. TWAITS. During the 1950s DOROTHY BILL-
INGS painted regularly at Lowestoft, submitting
work to the R.S.M.A. before the drifter fleet fell

into decline. ANTHONY P. BENTALL and F. W. BALD-WIN also visited the port at the time. DENNIS ROY HODDS studied at Lowestoft School of Art, to which he won a scholarship at the age of 12. A specialist in

marine subjects, harbour scenes and sailing craft, he has continued to paint in the area, as have ROBERT KING, MICHAEL NORMAN and M. W. COUP during the 1970s.

Lyme Regis
Dorset

No longer a commercial port, and now a resort on the A3052 and A3070, with narrow streets and colour-washed buildings, Lyme Regis is a centre for sailing schools, wind-surfing and geologists. 3½ miles E. of the town, the golden sandstone cliffs rise to 626 feet at Golden Cap, the highest cliff face in Southern England. A mile N.E. of the town, at Charmouth, the 12-year-old Mary Anning found the first complete skeleton of an ichthyosaur in 1811.

J. M. W. TURNER portrayed Lyme Regis in 1834 as a description of the poverty of the coastal communities, with wreckage being salvaged from a high, driving sea. Turner used a stylized perspective to stress the low sea front of the town as though the tide would swamp and swallow it. The Cobb, an eighteenth-century breakwater, juts out starkly in the picture while the church of St Michael dominates the skyline, but all are overshadowed by the wreckage and sea.

EDWARD PRITCHARD, painting along the S.W. coasts, produced a less threatening image, but which nonetheless embraced the roughness of the seas. SAMUEL P. JACKSON shared a similar image of Lyme Regis, as did WILLIAM BORROW. JOHN BRETT, picturing fishing vessels in the wide, rough bay, was less interested in the Cobb and harbour. ALFRED CLINT visited here briefly c.1860s, SAMUEL TROTMAN and W. F. BARKER, all seeing the low waterfront of the town and the compositional importance of the high

seawall and Cobb breakwater. CHARLES NAPIER HEMY visited the harbour during the 1870s, and again in the 1880s, after he had settled at Falmouth. CHARLES KNIGHT painted at the port and along the bay in the later 1880s, as did JOHN REID and the 'landscapist' GEORGE ADAMS touring in the late 1870s. THOMAS HART painted above the town and lower down, near the Cobb, during that decade. JAMES ALDRIDGE, a Worthing marine artist, visited the harbour near the turn of the century and until the Great War, again picturing the boisterous water of the bay. FRANK BRANGWYN made sketches in the harbour and around the bay during his period working along the south coast, before the Great War. JOHN EVERETT made small oil and watercolour sketches in the harbour area and the wide bay before and after the war. EDMUND MACE painted watercolours here during the late 1930s.

An oil painter, RUBY WALLACE, painted in the region during the first half of the 1950s, her first R.S.M.A. exhibit being *The Cobb, Lyme Regis* in 1951. MARY WILLIAMS, who studied under Claude Muncaster in the late 1920s and painted extensively along the Devon and Dorset coasts from the mid-1950s onwards, made onshore watercolours here from 1958. STEPHEN FREDERICK THOMPSON, a largely self-taught marine painter with a taste for vessels of the early twentieth century and producer of a wide variety of coastal pictures, has exhibited in London and the provinces since the mid-1970s, and lives at Lyme Regis.

Lymington
Hampshire

A Georgian town on the A337 with steep streets and terminal for the Isle of Wight car ferry. Beyond to the S. lie the Keyhaven and Pennington nature reserves and bird sanctuaries, and saltings that surround the Lymington river estuary. A maritime art gallery, The Old Customs House, contains an extensive collection of well and less well-known British marine painting from the eighteenth to the twentieth century.

J. M. GILBERT lived here from 1830 to 1845, making coastal and estuary pictures and scenes in the Solent. His oil paintings are notable for their soft colours and light, airy stroke. The estuary featured

in the Isle of Wight pictures of FRANCIS MOLTINO during the late 1840s, and those of THOMAS DEARMER between 1840 and 1867. ROBERT GROVES, a painter and book illustrator, lived here in his later years until his death in 1944, executing many fine pencil drawings of Lymington, especially the old shipyard and the river estuary. Etcher and watercolourist WILFRED WILLIAMS BALL lived here during 1911. The greater part of his work was done during the late nineteenth century, but he continued working until his death in Khartoum in 1917. ARTHUR STEWART MACKAY painted in the area from 1951 until 1974. He worked in oil, exhibiting with the R.S.M.A. from 1950, producing many pictures of tranquil Keyhaven harbour. CHARLES LINDLEY, a watercolourist, painted

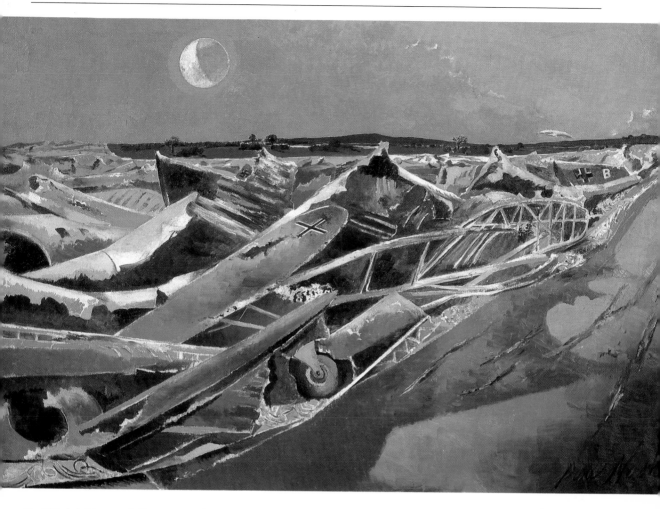

Paul Nash (1889–1946) *Totes Meer* Oil on canvas
40in × 60in (Tate Gallery, London)·

some of his last pictures here in 1957 and the Town Quay in 1958, before he died later that year. ROBERT JOHNSTON, chiefly a watercolourist, who painted landscapes in Australia for many years, and then marine subjects including (unusually) North Sea oil rigs, painted in Lymington in 1968. American-born oil-painter TIMOTHY WELLS, specialist in sailing ships and particularly American schooners, who initially studied portraiture under Felix Dicassio in New York, is now working in marine subjects of all kinds, and lives in Lymington. KEITH CHARMAN, whose oil pictures show the strong influence of William Wyllie and Montague Dawson and are distinctive for their dramatic lighting, also lives and works there, as does STUART BECK, member of the R.S.M.A., who stated that he began painting when 7 years of age, using his mother's oils on a shoe-box lid.

Lynton and Lynmouth

Devon

Now a well-known beauty spot and resort on the A39, 'discovered' by society in 1812 after the poet Shelley visited the place. Lynmouth, ¼-mile E. of Lynton, is at the E. end of the Valley of the Rocks, a spectacular coastscape of granite above Wringcliff Bay, with 800-foot cliffs.

NICHOLAS POCOCK painted in Lynmouth harbour in 1801, the 'undiscovered' harbour being familiar to him from his sailing days in the Bristol Channel.

WILLIAM HENRY MILLAIS, the brother of Sir John Millais, pictured the Valley of the Rocks in 1859, painting in the minute, Pre-Raphaelite manner.

Machrihanish
Strathclyde

A grey stone town on the B834, with fine hinterland scenery overlooking a 3½-mile-long, pale silver-gold beach stretching N. to Westport on the A83.

WILLIAM McTAGGART lived and painted here for two months in each year between 1860 and 1889, producing vigorous Impressionist pictures which appear to blend liquid and solid form and almost eradicate the human figure.

Maldon
Essex

A picturesque town on the A414, and a port since the middle ages, Maldon developed its own type of barge during the nineteenth century, built very broad and flat to carry complete hay-ricks along the shallow Blackwater estuary. Now the scene of Thames barge races held in July.

COLIN KENT, a watercolourist worked in the area during the later 1960s exhibiting with the R.S.M.A. (1969–1975). WILLIAM JASPER GELLER, working in watercolour, egg tempera and pen and ink, drew and painted barges here during the 1970s, distinctive for their accuracy and finesse. CLIVE KIDDER, marine and landscape painter and book illustrator, working in watercolour and acrylic, painted along the estuary during the later 1960s and 1970s, favouring the marshlands more than the images of sailing craft, the prime focus of the region. KENNETH DENTON, a Chatham-born artist, painted atmospheric oils on the estuary in the mid-1970s, concerned with the refracting light over the wide estuary and its effect on craft moving into the light source over the water. FRANK GARDINER, an illustrator and marine artist exhibiting with the R.S.M.A. since 1971, and specializing in historical subjects and harbour scenery, has painted extensively along the Blackwater estuary, often stressing the stillness of inshore waters pronounced by the reflections and distribution of motionless vessels upon them.

Margate
Kent

The northernmost of the Thanet trio of resorts, on the A28, its eastern suburbs almost joining Broadstairs at North Foreland. 'Margate Hoys' brought Londoners here by sea long before the railways; the great crescent of Sandy Beach was popular from 1750 after the Quaker, Benjamin Beale, a Margate glovemaker, invented the covered bathing machine.

J. M. W. TURNER paid frequent visits to Margate, portraying it as an elegant and youthful place. His watercolour of 1822, *Whiting Fishing off Margate*, is a *tour de force* of burnished reflections among fishing vessels on a still sea; a watercolour of 1830–31 shows graceful crescents curving into a haze above a reflecting harbour and an affluent woman and children strolling along a sunny lane above the heights of the town. From 1828 he took lodgings with a Mr and Mrs Booth during weekends there and in 1833 lived with Booth's widow until she moved up to London with him until his death in 1851. F. SARTORIUS and C. J. SARTORIUS both produced numerous views of Margate, their favoured area of the coast, between 1803 and 1818. Its resort nature was the chief concern of E. A. CROUCH who pictured its pier and jetty in pictures of 1828. The Pier, known confusingly as 'the Jetty', was almost wholly destroyed by a storm in 1978. JOHN DUJARDIN and GEORGE GAUBERT pictured shipping off the town here during the 1830s and '40s.

JOHN CHRISTIAN ZEITTER visited the town during the early 1840s, as did W. H. WILLIAMSON, and another versatile artist, J. W. YARNOLD. All pictured passenger vessels off the coast, fishing vessels and small steamers. EDWARD CHARLES WILLIAMS and GEORGE AUGUSTUS WILLIAMS visited the town in the later 1850s, and WILLIAM WARREN in the early 1860s. W. D. DOUST who usually painted on the Thames and Medway, came here at the end of the decade.

The Town Hall contains a portrait by the marine artist EDWARD FLETCHER (alias JOHN HAYES) of the town mayor (c.1890) for which the artist never received his promised fee of £80.

WILLIAM MINSHALL BIRCHALL occasionally pictured vessels off the coast here during the turn of the century, as did CHARLES DIXON and Edward Fletcher, who had painted the penniless portrait. ROWLAND HILDER included it among his Kent towns pictured in the 1930s, as did FRANK MIDDLETON and R. H. PENTON, both members of the Wapping Group during the post-war period.

Medway
Kent

A tidal river estuary extending 9 miles from the conurbation of Rochester-Chatham-Gillingham to

the Channel coast at Sheerness, just S. of the mouth of the Thames estuary, across the Isle of Grain.

Rochester

Charles Dickens's 'Cloisterham' or 'Dullborough': now the most picturesque of the Medway towns, on the S. bank of the river on the A2 and M2, not far from Chatham also on the S. bank. It is notable for its small, much-restored cathedral and enormous castle keep, a landmark for miles.

Upnor

2 miles to the N.E. on the A298, grew up around an artillery fortress built in Elizabeth I's reign to protect the naval dockyards at Chatham. This fortification is now impressively restored with a display of the history of the Medway defence system. It was only partially successful: in 1667 the Dutch Admiral, De Ruyter, sailed with panache into the Medway having burned Sheerness fort, and sent Van Ghent upriver during a pay arrears mutiny in the English fleet to destroy the deserted English warships there. Van Ghent burned several ships and towed off the flagship *Royal Charles*; but his vessels suffered severe damage from Upnor's guns and withdrew before destroying the rest of the fleet.

Miles Edmund Cotman (1810–1858) *Boats on the Medway, a Calm, c. 1845* Oil on canvas 22in × 20in (Castle Museum, Norwich)

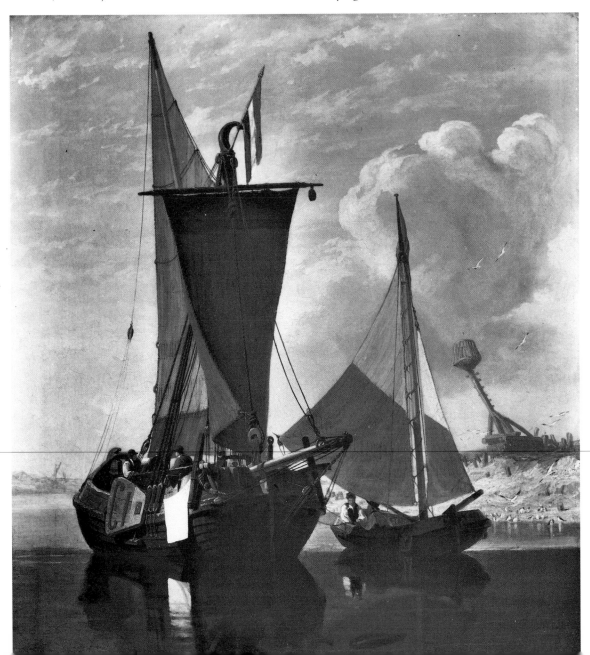

Chatham

A naval dockyard since 1547, when Henry VIII kept a storehouse at 'Jillyngham Water', this town is now a large conurbation with the residential sprawl of Gillingham stretching S.E. along the A2 and A229, off exit 3 on the M2. The massive eighteenth century earthworks which covered the hill behind the town were known as the Great Lines, giving panoramic views along the Medway. The Napoleonic Fort Amherst there is being fully restored.

THOMAS PHILLIPS made ink-and-wash drawings of the Medway during the later 1660s as part of a survey of the harbour defences of the realm carried out by the Admiralty. ISAAC SAILMAKER painted *The Royal Yacht off Sheerness* (c.1680), a portrait of both vessels and the fortress still rare at the time. WILLEM VAN DE VELDE THE ELDER made many drawings of vessels and wharfsides at Chatham during the 1680s. Some are reference drawings of the structure of new English capital ships, showing the stern carving and rigging details. Others record small vessels in all states of preparation and studies of harbour people and general perspective studies of the relative sizes of objects and figures across a wide estuary. Others are studies of harbour furniture and wharves themselves. Many of these studies proved the foundation for SAMUEL SCOTT's drawing method of marine subjects. Samuel Scott painted along the Medway between 1730 and 1765; his Five Days' Peregrination with WILLIAM HOGARTH and 3 other friends navigated the length of the river, which Hogarth recorded in satirical drawings such as warships firing broadside salutes as Hogarth clambers into a rowing-boat along two parallel poles.

JOHN CLEVELEY pictured ships built on the Medway but portrayed them on the Thames, as did PETER MONAMY and SAMUEL SCOTT. During the 1740s CHARLES BROOKING set a number of pictures off the Medway and DOMINIC SERRES made extensive watercolour drawings of shipping in ordinary and refitting in Chatham and along the estuary between 1760 and 1780. Often one can surmise the location of those watercolours from the vessels themselves rather than from a direct transcription of the area. Others of his compositions resemble those of Brooking, where a large vessel is standing off a coast in shallow water. ROBERT CLEVELEY pictured major warships lying in the waterway as did JOHN THOMAS SERRES, who, after his commission, visited the area to prepare drawing manuals for the Admiralty and record port facilities (c.1790–1815). Between 1828 and 1832 J. M. W. TURNER made watercolours and engravings of Castle Upnor, showing the Medway at sunset and littering the foreshore with visual puns of Upnor's defence of Chatham: a large musket pointing towards a target-like ring attached to

wreckage, a defiant dog facing the tide, and a seaman pulling on a massive boot beneath Upnor, the fort having 'done boot' – rendered help – or 'booted' Van Ghent back downriver. Turner made a number of views of Chatham during the 1820s, his summary sketches showing the shorthand method he employed for notation (a line of soldiers at the Great Lines marked as a series of 'x' strokes for their cross-belts); he worked from these for his 'England and Wales' series in the early 1830s; these pictures survive only in the engraved version. They show the conurbation of Chatham and Gillingham already in formation below the fortifications, and the massive keep of Rochester castle dwarfing all else along the river, including the huge ship-building sheds.

GEORGE CHAMBERS SR made watercolours here in the late 1830s (the work greyer in colour than formerly and 'harder', which he did not like), portraying transports on the river and frigates. ELIAS CHILDE, generally a landscapist, painted in the Chatham area with vistas along the line of the Medway during the later 1830s, as did JOHN DUJARDIN SR. E. W. COOKE made oil and watercolours along the Medway throughout his career, from the late 1830s onwards. He frequently painted the heavily laden hay barges moving in the late summer squalls on the river, and the chiaroscuro this offered. CLARKSON STANFIELD more often portrayed the large warships lying in ordinary at the Chatham naval yards and the ocean-going vessels refitting in the area. Many of his pictures employed E. W. Cooke's method of dramatic lighting to highlight the receding planes of the landscape beyond the ships.

FRANCIS MOLTINO and BARLOW MOORE, Painter to the Royal Thames Yacht Club, painted in the area during the 1860s. FRANCIS PETHER adopted his moonlit genre on the river at the same period. WILLIAM CRAMBROOK, essentially a landscapist, visited after 1840. G. W. BUTLAND worked from Chatham along the Medway regularly between 1831 and 1843, as did C. MINS, generally a landscapist, in 1839, and C. DOWNTON SMITH in the late 1840s. W. D. DOUST painted fishing vessels along the river in the mid-1860s, although he generally set his pictures at the mouth of the Thames and Medway. H. VALTER, generally a Birmingham landscapist, painted some vigorous if cluttered pictures in the Medway in the mid-1850s, the same period as JOHN CALLOW who made some windy pictures of traffic on the river. GEORGE CALLOW painted calmer scenes between 1858 and 1873. Hay barges on the estuary also attracted CHARLES THORNELY from the late 1860s until the 1880s. W. H. WILLIAMSON pictured fishing-boats on the estuary during the 1860s–70s. EDWARD FLETCHER, his style similar to W. L. Wyllie's, produced a number of Thames-like pictures in the 1880s.

Joan Eardley (1921–1963) *Breaking Wave* Oil on canvas
48in × 55in (Kirkcaldy Art Gallery) See p. 101

In 1884 WILLIAM LIONEL WYLLIE moved to Gillingham House, near Chatham, and shortly afterwards to Hoo St Werburgh, about 2 miles N.E. of Upnor, where he remained until 1906. During this time he painted a great number of pictures in oil and watercolour of the Medway, showing barges, Channel- and ocean-going ships and warships from Chatham to Sheerness. These pictures have been emulated both in style and content for the last 100 years. CHARLES S. MILLER, a coast and inshore painter from Islington, worked extensively along the Medway between 1883 and 1891; about half his 7

R.A., 16 Suffolk Street and 3 Institute of Oil Painters exhibits were set on the Medway. ALMA CLAUDE BURLTON CULL sketched warships lying here before the Great War, as did GERALD BURN. PHILIP WILSON STEER, at his most impressionistic as on the Thames, made watercolour sketches of the estuary after 1906. BRANSTON FREER, in greatly contrasting style, painted the river traffic before the Great War showing working and racing barges and larger vessels, his pictures resembling W. L. Wyllie's. WILLIAM MINSHALL BIRCHALL, an American watercolourist, continued to paint in the area and around the Thames and Channel coast until the early 1930s, in a style little changed since the turn of the century. Jack Merriott painted at intervals during the 1920s and 1930s, and the illustrator FREDERICK HARNACK. ROWLAND HILDER, an American-born painter and illustrator, pictured the Medway from the 1930s onwards very much in the manner he did the Thames, in a Wylliesque chiaroscuro which also revealed the influence of FRANK BRANGWYN.

Brangwyn himself painted and drew along the estuary before and after the Great War, during his 'barge travels' around the British coast. JOSEPH VINALL worked in the area at intervals after the Great War, as did WILLIAM ERIC THORP, at 17 years old the youngest member ever elected to the Artists' Society. LESLIE FORD of the Wapping Group and Langham Sketching Club and JOSEPH HALL both painted along the estuary during the 1930s. From the late 1940s onwards numerous painters of the Wapping Group and those working along the Thames estuary painted the landscape and increasing number of racing and pleasure craft along the Medway. EDWARD WESSON painted extensively along the river, particularly at Rochester and Chatham, pictures of which were commissioned by the Royal Engineers near the mooring of the *Arethusa* training ship. The skyline with its mingling of industrial and pre-industrial architecture set against a variety of vessels which have largely disappeared from the upper Thames docks also attracted VIC ELLIS, ROWLAND FISHER and HUGH LYNCH who painted frequently in the area until the early 1970s. Thames and Medway barges remain painting subjects of JACK POUNTNEY, KENNETH GRANT, CHARLES SAVAGE, ALAN RUNAGALL and DENNIS HANCERI.

Milford Haven
Dyfed

A flourishing resort on the A4076 backed by the beautiful, fiord-like creeks of the Daugleddau estuary, and a major terminal for super-tankers, the town was founded by Quakers who fled from America to avoid fighting in the War of Independence. Developed by Sir Charles Greville, a protector of Emma, later to be Nelson's mistress, it flourished on warships built for the Admiralty until 1814, when Greville's extortionate prices caused the removal of contracts to Pembroke Dock. The port then invested in fishing.

A London coast and landscape painter, F. W. MEYER pursued his taste for moonlit scenes here with a number of pictures in 1883. GEORGE STANFIELD WALTERS, of the Liverpool ship-painting family, toured here during the 1880s making sunrise pictures over the estuary in 1887.

The Mumbles – see under SWANSEA

The Needles
Isle of Wight

Standing in a row at the western tip of the Isle of Wight, there were once 4 Needles, until a 120-foot pillar named Lot's Wife (it resembled a pillar of salt) which stood in what is now the largest gap in the chain, collapsed in 1764. Three 100-foot chalk pinnacles remain. A red-and-white horizontally striped lighthouse dating from 1859 stands at the tip of the line, replacing an earlier cliff-top light. The Old Needles Battery on the headland now contains a gunnery museum.

The chalk stacks appeared in the background of ship-pictures by NICHOLAS and MATTHEW CONDY between the 1830s and the 1850s, and the paintings of the early steamship portraitists, F., I., J., and L. TUDGAY, working as individuals or together between 1850 and 1870. Many of their vessels are portrayed off the Kent and Sussex coasts, but many further west. JOHN HUGGINS portrayed warships off the Needles during the first three decades of the nineteenth century, and 'JOCK' WILSON at the same time.

A London artist, G. W. BUTLAND, painted the old light on the cliff-top in 1843 from seaward; C. B. HUE, *The Needles with the New Lighthouse, now in Progress*, for the British Institute in 1858. An Isle of Wight artist, GEORGE GREGORY, painted the Needles many times during his lifetime in the area, producing

five variants alone of a slightly disabled ship taking a line from a side-wheeler tug just outward from the light of 1859.

RICHARD HENRY NIBBS pictured the stacks in rear of his small passenger vessels, and W. J. LEATHAM of Brighton, as a background and as a composition in themselves between 1840 and 1855. SIR OSWALD WALTER BRIERLY pictured them during yacht-racing off the Isle of Wight as did THOMAS DUTTON, reproducing some of these yachting scenes. RICHARD BRYDGES BEECHEY pictured the 'perilous situation' of yachting-racers off the stacks as he did with the Channel Islands race during the 1830s. EDWARD TURTLE and J. M. GILBERT, island residents, portrayed them on numerous occasions, their work frequently appearing in stone lithograph. BARLOW MOORE and FREDERICK JAMES ALDRIDGE set vessels off the stacks, Aldridge painting well into the 1930s, as did GEORGE GREGORY. FRANK WATSON WOOD and

JOHN EVERETT both painted the area before the Great War.

JULIUS OLSSON produced a number of oils of the Needles area, particularly his exhibits at the big Portsmouth exhibition of 1938, *Evening Shower off the Needles* and *Becalmed off the Needles*. A marine oil-painter, TOM LEWSEY, who excelled at contemporary and past yachting and racing scenes in the Cowes and Solent area pictured the Needles frequently between 1946 and 1964, when his last R.S.M.A. exhibit was of the grand banks schooner *Bluenose* passing the Needles in 1935. JOHN MOORE, a marine watercolourist, worked in the region during the 1950s, concentrating on the lighting effects and atmosphere of the often squally coastscape. JOHN COBB, DERYCK FOSTER and TERENCE STOREY, painting contemporary and past events, have portrayed the formation as background subject.

Newlyn
Cornwall

Fishing remains the major industry of this port adjoining Penzance off the A30, when it has other-

Stanhope Alexander Forbes (1857–1947) *At Their Moorings, 1906* Oil on canvas 40½in × 62¾in (Ferens Art Gallery, Kingston upon Hull) See p. 168

wise declined or vanished throughout the rest of Cornwall.

The fishing industry attracted painters like WILLIAM INGRAM in the 1880s, and HENRY MARTIN, whose coastal pictures and genre scenes of fishing people constituted almost all his 20 exhibits at the Royal Academy over as many years. STANHOPE FORBES first visited Newlyn in 1884, and later founded the Newlyn School there in 1899, which continued under his auspices until 1939. Other members included NORMAN GARSTIN, HENRY SCOTT TUKE, FRANK BRAMLEY, IRELAND BLACKBURN, and THOMAS COOPER GOTCH. The School attracted students from all over the world, and its relatively conservative influence on coastal art was considerable. LAURA KNIGHT shared a house with the landscape and equestrian painter ALFRED MUNNINGS here between 1908 and 1913, before moving to Lamorna. JOHN GUTTERIDGE SYKES, marine artist and landscap-

ist, lived at Newlyn from 1915, until the close of his career in 1936. CHARLES GINNER, a founder member of the London Group and Camden Town Group, and essentially a landscapist, visited Newlyn during the early 1920s. ARTHUR WHITE, based at St Ives, visited and painted here during his career until c.1950. R. BORLASE SMART worked at intervals here until his death in 1947. ELLIS SILAS painted in the area from the early 1950s until c.1975. C. E. CHAMPION, watercolourist, painted in the vicinity until the mid-1950s. LESLIE KENT, studying under Fred Milner at St Ives from 1918–1920, later painted at Newlyn and visited here at intervals until the 1970s. SONIA ROBINSON, who has a particular interest in coastal and harbour scenery and is a member of the Newlyn Society of Artists, has painted in the area since the early 1950s. DAVID COBB, in 1979 President of the R.S.M.A., began painting professionally at Newlyn in 1946, moving to Hampshire in 1954.

Newquay
Cornwall

The largest resort in Cornwall and Britain's premier surfing centre, on the A392 off the A30. In the eighteenth and nineteenth centuries this was a thriving pilchard port, and became a resort after the arrival of the railway in 1875.

CHARLES NAPIER HEMY painted the pilchard fishery during the early 1870s and the harbour was visited during the last 20 years of the nineteenth century by JOHN U'REN, a watercolour artist, DUFF TOLLEMACHE and ROBERT GROVES, ALFRED WARNE BROWNE and EDMUND FULLER. EDWARD GOULDSMITH painted here near the end of the century, as did a Bristol artist, ARTHUR WILDE PARSONS. ROBERT MORSON HUGHES painted frequently here after 1910, painting seascape and harbour scenes in oil. An Australian-born watercolourist, DAVID DAVIES, who lived mostly in England after 1898, painted here at the turn of the century, and then at intervals until his death in 1924. RICHARD OLIVER BONNEY, living most of his life in Cornwall, and notable for his pure sea subjects,

painted the large seas in the area from the later 1920s onwards. During the 1970s he was President of the Newquay Society of Artists. JOAN CONNEW, a watercolourist, painted here during the late 1940s and throughout the 1950s, exhibiting with the R.S.M.A. until 1966. Watercolour painter, WILLIAM PIPER, painted in the region during the 1940s and 1950s, exhibiting *Off the Headland, Newquay*, at the R.S.M.A. in 1959. An oil and watercolourist, GYRTH RUSSELL, painter of coast, harbour and landscape, worked in the area before and after the Second World War, his opening pictures at the R.S.M.A. in 1947 being of southern Cornwall, and one of the last oils executed before his death in 1970 showing the *S.T.S. Sir Winston Churchill* at Newquay. PETER FREEMAN, watercolourist, has also painted in the area. HUGH CHEGWIDDEN, oil painter of marine still-life, sea and landscape and *trompe l'oeil*, has lived in Newquay since 1913. Some of Chegwidden's work has an almost surreal quality, rare in contemporary marine art.

North Shields – see under TYNESIDE

Pegwell Bay
Kent

A broad, mile-wide stretch of sand bounded to the N. by the low chalk cliffs just S. of Ramsgate, and to the S.W. by marshes. The traditional landing-place of the Jutland invaders Hengist and Horsa c.AD 450 and of St Augustine in 597, and site of the first –

now discontinued – international hoverport in 1968.

R. W. BENGOUGH, a London coastal artist, produced a number of pictures here and at Broadstairs during the 1830s, pleasing and conventional images, but WILLIAM DYCE's painting of 5th October 1858, *Pegwell Bay – Kent*, on occasion described as one of the most important pictures of the nineteenth cen-

tury, remains its most famous image. The picture looks westward from below the Ramsgate cliffs toward Hugin and Cliffs End in twilight, although such a particular place holds significance far beyond physical location. (see page 65).

Pembroke
Dyfed

Two small rivers produced a natural moat on 3 sides for this small market town on the A4075, overlooked by a massive castle, birthplace of Henry Tudor, later Henry VII, in 1457. A mile to the N.E., the fishing hamlet of Pater Church became *Pembroke Dock* in 1814 when the Admiralty began to build warships there, its wide straight Georgian streets forming a grid pattern. The largest wooden warship ever built, *The Duke of Wellington*, was launched there in 1852, and every Royal Yacht bar Charles II's *Mary* and present *Britannia*.

J. M. W. TURNER produced 3 pictures of the castle from the sea, with fishing vessels in the foreground, all with a stormy, torrid air, none of them with a satisfactory composition between sea and shore. The first two in 1801 and 1806, the most violent, the last in 1830 more tranquil.

A Cardiff painter, RICHARD SHORT, painted successfully here during the later 1890s, more modestly than Turner and with a quieter air.

GRAHAM SUTHERLAND first visited Pembrokeshire during 1934, and returned to the area thereafter each summer until the 1960s, and after he had become chiefly resident in the south of France. He particularly favoured the region of the river estuaries around Pembroke, their twisted driftwood and steeply sloping wooded shorelines. The Graham Sutherland Gallery, opened in 1976, is situated at Picton Castle, approx. 4 miles E. of Haverfordwest, on the Eastern Cleddau, about 6 miles N.E. of Pembroke itself. MICHAEL AYRTON, painter, designer, writer and broadcaster, painted in the area during the later 1940s, his work owing something to Sutherland and much to the Italian, Giorgio de' Chirico. JOHN ELWYN has also painted the coast here, as have NAP FISHER and JOHN ROGERS.

Pin Mill – see under IPSWICH

Plymouth
Devon

A major naval base and merchant port for over five hundred years. It was known as Sutton Harbour until 1439, and is situated on Plymouth Sound at the mouths of the Plym and Tamar. The departure-point of most major Elizabethan voyages of exploration, and later of Charles Darwin, the centre was razed by air-attack during the Second World War, but a certain amount of older building survives, including the third Eddystone light re-erected on the Hoe overlooking the Sound, the massive Citadel, and the former fortress and prison, Drake's Island.

In the mid-1790s NICHOLAS POCOCK was commissioned to paint a panoramic view of the naval dockyards at Plymouth (National Maritime Museum) which he completed in 1798. He also produced numerous oil and watercolours, including the oil *Wreck of the 'Dutton' in Plymouth Sound* and the charming watercolours of Drake's Island. A watercolourist, SAMUEL PROUT, was born and brought up in Plymouth. In 1796 he observed the wreck of the East Indiaman *Dutton* in Plymouth Sound and the experience inspired his series of monumental watercolours based on the subject of dismasted Indiamen aground. These were exhibited at the Society of Painters in Watercolours in 1819, 1820, 1822, 1824 and 1831. J. M. W. TURNER made drawings and watercolours here between 1825 and 1830, showing the bawdy fun of the men and women who supported British marine power, and the rickety town itself, its buildings shored up with timbers, and the great breakwater under construction since 1812, while ships covered the Sound and extended up the Hamoaze to Saltash. PHILIP HUTCHINS ROGERS painted here from 1808 until 1822, afterwards leaving for London, as did JAMES GRANT, resident from 1829 to 1831. A ship-portraitist, HENRY A. LUSCOMBE, lived at Sutton Place throughout his career (1854–65). NICHOLAS MATTHEW CONDY occupied a house in Devonshire Terrace during his career (1842–45), with his father NICHOLAS CONDY. He made excellent marine pictures in the Plymouth area, but died at 35 in 1851, the same year as his father. WILLIAM CALLOW painted here (see Devonport). HENRY MARTIN, a coastal and figure artist, lived here until moving to Penzance c.1885. CLARKSON STANFIELD recorded scenes here during the mid-1840s and a prolific watercolourist, WILLIAM COLLINGWOOD SMITH, concentrated on marine pictures here before 1849, many of the subjects being the Hamoaze and the outer harbour. A landscapist, CHARLES F.

William Callow (1812–1908) *Plymouth Dockyard after the Fire* Watercolour with scratching out, touched with bodycolour over pencil on wove paper 13¾in × 20⅜in (Yale Center for British Art, Paul Mellon Collection)

WILLIAMS, painted along the river Yealm 4 miles W. of Plymouth at the end of the 1860s, and in the harbour. WILLIAM WILLIAMS, a talented coastal painter, who was born in Penryn, Cornwall, in 1808, generally signed his pictures enigmatically 'Plymouth' although living most of his life in Bath and Torquay. A Bristolian, EDWARD PRITCHARD, made many vigorous, 'breezy' pictures in the Plymouth Sound waterway during the 1850s, contrasting with the more usual calms or tranquil Plymouth pictures. FREDERICK GAUBERT and CHARLES KNIGHT, the latter formerly a sailor, portrayed the trawler fleets which operated from the harbour as well as the naval shipping during the 1870s. CHARLES NAPIER HEMY visited the area from that decade; a marine watercolourist, JOHN U'REN, retired to Plymouth in 1898 but continued painting there.

GREGORY ROBINSON, painter of historical sea-pieces, was born here c.1887. Numerous pictures of his were set in the Plymouth area, although in later life he lived at Hamble, Hants. TERRICK WILLIAMS, the Impressionist, died in Plymouth in 1936. SIDNEY GOODWIN, the prolific nephew of Albert Goodwin, painted at Plymouth at intervals throughout his career (1867–1944), although chiefly in the Portsmouth and Southampton area. A watercolourist, ERNEST HARINGTON, concluded his exhibits at the R.S.M.A. in 1957 with a study of Mount Batten Castle, Plymouth, and painted here during the mid-1950s. PETER CARTER, originally an engineering designer, a member of the R.S.M.A., began painting in the Plymouth area from 1962. ELEANOR CHARLESWORTH painted in oils along the Plym during the early 1960s. DANIEL GLEESON, a pupil of Charles Napier Hemy's grandson, studied at Plymouth Art School during the later 1950s. CHARLES ERNEST CUNDALL produced numerous pictures in Plymouth during the Second World War and the early 1950s, such as *H.M.S. Exeter* at Plymouth in 1940. Thirty-six of his pictures are in the Imperial War Museum. E. W. MOYLE, marine watercolourist, worked here during 1966 and 1967. RONALD MORTON, exhibiting with the R.S.M.A. between 1967 and 1973, worked in Plymouth showing shipping, refitting yards and the estuaries. SYBIL MULLEN GLOVER, a watercolour-

ist, lived in Plymouth, and has work in the permanent collections of the Plymouth City Art Gallery.

Devonport

Now a western district of Plymouth, with which it was incorporated in 1914, Devonport was established as a naval base in 1691, and remains one of Britain's major naval dockyards. The massive covered-in, eighteenth-century ship-building slips which Turner portrayed in his *Ships being Paid-Off* (1829) remain today, including the gambrel timber roofs. These sheds were usually flooded when a ship had been built and the hull floated out.

WILLIAM CALLOW painted here, particularly watercolours recording the great dockyard fire of the 27th September 1840, when H.M.S. *Imogene* and *Talavera* were burned. NICHOLAS CONDY pictured many vessels in and out of commission here, watercolour calms which were often executed on tinted paper with a heavy use of body colour. This generally distinguishes them from the lighter work of his son, NICHOLAS MATTHEW CONDY.

Polperro
Cornwall

A fishing and tourist resort on the A387, with tightly-packed whitewashed cottages and very narrow streets from which non-resident traffic is normally banned. In 1824 a violent storm demolished the harbour breakwater, wrecked 50 boats and damaged houses; but the village continued to earn a living by fishing and smuggling. JOHN ROBERTSON REID, a pupil of William McTaggart, lived and painted here during the first two decades of the twentieth century. Reid painted in oil and watercolour, particularly harbour and coastal subjects, exhibiting at the R.A., Royal Scottish Academy, and many other London and regional venues. He died in 1925. JACK MERRIOTT, chiefly a landscape artist and portraitist, but at one time president of the Thameside Wapping Group, and a painter of estuaries and coasts, lived here through the earlier part of his career, from the early 1930s, until the late 1950s when he went to Storrington, Sussex.

Poole
Dorset

A major yachting and holiday resort adjoining Bournemouth on the A35. Within the centre of its wide, sheltered harbour, ¾-mile offshore, is the nature reserve of Brownsea Island. Poole was once a principal port for North American trade.

Toward the end of the nineteenth century the harbour and its Frome estuary attracted English Impressionists. Previously ALFRED CLINT, a devotee of the sunrise and sunset theme, regardless of its unsaleability, had painted here in the 1870s. LESLIE THOMPSON, a Scot living in London, where he exhibited over 160 paintings, painted Poole Harbour between 1887 and 1888. An Impressionist, FREDERICK WHITEHEAD, selected the harbour as a subject in the 1890s, and also his sister, ELIZABETH WHITEHEAD, normally a still-life artist, whose outdoor pictures closely resembled her brother's. TERRICK WILLIAMS made oil pictures here at the turn of the century. JOHN EVERETT lived at Corfe Castle, near Poole, c. 1900, and painted shoreside pictures in and around the harbour. AILEEN MARY ELLIOTT, etcher, oil and watercolourist, painted in Poole during the 1940s, showing pictures of the quayside at the R.S.M.A.'s inaugural exhibition of 1946. EDWARD WESSON, much influenced by Boudin, taught at Bournemouth and Poole during the 1950s, and painted in the area. EDWIN MEAYERS, watercolourist, painted harbour scenes during the mid-1950s, as did RUBY WALLACE. ERNEST FRANK WILLS worked here during the same period, producing watercolours, as did JOHN MORTIMER, again painting along the quayside. During the early 1960s, R. A. L. EVERETT painted on Brownsea Island, picturing the broad harbour in oil. ELIZABETH DEAKIN studied art here under Edward Wesson during the 1950s, and subsequently painted here. ROY ETWELL WEAVER studied at Poole Municipal College of Art during the mid-1930s. MARY WILLIAMS, a marine watercolourist, has painted at Poole at intervals from the 1950s until the late 1970s.

Porthcawl
Mid-Glamorgan

Now a busy resort on Swansea Bay, 2 miles S. of junction 37 on the M4, Porthcawl was a prosperous coal port between 1860 and 1890. Its outer harbour is filled with pleasure craft and its long beaches under high limestone cliffs the scene of surf-boarders.

RICHARD CALVERT JONES, who was taking calotype photographs in the Swansea Bay area during the 1840s, made watercolour sketches of colliers trading here. EDWARD DUNCAN visited here in the early 1860s, while staying at The Mumbles, picturing the

same vessels. They offered a subject to RICHARD SHORT, who at the height of the coal trade in the 1880s used them among his 14 Royal Academy exhibits.

Alma Claude Burlton Cull (1880–1931) *The Eve of the Coronation Review, 27th June 1911* Oil on canvas 38in × 74in (National Maritime Museum, London)

Portsmouth
Hampshire

Still a major Royal Naval port, 'Pompey' or Old Portsmouth was severely damaged during air-raids of the Second World War, but retains much of its old building, a dozen forts, two Naval museums, the preserved submarines *Holland I* and *Alliance*, the 1817 frigate *Foudroyant*, Nelson's *Victory* and Henry VIII's *Mary Rose*. A major ferry-port to the continent and Isle of Wight, its harbour is usually crowded with naval ships and between 3,000 and 4,000 yachts.

JOHN CLEVELEY THE YOUNGER executed pictures of the Spithead review of 1773 although he was on an Icelandic cruise at the time and his father drew the source pictures of the event. The same subject was commemorated by DOMINIC SERRES and FRANCIS HOLMAN. Serres produced a great number of water-colours and oils of vessels at Portsmouth, particularly of reviews. He was followed keenly in this by his son, JOHN THOMAS SERRES, who also worked at the port as part of his duties as 'Draught-Man to the Hon. Board of the Admiralty' between 1720 and

1780. NICHOLAS POCOCK painted what is generally considered his *calm* masterpiece in oil, *The Ships in which Nelson Flew His Flag . . .* (1812) set off Spithead. Pocock painted oils and watercolours frequently here between 1790 and 1815, the watercolours as usual superior to his oils.

Artists of the Dutch tradition worked in Portsmouth because of the subject-matter offered by the large naval vessels. JOHN M. WHICHELO, between 1810 and 1844 'Official Marine and Landscape Painter to H.R.H. the Prince Regent', set many pictures in the harbour from 1812 onwards. WILLIAM JOY and JOHN CANTILOE JOY settled at Portsmouth during the 1850s, painting oils and watercolours of the large sailing and steam-sailing vessels and warships until the mid-1860s.

WILLIAM ADOLPHUS KNELL produced crowded watercolours of Queen Victoria's visit to the fleet and the massive flagship *Duke of Wellington* in 1853, the 3-decked sailing warship contrasting with the steam paddle-wheeler Royal Yacht *Fairy*. The diverseness of the shipping attracted landscape and subject painters like ROBERT DUDLEY and resulted in pictures such as *Her Majesty's Armour-Clad Turret Ship 'Monarch' Having on Board the Remains of George Peabody, Leaving Portsmouth Harbour for America* (1870), the ship rather than the deceased Peabody being the stimulus. SIR WALTER OSWALD BRIERLY, best known for his magnificent lithographs and engravings, produced work set here from the 1830s to 1860s, especially during his period as marine painter to Queen Victoria. The far lesser-known JAMES MAULE was more typical of visiting inshore artists who made views here during the 1840s, seeking a safe sale on the popularity of the place; SAMUEL JACKSON, GEORGE GAUBERT and WILLIAM SMITH all worked the area at that period. E. W. COOKE worked here frequently during his middle career, as did CLARKSON STANFIELD. He included Portsmouth in his coastal series of the late 1840s, and both he and Cooke used the harbour for reference and source studies.

W. F. MITCHELL, a ship-portraitist and watercolourist, was resident in Portsmouth from 1860 until 1907, painting all the major ships which entered the harbour. A meticulous observer, he consecutively numbered all his pictures, some 3,500 in all. Many of these ships have no other surviving visual record; others offer great contrasts, such as the wooden sailing 3-decker H.M.S. *Victoria* and the gun-terraced armoured steamship *Victoria*, Admiral Tryon's flagship, of just thirty years later.

The great WILLIAM LIONEL WYLLIE kept a studio on the outskirts of the harbour from the later 1880s until his death in 1931. His brother CHARLES WILLIAM WYLLIE painted at Portsmouth, able to utilize his brother's studio: his *Portsmouth, Ebb Tide* went to the Chantrey Bequest for £100 in 1881. HAROLD WYLLIE, W. L. Wyllie's son, lived at Portsmouth c.1900 to 1910. Later a council member of the R.S.M.A., he exhibited 3 pictures at the big marine painting exhibition held there in 1938. ALMA CLAUDE BURLTON CULL under commission from Edward VII painted the fleet at the Coronation Review here in 1911, among the best paintings of Dreadnoughts made during the Edwardian period. PRESTON CRIBB, a Birmingham illustrator and marine artist, studied in Portsmouth during the mid-1890s, and illustrated vessels there before and after the Great War. SIDNEY GOODWIN, carrying the style of work of the nineteenth well into the twentieth century, painted numerous watercolours at Portsmouth well into the 1930s. HILARY STRAIN, who married Harold Wyllie,

lived and painted at Portsmouth during the first decade of the century.

CHARLES PEARS, the first President and a founder of the Society of Marine Artists (1939) contributed 5 pictures to the big marine show of 1938 and produced numerous pictures set in Portsmouth, particularly during the 1930s. CECIL KING, marine and landscape artist, showed 7 naval pictures at Portsmouth during 1936 and 4 in 1938. LT COMDR J. S. DALISON, who painted naval subjects for 10 years between 1938 and 1948, painted here during the late 1930s. ROWLAND LANGMAID, better known for his portraiture, also pictured vessels at the 1938 Portsmouth exhibition, in a style similar to that of W. L. Wyllie showing the *Victory* 'dressed' on Trafalgar Day. WILLIAM HENRY LUDLOW, painting throughout the 1950s and 1960s, produced pictures of the small-boat harbours of Tichfield and Hayling which became more frequent from mid-century, such as *Summer Shower over Tichfield Haven* (1969). LESLIE KENT, a prolific painter of sailing vessels, also painted in the Tichfield and Hayling area during the 1950s and 1960s. WILFRED JEFFERIES worked in Portsmouth from the late 1940s until 1969, showing vessels and waterfront scenes. DAVID HOLMES, while senior lecturer at Portsmouth Polytechnic and Vice-Chairman of Portsmouth European Centre during the 1970s, lived and painted around Hayling Island. The self-taught HUGH KNOLLYS, who served in the Royal Navy for 27 years, painted various pictures at and near Portsmouth from 1947 onwards, reflecting the past and present of the port. His work is permanently on show on H.M.S. *Nelson*, H.M.S. *Ambushade* and H.M.S. *Glasgow*. FRANCES PHILLIPS, influenced by Pissarro, Sisley and Sargent, who advised her in her method of painting the sea 'free, like hair', painted in the Solent and Portsmouth area until the later 1970s. WILLIAM CARTLEDGE made watercolours in Portsmouth harbour during the 1950s. In the 1960s RAY EVANS and CAPT. ROGER FISHER, who illustrated the Silver Jubilee Review, painted in the harbour. DAVID COBB, President of the R.S.M.A., member of the Board of Governors of H.M.S. *Foudroyant*, was commissioned in 1978 to execute 17 oils depicting the Battle of the Atlantic, and 2 series of pictures of the naval Pacific war for the collection of the Royal Naval Museum at Portsmouth.

Ramsgate
Kent

One of the trio of Thanet resorts together with Margate and Broadstairs. This town rose to prominence in the early nineteenth century with superb Regency terraces curving up on either side of the harbour. It remains one of the busiest on the S. coast, and was the landing place of 82,000 troops evacuated from Dunkirk in 1940.

PHILIPPE JACQUES DE LOUTHERBOURG included it in his tour of the S.E. coast c.1795.

The beach is the one portrayed in WILLIAM POWELL FRITH's *Life at the Seaside* (1854) bought by Queen Victoria at the Royal Academy for 1,000 guineas. A marine painter, WILLIAM BROOME, lived during the 1880s in Spencer Square; Ramsgate Public Library possesses three pictures of Broome's concerning the wreck of the *Indian Chief* on the Kentish Knock (signed 1881), the rescue of its crew by the Ramsgate lifeboat which is towed into harbour by the steam tug *Aid*, and the lifeboat lying off the South Goodwin lightship. These pictures were reproduced as oleographs and sold as fund-raisers for the Royal National Lifeboat Institution, and can often be seen in the public and private houses in the Ramsgate area. Broome also painted many valuable pictures recording the transition of sail to steam in ocean-going ships. An author and marine watercolourist, PETER FREDERICK ANSON, who exhibited with the R.S.M.A. from 1939, became a monk at St Augustine's Abbey, Ramsgate, in 1958. A founder member of the R.S.M.A., LESLIE JOSEPH WATSON crewed a 30-foot yacht out of Ramsgate during the 1930s, and painted there before and after the Second World War. ROWELL TYSON, whose modernist approach makes his work distinctive in marine art, lives at Ramsgate.

Rochester – see under MEDWAY

Runswick
Yorkshire

In 1682 the original Runswick village fell into the sea from erosion. The later houses and cottages of this village on Runswick Bay, 7 miles N. of Whitby, are spread along the foot of the brown, terraced cliffs.

A Manchester artist, FREDERICK WILLIAM JACKSON, worked here and made numerous pictures between 1885 and 1903.

William Broome (1838–1892) *The Wreck of the 'Indian Chief'* Oil on canvas 29in × 19in (Ramsgate Public Library)

Ryde
Isle of Wight

A tiny fishing settlement that grew into a major holiday resort after the building of a mile-long pier in 1814, Ryde has a great number of fine Regency and Victorian buildings and a wide sweep of sand, which at low tide extends almost a mile out to sea.

W. A. FOWLES of Ryde was born and lived throughout his career here. He did not exhibit in London and his pictures are slightly naïve in concept and technique, but the best are of a high quality. One is at Ryde Town Hall and the National Maritime Museum in London has three. There is dispute as to whether he was born in 1840, or worked from that date until 1860. His *Schooner 'Alarm' off the Eddystone* is dated 1852 (which would make a working age of 12 years if born in 1840) and an oil of the *American Yacht 'Alice'* is as late as 1875, so his work flourished between these dates. FREDERICK IFOLD, a figure painter, made beach-scene pictures here in 1848, when Ryde had become a middle-class resort offering him a subject. EDWARD TURTLE lived in Union Street here throughout his career, picturing most coastal areas of the Isle of Wight over his 44 working years, including *Chalk Bay, I.o.W.* (1840) at the Royal Academy, and 7 at the Suffolk Street Galleries. HAROLD WYLLIE was painter to the Royal Yacht Club here during the 1930s.

Rye
East Sussex

A picturesque port on the Rother and A259, noted for its eighteenth-century 'Mathematical' tiles and

striking medieval appearance. Once a great smuggling centre, many of the houses have interconnecting attics which offered escape from excise officers. Rye Harbour, 1½ miles to the S.E., and quite distinct from Rye along the Rother Estuary, has a quay and slipway subject to a dramatic tide variation. J. M. W. TURNER painted the estuary during visits of the 1820s, one painting showing horses galloping with beach carts along the causeway there to escape the incoming tide.

JOHN THORPE painted tranquil scenes of vessels being repaired in Rye Harbour in the late 1830s. P. POWELL pictured Coast Blockade ships at Rye in 1842. CLARKSON STANFIELD made careful watercolours in the late 1840s, which appeared in his volume, *Coast Scenery*, of 1847. JOHN BRETT, sailing around the coast after his rows with Ruskin, painted watercolours here, following his own devices, and a Scot, LESLIE THOMPSON, portrayed the fishing vessels during the 1890s. SIR FRANK BRANGWYN and SIR FRANK SHORT both drew and painted here: Brang-

wyn, when he had left William Morris's workshops and was living as a barge-boy along the S. coast in the mid-1880s, and Short throughout the later 1880s, and 1890s, work which he ultimately produced as etching and mezzotint.

In 1925 PAUL NASH settled at Idden near Rye, on return from a visit to Florence and Siena, the coast there contrasting with that at Dymchurch, where he had painted in the early 1920s. At Idden he produced a large number of landscapes but the coastscapes of that time formed a transition between the semi-abstract of Dymchurch Wall, such as *Winter Sea* (1925–1937) and paintings like the surreal *Totes Meer* of the 1940s. NEVILLE PITCHER, who painted marine subjects from c.1907, and exhibited with the R.S.M.A. from 1946 until 1958, lived in Rye until his death in 1959. LEOPOLD PASCAL began his R.S.M.A. exhibits in 1952 with a view of Camber Sands, near Rye, the year S. B. ROBERTSON RODGER painted hulks at Rye Harbour.

St Aubin – see under JERSEY

St Brides Bay – see under FISHGUARD

St Helier – see under JERSEY

St Ives

Cornwall

During the nineteenth century this holiday resort and artists' haunt on Carbis Bay at the end of the A3074 was the largest pilchard port in Britain, exporting fish as far as the Mediterranean. The harbour wall of 1770 was designed by John Smeaton. It was 'discovered' by artists during the late nineteenth century, and *Dual Form*, a sculpture by Barbara Hepworth, standing outside the Guildhall, is testament to its reputation: there are numerous art galleries reflecting contemporary coastal painting and a sizeable art community.

In the winter of 1883–4 J. A. McN. WHISTLER and WALTER RICHARD SICKERT visited the town and harbour and the region began to attract painters of the 'English Impressionist' movement as well as those working in more traditional style. Of the latter, an Exeter-based seascapist, FRITZ ALTHAUS, visited after 1893; during the same decade ALFRED WARNE BROWNE produced pictures of mediocre quality raised after his move to Cornwall in 1896. EDMUND G. FULLER was resident at St Ives throughout his productive period of 1894–1904, producing such pictures as *The Sun-Kissed Foam* (1899), *Cornwall's Iron-bound Coast* (1902), and *Crossing the Bar* (1904).

BRYAN HOOK, a Surrey painter who worked extensively along the Cornish coast, and the watercolourist SAMUEL JACKSON worked here at the end of his career in the late 1890s. CHARLES MOTTRAM painted in the area in the 1890s, and moved permanently to St Ives in 1901, producing pictures such as *A Stiff Breeze off Godrevy* (1903). A Londoner, HENRY MUSGRAVE, made some rather robust pictures in the late 1880s, and JOHN REID, leaving London for Cornwall permanently in 1904, painted shoreside pictures of fisherfolk during the 1890s. EDWIN HAYES, working in a far freer style, concentrated on the deserted shore and sea at the same period. The Impressionist, TERRICK WILLIAMS, although Graves' *Dictionary* describes him as 'domestic' painted marines in the area from the end of the century. During the 1890s members of the future Newlyn School, FRANK BRAMLEY, THOMAS COOPER GOTCH, NORMAN GARSTIN and HENRY SCOTT TUKE and STANHOPE FORBES produced work in the area.

The fisherman ALFRED WALLIS was 'discovered' in St Ives by CHRISTOPHER WOOD and BEN NICHOLSON who saw his primitive pictures there in 1928; his paintings had a cardinal influence on Nicholson and his writings in *Unit One*. PETER MOFFAT LINDER, marine and landscape painter in oil and watercolour,

lived at St Ives through most of his long career, c.1872–1949, painting widely along the S. and W. coast, and on the Continent. LOUIS GREER lived the greater part of his life there, dying in 1920. MAURICE PHILIP HILL, member of the St Ives Society of Artists, lived and painted there from 1892 to 1952. JOHN ROBERTSON REID, pupil of William McTaggart, visited during the first decade of the century, while living in Polperro, Cornwall. JULIUS OLSSON lived at St Ives from 1890 until 1911, when the Chantrey Bequest bought his *Moonlit Bay* and he moved to London. LESLIE KENT studied at St Ives under FRED MILNER from 1918 to 1920. WILLIAM PARKYN was resident here during the last twenty years of his career until his death in 1949. MARY McCROSSAN, a Liverpool artist, settled at St Ives in 1931, where she stayed for the final 3 years of her career. An oil and watercolourist, ARTHUR WHITE, lived and painted at St Ives where he was born (1865) until his death in 1953. Most of his work was exhibited with the Royal Institute of Oil Painters. R. BORLASE SMART, pupil of Julius Olsson, lived at St Ives from the turn of the century until his death in 1947. A moonlit study of the port in oils was his last major exhibit. ELLIS SILAS, Sickert's widely-travelled pupil, visited the harbour after a 3-year expedition to Papua New Guinea; his *H.M.S. 'Wave' Ashore at St Ives* is in the National Maritime Museum.

HUGH RIDGE, practising marine oils, lived at St Ives during his career c.1949–1976. SHEILA MacLEOD ROBERTSON, best-known for her studies of skyscape, wave and rock formations, has produced much work in the area, as a member of the St Ives Society of Artists. SONIA ROBINSON, another member of the Society, has painted distinctive harbour studies here, as has BERYL SEDGWICK, a musician until 1962, who began painting in 1964. C. E. CHAMPION, watercolourist, painted here during the mid-1950s. RODNEY BURN was elected President of the St Ives Society of Artists in 1963, and painted in the area during the 1950s and later 1960s. HOWARD BARRON worked in the area until 1961, when he pictured French fishing vessels in the harbour. LILY BARNARD, who painted all aspects of the sea since the early 1930s became a member of the St Ives Society of Artists in 1962, and lived at St Ives thereafter.

St Mawes – see under FALMOUTH AND ST MAWES

St Michael's Mount

Cornwall

A granite island rising to 300 feet in Mount's Bay. The Benedictine priory of 1135 was dedicated to the Archangel said to have appeared in 495 to local fishermen.

J. M. W. TURNER made 3 watercolours of 'Mount St Michael'. The first was engraved in 1814 for his 'Southern Coast' series, the second in 1835 for *Milton's Poetical Works*, and the third in 1837 for the 'England and Wales' series. He made an oil in 1833. He used the castle on the island as the usual device to symbolize wreck and decay, ruin and salvage, in 1837 depicting timber beneath the ruins being divided on the beach to be sold. HAROLD JOHN JOHNSON digressed from his classical landscapes to make watercolour coastscape, including *Mounts Bay – Squally Weather* after a visit of 1850. His work has been much praised by Martin Hardie, the authority on watercolour, who especially admired Johnson's draughtsmanship and study of boats. A watercolourist, JAMES GEORGE PHILP, painted here in 1853, like Turner picturing wrecks on the Cornish coast, and another watercolourist, JOHN MOGFORD, chose the ebbing tide here in 1863. JOHN CALLOW also used the medium for shipping scenes here in the 1860s, often dramatic and owing much in style to William his elder brother. HARRY COLLS, a London painter, used oil for the pictures he made here after a visit of 1888, shown in London in 1889. HENRY MOORE, marine painter, worked here during the 1890s, as did EDWIN HAYES at the turn of the century. Hayes produced a number of powerful 'pure sea' pictures, of which *Harlyn Bay* is possibly the best known. JULIUS OLSSON painted in the bay before the Great War. ROBERT BORLASE SMART, his pupil, painted here before and after the Great War. ELLIS SILAS pictured coastal compositions here. ARTHUR WHITE worked here during the 1930s, as did MAURICE HILL.

Marine painter STANLEY ROGERS painted here in 1946, his pictures being in the R.S.M.A.'s inaugural exhibition that year, and CHARLES SIMPSON painted storms here during 1947.

Overleaf Joseph Mallord William Turner (1775–1851) *St Michael's Mount, Cornwall* Watercolour on paper 12¼in × 17½in (University of Liverpool)

St Peter Port – see under GUERNSEY

Saltash
Cornwall

A small market town on the A38 with narrow streets, and seventeenth- and eighteenth-century buildings, on the Cornish side of the Tamar; it is connected to Plymouth by the spectacular Royal Albert railway bridge of 1859 and a graceful suspension bridge of 1961.

J. M. W. TURNER's watercolour of marines going ashore here in 1825 was praised by Ruskin in Volume One of *Modern Painters* for its beauty and accuracy of reflections, although the letterpress accompanying the engraved work described Saltash as 'narrow and indifferent'. Turner portrayed the town as a pyramid of buildings with the tower of St Nicholas chapel at the summit.

Sark
Channel Islands

The last feudal state in Europe, Sark is governed by the seigneur J. M. Beaumont, who inherited his title in 1974 on the death of Sibyl Hathaway, Dame of Sark. Only bicycles and horse-drawn transport are permitted on the island 3 miles long and 1½ miles broad.

THOMAS PHILLIPS visited during his tour of the fortifications of the Channel Islands in 1679–80, although Sark has no fortifications.

R. H. HUE painted the heights of the E. coast during the early 1850s; ARTHUR BELLIN, a London marine artist who worked extensively in the Channel Islands, made two of his Royal Academy exhibits on Sark, including *The West Coast of Sark* (1882) from the heights above Havre Gosselin and Gouliot Passage which divides Sark from the tiny, privately-owned Brechou Island, and *The End of Little Sark* (1882), the far southern promontory, one of three pictures in the Suffolk Street Galleries.

Scarborough
North Yorkshire

A major resort, fishing and cargo port on the N.E. coast, connected to the A165, A64, A170 and A171. The Vikings gave the name 'stronghold of Skarthi' to the high grey headland which separates Scarborough's twin bays, where the Romans had previously built a signal station. Later a medieval castle dominated the crag, and it is the chief coastline feature in the majority of nineteenth-century marine pictures

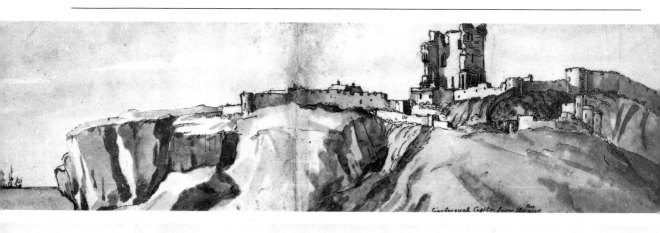

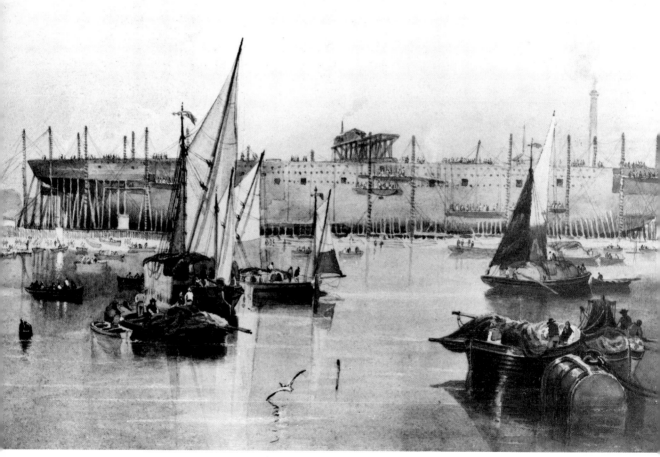

Top Francis Place (1647–1728) *Scarborough Castle from the North West* Pen and wash drawing on paper 4⅜in × 16⅝in (British Museum)

Above James Wilson Carmichael (1800–1868) *The Building of the 'Great Eastern'* Watercolour 8½in × 12⅝in (National Maritime Museum, London)

of Scarborough. The massive Grand Hotel, ¾ mile to the S., was the largest brick building in Europe when completed in 1868. The art gallery includes numerous pictures by the Hull School.

FRANCIS PLACE made line and watercolour drawings of Scarborough Castle and the headland on a

visit during the 1680s. This is probably the earliest marine view of Scarborough.

A watercolourist, HENRY BARLOW CARTER (fl.1827–30) was born in Scarborough in 1803, dying there in 1868. Many of his pictures recorded the S. coast (Plymouth), but those of the N.E. are of a high quality. JOSEPH N. CARTER lived here, most of his work shown at the Portland Gallery between 1857 and 1860, before it closed in 1861. THOMAS CHAMBERS of 18 St Nicholas Street painted shoreside scenes of the herring and lobster fishery during the 1850s. The far better-known FREDERICK CALVERT produced some excellent paintings set offshore, with shipping in choppy seas off the town and its high headland, portraying the buildings rising in terraces of contrasted light and shade. JAMES BURTON worked in the port during the 1830s. Another artist who generally worked on the S. coast, JOHN THORPE, visited in 1842, picturing the Scarborough light. WILLIAM J. CALLCOTT worked in the area during the 1850s, particularly portraying the castle from the harbour and shipping. A Newcastle-upon-Tyne artist, JAMES WILSON CARMICHAEL, died in Scarborough in 1868. RALPH STUBBS painted coast scenes in the region over a period of 30 years until the late 1880s. ALBERT STRANGE lived and painted at the resort c.1883, and taught at the School of Art, Scarborough. CHARLES THORNELY travelled frequently from London from 1858 to 1898 to work in the area. HENRY REDMORE of the Hull School made many versions of fishing vessels off the harbour as did JOSEPH McINTYRE during the 1870s and 1880s. JOHN ATKINSON GRIMSHAW painted a number of his evocative dock scenes here in the 1880s, and NELSON DAWSON recorded the new steam trawlers returning to harbour at the end of that decade, including them among his 14 R.A. exhibits. ERNEST DADE was a native of Scarborough, returning there on leaving Chelsea in 1887, and although described as specializing in 'seashores' painted those and offshore pictures at Scarborough. A Bristolian, EDWARD GOULDSMITH, made paintings with a grey northern light during his visit of 1891.

LESLIE JOSEPH WATSON went to sea with herring drifters during the 1930s, sailing out of the port, and painted the coastal region and shipping here. GEOFFREY WILSON pictured the herring fishery during the late 1950s and early 1960s. JOHN COOPER, a specialist at painting the working trawlers of the E. coast, has painted the harbour and the North Sea vessels here since the mid-1960s.

Sennen Cove – see under LAND'S END

Shoreham-by-Sea
West Sussex.
Originally a small fishing village built on a spit ½-mile wide caused by the river Adur turning and running parallel to the sea for a mile along the shore. On the opposite bank is Southwick, part of the conurbation of Brighton and Hove. There are superb views from the fishing harbour down the coast.

JAMES BURTON, essentially a landscapist, painted along the coast here in the 1830s, showing the mixture of fishing craft (with their sails set on the beach), tourists and townscape which is typical of photographs up to the Edwardian period. JAMES BARNICLE, a prolific coastal painter with 123 London exhibits, painted the harbour in the early 1830s, and ALLAN F. BARRAUD the 'Shoreham Luggers' of the 1870s.

THOMAS F. CLARKE, exhibiting work from 1932 to 1960, painted oils here during the late 1940s, picturing the foreshore and the fishing vessels. SYBIL JEPSON, watercolourist, opened her R.S.M.A. exhibits in 1954 with *Relics of the Past, Shoreham*. FRANK FRIEND, working along the S. coast in oil and watercolour between 1957 and 1975, visited Shoreham, picturing *Merlin Rocket, off Shoreham*, in 1974. ROXANE LOBANOW-ROSTOVSKY, picturing marine still-life, produced a powerful picture in the later 1970s of dead sea birds reduced almost to an abstract pattern set against the angular concrete of the Shoreham defences along the tideline, in a style reminiscent of 1930s' surrealism.

Southampton
Hampshire
The long inlet of Southampton Water is lined by 6 miles of docks and has been Britain's main passenger port for two centuries. Until the Second World War it was associated with the great trans-Atlantic Cunard liners and the Supermarine Aviation works which built the racing seaplanes which won the Schneider Trophy. Despite extensive war damage it still retains much sixteenth-, seventeenth- and eighteenth-century building. Southampton Art Gallery has an extensive collection of British nineteenth-and twentieth-century marine and landscape paintings.

DOMINIC SERRES produced various delicate and

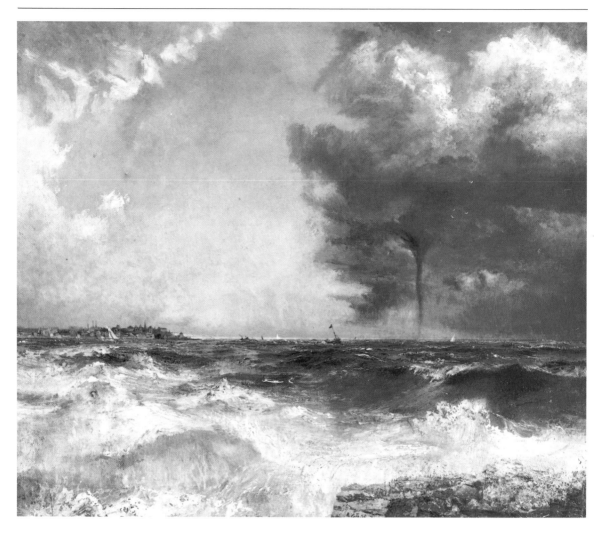

Richard Eurich (1903–) *Waterspout in the Solent, 1954*
Oil on canvas 20in × 24in (Private Collection)

tranquil watercolours of Southampton Water, such
as vessels off Calshot Castle, which closely resemble
those of Robert Cleveley. WILLIAM SHAYER lived
throughout his career at Southampton; he exhibited
426 pictures in London, many showing fisherfolk
and harbourside scenes in the area. GEORGE CHAM-
BERS JR, son of the famous George Chambers of
Whitby, lived and worked in the region. His pictures
of Southampton have a loose, impressionistic tech-
nique unlike those of his father. F. K. OFFER, an
almost unrecorded artist from Hampshire or Dorset,
is known largely for his calm coastal scenes in
Southampton Water. JAMES BARNICLE painted quay-
side scenes in the 1830s. WILLIAM FREDERICK MITCH-
ELL was born at Calshot Castle in 1845. He painted

as an amateur until recognized by Griffin's of The
Hard, Portsmouth, who as his agents published
chromolithographs of his men-of-war. Mitchell
specialized in picturing wrecks, warships and yachts,
working mainly for naval officers, and appears to
have been deaf and dumb. A Nottingham artist,
HENRY DAWSON, was typical of his peers in his R.A.
exhibit of 1866, *Southampton Water, Calshot Castle
and the Isle of Wight*, in reflecting the taste for
narrative panoramic marine view. THOMAS DEARMER
worked similarly in making views of Southampton
from below the Itchen's Ferry, upriver from the
port, in the 1850s.

LEONARD C. ALFORD was resident at Southampton
from 1885 to 1904, most of his R.A. exhibits pictur-
ing the area. ROBERT LESLIE, a prolific and successful
marine artist with a wide range of London exhibits,
retired to Southampton, painting the port and traw-
ler fleets in the Solent. GEORGE PONTIN, etcher and

oil painter, lived at Southampton from 1898 until the Great War. SIDNEY GOODWIN, Albert Goodwin's nephew, was resident here from 1912 until 1917, where he pictured vessels of all kinds in a lighter if traditional style resembling that of his uncle.

HAROLD WOODS, a watercolourist, painted in the dockyards in the late 1930s, contributing to the Portsmouth exhibition of 1938. EDGAR PULLIN pictured the busy stretch of Southampton Water in 1946, and painted at intervals here until 1960. Watercolourist DOUGLAS ETTERIDGE painted the dockyards in the early 1950s, when ARTHUR MACKAY was portraying evening scenes on Southampton Water in oil. NANCY HEARSEY worked in oil in the Solent area during 1954 and 1955 as did DAVID BIRCH in 1958

and 1959. WILLIAM HENRY LUDLOW's last exhibits at the R.S.M.A. in 1969 were of the inner harbour and pier at Southampton.

ROBERT KING, painting at Southampton and Norfolk, has produced many pictures of the area, as has RICHARD EURICH. One of the most powerful images of the Solent is his *Waterspout* painting of 1953, a stark contrast to the vast mass of bland small-boat pictures churned out by scores of third-rate painters in the area. Eurich settled at Dibden Purlieu, near Southampton, after the Second World War. A self-taught, Bristol-based painter, MAURICE TAYLOR made a number of early pictures in the Southampton waterway, especially of the working tugs of the port, rather than the sailing vessels.

Southend-on-Sea – see under LEIGH-

ON-SEA

Southwold

Suffolk

Formerly a prosperous fishing village and now a small, elegant Regency town dominated by the high, shimmering white tower of Southwold Light, and arranged around seven 'Greens' which mark the site of buildings never rebuilt after a fire of 1659. The town was often molested by Dunkirk raiders, and the S. end is dominated by Gun Hill, originally mounting six cannon that were already 150 years old when George II parsimoniously supplied them at the public's request in 1745.

THOMAS PHILLIPS executed drawings of the Battle of Sole Bay, when the Dutch launched a surprise attack upon the Anglo-French fleet at anchor off the port in the late spring of 1672. A plan of the battle, inscribed by the Younger van de Velde *1672 felips*, was also made by Phillips and may imply a closer professional relationship with the Dutch painters. The Dutch were forced to withdraw only after a savage fight portrayed in 7 paintings by the VAN DE VELDES, executed as designs for 5 tapestries now at Hampton Court, and the Dutch artists' first major commission from Charles II.

CHARLES TAYLOR SR painted the high light here during the 1840s, and fishing and squall scenes off the coast. C. H. MARTIN pictured the light during the end of the decade, and vessels close-hauled under

a strong wind. FRANCIS MOLTINO painted the coast and fishing vessels off the harbour in the early 1860s and J. F. BRANEGAN early in 1871.

ALFRED CONQUEST, a landscape and coastal painter, was typical of his time and genre, painting *From Southwold Pier* in 1886, a view now gone as the pier's seaward end was destroyed in the storms of 1979. JAMES CALLOW painted coastal scenes here during the 1880s, as did ERNEST DADE, c.1889. GEORGE STANFIELD WALTERS worked here, c.1890–1895, and HENRY MOORE during the last 10 years of the century. PHILIP WILSON STEER also made watercolour work here while at Walberswick. MUIRHEAD BONE, visiting the area during 1913, made drawings, and etchings set to the S. of the town, near the ferry. CAMPBELL A. MELLON painted in the area during the 1930s.

F. W. BALDWIN, watercolourist, painting along the Suffolk coast during the 1950s, painted tidal scenes here in 1953 and 1954. DOROTHY BILLINGS worked here at the same period, showing the wind-blown atmosphere of the open coast. By contrast, LAWREY VORHEES painted quiet water studies here in the early 1970s, shown at the R.S.M.A. in 1973 and 1974. HUGH KNOLLYS painted along the river estuary here in 1979, recalling a wind which capsized his subject boats and blew his palette into the water.

Staithes

North Yorkshire

A fishing village on the A174 at the seaward mouth

of a steep gorge which marks the North Yorks/ Cleveland border, approx. 8 miles N.W. of Whitby. James Cook the explorer was apprenticed to a hab-

erdasher in Staithes for 18 months in 1744. GEORGE WEATHERILL, a painter later associated with Whitby, was born at Staithes in 1810. He was an excellent watercolourist, and his daughter Mary an accomplished painter as was his son, Richard. MARY WEATHERILL was also a coastal painter, exhibiting 6 pictures in London. The family moved to Whitby in 1869.

The village was the site of an art colony between c.1884 and c.1910. It comprised between 25 and 30 artists, the most notable being GILBERT FOSTER, FREDERICK JACKSON, JAMES BOOTH, CHARLES MACKIE, FREDERICK MAYOR and LAURA KNIGHT. FREDERICK MAYOR, whose work showed an influence of Frank Brangwyn, produced a large number of coastal pictures in the area from the early 1880s, generally in watercolour and bodycolour (opaque watercolour), until c.1914. CHARLES MACKIE, whose great concern was the effect of one colour upon another, working during the same period, exerted a powerful influence on Laura Knight whose prime concern was the life of the fishing community there, for which she had initially been inspired by the Newlyn painters. The atmosphere at Staithes was harsher than at Newlyn, which was mirrored in her pictures. She moved to Newlyn in 1910. FRANK WALSEY worked at Staithes during the late 1880s and early 1890s, before leaving Whitby for the South West in 1903.

Sunderland

Tyne and Wear

Britain's major ship-building centre after the Clyde, and equally famous during the nineteenth century for its lustre-ware pottery, usually displaying the cast-iron span of the Wearside bridge beside the port and shipping. This span of 1796 was replaced in 1929 by a vaulting, red-and-white girder arch.

WILLIAM ANDERSON was born in Sunderland in 1757 and trained as a shipwright here. Like Samuel Scott, he initially made his name at the R.A. with such compositions as *The British Squadron going into the Tagus with Spanish Captured Ships* (1798) but he portrayed many coastal scenes off the area of Sunderland at the mouth of the Wear, and northward on the Tyne. His work is said to have influenced John Ward of Hull, where he painted after the turn of the century.

STUART BELL trained here as a theatrical scene painter in the mid 1840s (the occupational beginning of numerous marine artists), and his coastal pictures of the region have a prime asset of illustration: narrative action; they also convey the coldness and bleakness of the offshore North-Sea fishery.

JAMES WILSON CARMICHAEL painted here c.1850, and HENRY REDMORE of the Hull School at intervals during the 1870s. ROBERT F. WATSON visited here during the 1860s, and ERNEST DADE at the end of the 1880s. ARTHUR HESLOP made pictures in the region before the Great War.

FREDERICK WILLIAM HOPPER was the General Manager and Director of William Pickerskill's Shipyard, Sunderland, from the early 1920s and for the next 38 years designed every vessel built by the yard. He painted a picture of each ship, which was presented to each female launching sponsor. He was a specialist in steam vessels dating from 1891 (the year of his birth). TERENCE LIONEL STOREY, a prolific painter and illustrator, was born in Sunderland in 1923, studying at Sunderland School of Art. The wide range of his subject-matter (including aircraft, protraiture and landscape) includes scenes of the Sunderland area. MARY WILLIAMS, a watercolourist, has work in the permanent collections of the Sunderland Museum.

Swansea (Abertawe)

West Glamorgan

'The metallurgical capital of Wales' was another small fishing village which became a major industrial port by the early nineteenth century. Its hinterland supplied cheap coal and copper ore: by 1850 the port handled 10,000 cargo ships a year. Zinc, tinplate and copper smelters dominated the skyline for 150 years; these industries declined rapidly in the early 1950s. A university town, Swansea has landscaped much of the dereliction since 1970, and pursued new industries to support its cultural centres.

NICHOLAS POCOCK produced numerous watercolours of the Swansea Bay area, visiting it initially as the master of a Bristol merchantman, the *Lloyd*. Some of these views show the coast in 1790 toward Neath and the Briton Ferry, from 'Neath Bay' before the landscape was built over. In 1802 he illustrated the coal boats and merchantmen in watercolours of great charm. The REV. CALVERT JONES, an excellent marine and figure artist, was born in Swansea, c.1804. Jones became rector of Loughor (near Swansea) in 1829 and having private means painted for his own enjoyment, finding no need to exhibit in London. An enthusiast of calotype photography, he nonetheless studied in the studio of GEORGE CHAM-

BERS, at the probable recommendation of JAMES HARRIS of Swansea. His work is excellent, but did not receive proper recognition until 1973. Many of his pictures portray the port of Swansea, and southern Welsh cargo vessels. He died in 1877. Usually recorded as 'Very little known', JAMES HARRIS arrived in Swansea, c. 1828, when about 18 years of age, with his father JOHN HARRIS, also a painter, and became established as a carver and gilder at 40 Wind Street. He went to sea in copper-ore freighters, and made the acquaintance of the marine painter, GEORGE CHAMBERS, who gave him tuition. His work was bought by the principal local families and ship-owners, and on the death of his father in 1836 he maintained the business for the next decade. He was a friend of EDWARD DUNCAN, who visited him here; his son-in-law was the eldest son of SAMUEL WALTERS of Liverpool. In 1844 he moved to the fashionable quarter of Swansea, The Mumbles. Although not so talented as Calvert Jones, his work commanded prices in the 10–15 guinea range late in his career. A Bristolian, EDWARD PRITCHARD, painted in Swansea during the 1850s, as did his fellow Bristolian GEORGE WOLFE. These artists often showed the oyster-fishery and the spectacle of sunrise over the windy sweep of the coast here. GEORGE FREDERICK GAUBERT also showed this aspect of Swansea during the middle decade of the century. J. H. HARRISON, probably a seaman, possibly a master mariner resident at 4 Rodney Street, was painting in Swansea, c. 1900, often picturing Westcountrymen trading at Swansea.

The Mumbles

A high headland to the S.W. of Swansea Bay, now joined to Swansea by a long promenade lined by hotels, pubs, shops and amusements. The name probably derives from the colloquial Welsh for a pair of female breasts which the outcrop vaguely resembles.

NICHOLAS POCOCK included this headland and shore in his watercolours of 1790, the light, blueness of his pictures reflecting the clear, long distances typical of the area. CALVERT JONES pictured it throughout his career, over the period when it became the fashionable playground of the industrial port. JAMES HARRIS moved here in 1844 and painted here until 1882, before leaving for Reynoldston in Gower. EDWARD DUNCAN visited the region during Harris's residence. His own watercolours, strong in blue and green, concentrate on the shoreside oyster fishery and inshore craft.

Tarbert

Strathclyde

A thriving fishing port and resort on a mile-wide isthmus separating Loch Fyne in the E. from West Loch Tarbert and access to the Sound of Jura in the W. Formerly the chief port of the Loch Fyne herring industry, fishing is still its major occupation together with tourism.

KATE MCCAULEY painted the herring fleets and crowded quays here during the 1880s. An Edinburgh painter, MASON HUNTER, worked in Kintyre during the 1890s, picturing the harbour in twilight in 1895. The little-remembered Glasgow artist, ANDREW BLACK, painted here during the early 1880s, making quayside pictures among the trawlers.

ALBERT GORDON THOMAS painted at Tarbert frequently throughout the 1950s until the early 1960s, his first R.S.M.A. exhibits being the reflections in the harbour.

Tenby

Dyfed

Daniel Defoe described Tenby as 'the most agreeable town on all the south coast of Wales, except Pembroke' after a visit of 1724. In Welsh *Dinbych-y-Pysgod* – 'Denbigh of the Fish' – it is now a flourishing resort on the A478, its harbour one of the most attractive in Britain, overlooked by ascending ranks of well-proportioned Georgian and Regency buildings.

NICHOLAS POCOCK made a number of energetic watercolours, notable for their (now faded) blue light, of Tenby during 1789, where he had traded as a merchant captain out of Bristol.

JOHN MOGFORD, a watercolourist, worked here in 1858 and 1859, painting in the harbour and Lydstep Bay. GEORGE ALBERT ADAMS, on an excursion from the S.E. coast, painted the spectacular rock scenery which lies to the S. and N. towards Saundersfoot, in a visit of 1863. GEORGE AUGUSTUS WILLIAMS made night and moonlit scenes in the harbour and off the coast during the early 1870s.

SIDNEY CAUSER, a watercolourist, painted at Tenby during the mid-1930s and exhibited pictures of the area at the Portsmouth marine exhibition in 1938.

AUGUSTUS JOHN, brother of the portraitist and landscapist Gwen John, was born here in 1878 leaving here during the early 1890s to attend the Slade School in London. John returned here during the

1920s, when he painted extensively in Wales in the company of J. D. INNES and DERWENT LEES. His pictures were flamboyant, highly coloured and very often indistinguishable from those he made in Dorset or the South of France, saying more about John than they did about the coast. DAVID JONES, essentially a landscapist who stayed at Eric Gill's art colony in Capel-y-ffin, near what was then the Monmouthshire border, visited Tenby during the later 1920s, painting on Caldy Island, in Carmarthen Bay, about 2 miles offshore from Tenby. In the later 1930s, and subsequently during the 1960s, GRAHAM SUTHERLAND painted here and along much of the Pembrokeshire Park coast.

Thames Estuary

Pool of London
Tidal waterway extending from the wharves E. of London Bridge through Tower Bridge at St Katherine's Dock, giving access to the deep-water docks above Greenwich Reach. Commercial dockyards which expanded from the mid-sixteenth until the late nineteenth century, and at their height c. 1900. They declined rapidly after 1945.

Limehouse, Wapping and Surrey Dock
Wharves and warehouse areas from the eighteenth until the late twentieth century on the N. and S. bank of the river E. of the Pool of London, now being extensively redeveloped.

Deptford
During the early eighteenth century the most important naval dockyard in England, immediately to the W. of Greenwich, on the southward curve of the Thames at Greenwich Reach. Separated from Greenwich by Deptford Creek.

Greenwich
Site of Royal Palace of Greenwich, Royal Naval College and National Maritime Museum. Now a major tourist area, on the S. bank of the river opposite the Isle of Dogs, a deep-water dock area.

Blackwall
A dockyard area 1½ miles E. of Greenwich which expanded after the decline of Deptford, notable for merchantmen and frigates built there during the early 1800s.

Woolwich
During the eighteenth century an extensive naval dockyard and naval training centre, on the S. bank of the river 5 miles E. of Greenwich. It remained so until after the Great War.

Erith and Dartford
Ports on the S. bank of the river 10 miles E. of Woolwich, now large commercial and residential areas, extensively redeveloped.

Tilbury
Tilbury on the N. bank 9 miles E. of Dartford is a complex of container docks, although ¾ mile inland it remains almost rural.

Gravesend
Opposite on the S. bank this was initially a ferry port and is now the headquarters of the Port of London Authority's Thames Navigation Service. It offers superb views of the Essex shore.

ISAAC SAILMAKER was employed in recording shipping on the Thames during the 1650s, when he pictured the Commonwealth fleet – ships noticeably free of grandiose carving – lying off Mar Dyke, 1½ miles N. of Dartford. The VAN DE VELDES, WILLEM THE ELDER AND YOUNGER, recorded shipping and incidental Thameside views as their background from 1672 until c. 1703. Their first major work was Charles II's visit to the combined English and French fleets below Gravesend on the 5th June 1672, on the eve of the Battle of the Texel. Their formal pageant commissions included James II's coronation with decked barges and wherries, sightseers and pontoons with figures holding fireworks below Greenwich Reach. Willem the Elder pictured the departure of William of Orange and Princess Mary for Holland (Nov. 1677) downriver on the Mary yacht, the basis of his son's picture of the flotilla becalmed at Erith on 19th Nov. Downriver at Gravesend Willem the Younger recorded the arrival of Princess Mary (wife of William III) from Holland in 1688, the Mary yacht flying the white standard reading 'For the Protestant Religion and the Liberties of England'. The picture shows a scene crowded with yachts and warships and the church-tower of Gravesend along the line of the coast. From 1672 both artists had studio facilities in the Queen's House, Greenwich (now part of the Nat. Maritime Mus.), until moving to Westminster in 1685.

PETER MONAMY, of Channel-Islands' origin, worked as a sign-painter at London Bridge c. 1700, where he began painting shipping in calms on the Thames. Most of his compositions were closely based on the van de Veldes', and his river scenes are general in location. JOHN CLEVELEY THE ELDER was

Samuel Scott (1701/2–1772) formerly attributed to Peter Monamy (1684/6–1749) *The Old East India Wharf at* *London Bridge* Oil on canvas 63in × 54in (Osterley Park, London)

born at Deptford, c.1712, the son of a shipwright, and remained registered there as belonging to the ship *Victory*. Cleveley made numerous riverside pictures concerning the Deptford yards: the launch of the *St Albans* records an event; there are 3 variations on the theme which also show ships lying in the river which never came up to the naval yards there, and the river is used as a backdrop for their departure. He also recorded royal river pageants at Greenwich and Erith. Most of SAMUEL SCOTT's general working drawings appear to have been made on the spot along the wharfs from Deptford, Wapping and Greenwich, but in the notational style of the van de Veldes. In the 1750s he carried out oil pictures at Westminster, Wapping and downriver at Cuckold's Point. JOHN CLEVELEY THE YOUNGER studied drawing under PAUL SANDBY at Woolwich in the mid-1760s, and made a large number of watercolour drawings of vessels in the Thames in the area. DOMINIC SERRES painted (and organized) a number of pageants on the Thames between 1760 and 1790, as a marine painter instigating the firing of salutes by ships at the opening of the Royal Academy in 1768. CHARLES BROOKING was born in Deptford, c.1723, and grew up in the shipyards there. JOHN THOMAS SERRES painted wharfside pictures at Wapping and Shadwell during the 1790s, genre pictures similar to those of Samuel Scott. NICHOLAS POCOCK made aerial panoramic views of Woolwich dockyards during the later 1780s, which reveal his lack of practice at architectural drawing but his great knowledge of ships. The diarist and painter JOSEPH FARINGTON painted views of the Deptford yards at the period, for which Pocock painted the ships.

From c.1790 J. M. W. TURNER began to record riverside scenes in the London Bridge, Tower and Wapping area, a mixture of Hogarthian narrative and Romanticism; between 1800 and 1830 he produced numerous oils and watercolours of the tidal reaches from Waterloo Bridge and London Bridge, the Tower and the docklands areas. His projected series, 'Picturesque Views of London' to be engraved by Heath, never came to fruition, but in the mid-1820s he made drawings and watercolours for this as far as Woolwich. His oil of the warship *Téméraire* being towed to the breaking-yard at Rotherhithe in 1838 is the best known of his Thames pictures. GEORGE CHAMBERS painted few scenes on the Thames river itself; his decoration of the inn, *Prospect of Whitby*, where he lodged on his arrival in London, c.1830, helped establish his reputation, where 5 members of the Langham Sketching Club conceived the Wapping Group in 1947.

A prolific landscapist, CHARLES DEANE, painted along the Thames during the mid-1820s to late 1830s, at Limehouse Reach (1829), Woolwich, Greenwich, the Pool, and upper reaches where the city and dock skyline dominated the waterway. ELIAS CHILDE worked along the lower tidal estuary during the 1830s: approximately three-quarters of his work was landscape, but the tidal Thames alternated with the Kent and Sussex coast made up the remainder. Prolific in oil and watercolour, Childe had 495 London exhibits between 1798 and 1848, 59 in the R.A., 114 in the British Institution, and 314 at the Suffolk St Galleries. JOHN DUJARDIN SR frequently worked in the Mar Dyke and Gravesend area between 1830 and 1860, a 'landscape' painter who used the broader Thames reaches for coastscape. About a quarter of his 59 pictures at the British Institution were in this category. His Thames pictures overlapped in date with those of his far less prolific son, JOHN DUJARDIN JR, with whom he is frequently confused. Dujardin Jr, classified as a sea painter, actually did less work in the field than his father. His largest Thames work was a view of Greenwich which he painted jointly with JAMES WEBB in 1857, shown at the British Institution in 1858. C. M. HAWTHORNE painted along the lower estuary from Greenwich and Woolwich down to Gravesend between 1833 and 1844, concentrating on the barges and fishing smacks of the region. ALFRED HERBERT, whose pictures often resembled those of JOHN CALLOW, selected the same subject and region as Hawthorne during the later 1840s and 1850s, as did RICHARD LEITCH. FRANCIS MOLTINO, watercolourist, painted at the Pool of London during 1865 and 1866, and in the lower tidal estuary. These Pool scenes preceded the Venice subjects with which Moltino ended his career.

BARLOW MOORE, painter to the Royal Thames Yacht Club, began painting Thames barges in the later 1860s, in the Greenwich region and the other river traffic before moving to Erith late in his career. HENRY PETHER, specialist like his father, ABRAHAM, in moonlit scenes, painted extensively in Greenwich and downriver from 1850 to 1865. Graves' *Dictionary* lists him in error as living in Greenwich, but he was actually a resident of Camden and Clapham. GILES FIRMAN PHILLIPS lived at Greenwich from 1836 to '38. His 17 R.A. exhibits included 9 Thames scenes; he painted at Blackwall and Greenwich in 1837 and in the Isle of Sheppey district in the early 1840s, and Erith in the later 1840s. He was a prolific painter with 103 London exhibits, 50 in the Suffolk St Galleries and 16 at the New Watercolour Society. S. D. SKILLET lived at Limehouse and produced a large selection of tidal Thames pictures in the Limehouse, Wapping, Greenwich and Blackwall areas between 1845 and 1856, such as his *A Squall in Blackwall Reach* (1841). He had 8 R.A. exhibits, 4 at the British Institution, 3 at the Suffolk St Galleries and

the remainder at other London galleries. ROBERT CROZIER exhibited 11 pictures at the R.A. between 1836 and 1848, 7 of them scenes in the tidal Thames between the Pool and Gravesend. So were 4 of the 5 he showed at the British Institute. WILLIAM CRAMBROOK, a landscape and marine painter, pictured the upper areas around the Pool of London, particularly when he moved from Deal to central London from 1840. G. W. BUTLAND painted along the tidal length during his chief working period, 1831 to 1843, while living at Greenhithe in the late 1830s and then his period in Fulham, before leaving London. During the early 1840s he made pictures at Half-Way House and Reach, very similar to paintings he made on the Medway. C. DOWNTON SMITH painted in the region of Greenwich, Erith and Greenhithe during the early 1850s, mainly river traffic scenes of barges and moored vessels.

C. E. STRONG lived at Gravesend at the beginning of his career, 1851 to 1853, before moving to Dartmouth. Most of his Thames pictures were set there and upstream as far as Leigh, showing barges and shrimpers. A Peckham landscape artist, WILLIAM WARREN, painted along the lower Thames, particularly Tilbury during the late 1860s, including two *Sunrise off Tilbury* shown at the British Institution in 1866. EDWARD CHARLES WILLIAMS, one of the talented Williams family of artists, painted numerous coastscapes at the mouth of the Thames estuary during the last 20 years of his career, between 1850 and 1865. GEORGE AUGUSTUS WILLIAMS of the same family painted a small number in the same region during the early 1860s. GEORGE CHAMBERS JR worked along the lower Thames from 1848 until the later 1850s, from the area of Greenwich Reach eastwards.

W. D. DOUST, living at Greenwich between 1859 and 1864 (at 7 Horseferry Road 1859–1860, and 7 Sophia Place, 1860–1864), preferred to paint at the mouth of the estuary, off the Isle of Grain and the entrance to the Medway. J. A. McN. WHISTLER painted extensively along the Thames between Battersea and Tower Bridge, between 1859 and the late 1880s, tonal studies referred to as 'symphonies' and 'nocturnes' (see page 75). FREDERICK WINKFIELD painted chiefly tidal Thames scenes (apart from coastscape) between 1873 and 1904. His subjects extended from the upper Pool down Greenwich Reach, Blackwall and as far as Gravesend and the Medway. He exhibited 76 pictures in London, with 21 at the R.A. and 27 at the Suffolk St Galleries. R. J. BIDDLE exhibited watercolours of the barge traffic in the Pool and the lower estuary between 1877 and 1882. FREDERICK WHITEHEAD painted many excellent quasi-Impressionist pictures in the region in the later part of his career, between 1880 and 1904, particularly in the Greenwich Reach area. T. HALE

SANDERS specialized in river scenes but particularly the tidal Thames; 5 of his 10 R.A. exhibits were of this subject. Between 1874 and 1898 he painted along the length of the estuary from London Bridge down to Sheerness. FRANK MURRAY made pictures in the London docks area, particularly the Pool between 1876 and 1892, usually concentrating on the ocean-going steamers, their overhaul and refitting. A typical R.A. exhibit of Murray's was *Dry Dock on the Thames* (1885). He undertook various commissions for the P & O Steamship Company, and his 1899 R.A. exhibit was a panel from the frieze he painted for their board room.

ROBERT GALLON painted along the lower estuary during the 1890s. His style gave a marked sense of space which suited the wide but crowded body of water from Greenwich to Gravesend. CAPT. ALEXANDER MAITLAND exhibited 17 paintings in London between 1887 and 1904, 13 at the R.A. With a number of tidal Thames subjects. Maitland found the barge flotillas especially attractive, as did CHARLES DE LACY. From the mid-1880s until 1918 de Lacy worked as an illustrator and painter, and a great number of his pictures concern the Pool of London and the area of Limehouse and Greenwich Reach. His style, like that of EDWARD FLETCHER and CHARLES DIXON, reflected William Wyllie's. Edward Fletcher painted widely along the length of the estuary from c.1880 until 1910. The greater part of his work was in the region of Tower Bridge as far as Greenwich but he also produced a large number of pictures of the estuary further eastwards. ADOLPHE RAGON painted along the estuary during the 1890s, particularly towards Gravesend and Dartford where the breadth of the river with large cargo vessels became more marine in atmosphere. GERALD M. BURN, who had a taste for painting the new armoured sail-less battleships built during the last 15 years of the nineteenth century, recorded their construction and launching on the Thames: H.M.S. *Sanspareil* in 1887 and one of the pre-Dreadnoughts of 1899 were both R.A. exhibits.

WILLIAM LIONEL WYLLIE painted the tidal Thames throughout the duration of his career, from c.1870, but most often around the Pool of London and on the wide estuary below Dartford. His studies of Thames barges became the model for many imitators through the course of the twentieth century, although after he moved to Portsmouth in 1906 his work had a south coast stress. FRANK WASLEY, a Whitby artist, moved to Henley-on-Thames in 1914 and painted a number of pictures of the tidal Thames in a freer manner than Wyllie but with the same atmospheric contrast of light and dark on the industrial river. He favoured the region of London Bridge and the Pool, as far as Greenwich. JACK MERRIOTT,

Philip Wilson Steer (1860–1942) *Low Tide, Greenhithe*
Watercolour wash on paper 8¾in × 12in (Tate Gallery,
London)

later President of the Wapping Group, painted along
the river from c.1925, until his death in 1968. PAUL
AYSHFORD, 4th Baron Methuen, marine, landscape
and figure painter who studied under Sickert, and
trustee of the National Gallery and Tate Gallery
1938–1945, Staff Captain London Monuments and
Fine Arts Officer 1940–1944, painted numerous pic-
tures along the Thames before the Great War and
during the Second World War. The Imperial War
Museum has 3 oils depicting invasion craft being
built at the West India Docks. JOHN EDGAR PLATT
painted wartime traffic on the Thames during both
wars and victory celebrations upon it. MARTIN
HARDIE, a watercolourist and art historian, painted
along the upper and lower river, his last pictures at
the R.S.M.A. being made in 1951 near Lower Hal-
stow. FREDERICK (FID) HARNACK, illustrator of *Yacht-*

ing Monthly and *Ships and Shipping*, painted the lower
river and seaward reaches at intervals from the 1920s
until the late 1960s.

The painter and illustrator, ROWLAND HILDER,
much influenced by W. L. Wyllie, began painting
along the Thames while a student at Goldsmiths'
College, New Cross (near Deptford) in 1921 and
later when he lived at Blackheath overlooking the
river. His work covers the transition from the last
sailing cargo vessels to container craft and tourist
nostalgia, although Hilder frequently repeated the
images he made in the 1920s and 1930s from the
Pool to Dartford well into the 1970s. American-born
WILLIAM MINSHALL BIRCHALL painted ocean-going
sailing vessels and Channel craft on the Thames
estuary well into the 1930s, in a style very much of
the late nineteenth century.

ERIC RAVILIOUS, while employed as a War Artist,
pictured the destruction of mines at Sheerness during
the early months of 1942, drawing the roughs of the
finished pictures beside the mine-disposal group and
later producing a watercolour entitled *Dangerous*

Work at Low Tide. The prolific ARTHUR BURGESS made oil and watercolours in the London docks throughout his career, c.1900–1957, particularly in the late 1940s. CURTIS DELMAR-MORGAN, watercolourist, painted at the lower estuary, around Canvey Island, between 1946 and 1947. REGINALD DAVIS painted in watercolour at the confluence of the Thames and Medway during 1950–1952, as did SNOW GIBBS, a landscape painter who indulged in a brief marine interlude at the turn of the decade. JOSEPH HALL worked in the same area in the same medium at that time. During the 1950s ERNEST HARINGTON painted along the river, especially in the Greenwich area, on a theme of 'industrial' and 'waterside' Greenwich. NANCY HEARSEY painted at Greenwich at the same period. MAX HOFLER painted further up the curve of Greenwich Reach in the Surrey Docks area between 1947 and 1950 as did GEORGE RAFFAN.

ARTHUR KNIGHTON-HAMMOND worked in watercolour and pastel at Greenwich in 1949: *The Thames from the Ship Hotel, Greenwich*. A watercolourist, DOROTHY HUTTON, better known for flower pictures, painted in the area of the Pool during a Royal visit of May 1954. A member of the Wapping Group, CHARLES MIDDLETON painted along the lower Thames, as did R. H. PENTON from 1947 until 1955, his pictures of past and present ranging up to Blackwall (just below Greenwich) down as far as Tilbury, picturing grain ships, drifters and warships. RODNEY WILKINSON painted in the Greenwich Reach area in 1952; FRANCES WATT less usually painted upriver at Chelsea in the later 1950s, concentrating on the smaller river-craft that were to become more common later. Until 1950 the oil and watercolourist, JOSEPH VINALL, had painted on the upper river and the Pool. In 1946 he worked at Limehouse Reach, where JOHN VIDEAN painted in 1951/52, and along the wharfs near London Bridge. During this period LESLIE FORD, a member of the Wapping Group and Langham Sketching Club, produced watercolours of *The Thames from Tunnel Pier* and a series of 'Gateway to London' pictures. Throughout the 1950s ANNE CHRISTOPHERSON painted a series of pictures at Greenwich now in the collections of the National Maritime Museum. HENRY JAMES DENHAM produced some of the last pictures of his career at the Pool of London between 1947 and 1950. JOHN S. SMITH produced Thames pictures in the early 1950s, including the somewhat prematurely titled *Last of the Thames Paddlers* (1954).

EDNA GUY, living opposite the Thames at Cheyne Walk, Chelsea, exhibited Thamesside pictures with the R.S.M.A. from 1950 until 1966, showing rivercraft in the mist, Battersea and a number of views originally painted by J. A. McN. WHISTLER and now in their latter-day guise. CHARLOTTE HALLIDAY worked along the river during the later 1950s and 1960s, exhibiting Thames pictures with the R.S.M.A. between 1960 and 1964. ALAN MIDDLETON worked in oil in the London Bridge and Pool area during 1961, the period when FRANK BELCHER made some of his last pictures, the oil, *After Rain at Blackfriars*, and watercolours of Blackfriars and the Nelson Dock. He died c.1963. FRANCIS LEKE painted down the river at Gravesend at the same time. From the early 1960s JEAN BARHAM began exhibiting pictures of the tidal Thames, especially of the area around Greenwich and St Katharine's Dock, the latter transformed by redevelopment during the later 1970s. Her work later appeared at the World Trade Centre, in the gallery of the *Cutty Sark* clipper, and in the form of a Greenwich mural, *The Barge Race*. DOROTHY BILLINGS, oil and watercolourist, painted in the area from 1951 to c.1960.

The artists of the Wapping Group, BERNARD BOWERMAN, VIC ELLIS, ROGER FISHER, JOHN ALFRED DAVIES, PETER GILMAN and GORDON HALES worked regularly along the length of the tidal river after the formation of the Wapping Group in 1948. DENNIS JOHN HANCERI of the group, KENNETH GRANT, ERIC THORP and JOSIAH STURGEON produced pictures of the seaward reaches of the river more frequently than the upper areas throughout the 1960s and 1970s, as the docklands declined. MAUREEN BLACK, living at Blackheath, a founder member of the Greenwich Printmakers Association, and working in oil, gouache, acrylic and egg tempera, produced a wider variety of subject along the docklands during the 1970s. TERENCE STOREY, in the subject tradition of the van de Veldes and Samuel Scott, pictured warships and the royal yacht upriver during the Jubilee celebrations of 1977, although the images lacked the vitality of the seventeenth- and eighteenth-century subjects. JACK DENNIS POUNTNEY, STEPHEN THOMPSON and KEITH CHARMAN painted along the Pool and lower river, although usually recording barges for their greater visual interest. The same subject-matter has engaged ROGER REMINGTON, ALAN RUNAGALL, CHARLES SMITH, BERT WRIGHT and CHRIS ARNOLD of the Wapping Group, usually from Gravesend to Greenwich Pier. PAMELA DREW, official artist to the RAF from 1953–1959 and notable for her pictures of ship-building and deck superstructure, produced some more vigorous paintings of the industrial Thames during the late 1960s, and *The Arrival of Francis Chichester in 'Gypsy Moth IV' through Tower Bridge 7th July* (1967). JOHN ALAN HAMILTON executed 60 pictures of the marine fighting of the Second World War during the mid-1970s (Imp. War Mus.) now on permanent display on H.M.S. *Belfast*, moored below Tower Bridge.

Tilbury – see under THAMES ESTUARY

Torquay – see under BRIXHAM AND TORQUAY

Tyneside

Tyne and Wear

A conurbation of resorts and docklands extending inland from Tynemouth to Newcastle-upon-Tyne. In 1838 Finden's *Ports and Harbours* observed that, 'in consequence of the danger of the entrance to Shields Harbour in stormy weather with the wind from the eastward, more vessels are lost here than at any other harbour in Great Britain'. The headland beyond the Tyne's mouth is capped by the yellow-walled ruins of the Benedictine Tynemouth Priory, a dominant feature in much nineteenth-century painting. The salt-sea wind has eroded the gravestones all around it. Beyond stands a statue of Nelson's colleague, Admiral Collingwood, and the Watch House of the Volunteer Life Brigade and museum of wrecks and coastal rescues. The seafront curves away in crescents of white hotels. Long Sands beyond the headland run N. to Whitley Bay.

A Sutherland artist, WILLIAM ANDERSON, painted inshore pictures here during the earlier nineteenth century, the versatility of his Dutch style which usually portrayed calms showing storms and the Tynemouth lifeboat in 1824. The marine painter, JAMES WILSON CARMICHAEL, was born in Newcastle-upon-Tyne in 1800. Carmichael painted widely along the Northumberland coast, and in the south, and Thames Estuary, as well as Tyneside. He died in Scarborough in 1868. J. M. W. TURNER made what has been described as his most tragic 'wrecker' picture set here in 1829–30, showing brigs going aground and breaking up beneath the Priory while the beach is covered with men eagerly hauling the wreckage ashore. Their sheer number and orderliness implies they are wreckers; meanwhile a lifeboat goes out under the black void of storm to another ship.

Between the 1840s and 1860s ROBERT F. WATSON spent part of each year in the town painting along the N.E. coast, especially *Flamborough Head* and *Shields Bar* with trawlers and colliers at the mouth of the river. In 1860 he was able to ask 100 guineas for *Shields Harbour, the Great Coal Port*, at the British Institution. A watercolourist, WILLIAM COLLINGWOOD SMITH concentrated upon coastal subjects here before 1849, again stressing the hazards of the Tyne coast in titles such as *Brig on the Rocks at Tyne in a Gale of Wind* (1845). ALFRED WILLIAM HUNT made vigorous watercolours here during the mid-1860s, particularly the superb *Blue Lights, Tynemouth Pier*, the iron foreground structures shown with a Pre-Raphaelite finesse.

JOHN F. SLATER painted here at intervals from c.1911 until 1936, after he had become resident at Whitley Bay, Northumberland. ARTHUR HESLOP, a Newcastle artist born there in 1881, painted marine subjects in oil and watercolour in the area until his death in 1955. CHARLES NICHOLSON, master mariner and accomplished watercolourist, painted the Tyne shipping until 1952, having sailed from the area since the Great War. ALAN COOK, living at Whitley Bay, painted the shipping on the Tyne until 1974, having exhibited oils and watercolours of the estuary and waterfront with the R.S.M.A. since 1959. ROBERT C.D.LOWRY painted along the Tyne in the late 1960s, first exhibiting pictures of Tyneside with the R.S.M.A. in 1968 and submitting pictures there until 1974.

North Shields

Now part of the conurbation of the Tyne waterfront, a trawler port at the base of a high steep hill, with a thriving fish market. CHARLES NAPIER HEMY began painting here at Sea View House during the late 1850s, before spending three years in a Dominican monastery. A Newcastle painter, ROBERT JOBLING, executed moonlit scenes of the dockland and river. JAMES WILSON CARMICHAEL of Newcastle made early pictures here before going to the S. coast. JAMES FRANCIS DANBY pictured North Shields at dawn on the river in 1864, the silhouettes of sailing vessels and paddle-steamers in the clear light, resembling the work of the American luminist, Fitz Hugh Lane, itself inspired by Robert Salmon.

Opposite Alfred William Hunt (1830–1896) *Travelling Cranes, Diving Bell & etc. on the Unfinished Part of Tynemouth Pier* Watercolour 12¾in × 10⅝in (Christopher Newall)

Overleaf Henry Moore (1831–1895) *View of Robin Hood's Bay, near Whitby* Oil on canvas 11½in × 17⅜in (Christopher Newall)

Walberswick

Suffolk

A village at the end of the B1387, on the S. bank of the River Blyth which separates it from the boat-yards of Southwold. Once a flourishing port and now a centre for small-boat sailors.

The Impressionist, PHILIP WILSON STEER, visited in 1884, and in subsequent years during the decade. He made a large number of watercolour pictures along the long beach S. of the Blyth and the marsh-lands to the S.W., which did much to establish his early reputation. DAVID MUIRHEAD BONE, working in East Anglia during 1913, drew around the area and later published etchings of the Blyth and Walberswick ferry. Although associated with architec-tural and industrial scenery, he later produced a great body of marine pictures in the North Sea area as an official war artist, and the Walberswick work was some of the earliest he made in a coastal area. The architect, CHARLES RENNIE MACKINTOSH, later nota-ble for his landscape subjects, drew and painted here between 1914 and 1915, the sea and land appearing to interlock in his pictures as though both were solid objects. CAMPBELL A. MELLON, who had studied under Sir Arnesby Brown after the Great War, when over 40, painted along the coast here during the later 1920s and 1930s. PHYLLIS MAY MORGANS, working in oil, watercolour, gouache and egg tempera, book illustrator, demonstrator and critic, has lived and worked at Walberswick since the 1960s.

Wapping – see under THAMES ESTUARY

Whitby

North Yorkshire

An old whaling-port on the A171, 16 miles N.W. of Scarborough. St Mary's church has many memorials to whalers, and the Abbey, founded c.670, stands on the headland above the town. It was the home port of the explorer James Cook, all of whose vessels were built at the Fishburn Yard there.

GEORGE CHAMBERS SR was born in Whitby in a tenement court (now gone) below the headland, and earned his living filling coal sacks at the dock until 1811, before going to sea. From 1820 he worked for three years as a house-painter and ship-portraitist, before leaving for London. His portrait of Whitby for ship-owners in London led ultimately to Royal commissions at Windsor. He was followed by his sons, especially GEORGE and WILLIAM HENRY CHAMBERS, as well as his younger brother, WILLIAM, and the Weatherill family of Whitby. MICHAEL SCURR was born here in 1800, and THOMAS DOVE, a Liverpool painter whose rare surviving work closely resembles Chambers', and who studied under him, died here in the Infirmary in 1887. RALPH STUBBS JR, a native of Hull, painted primarily in Whitby between 1860 and 1888. The watercolourist, GEORGE WEATHERILL, born at Staithes, settled in Whitby, c.1869. His few London exhibits meant his reputation remained local during his lifetime despite substantial talent. His daughter, MARY WEATHERILL, also a coastal painter, exhibited half a dozen pictures in London.

EDMUND JOHN NIEMANN, generally a landscapist, produced a number of fine marine pictures at Whitby, such as *Wreck on Whitby Scar* (1869). A London artist, FRANK OSWALD, had selected Whitby Scar for his marine pictures of 1864. JOHN A. GRIMSHAW stayed and worked in Whitby during the early 1880s, and a Birmingham artist, JAMES VALENTINE JELLY painted some superb, small-scale pictures of the inner harbour in the late 1890s, concentrating on minute areas which were self-contained. SAMUEL JACKSON did watercolours with a perspective low on the foreshore, revealing the height of the cliffs and buildings of the distant town. J. EVERARD, a barely recorded artist with an illustrator's style, produced pictures with a slightly stiff, formal charm during the late 1880s. By contrast, JAMES AIKEN and RICHARD BAGSHAW made breezy, open, offshore pictures during the 1890s typical of the early Edwardian image of the North Sea fishery.

FRANK WASLEY, a highly talented post-Impressionist, lived and painted in Whitby c.1880 until 1903, when he moved to Weston-super-Mare. He only achieved deserved notoriety in the 1970s. ERNEST DADE, a Scarborough artist, painted at Whitby after his return to the N.E. in 1889; in the 1914–1918 war he painted a powerful picture now in the Imperial War Museum, *A Convoy Passing Whitby High Lights*, and continued to visit there until his death during the 1930s. His work is now rare.

DAVID FELL, a Yorkshire artist, who has developed a watercolour technique he refers to as 'waterline', has painted a large number of pictures of Whitby and its surroundings, quaysides and vessels, since the early 1950s. Between 1971 and 1978 he held 14 one-man exhibitions throughout the N. of England, contributed to *Britain in Watercolour*, and his work appears in permanent collections in Oldham, Halifax, Amsterdam, and private collections in Europe and America.

Whitehaven

Cumbria

From a small hamlet with one 9-ton vessel, the *Bee*, this town on the A595 grew into a major coal port, laid out by the Lowther family on a gridiron pattern, the first town in England deliberately planned since the middle ages. Two of the Lowthers' pits, the Duke of 1747 and the Wellington of 1840, had their buildings designed to resemble ruined castles. The Haig colliery still runs out beneath the sea, but the tourist trade has replaced iron and coal in a town of fine Georgian and Victorian buildings. It was attacked in 1778 by a Scots-American, John Paul Jones, who attempted to burn 3 merchant ships and failed. There is a museum and art gallery.

ROBERT SALMON was born in Whitehaven, the son of Francis Salomon, jeweller and silversmith, in 1775, 3 years before Jones's raid. His earliest known work, *Two Armed Merchantmen Leaving Whitehaven Harbour* (1800), was followed by his first Royal Academy exhibit, *Whitehaven Harbour*, in 1802. It is not known when he left the town, and that he was native there has only been established since 1967. Salmon's successor in Liverpool, JOSEPH HERD, was born in Whitehaven in 1799, the son of a saddler. His first exhibit, *Portrait of a Gentleman*, was in the Whitehaven exhibition of 1826. His earliest ship-picture is dated 1828, of the Whitehaven-built steamer, *Countess of Lonsdale*, although he probably studied initially under the portrait-painter George Sheffield the Elder of Wigton. He left for Liverpool c.1833.

J. M. W. TURNER may have visited to paint nearby Cockermouth Castle. A fine picture of 1834 for the 'England and Wales' series on the theme of wrecks shows the coast towards Whitehaven from just off-shore, with coffins riding in the whirling, sucking swell, the distant port in sunlight, and a dark squall symbolizing death and hardship blowing in off the sea.

Winterton-on-Sea
Norfolk

A village 16 miles N.W. of Cromer on the B1159 off the A149. When Daniel Defoe visited Winterton in 1725 he wrote that half the houses in the village were constructed from the timber of wrecked ships. The number of vessels lost off the 'corner of England' made the region as notorious as Happisburgh, 8½ miles to the N.W. The huge 132-foot tower of Winterton church served as a warning landmark and contains the flotsam of scores of wrecks. The wide, sandy beaches are backed by massive sand dunes that stretch northward and southward.

FRANÇOIS LOUIS THOMAS FRANCIA, who so influenced Richard Parkes Bonington, visited here in 1815; he rarely painted a direct location and concentrated on seascape, but pictured the wreck of the *Providence* here in that year.

Woolacombe Sands
Devon

A 2-mile-long stretch of sand beneath the gorse-covered whale-backs of Woolacombe Down, just S. of Woolacombe on the B3343. N. of the resort itself cliffs and a rocky foreshore replace sand, a stretch of coast subject to the second largest rise and fall of tide in the world.

The Pre-Raphaelite, ALBERT GOODWIN, visiting Ilfracombe, painted the long beach during the 1880s, his delicate, precise watercolours reflecting the natural world which he believed was a continuing revelation of God.

Worthing
West Sussex

Until the 1780s Worthing was merely a collection of fishing cottages near the village of Broadwater; it is now the largest resort in West Sussex, on the A27, approx. 7 miles W. of Brighton and Hove.

A marine oil and watercolour painter, FREDERICK JAMES ALDRIDGE, lived at Worthing throughout his life, from 1850 until 1933, painting along the S. and W. coasts, and attending the regattas at Cowes for 50 consecutive years. His work is of very high quality in watercolour, less so in oil, which was a less usual medium for him. His later pictures show a blend of sailing and steam vessels which make them fascinating period references; he carried his style well into the twentieth century. BENTINCK CAVENDISH DOYLE, a marine (and flower) painter, lived at Worthing from 1916 until the end of his career in 1928. EDWARD LESLIE BADHAM, who painted largely along the Sussex coast, worked in the vicinity regularly before and after the Great War. The self-taught historic and contemporary marine painter, LESLIE ARTHUR WILCOX, turning to marine art in his early 40s, lived at Rushington, approx. 3 miles W. of Worthing. A watercolourist, WALTER JOHN BRAZIER, pupil of EDWARD WESSON, studied at Worthing School of Art and Brighton, in 1946, and with an interlude of crewing minesweepers during the Second World War has lived and painted at Worthing. A landscape and coastal painter, PHILIP PADWICK, painted some of his last pictures at Worthing and Littlehampton, 4 miles W., in 1957, before his death in 1958. A watercolour painter of beach scenes, ROBERT WILLIAM A. JESSEL, lived at Worthing, exhibiting with the R.S.M.A. during the 1970s in his 80th year. RICHARD HALFPENNY, painter of historic steamships and naval aviation, lives at Worthing.

Index

References to illustrations are shown in italic